LITTLE
BY
LITTLE

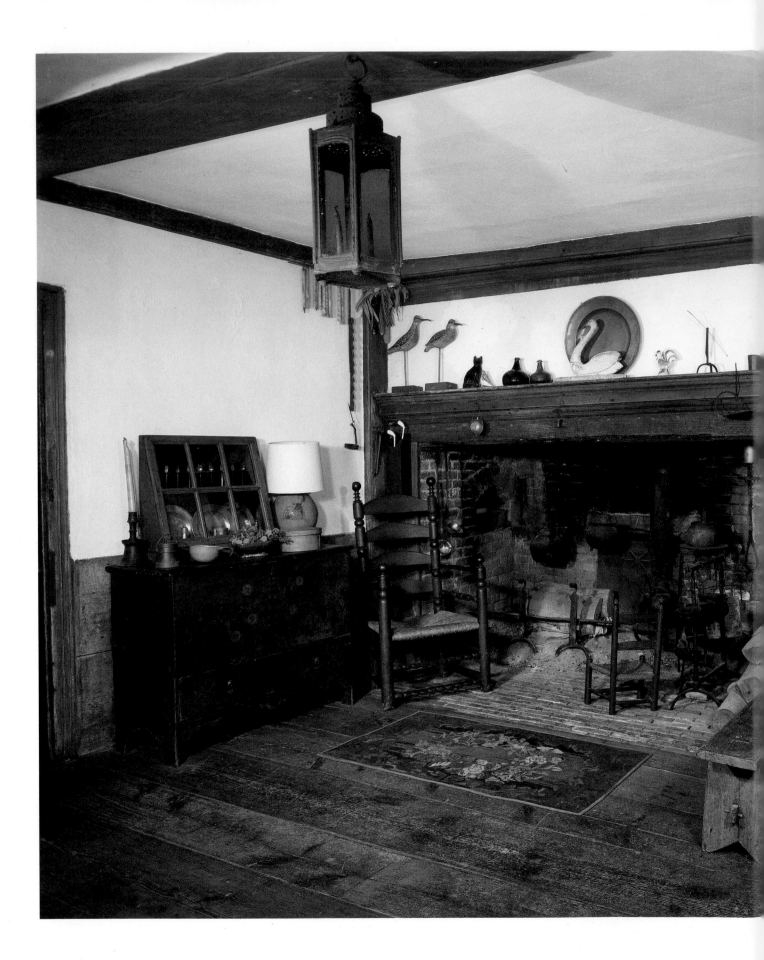

LITTLE
BY
LITTLE

Six Decades of Collecting
American Decorative Arts

Nina Fletcher Little

E. P. DUTTON, INC.
NEW YORK

BOOKS BY NINA FLETCHER LITTLE
American Decorative Wall Painting 1700–1850 (1952; enlarged edition, 1972)
The Abby Aldrich Rockefeller Folk Art Collection (1957)
Early Years of the McLean Hospital (1972)
Country Arts in Early American Homes (1975)
Neat and Tidy: Boxes and Their Contents Used in Early American Households (1980)

(Overleaf, pages ii–iii): Kitchen fireplace in our early-eighteenth-century farmhouse. W. 8′6″.
(Overleaf, page vii): Illustration from the journal of Alfred Abell, Lempster, New Hampshire, c. 1837. Ink and watercolor on paper, 2¾″ x 7½″.

Unless otherwise indicated, all of the color plates and black-and-white illustrations in this book are by Richard Merrill.

Rufus Porter's signature, illustrated in the introduction to this book, is reproduced from *Rufus Porter Rediscovered* by Jean Lipman by permission of Clarkson N. Potter, Inc. Copyright © 1968 by Jean Lipman.

Book design by Marilyn Rey

First published, 1984, in the United States by E.P. Dutton, Inc. / All rights reserved under International and Pan-American Copyright Conventions. / No part of this book may be reproduced or transmitted in any form or by any means, electronic or mechanical, including photocopy, recording, or any storage and retrieval system now known or to be invented, without permission in writing from the publishers, except by a reviewer who wishes to quote brief passages in connection with a review written for inclusion in a magazine, newspaper, or broadcast. / Published simultaneously in Canada by Fitzhenry & Whiteside Limited, Toronto. / W / Published in the United States by E.P. Dutton, Inc., 2 Park Avenue, New York, N.Y. 10016. / Printed and bound by Dai Nippon Printing Co., Ltd., Tokyo, Japan. / Library of Congress Catalog Card Number: 84-70630. / ISBN: 0-525-24265-1. / 10 9 8 7 6 5 4 3 2 1 First Edition

In affectionate memory of
Edna Little Greenwood
whose knowledge and enthusiasm
inspired our lifelong interest
in collecting New England country arts

Contents

Bert and Nina with Jack's 1930 Model A Ford

Foreword

Visitors to historic American houses or museums with collections arranged in pe-
riod rooms often conclude that although they may be nice places to visit, no one
would want to live there. Somehow, the houses generally seem formal and un-
comfortable. We are sure that those of you who have had the pleasure of visiting
our parents have found just the opposite. Although the houses in which we were
raised and have enjoyed much of our lives were certainly different from those of
most of our friends and neighbors, they gave off a feeling of warmth, of infor-
mality, and especially of *home*. It never occurred to us that others did not eat off
blue Staffordshire plates or use old leather firebuckets for waste baskets. Our ma-
ternal grandfather used to complain, "Nina, there's not a single comfortable chair
in this house!" In our youth, we were less aware of this than of the firm admoni-
tion *not* to tip back in the chairs.

Early memories of our parents' collection include the use of warming pans (fig. 34) and snooty eagle carvings. Boxes stumped us with ingenious locks, and a wooden duck hanging from the ceiling in the living room was (and still is) bedecked with mistletoe at Christmas (fig. 231). A grandfather clock (fig. 17) went "ka-stink" on the hour instead of chiming mellifluously (it had a cleft bell). A Grand Banks schooner's foghorn brought us in to meals on "lucky" or "unlucky" plates decorated with Salem clipper ship portraits (the luckies were ships that had been connected with the family, while the unluckies had forbidding, strange names). However, all of this seemed pretty normal to us. As we grew older, we became more interested in the ever-changing group of sometimes grim-faced portraits—many of them of the "finger up" (fig. 160) or "finger down" variety (fig. 158). These "wall-to-wall primitives" often seemed to admonish convivial family gatherings and to provide uncomfortable moments even in the bathrooms. The "W.C." collection did not refer to watercolors in *our* family!

Later on, we appreciated our parents' forbearance toward our own collections of quite different sorts of "antiques," including old radios, phonographs, stuffed animals, Scotties, and even ancient automobiles (although they suggested that postage stamps, for example, were much easier to store when it came time for them to find spaces for their own cars in the driveway). Obviously the collecting bug is highly contagious and is no respecter of persons or purses.

Through the years, we have been privileged to meet many interesting and distinguished people in the antiquarian field, a number of whom brought with them items from their own collections to discuss with our parents and, in some cases, to offer them for exchange or sale. Dinner-table conversations are still sparked by discoveries of historical puzzles, or the way in which new additions tie in with previous purchases. Debates over the authenticity of various pieces also provide food for discussion.

Our parents somehow always seemed to be ahead of other collectors, in whatever field it might be: miniature china, painted furniture, wooden weathervanes, decoys, amateur landscapes, or folk portraits. Such things found their way into our family homes before many others were collecting and writing on them, or before they had become the subject of an exhibition. Each piece had a past (carefully annotated, in most cases, on an attached jelly label) or was begging for further research. Each object found its proper niche in the Littles' collection, but it was a long time before we noticed that chairs, rugs, and small accessories could often be seen in the folk art paintings hung above them.

Our parents' collection has always been a dynamic one. Some familiar faces are now in museums, and many pieces have been gathered by them since we moved into our own homes. The variety of furnishings, as well as our early obliviousness to them as a "collection," has made this book fascinating reading for us. Those of you who know Bert and Nina Little, or have helped them to collect, or have added to their knowledge, will surely find this chronicle as interesting as we have. Many more of you, however, will simply enjoy learning how, over a period of more than half a century, a couple have put together a remarkable collection—little by little—for fun and intellectual stimulation.

JOHN B. LITTLE
SELINA F. LITTLE
WARREN M. LITTLE

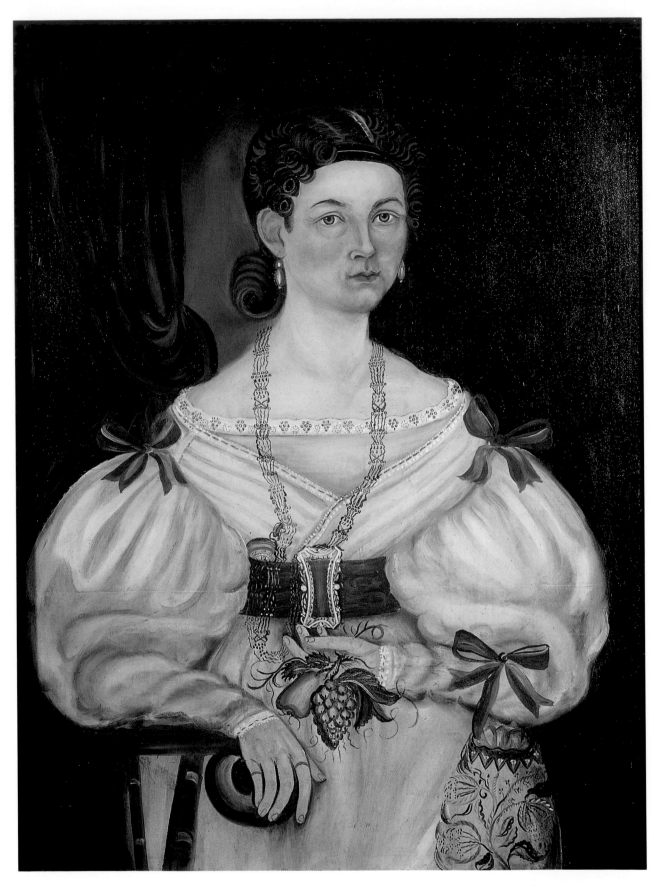

Eliza Ann Farrar, Worcester, Massachusetts. Attributed to Asahel Powers of Springfield, Vermont, c. 1834. Oil on canvas. 34½″ x 25½″. Powers was an itinerant artist noted for his decorative compositions and unusual accessories. This portrait is one of five of the Farrar family in our collection, including Eliza's parents, a brother, and an aunt.

Introduction

Perhaps the easiest way to establish the genesis of our collection and, incidentally, to explain my part in this chronicle is to state that I, Bert, spent most of the first twenty years of my life in Salem, Massachusetts, as one of a lively family of five, with a father who had a craftsman-type workshop at the back of our house. In it, during my years between nine and eleven, I sat for hours watching him *conserve* (the present-day word for it) varied items of early furniture and metalware, and, even more intriguing, fashion both reproductions of period tea services and create pieces of his own design from flat sheets of silver. In addition, on weekend afternoons, he would take me with him on walks about Salem, particularly along streets near the harbor, stopping occasionally to see a friend's home, sometimes quietly indicating pieces of old furniture he had refurbished, or to talk with an old crony in a cobwebby sail loft or warehouse on the waterfront and get him to tell stories of his voyages during the last of Salem's shipping days. These experiences, enlarged by Father's many references to dates and details, planted the seeds of my interest in houses and furnishings of an earlier time.

Soon after our marriage, Nina and I found a mutual interest along these lines. My part was largely in driving us all over New England, when I was free on weekends, to photograph with my small camera some of the houses from which objects in our collection had come. Also, I would record (from carefully prepared notes) whatever I could look up in libraries or public records offices. One thing I think readers will soon discover is that we never felt we were making a collection in the formal sense. Rather, as anything exemplifying an element in an earlier American way of life caught our combined attention—from furniture, folk art, and ostrich eggs, through domestic utensils and decoys, to lighting devices—we acquired the item if it was of good quality and then fitted it into our daily life and study. At one period, we had a special interest in picking up various lighting devices and arranging them as accents, if you will, all over our home. However, a fellow member of the Rushlight Club was reported to us as having expressed disappointment at "not having been shown" our collection during his afternoon's visit. Although there are usually an average of four lighting items to be found in almost every

room, his reaction clearly demonstrates our philosophy of arranging our pieces informally. Our collecting experiences have not only been great fun but also a very real education, and it has always been a pleasure to share them with others.

As a young married couple in the mid-1920s, Bert and I lived in a modest apartment in Cambridge, Massachusetts, but we soon began to look for a small house in the country in which we could spend out-of-town weekends. Bert was an enthusiastic member of the Society for the Preservation of New England Antiquities, and he suggested that we hunt for an early cottage as being more interesting than the one-story bungalows that were then popular. After a few months' search, we found just what we were looking for: a little 1825 house, completely unrestored, about thirty-five miles west of Boston. There, during the coming months, we learned the basics of early building construction, and I even penned my first-to-be-published article, titled "Restoring the Personality of an Old House."

Immediately, however, we were faced with the question of furnishings. When we discussed this problem with Bert's cousin Edna Little, who lived nearby (later Mrs. Arthur Greenwood, whose fine collection of Americana is now in the Smithsonian Institution), we said that antiques seemed to be too expensive for our budget. She disagreed, replying that if I would accompany her to little-known local shops and small family auctions, I could pick up simple old pieces for less than modern copies. This I eagerly did, and so began our collecting of New England country furniture and related decorative arts.

Every serious collector develops a personal philosophy (even if unconsciously) that guides the choice and scope of his or her acquisitions. Some concentrate on specific categories, such as Chinese export porcelain, handmade quilts, or Victorian furniture. Others collect to improve the quality of their current holdings, gladly disposing of earlier purchases if better examples become available. To many, the aesthetic appeal of the objects is paramount; to others, research into the background of a piece is as exciting as ownership.

I purchased the colorful box illustrated here (fig. 1) in the days before painted decoration had received much attention. The surface was covered with dirt and old varnish that obscured the details of the brush strokes and the brightness of the colors. The box and an accompanying small portrait were found together at an antiques show. On the back of the portrait was an old strip of paper inscribed in pen and ink: *Rufus Porter, who died Dec. 21 1834 AE 25.* Although I realized that the date of death was an error, I jumped to the conclusion that this was a treasure, a youthful likeness of the famous fresco painter (1792–1884). Careful hunting in an 1878 Porter genealogy established the disappointing fact that the Rufus Porter of the picture belonged to another family. He had been born in North Falmouth, Maine, in 1810 and apparently had no close kinship with Rufus the decorator. After several years, I decided to have the box cleaned. The cleaning revealed that the style of lettering on the lid closely parallels Porter's known signature (fig. 2), which appears on a wall formerly in the Emerson house in Wakefield, Massachusetts. The designs also are typical of some of those seen in Porter's work. The box seems to have been inscribed by Porter as a gift to Pauline (King) Porter (wife of the artist's first cousin), after whose brother Rufus King he named his second son.

Time and space do not permit discussion and illustration of many of the items owned by us, nor would doing so be desirable, as comparable examples are to be found in other public and private collections. We have therefore chosen represen-

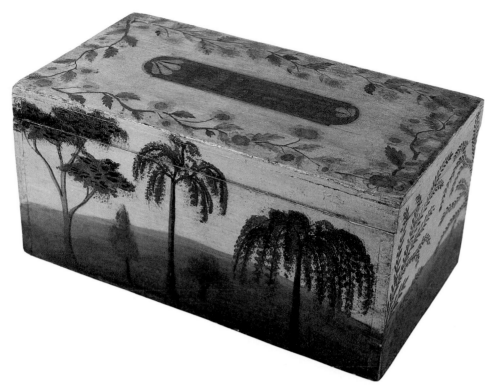

1. Box with painted decoration. Attributed to Rufus Porter. Lettered on the cover: *P, Porter.* 1835–1840. W. 13¼″, H. 6½″. Probably painted as a gift to the artist's cousin-in-law, Pauline Porter.

2. Rufus Porter's signature on a mural of 1835–1840 in the Emerson house in Wakefield, Massachusetts.

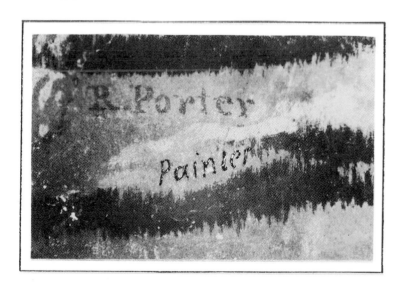

tative pieces in many categories that have become especially valued by us for their rarity, their significant documentation, or the memorable circumstances involved in their acquisition from one or another of the loyal dealers, past and present, who have offered their treasures to us over the years. We hope that those who read these pages will find interest in our selections and will pass on to others the chronicle of their own collecting experiences.

LITTLE
BY
LITTLE

I

The Lighthearted Twenties

The 1920s were a stimulating time for young collectors about to embark on the uncharted sea of acquiring antiques. Although the restrictions of World War I had only recently ended, Prohibition, bringing with it a strange new life-style, was in full swing. Speakeasies, silver purse-flasks, abbreviated skirts, and cloche hats were all part of a brief period of high prices and gay abandon, whose hectic tempo was symbolized by the popular hit "Ain't We Got Fun."

In the 1920s, the so-called horse-and-buggy days had come to a close following the full development of the motorcar. In its wake came greater and faster mobility that signaled the end of the era when amateurs could hope to find good antique furniture on almost any country porch, or to pick up valuable china being used for the kitty's milk bowl. Dealers, of course, knew where to find plenty of good merchandise at the source, but for the neophyte, small out-of-town shops and country auctions provided the best opportunities to observe, acquire, and learn.

Reference books, then as now, were a girl's best friend, and one of my first purchases was accomplished through this medium. One rainy afternoon in the winter of 1927, I discovered in the Cambridge Public Library a copy of N. Hudson Moore's *Old China Book* with a copyright date of 1903.[1] Within a few short hours, I became so fascinated by the subject that, although I did not know it then, the study and collecting of ceramics would become one of my lifelong interests. What first caught my eye in Mrs. Moore's compendium were the illustrations of early-nineteenth-century American scenes printed on dark blue English Staffordshire pottery. This ware, although then entirely unknown to me, had enjoyed increasing popularity since the appearance in 1878 of a chatty volume titled *The China Hunters Club*, authored by "The Youngest Member."[2] In October 1901 appeared the first issue of an absorbing monthly periodical called *The Old China Magazine,* which continued through September 1904 and specialized in "old blue" made for the American market.[3] After this time, historical Staffordshire became an important collectible, and interest in it by a specialized group of avid collectors has never abated.

The Magazine Antiques began publication in Boston in January 1922 and has since

been the bible of all aspiring collectors. Its informative articles, valuable illustrations, and new and exciting research are still eagerly awaited on the first of each month. We have been privileged to know well the three distinguished editors—Homer Eaton Keyes, Alice Winchester, and Wendell Garrett—who guided the magazine during its first sixty years and have graciously accepted for publication some forty-five of my articles since 1938.

To return to 1927, I read eagerly Mrs. Moore's descriptions of blue-printed earthenware and decided I should like to be venturesome and own at least an example. There was, however, one big problem. I had never actually seen a piece and therefore did not know exactly what I was looking for! One day in the spring, I visited a small shop in Ipswich, Massachusetts, and caught a flash of blue in a shadowy corner. After hesitant investigation, I emerged triumphantly bearing a shallow 9¾" bowl with a beaded edge that pictured *Table Rock, Niagara* in the bottom and a *Catskill Mountains, Hudson River*, scene around the outside (fig. 3). This prize cost me $17.50, even at that time a modest price. The bowl was the precursor of many other blue Staffordshire treasures that came my way during the next few years. Plates were then the items most in demand and could be attractively arranged out of harm's way on an old-fashioned plate rail (fig. 4). My taste also ran to hollowware, and I soon discovered that soup and gravy tureens were going begging because soup served at the table had long since gone out of style and tureens that required space were hard to display. Figure 5 illustrates an old family sideboard exhibiting a group of blue-printed tureens, with accompanying ladles and trays.

Important series of dark blue Staffordshire pottery decorated with American scenes were made by a number of English factories between 1818 and 1830. Several firms issued only a few views each, and the makers of others are still unidentified. Most of the "old blue" intended for export to this country came in the form of tableware, and each maker adopted one or more distinctive borders by which his tea and dinner sets could be easily recognized. Some of the historical views have now become very scarce, and when they appear printed on certain forms of tableware, they are considered extremely rare. In figure 6 is arranged a selection of small, desirable pieces that includes views of *St. Paul's Chapel* (New York) with a medallion of Thomas Jefferson; *Vevay* (Indiana?); *Catholic Cathedral* (St. Patrick's on Mott Street); and the *Boston State House* by Ralph Stevenson & Williams. Many potters issued various series of fine English views that, although much less valuable in America, are handsome and eminently collectible. I was delighted when I found the still-life picture in figure 7 because it exhibits flowers arranged in a blue Staffordshire vase decorated with a view of an English country house.

I think most collectors will agree that it is the antiques one did not buy (and should have) that remain the longest in memory and cause the greatest regret. This fact was brought home to me at one of the first antiques shows I ever attended, and even then I should have known better. Soon after entering the hall, I spied a Staffordshire *Hartford State House* cup and saucer by Andrew Stevenson. Although I knew the view was very rare, I was young and felt it imprudent to spend my money on the first object I saw, so I decided to look around before reaching a decision. As you have no doubt guessed, the cup and saucer vanished before I returned. I have never found another at that price to buy, nor have I ever ceased to regret my procrastination. Now, at an antiques show preview, I seldom let a coveted piece out of my sight until I have definitely made up my mind.

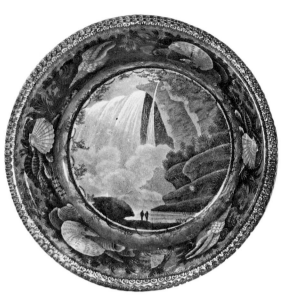

3. Two blue-printed Staffordshire bowls, England. Left, *Table Rock, Niagara*, Enoch Wood & Sons, 1820–1825. Diam. 9¾". Right, *United States Hotel*, Philadelphia, Tams, Anderson & Tams. 1826–1830. Diam. 10¾".

4. Group of blue Staffordshire pieces, England, 1820–1830. On plate rail, from left: *Governor's Island*, Andrew Stevenson; *Church and Buildings Adjoining Murray Street*, Andrew Stevenson; *Louisville, Kentucky*, Clews; *Capitol at Washington* with *Aqueduct Bridge at Little Falls* and portraits of Jefferson and Lafayette, Ralph Stevenson; *New York from Brooklyn Heights*, A. Stevenson. On sideboard, from left: Pitcher, *"Welcome Lafayette . . ."*, Clews; soup tureen, tray, and ladle, *Landing of Lafayette*, Clews; pitcher, *Mount Vernon, Seat of Gen. Washington*, maker unknown. Above: Watercolor of the ship *John Bertram*, after Clement Drew.

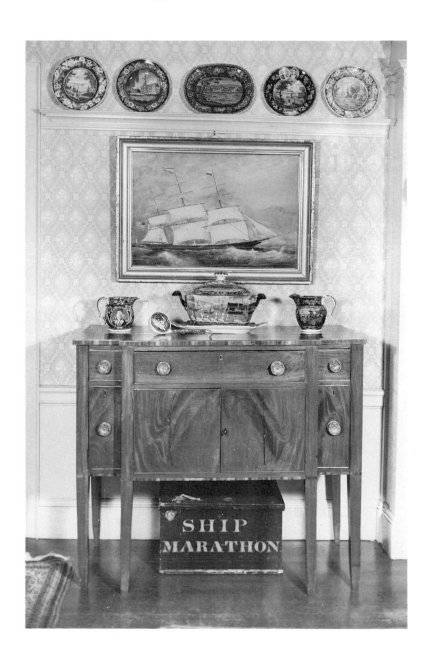

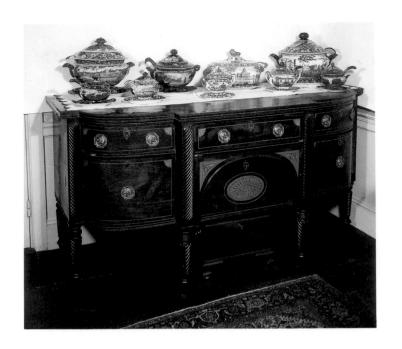

5. Sideboard with soup and gravy tureens, 1820–1830. Soup tureens from left: *Upper Ferry Bridge*, Stubbs; *Belleville on the Passaic*, Wood; *Boston State House*, Rogers; *Caius College, Cambridge* (England), Ridgway. Gravy tureens from left: *Fulton Market*, Ralph Stevenson; *Upper Ferry Bridge*, Stubbs; *Boston State House*, Rogers; *Exchange, Charleston*, Ridgway; *Passaic Falls*, Wood.

6. Group of desirable small blue Staffordshire pieces, 1820–1830. Top: Plates, *St. Paul's Chapel*, with medallion of Thomas Jefferson, and *Entrance of Erie Canal at Albany*, Ralph Stevenson and Williams; *Vevay* (Indiana?), maker unknown; *Borham House, Essex* (England), with medallions of Washington and Clinton, Andrew Stevenson. Center: Cup, *University of Maryland*, maker unknown; sauce boat, *Catholic Cathedral, New York*, Andrew Stevenson; pickle leaf, *Arms of South Carolina*, Mayer; custard cup, *Fulton Market*, Ralph Stevenson. Bottom: Cup plates, *Boston State House*, Ralph Stevenson and Williams; *Woodlands near Philadelphia*, Stubbs; *Philadelphia Custom House*, Ridgway; *Staughton's Church, Philadelphia*, Ralph Stevenson and Williams.

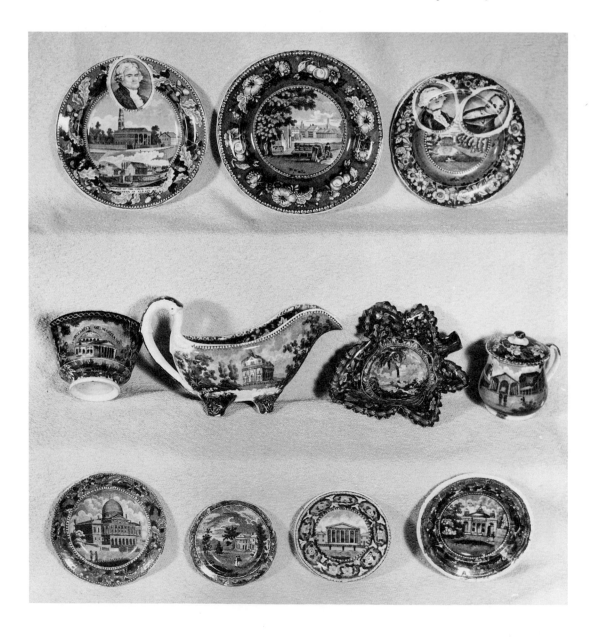

My husband and I soon decided that there was no environment more congenial to the enjoyment of our budding collection of antiques than an old house of appropriate period. During the early years of our marriage, we lived in a small in-town apartment, but for use on weekends and holidays, we invested in a tiny cottage in Hudson, Massachusetts, thirty-five miles west of Boston. Built around 1825, the little house was just what we wanted. It had never suffered the indignities of plumbing, heating, electricity, or telephone, and in it, our sparse furnishings looked completely at home. During the next few months, we learned the basics of country living as it was experienced a hundred years earlier: how to build a fire on the hearth that would burn briskly on days so cold that tomatoes froze hard as golf balls on the pantry shelves; how to prime the antiquated kitchen pump that was the sole source of water in the house; how to wash dishes for a crowd using only a single kettle of water heated on the kitchen stove; how to react when a garden snake was discovered peacefully shedding its skin under the boxed-in kitchen sink; and how to cope with many other practical aspects of daily life within the period of the house. Looking back at an account book I kept at the time, I see that our first purchase was a much-needed "antique oil lantern." Bert's brother-in-law painted the charming view of Little Acres as it appeared in the late 1920s (fig. 8).

The most important piece we ever bought for the cottage was a large pine "North Shore" dresser, and we soon began to pick up an occasional example of New England pottery to fill its scalloped shelves (fig. 9). Redware jugs and jars were then easy to find, although rarer forms began to emerge later, following the research of Lura Woodside Watkins and the publication of her book, *Early New England Potters and Their Wares* (1950).

Identification of all our pieces, whether by means of marks, family history, or documentary research, has always been of primary interest to me and has opened up absorbing fields of study. New England redware, for instance, is seldom marked, so the acquisition of the jar in figure 10 was particularly exciting. The interior is glazed, but on the exterior, the clay is incised with the following curious legend: *May ye 8 1739 JD hur Jug price 2s 6d Give me to make with your hand and I will fill it if I can.* A handwritten letter accompanying the piece states that it was made for his wife by one John Day of Pownal, Maine, and thereafter descended through six generations of Day family daughters.

The large bowl and two mugs illustrated in figure 11 are believed to be products of the small Lowell pottery in Orange, New Hampshire, carried on by three generations of the family from 1818 to 1872. Written in the glaze of the bowl is the name *Hazen of Orange N H,* a small town located midway between Bristol and Lebanon. One Jesse Hazen is said to have worked in the local pottery in the early period, when he managed to identify his handiwork in this unusual manner.

Before the middle of the seventeenth century, red earthenware made from local clay was to be found in Massachusetts homes. One of the earliest kilns for baking was built in Salem, to which the Reverend Francis Higginson referred as follows in July 1629: "It is thought here is good clay to make Bricke, and Tyles and earthen pots, as need to be."[4] Milk and pudding pans, jars, porringers, and platters were some of the "earthen" vessels recorded from 1675 to 1681. These forms, in addition to bowls, mugs, baking dishes, pie plates, collanders, and chamber pots, continued in use until the mid-nineteenth century. Shining lead glazes with striking variations in color characterized most of the better pieces, and others were enhanced by slip decoration derived from white pipe clay (fig. 12). Early pieces

sometimes bore incised lines or wavy bands made with a sharp, pointed tool or a small metal comb, before glazing (fig. 11). Notched rims were accomplished through the use of a coggle wheel. The group of pottery-making tools in figure 13 includes a stilt, slip cups, a plate mold, and a wooden coggle wheel.

An overview of the past half century indicates that collecting has followed many different trends. Some categories have diminished in interest while others have accelerated to an amazing degree. In the 1920s, most young antiquarians felt that their homes were not complete without a warming pan beside the hearth, a spinning wheel in the parlor, a patchwork quilt on the bed, hooked rugs on the floor, and a ship in a bottle on the windowsill. Refinished pine corner cupboards were also in such demand that convincing examples newly made up of old or reused wood often presented serious problems of authenticity to the unwary.

Warming pans are no longer a "must" in every home, although they still provide gleaming spots of decoration. Especially to be desired are the eighteenth-century examples with large brass lids that completely cover the iron pan below (see fig. 34, right). But the joy of a warming pan can never be fully appreciated until a person has used one for its original purpose by filling it with hot fireplace coals and running it between the bedcovers in a cold, unheated room. "Warming panns" were in common use in England before the Pilgrims left their native shore, and their use was perpetuated in the Colonies as long as fireplaces provided the only bedroom heat. Although many pans were imported from England along with other metal goods, some were made by braziers working in New York City. On November 19, 1744, *The New-York Weekly Post-Boy* ran an advertisement by one John Halden, Brazier from London, stating that he made and sold "Warming-pans and all other Sorts of Copper and Brass Ware."

The pans most often seen today are made of brass, or occasionally of copper, with lids that fit snugly within an outer rim, and they are fitted with well-turned wooden handles. Unfortunately, few bear family histories or other identifying marks, so the example in figure 14, bought in 1966, appears to be unique. It is a rare experience when a single artifact is able to re-create in imagination the essence of a given historical period.

The ancient Bell Tavern was a famous hostelry well known for gay parties. Before its demise after the mid-nineteenth century, it stood at the intersection of Main and Washington streets in Danvers (now Peabody), Massachusetts, on a "great thoroughfare" that led from the east and north into Boston. On September 11, 1759, Francis Symonds petitioned for a license, stating that he lived "on a Varry Grate Corner." Besides being the landlord, he was a local poet, a dealer in chocolate, and an active patriot during the Revolutionary War. All the officers of the First Regiment in Essex County were requested to assemble at the house of Mr. Francis Symonds, Innholder, in February 1775, in anticipation of trouble to come. Soon the Bell Tavern was a rendezvous for forces pushing toward Lexington on April 19, and two months later the Salem regiment under Colonel Timothy Pickering stopped there for refreshment during their march to the Battle of Bunker Hill.

After the war's close, the citizens of Danvers evidently wished to present Symonds with a token of their esteem and decided on a warming pan as a practical gift. From the inn's signpost hung a wooden representation of a bell inscribed with the couplet: "I'll toll you in if you have need/ And feed you well and bid you speed." Below the bell, a second signboard read: "Francis Symonds makes and

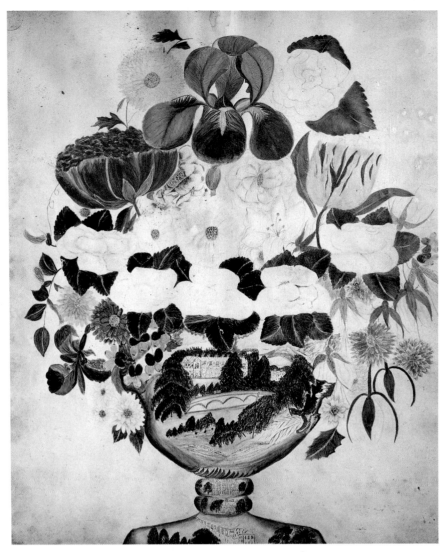

7. Still-life picture of flowers arranged in a blue Staffordshire vase, painted by Maria S. Perley, Lempster, New Hampshire, c. 1840. Watercolor on paper. 17¼ x 14″.

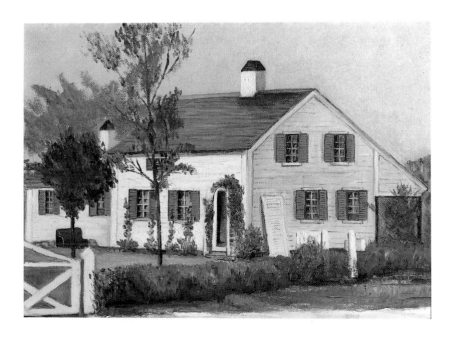

8. *View of Little Acres*, Hudson, Massachusetts, by Talbot Aldrich. Oil on canvas. 10″ x 14″. Our first small house in the country as it looked in the late 1920s.

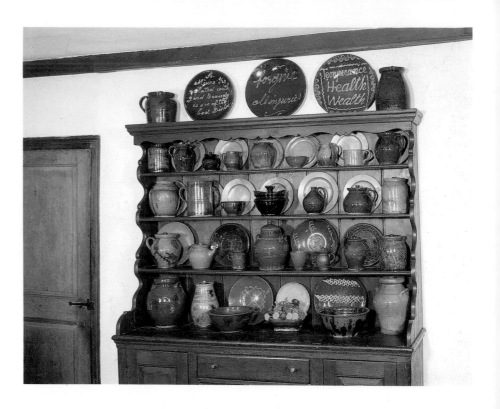

9. Pine "North Shore" dresser, c. 1790, with New England redware pottery. H. 80¼", W. 63½". One of the first pieces of antique furniture we purchased, in 1928. We subsequently decided that the upper section was a replacement.

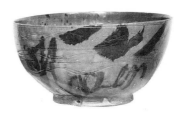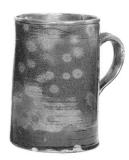

11. Three pieces of redware made in Orange, New Hampshire, 1820–1830. Black glazed mug at left, H. 7½". Written in glaze on the bowl, *Hazen of Orange NH*, Diam. 10½". Mug at right, green and yellow glaze, H. 8".

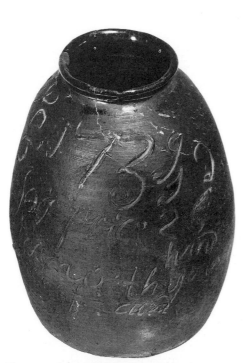

10. Very early redware jar made by John Day, Pownal, Maine, 1739. H. 10". Incised on the exterior: *May ye 8 1739 JD hur Jug price 2s 6d Give me to make with your hand and I will fill it if I can.*

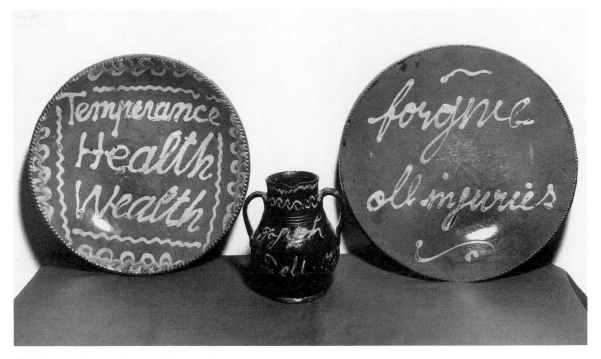

12. Two redware plates with amusing mottoes in white slip. Diam. 13″ and 14½″. The three-handled red-ware pitcher is marked in slip *Joseph Goodell 1788.* H. 7″. Joseph Goodell was born in 1735. His son and grandson lived in Orange, and the pitcher may have been made there as a presentation piece to mark an anniversary. The piece was sold at a family auction in nearby Winchester, New Hampshire, with a history of having descended in the owner's family since 1800.

13. Group of nineteenth-century Pennsylvania pottery-making tools. Top row: Stilt or cockspur for stacking plates in a kiln; marzipan mold; cup used for pouring slip at Thomas Haig's Old Pottery in Philadelphia. Depressions on both sides were shaped to accommodate the potter's thumb and fingers. Second row: Slip cup with multiple pouring spouts, originally fitted with goose quills, to produce four parallel lines of slip decoration; plate mold impressed *John Bell 1857;* wooden coggle wheel that produced notching on the rims of large dishes (see fig. 12).

sells/ The best of Chocolate also Shells." Each of these verses is engraved on a different side of the pan, one of which is accompanied by an outline of the bell (fig. 15). But complete documentation is found on the lid (fig. 14), on which is engraved in different areas the following legends: *Bell Tavern, Danvers, Massachusetts: Francis Symonds Esq. Inn Keeper and Poet: Patriot and Friend of Washington:* and in the center, *From the Townspeople.*

If warming pans and spinning wheels have not reached the greatest heights of collectibility during the last fifty years, this is not true of quilts and coverlets, which have become increasingly sought after since the 1920s. My first quilt was made from various squares of patchwork combined in no recognizable pattern. It was found in a small shop in North Sandwich, New Hampshire, and looked "old-fashioned" on my four-poster bed. Before long, I invested in a second quilt; this one had printed squares alternating with white areas, on which the names of girl friends of the maker were gracefully handwritten in black pen and ink. This was the simplest form of "friendship" quilt, but I remember it with nostalgia because, along with my cherished flax wheel, it unfortunately disappeared in the only illegal entry we ever had at the cottage. For some time after this occurrence, I felt nervous when alone at night in the house. One late spring evening, I heard strange, unfamiliar rustlings outside, and when I crept to the window, I saw several odd shapes moving about on the grass. However, dawn revealed to one unused to country sounds three neighboring cows that had strayed from home and were peacefully munching in greener pastures than their own. During the early 1950s, many really exciting coverlets began to come our way, and these are illustrated in appropriate sequence in Chapter VII.

In the early 1920s, hooked rugs were popularly believed to date from Colonial days, meaning any time from 1700 on, and were therefore considered the most suitable floor coverings for old interiors of any period. Most hooked rugs were hooked on burlap after 1850 and were made by late-nineteenth-century housewives using long cotton or woolen strips saved from other domestic fabrics. In the 1920s, so-called scatter rugs were to be found stacked in tempting piles in most of the smaller shops, many of which had certainly originated in Canada only twenty or thirty years before. But they had some age, if not antiquity, and when they were carefully selected, the hooking was of high quality, the floral patterns were well designed, and the colors rich but seldom garish. In our home, the rugs I bought in the 1920s have outlasted more than fifty years of service and still give comfort to the feet and pleasure to the eye (fig. 16). I eventually discovered that some of the "hooked" rugs we owned were not hooked at all, although *hooked* is still in use as a generic term. Earlier in date and more fragile in workmanship, these other rugs were created with a needle and are now known as *yarn-sewn* or *shirred* according to the techniques by which they were made. As the interest in coverlets gained impetus in the 1950s, so did the study of homemade rugs, and at that time, a number of representative examples were added to our collection and will be discussed in Chapter VII.

September 25, 1929, witnessed a significant event in the collecting world: the opening of the Girl Scouts Loan Exhibition, held for two weeks in New York City at the galleries of the American Art Association. Over nine hundred pieces were on loan from many of the greatest private collections of American decorative arts, comprising the highest quality furniture, paintings, prints, ceramics, glass, and textiles. This exhibition was one of the first to illustrate the range and quality of

American antiques that existed in a field that we young people were just setting out to explore. At the end of the same year occurred another event that was destined to be one of the first in a still-continuing series that has become of great importance to the field of collecting. The November 1929 issue of *The Magazine Antiques* carried a full-page announcement that read in part as follows: "Boston Antiques Exposition at the Hotel Statler, December 9th to 13th, this important event offers an unparalleled opportunity to view at one place and time some of the most noteworthy antiques in America." We, with many other enthusiasts, attended this pioneer antiques show, and I came happily home with several desirable pieces of "old blue" to add to my growing collection. But even as these memorable exhibits and sales were taking place, the lighthearted era of the 1920s had already ended, and with the advent of the Great Depression came an inevitable change in the perspective of the young collector.

14. Warming pan presented to Francis Symonds, innkeeper of the Bell Tavern in Danvers, Massachusetts, c. 1785. Engraved on lid: *Francis Symonds Esq. Inn Keeper and Poet; Patriot and Friend of Washington.* In the center is engraved: *From the Townspeople.*

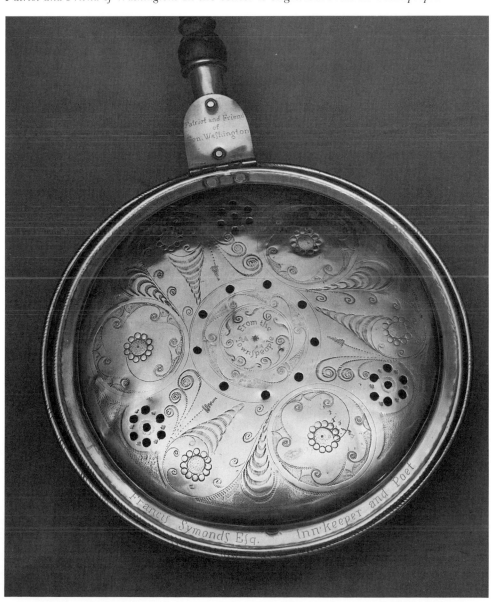

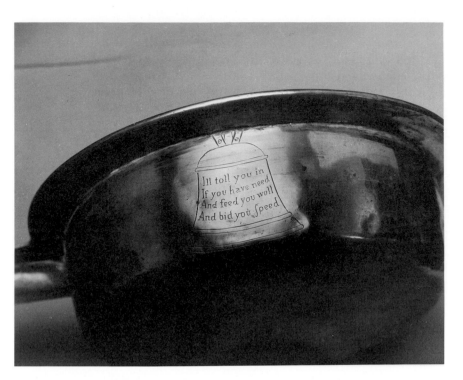

15. One side of the Bell Tavern warming pan, which bears the outline of the tavern's signboard, carved in the shape of a bell and carrying the couplet, "I'll toll you in /If you have need /And feed you well / And bid you speed."

16. Hooked rug purchased in 1927, late nineteenth century. 31″ x 61″. Rugs of this type were considered "antique" when they became popular during the 1920s.

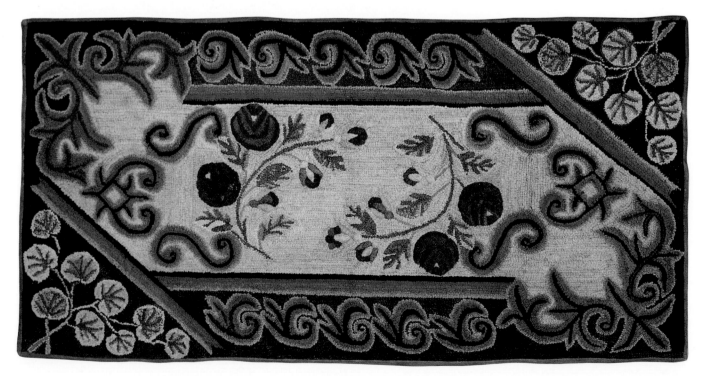

II
The Burgeoning Thirties

During the opening years of the 1930s, the impact of the Depression brought about a rapid change in the outlook of the new collector. Young and old were feeling the financial pinch, and some smaller shops were forced to close. Country auctions of household goods became widespread and were frequently worthwhile attending for those who still found themselves able to buy. Fortunately, the large antiques shows, which were soon to be held in several major cities, continued to prosper as they enabled exhibitors and collectors to meet under one roof and to examine a large range of carefully selected merchandise. In March 1930, New York City's second Antiques Exposition opened in Grand Central Palace with considerable fanfare, announcing itself proudly as "the greatest event that has ever occurred in the field of antiques in this country. Everyone interested in Antiques, Art, or Interior Design will be there." Unfortunately, Bert and I were not able to attend, but from 1935 on, I made annual pilgrimages to shows in New York and other places, and in addition to catching up on all the current antiques gossip, I was able to make many gratifying additions to our household furnishings.

One of the subjects that began to interest us at this time was antique clocks. This interest was not surprising as I had recently inherited a tall clock assembled by my great-great-grandfather, who had been a clockmaker in Bath, Maine, during the 1820s. John Masters had come from Devonshire, England, in 1787 to serve an apprenticeship with his uncle in St. Johns, Newfoundland. There he made and sold timepieces until the great fire of 1818 burned him out and he left Newfoundland, traveling to Boston and then on to Maine to ply his trade.

Our first purchase of a clock in 1930 was the piece shown in figure 17, which had never been moved from its position in the Captain Nathaniel Webber home in Gloucester, Massachusetts, since its installation by Simon Willard himself in the late eighteenth century. On the dial is lettered the following legend: *Warranted for Capt . . . / Simon Willard*. Miss Caroline Webber, the last descendant to live in the old house, knew the story behind this unfinished inscription. The clock was originally intended for a Gloucester sea captain and had been brought over the road from Roxbury by Willard himself. However, owing to several unsuccessful fishing

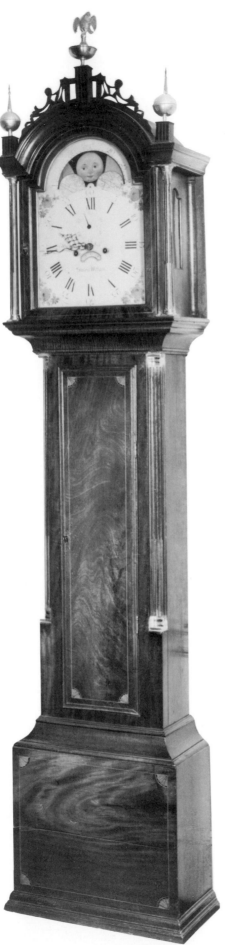

17. Tall clock by Simon Willard, late eighteenth century. H. 90″. A rare feature is that the name *Simon Willard* has been incised twice on the plate behind the dial. Originally installed in the Captain Nathaniel Webber house, Gloucester, Massachusetts, by Willard himself.

18. Inscribed on the dial, *Warranted for Capt . . . /Simon Willard*. Simon Willard's label inside the door of the clock in figure 17.

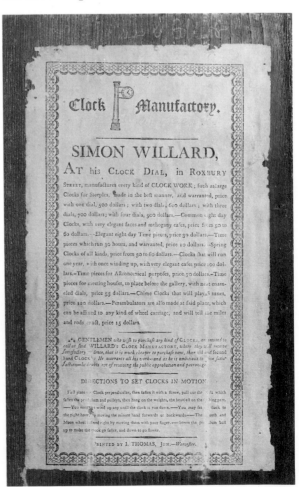

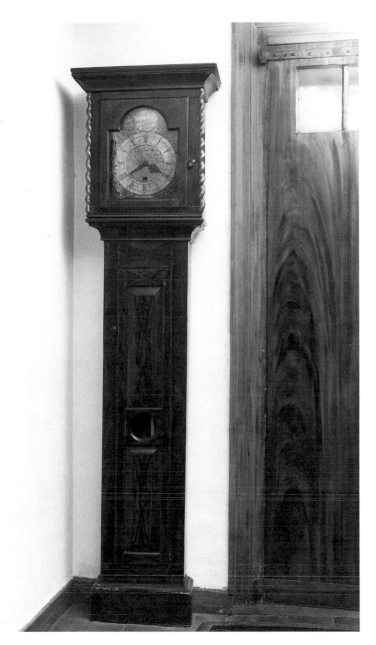

19. Tall clock inscribed by David Blasdel of Almsbury, Massachusetts, 1750. H. 81″. (Courtesy Peabody Museum of Salem; photograph by Mark Sexton)

20. Brass dial of Blasdel clock in figure 19. 13¾″ x 10″. Engraved at top: MADE BY/DAVID BLASDEL/IN ALMSBURY/MDCCL. (Courtesy Peabody Museum of Salem; photograph by Mark Sexton)

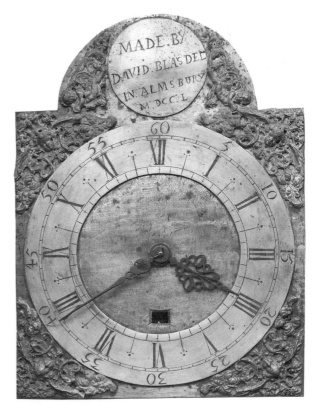

15

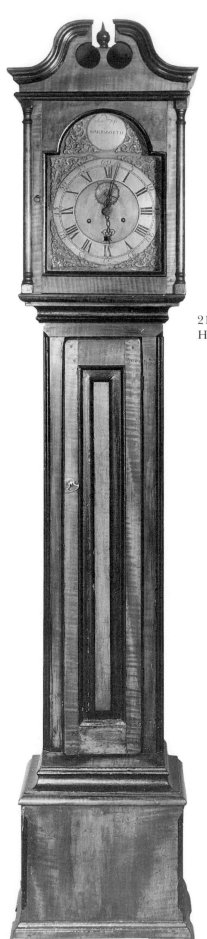

21. Tall clock by *John Foss,* /SOMERSWORTH, New Hampshire, 1772–1777. H. 81″.

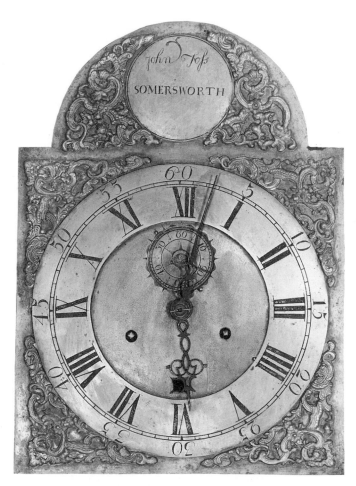

22. Brass dial of tall clock in figure 21. 14¾″ x 10⅝″. Engraved at top: *John Foss* / SOMERSWORTH.

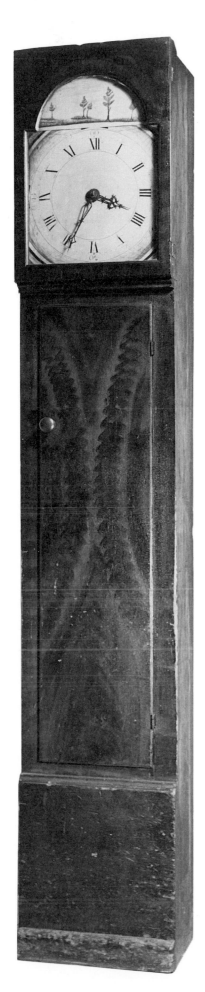

23. Tall clock by John Perkins, Fitzwilliam, New Hampshire, with wooden works, 1821. H. 81″. Cut into the back of one of the gears is the inscription: *September 18, 1821 / John Perkins / No. 67 / J P 73 / Fitzwilliam, N.H.* The names of several men who later serviced the works are penciled on the inside of the door. (Photograph by T. F. Hartley)

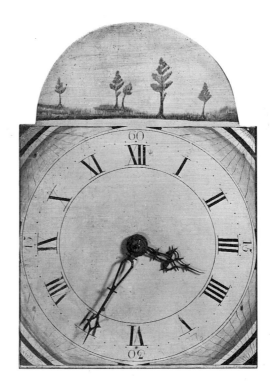

24. Dial of the Perkins clock in figure 23. 17″ x 12″. The ingenuous decoration of the five asymmetrical trees is particularly pleasing.

trips, the prospective owner refused to accept it, and Willard reluctantly started back toward Boston, peddling the clock from door to door. As he passed through Fresh Water Cove, Captain Webber came out of his house and decided to make the purchase. Willard set the clock in the low-ceilinged parlor, thus necessitating the removal of the center eagle, which remained put away for over a hundred years. Pasted inside the door is Willard's rare label (fig. 18), printed in Worcester, Massachusetts, by Isaiah Thomas, Jr.

The oldest clock we own was made by David Blasdel of Almsbury (Amesbury), Massachusetts, in 1750 (fig. 19). It is an interesting example, by a provincial Essex County maker, of which the dial, hood, and grain-painted case echo an English precedent of fifty years before. Blasdel was a blacksmith as well as a clockmaker and at the top of his embossed brass dial is incised the following: MADE BY/DAVID BLASDEL/IN ALMSBURY/MDCCL (fig. 20).

A more elegant appearance distinguishes the tall clock in figure 21. The original surface of its curly maple case is mellowed by age and enhanced by a black-painted center panel and moldings. Engraved on a circular boss at the top of the brass dial is the name *John Foss*/SOMERSWORTH (fig. 22). John Foss, son of Joshua, was baptized in Rochester, New Hampshire, on September 18, 1732.[1] He later lived for a time in Somersworth, which was part of Dover, New Hampshire, until it became a separate town in 1754. Foss was a pew holder at the time of building the new meeting house in 1772[2]; purchased part of the estate of one Ebenezer Wentworth at a vendue in 1773[3]; and is noted in a town record as having moved from Somersworth to Barrington, New Hampshire, on February 14, 1777.[4] He died in 1819 and was buried "in the ground of his father," probably a private family plot in Locke's Mills.[5] It seems unlikely that Foss spent a lifetime making clocks, as only one other (earlier in date) has come to my attention, through the kindness of Charles S. Parsons. Although the dial of that clock is similar to ours and bears the same maker's inscription on the boss, it has only one hand, and the tall, narrow pine case is unadorned.

Forty years later, in another small New Hampshire town, a father and son were making tall clocks fitted with up-to-date wooden faces. Robinson Perkins, the father, became a watch- and clockmaker in Jaffrey, New Hampshire, as early as 1795, after trying his hand as a blacksmith. In 1810, he moved to Fitzwilliam with his son John (1801–1832) and built the white-pillared mansion that still stands facing the common. Robinson marked his early clocks *R. Perkins/Jaffrey* with an identifying number on each dial, of which several are said to have been located by the Jaffrey History Committee many years ago. John, the son, was known as a schoolmaster and not as a maker of clocks, and it was only an unexpected circumstance that disclosed his connection with the piece in figure 23, as it bears no visible identification. One day, sometime after our purchase of the clock, two friends persuaded me, much against my better judgment, to allow them to take apart the wooden works. To everyone's amazement, a short verse from *Hamlet* was disclosed, cut into the back of one of the wooden wheels, accompanied by the following inscription: *B 67 - September 5th, 1821 / LXVII*. Following the removal of another wheel, an even more interesting inscription was revealed: *September 18, 1821/John Perkins/ No. 67 / J P 73 / Fitzwilliam, N.H.*

When the old building that had housed the Perkins clock shop was sold in the early twentieth century, the second floor was still full of odds and ends of clock-works, cases, and parts, which were eventually dispersed and lost from sight. As the inscriptions on the John Perkins clock were cut into the inside surfaces of the

wheels, where they could not possibly have been seen unless the works were dismantled, it is surmised that John assisted his father in making parts and, when so doing, could not resist the temptation to inscribe his name, the date, and the number of the clock on two of the wheels. The austere pine case is painted and grained, and penciled inside the door are the names of four different men who cleaned or repaired the works between 1842 and 1858, but unfortunately none of the names was local to Fitzwilliam.

After we acquired the John Perkins clock in 1938, I became increasingly aware of the interest and variety to be found in the painted wooden dials of the first quarter of the nineteenth century. Each one is different. Some exhibit naïve landscape views, such as the Perkins dial in figure 24. A few include ships or houses (fig. 25), and many display ingenuous still-life motifs, sometimes combined with the makers' names (fig. 26). Scant information is available concerning the painters of these country clockfaces. The statement has been published that Riley Whiting of Winchester and Winsted, Connecticut, made and painted his own cases and dials.[6] One informative notice, however, appeared in the *Connecticut Courant* for January 19, 1801, which suggests that some of this work was done by local family painters. Luther Allen, born in Enfield, Connecticut, in 1780, advertised as follows in the *Connecticut Courant* for January 19, 1801: "Portrait Painting in oil of all sizes, from busts to full figures . . . Miniature painting, Hair-work & Coach and Carriage painting done in the neatest and best manner, and embellished with gilding and drawings, after the most approved *New-York* fashions; Sign painting . . . together with clock-face painting, etc. Copperplate engraving of almost every kind . . ." A bust-length portrait, together with several miniatures owned by descendants, prove that Allen was a competent folk artist, and he was no doubt responsible for some unidentified painted dials on Connecticut tall clocks.

To those interested in painted decoration, Connecticut tall clocks of the first quarter of the nineteenth century are especially appealing. Some of the cases are grained and painted in wonderfully fanciful patterns, and the wooden faces exhibit a great variety of naïve designs. The tall clock in figure 27 is attributed to Silas Hoadley and has eight-day wooden works. Hoadley was born in Bethany, Connecticut, in 1786; served an apprenticeship to his uncle in the carpentry trade; and formed a brief partnership with Eli Terry and Seth Thomas. After 1813, he continued to make clocks on his own until he closed his works in 1849. This case is particularly colorful. It combines graining, painted medallions, and trompe l'oeil inlay, and it features a stylish short door with a double-arch top.

Dwarf, or "grandmother," clocks have always appealed to collectors. Usually not more than five feet in height, they date generally to the first quarter of the nineteenth century and have brass eight-day movements. Although many were made in the style of full-sized clocks, some were quite original in design, among them the few examples attributed to Jonathan Winslow. Two noteworthy features are his reverse-painted glass dials and the exposed hands on the fronts of the faces (fig. 28). Very little is recorded concerning Winslow's clockmaking career. It is said that he also followed the jeweler's trade and was the inventor of the silver pen. Born the son of a country doctor in Hartwick, Massachusetts, on August 15, 1765, he was apprenticed to Benjamin and Timothy Cheney before establishing his own business. He apparently moved from place to place, living in different towns in Massachusetts, including Warren, New Salem, Worcester, and Springfield, where he died on July 20, 1847. Winslow appears to have been one of the few makers, and perhaps the only one, to adapt wooden works to dwarf tall clocks.[7] The cases

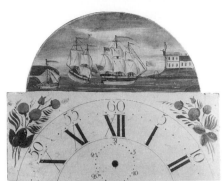

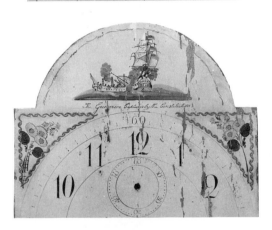

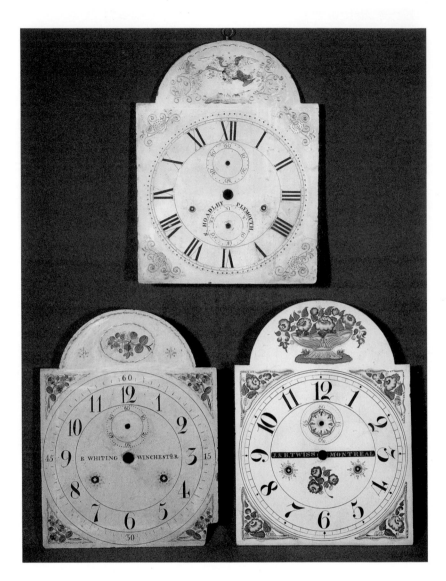

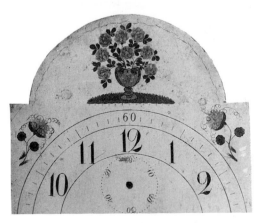

25. Four dials from country tall clocks, first quarter nineteenth century. Average size 16″ x 12″. Top to bottom: (1) Naïve landscape, maker unknown; (2) Signed: *A. Edwards, Ashby* (Massachusetts); (3) Painting titled *The Guerriere Captured by the Constitution*, maker unknown; (4) Still-life vase of flowers, maker unknown.

26. Three dials signed with the makers' names, first quarter nineteenth century. Average size 16″ x 12″. Top: *Hoadley, Plymouth* (Connecticut). Left: *Whiting, Winchester* (Connecticut). Right: *J & R Twiss, Montreal* (Canada).

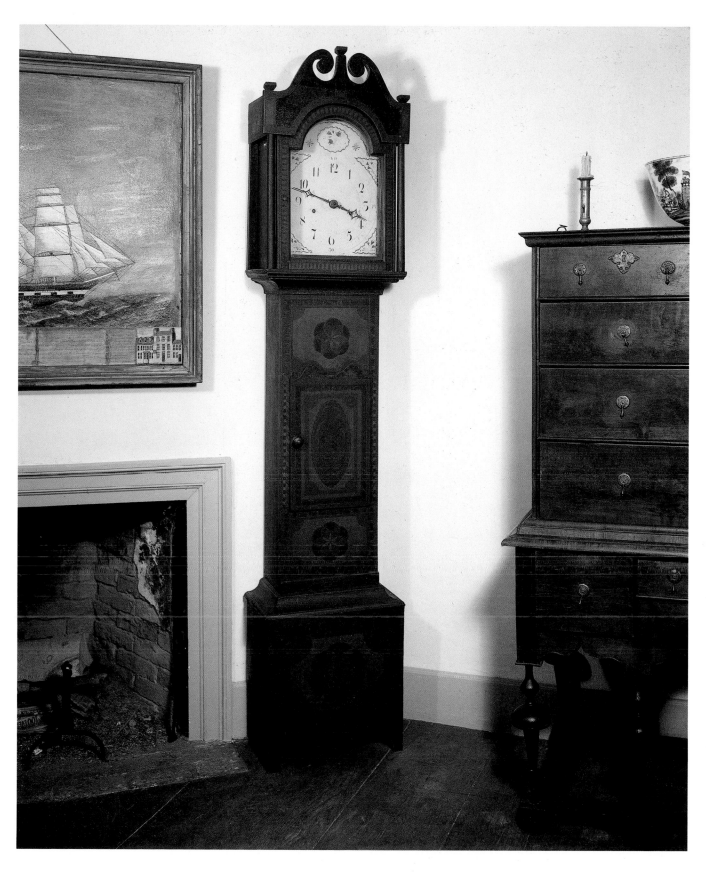

27. Tall clock with wooden works attributed to Silas Hoadley of Plymouth, Connecticut, 1815–1825. H. 83½". The tops of the scrolls and of the center finial have been restored.

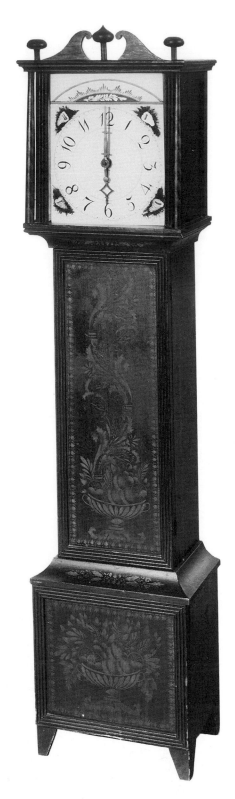

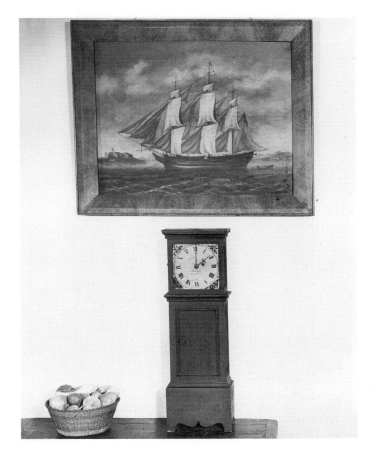

29. Shelf clock, *R. Bracket, Vassalboro* (Maine), 1810–1825. H. 29″. Little is recorded about this maker, and few clocks are known that bear his name. Painting above the clock: *Ship off Castle Island, Boston.* Signed at lower right: *S. Crehore, 1806.* Oil on wood. 23½″ x 30″. The grain-painted frame is original. Several of the Crehores were cabinetmakers in Dorchester, Massachusetts, in the late eighteenth century.

28. Dwarf clock with wooden works by Jonathan Winslow, New England, c. 1820. H. 47¾″. The finials are replacements copied from another Winslow clock. The dial is reverse-painted on glass with pewter hands exposed on the exterior. The black-painted case is decorated with gold stenciling.

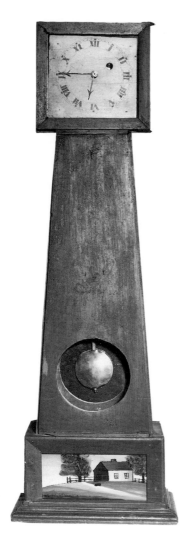

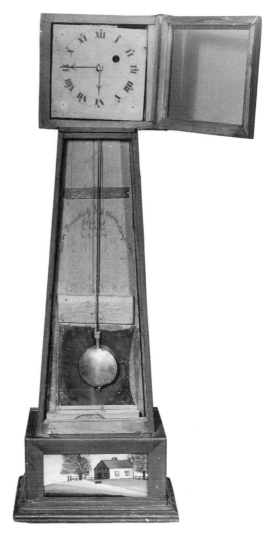

30. Red-painted country banjo clock, Newington, N.H., c. 1835. H. 36½″.

31. Banjo clock in figure 30. The front panel slides sideways to reveal the inscription: *Made and warranted by T. G. Furber Newington N.H. / Clocks.*

32. Brass works of the clock in figure 30. Incised with name of the maker: *G. G. Brewster, Portsmouth, N.H. 1835.* (Photograph courtesy Charles S. Parsons)

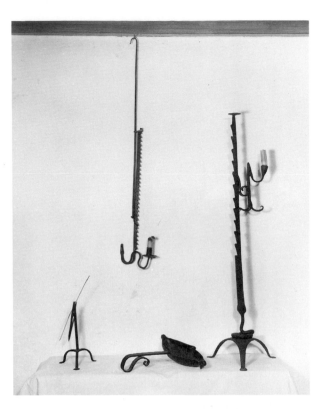

33. Several types of iron rush holders, seventeenth or eighteenth century. Top: Hanging rush and candleholder with adjustable trammel. H. 37½″ as pictured. Left: Table rush holder with hand-dipped rush. H. 9¼″. Center: Rare grisset for making dipped rushes by drawing them through hot animal fat. L. 12½″. Right: Standing rush and candleholder with the form of a coiled cobra holding the shaft. H. 38″. Found in Cornwall, England, in 1934.

34. Fireplace wall exhibiting several kinds of lighting devices, two types of warming pans, and an English overmantel painting illustrating the apocryphal story of Tobias and the Angel. 49″ x 45″.

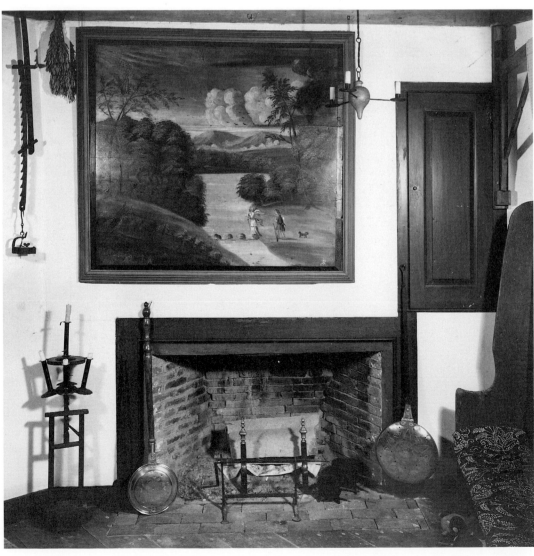

of the four Winslow clocks known to me all exhibit painted decoration, either graining to resemble mahogany or stenciling in gold on a black ground, as in our example.

Early in our collecting career, we began to realize that both tall and dwarf clocks occupied precious floor space, whereas others that rested on a mantel or shelf obviated that problem. Accordingly, we purchased a labeled Eli Terry shelf clock. Although its wooden works ticked on and off for many years on our parlor mantel, we became sadder but wiser when we discovered that the painted face and the pictorial glass tablet were not original but replacements.

In the meantime, several other shelf clocks came our way, including an acorn clock and the two country examples that have since remained among our favorites. The clock in figure 29 is inscribed on the face *R. Bracket / Vassalboro* (Maine). Only three or four similar ones have been found, one of which (not ours) was presented as a wedding gift to the present owner's great-grandparents when they married and moved to a farm in Augusta, Maine. Bracket is also known to have made at least two tall clocks, and the case of one of them is of conventional early-nineteenth-century design.

Quixotic pieces by little-known makers are, we feel, the most fun to live with and are particularly rewarding to research. The wall clock in figure 30 certainly belongs in this category. Predicated on the basic form of the popular banjo design, the case is painted red, and the dial has only one hole for the insertion of a winder. The vertical front panel slides sideways to reveal the pendulum. Behind this panel, on a thin piece of pine, is the following handwritten inscription: *Made and Warranted by T. G. Furber Newington N.H./Clocks* (fig. 31). Thomas Gerrish Furber was born in Newington on September 14, 1818, and married Elizabeth Dow there on May 7, 1837. Various entries in the New Hampshire *Registry of Deeds* indicate that he was active in Newington until at least 1862. He was, incidentally, a cabinetmaker of sorts, as a desk signed by him has been recorded, and he assembled this clock and made the case.

The maker of the brass works in the Furber clock is identified as follows through a metal plate located behind two of the wheels: *G. G. Brewster/Portsmouth N.H. 1835* (fig. 32). George Gaines Brewster was born in Portsmouth on April 5, 1797, and attended Master Tuft's School. In the *Portsmouth Directory* of 1827, he offered his services as a repairer and seller of watches and timepieces, and also as a surgeon-dentist—two professions that he carried on simultaneously for quite a number of years. Brewster clocks may be identified by his name incised on the metal backplate, but only a few that are fitted with his works are now known.[8]

Although the tight money situation inhibited the purchasing of major antiques during the 1930s, there were many people quietly forming specialized collections. Unfortunately many of these individuals were entirely unknown to one another. Therefore the most stimulating development of the decade, as far as we were concerned, was the formation of four different collectors' clubs in the Boston area from 1932 to 1934. Monthly meetings afforded convenient places to foregather, encouraged the study of unusual pieces from the members' collections, and provided the opportunity to meet congenial people with whom to exchange ideas and information. An observation made by one founding member sums up the tenor of all the early collectors' club meetings: "To hear a group of Rushlighters engaged in a discussion, is to be reminded of the discussions which must have taken place around the Tower of Babel!" Eventually all the clubs issued informative

publications and held scholarly exhibitions, which contributed greatly to the enjoyment of their members, as well as to the knowledge of the general public.

The first group to gather, on Founders Day, November 16, 1932, was to become the Rushlight Club, and it consisted of men and women interested in all forms of early lighting. Well before this date, however, Bert had started to pick up unusual pieces of lighting equipment, though he had no idea that there were many other eager students in the field. Iron and wooden examples were then—and have remained—our major interest, and from small beginnings in the 1930s, we have gradually built up a modest but representative collection of old lighting devices. One of the most rewarding features of all the collectors' clubs was the pleasure of meeting distant members and hearing about their special interests. One early spring day, Dr. Kei Enoki, a distinguished orthodontist from Tokyo who was attending a medical meeting in Florida, was invited to address the Rushlight Club. By special arrangement, he made a visit to our farm before the meeting, bringing complete equipment for digging up and transporting to Japan some of the *Juncus effusis*, the variety of "soft rush" that grows wild in certain boggy meadows in New England. Dr. Enoki was studying the American form of the plant because rushes are especially cultivated in Japan as cores for temple candles. He was also interested in our iron rush holders, which originally provided even more primitive illumination than that derived from hand-dipped candles (fig. 33).

At some point, most people face the problem of how to display their collections in a home environment. Many Rushlighters opted for shelving built in special rooms or fitted into reconditioned basement areas. This formal type of installation never appealed to us, and because our collection is not very large, most of our pieces have been integrated into existing room settings. In figure 34, a wooden lighting trammel with a betty lamp attached is hung beside a corner of a fireplace wall. Below it stands an adjustable wooden candleholder with its top notched to support four iron hog-scraper sticks. A small wood-and-iron chandelier with its original twisted hanger is suspended from a beam above. Figure 35 shows an early chest-on-frame used for the display of several other lighting devices.

An extremely elegant lighting accessory came to us many years later in the form of an early-eighteenth-century quillwork wall sconce acquired directly from the old Jacob Wendell house in Portsmouth, New Hampshire (fig. 36). Quillwork (or filigree work) was composed of different units of rolled or twisted colored papers that were pasted by an edge to a wooden backing and arranged in varying designs that often utilized metal, wire, beads, feathers, shells, waxwork, silk threads, and a profusion of mica flakes to make the composition sparkle when seen by candlelight. The sconces were glazed and mounted within shadow-box frames, and many were provided with wooden sockets at the base to support a silver candle arm for after-dark illumination. The candle arm of our sconce has long since disappeared.

Our piece exhibits two inscriptions that include the names of *Rindge* and *Wendell*, both handwritten on the reverse of the backboard. The union between these families occurred when Mehetabel Rindge Rogers and Jacob Wendell, both of Portsmouth, were married in 1816, and it was apparently at that time that the sconce came from Mehetabel's Rindge ancestors to the Jacob Wendell house. Mehetabel's great-grandmother was Mrs. John Rindge (Ann Odiorne) of Portsmouth. John Rindge was born in 1695,[9] and it is possible that his wife Ann was the original owner, or maker, between 1720 and 1740, the period when similar sconces are believed to have been made.

During 1933 and 1934, three other collectors' groups were formed in Boston,

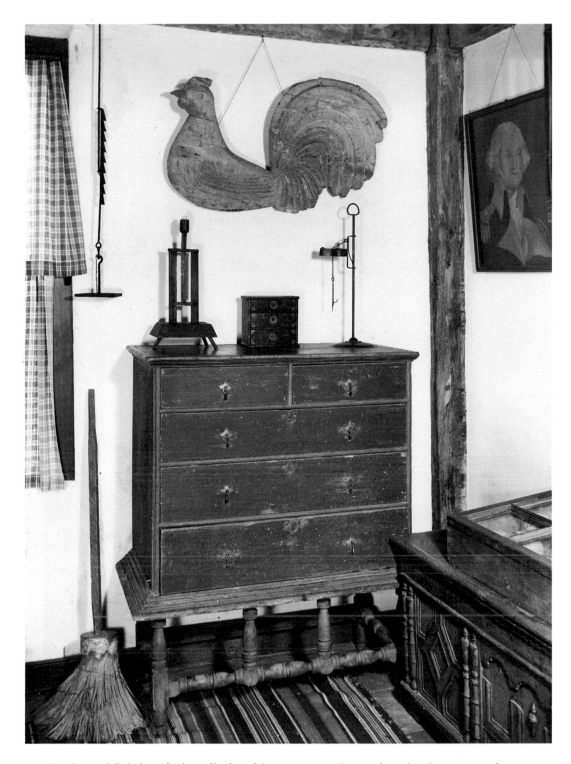

35. Several lighting devices displayed in a room setting: A hanging iron grease lamp, an adjustable wooden candleholder, and a betty lamp on stand, dated *1812*. The cock is a late-eighteenth-century weathervane from Maine. L. 34″.

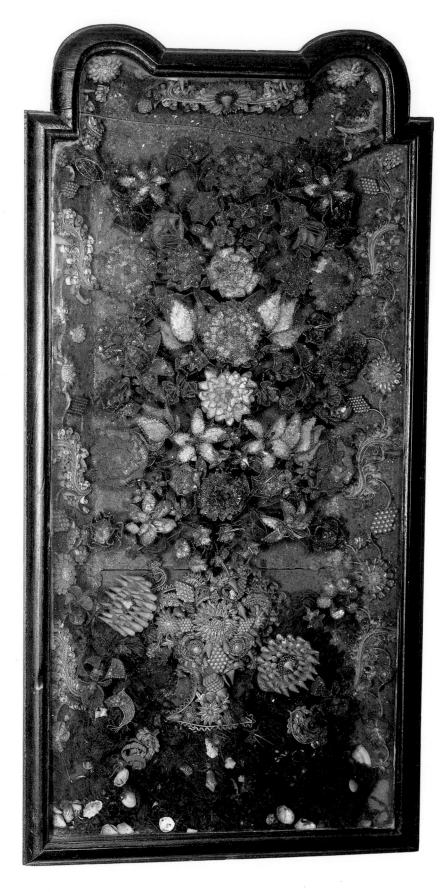

36. Quillwork sconce, with candle arm missing, from the Jacob Wendell house, Portsmouth, New Hampshire, 1720–1740. 29″ x 14″. Handwritten in ink on back of frame: *Mrs. Rindge No. 1.* This could refer to Mrs. John Rindge (Ann Odiorne), who may have been the maker. The sconce eventually descended to Mrs. John Rindge's great-great-granddaughter Caroline Quincy Wendell. Also written on the back of the frame is a second inscription: *Given to James Rindge Stanwood for his* [Rindge] *name by his Aunt Caroline Q. Wendell, 1882.*

in all of which I took an active part: The Early American Glass Club, founded on January 18, 1933, was followed by The Wedgwood Club and the China Students' Club. Pattern glass was enthusiastically collected in the 1930s, and there was particular interest in the New England Glass Company, the Boston & Sandwich Glass Company, and the Pittsburgh factories, all of which produced pressed-glass tableware. Some members of the Glass Club, including me, preferred blown glass of a slightly earlier period, and I will never forget how delighted I was when I found the large, blown three-mold dish with waffle sunburst, illustrated in figure 37, reputed to have belonged to an old Cape Cod family. Glass lamps were especially appealing because of our interest in lighting, and figure 38 exhibits a few of the pieces that we acquired during the 1930s. A complete neophyte, I spent my first meetings listening and learning. Although we never made a significant collection of American glass, I still treasure the blown pieces that I collected during my years as an early member of the Glass Club.

The first Boston meeting of The Wedgwood Club took place on October 28, 1933. This group, as the name implies, was dedicated to the study of pieces made by the first Josiah Wedgwood, his contemporaries, and his early followers. Wedgwood ware was a subject that had wide ramifications and opened up to club members a rich and varied field of eighteenth- and early-nineteenth-century ceramics. Because the club was moderate in size, its members were encouraged to bring examples from their own collections to illustrate the special topics covered at the monthly gatherings. Judging the quality of any ceramic object depends greatly on one's sense of feeling and touch, and this was abundantly provided at the stimulating meetings of The Wedgwood Club. Of the four original collectors' clubs, only The Wedgwood Club is not now in existence.

Among the many types of earthenware produced by the Wedgwood firm, one of my favorites has always been creamware (or Queensware, as it was called by Josiah Wedgwood). Creamware consists of an earthenware body covered with a cream-colored lead glaze. A great variety of objects was made in this medium, both decorative pieces for the table and practical utensils of all kinds for the kitchen. Queensware dairy equipment was one of Wedgwood's specialties and included large milk pans with matching spoons for raising and skimming Devonshire clotted cream. The dish and spoon in figure 39 were made for the dairy of Haldon House, Exeter, Devonshire, the late-eighteenth-century seat of the Palk family, whose crest in sepia appears on the examples shown. Tracing these pieces back to their original owner was an enjoyable piece of research that necessitated references to *Burke's Peerage,* books on English country houses, histories of Devonshire, and Palk family genealogies. The small, unmarked, perforated dish included in figure 39 was also made for hand-skimming cream. The Wedgwood firm also made delightful miniature pieces for children, but because of their fragile nature, few have survived intact. The set shown in figure 40 rests on its original circular tray and contains tea and coffee pots, each with six matching cups and saucers; a sugar box and waste bowl; a tea caddy; and a hot-water kettle.

On April 17, 1934, the China Students' Club assembled in Boston to organize a ceramic study group. From its inception, this club concentrated on study and research. Its members were expected to prepare and present papers at the monthly meetings, and eventually to organize public exhibitions of examples from their own and other collections. The China Club did not specialize in one field of ceramics, and therefore it attracted persons involved with pottery and porcelain of many periods and nationalities. Great merriment was caused, however, by an in-

cident that occurred at one of the club's early "milestone" birthdays. The hospitality committee had arranged to have a large cake with candles to celebrate the occasion and had ordered one to be decorated with the club's name in pink and white frosting. Imagine the members' surprise at finding, when the cake was unveiled, that the bakery had emblazoned on the top what they apparently considered the correct grammatical title of our organization: *The Chinese Students Club!* Before I joined the club, my primary interest had been in English earthenware of the late eighteenth century and the first half of the nineteenth century. In time, my focus broadened, and I gradually began to acquire earlier pieces, along with certain types of European ceramics, all of which added depth and variety to our collection.

Useful wares, especially the utilitarian objects more commonly associated with silver or tin, had not then received the attention accorded to more important categories of ceramics. Beginning in the 1930s, however, pieces of this sort were one of our enthusiasms, and jointly we gave several informal programs called "Ceramic Utensils and Gadgets" that traced an imaginary day's activities in an eighteenth-century English country household. The examples shown included many items created by potters for the apothecary, and the bedroom, nursery, kitchen, and dairy. Dainty strainers for tea and punch, fragile tea and pap spoons (fig. 41), porringers, and gentlemen's shaving basins (fig. 42) are only a few of the useful pieces in our collection that are more often seen in metal than in china.

Food and beverage warmers with hot-water containers, similar to modern double boilers, were also supplied by many factories for use in the sick room or nursery. Josiah Wedgwood filled an order for "a cream coloured tea kettle and lamp and saucepan" as early as 1773, and he advertised in his cream-color catalogue of 1774 "Night Lamps, to keep any liquid warm all night."[10] Figure 43 illustrates three types of nursery lamps, or food warmers, each exhibiting a ring within the base to hold a tin or china lamp. Most of these lamps have now unfortunately disappeared. The blue-printed piece in the center has lost its cover but still retains its matching whale-oil lamp. The tin lamp at the right is early in date but not original to the Wedgwood warmer beside it.

Because of our continuing interest in historical blue Staffordshire, we were soon attracted to Liverpool ware printed in England with American patriotic scenes, based on contemporary engravings, and during the 1930s, we collected a number of large pitchers decorated with ships and other maritime subjects. One jug in particular turned out to be an unexpected rarity, as it satirized a local American incident that took place in Newburyport, Massachusetts, in 1805 (fig. 44). In the early part of that year, the engraver, James Akin, late of Philadelphia, became embroiled in a heated altercation with one Edmund March Blunt, a local citizen of considerable importance, still remembered for his publication of the *Coast Pilot* in 1796 and *An Appendix to the Practical Navigator* in 1804. A dispute arose over payment for some charts that Akin had executed for Blunt, and when the two men chanced to meet in Joseph Foster's hardware store, Akin slapped Blunt in the face. The angry Blunt thereupon snatched up an iron skillet lying nearby and hurled it at his adversary, and although the missile missed Akin, it did hit Captain Nicholas Brown, another esteemed local resident. Akin, an able satirist, was so chagrined by the episode that he put a notice in the *Newburyport Herald* on June 25, 1805, and also circulated broadsides featuring a scathing cartoon, accompanied by sarcastic verses. This cartoon he titled *A Droll Scene in NewburyPort Infuriated Despondency.*[11] When Captain Brown next sailed for England, he took Akin's

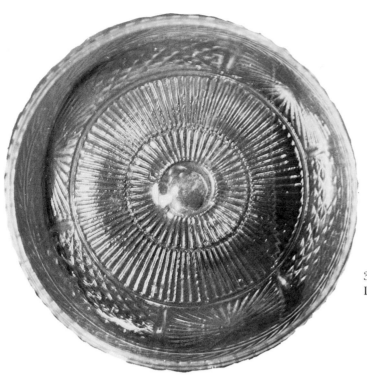

37. Blown three-mold glass dish, 1825–1835.
Diam. 10¼″.

38. Group of blown glass lamps, 1815–1835. Ranging in height
from 4″ to 11¼″, including burners. The long wick tubes with
extinguishers on lamp at left (not original to this lamp) were
for burning camphene. The short tubes were used with whale
oil. At center is a blown three-mold peg lamp inserted in a
pewter chamber stick.

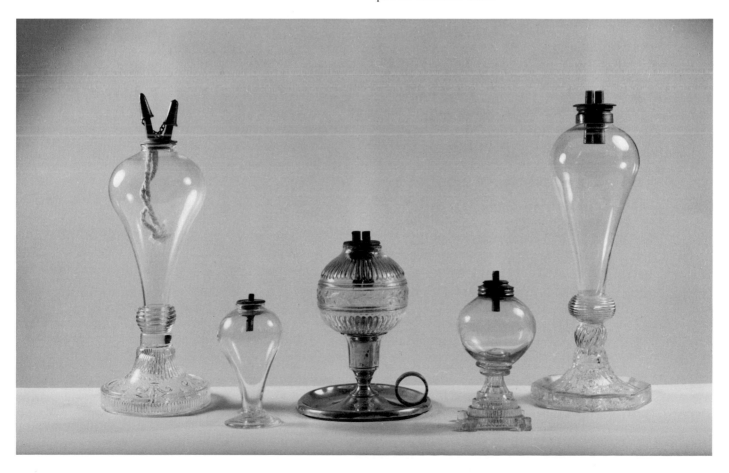

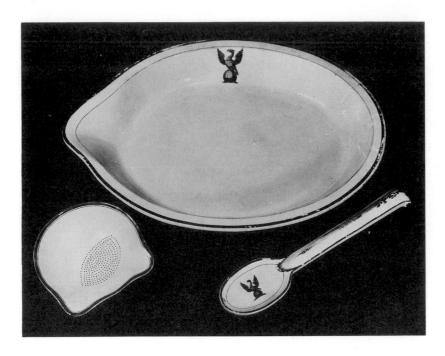

39. Creamware dairy utensils, late eighteenth century. The large pan for raising cream bears the crest of the Palk family of Haldon House, Exeter, England. 22″ x 16½″. Matching spoon for skimming cream. L. 14½″. Both pieces are impressed *Wedgwood*. The creamware strainer with green edge is unmarked. 7″ x 6¾″. (Photograph by T. F. Hartley)

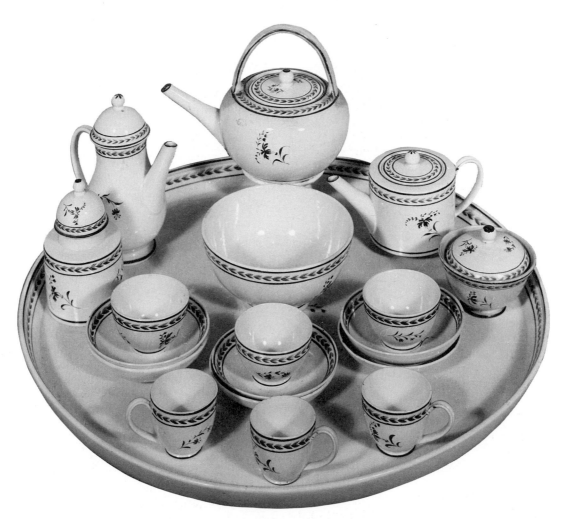

40. Miniature creamware tea and coffee set with original tray, c. 1800. Sepia decoration. H. of kettle 5″. Impressed *Wedgwood*.

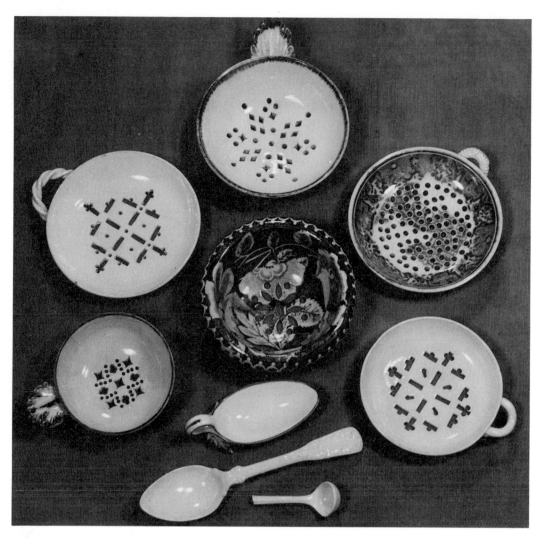

41. Six tea and punch strainers, of creamware, blue Staffordshire, and Caughley porcelain, first quarter nineteenth century. Diam. 2½″ to 3¼″. Three creamware spoons for tea, pap, and salt, first quarter nineteenth century. Teaspoon, L. 5⅛″. (Photograph by T. F. Hartley)

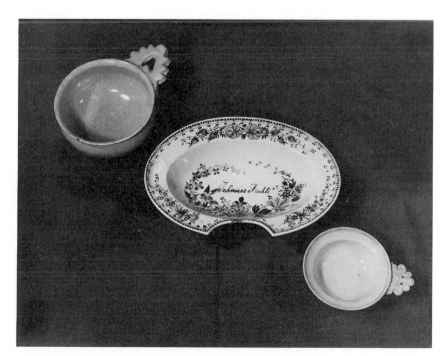

42. Group of useful pieces: English tin-enameled bleeding bowl, last quarter seventeenth century. Diam. 5½″. Dutch barber's basin, c. 1825. Creamware with enameled decoration, inscribed: *Johanes Ruble.* L. 10½″. English creamware porringer, c. 1800. Diam. 4½″. (Photograph by T. F. Hartley)

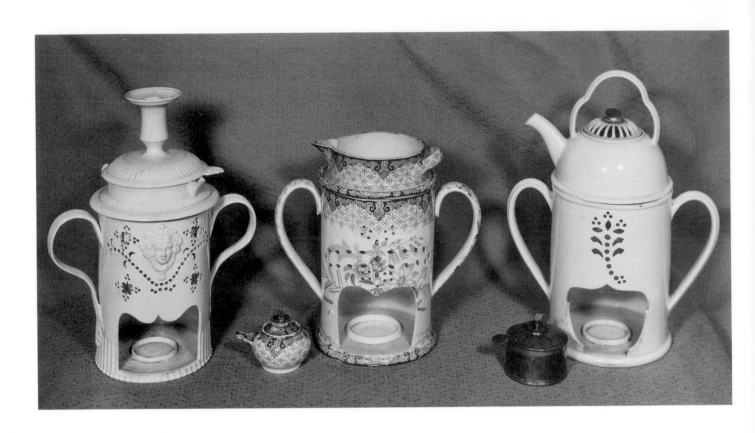

43. Three English food warmers, fitted with second containers for hot water, were heated by small ceramic or metal lamps. Left: Creamware with candleholder attributed to the Leeds Pottery, c. 1800. H. 11″. Center: Warmer printed in light blue, lacking cover but retaining its original matching whale-oil lamp, 1830–1835. Marked: *Heath.* H. 8½″. Right: Queensware nursery warmer impressed *Wedgwood*, late eighteenth century. H. 12″. The tin lamp is appropriate in style but is not original to this piece.

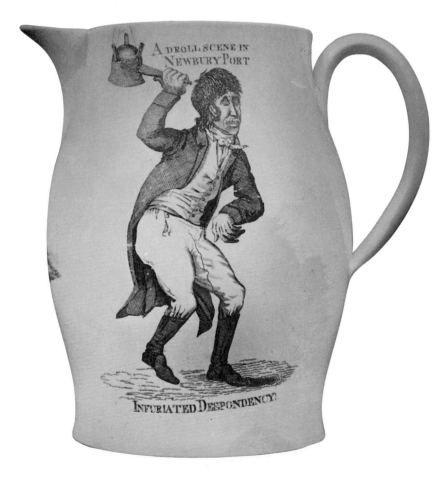

44. Rare Liverpool jug with decoration copied from an engraving by James Akin, Newburyport, Massachusetts, 1805. H. 7¼″. The figure with an upraised skillet caricatures Edmund March Blunt during an altercation with Akin. Inscribed: *A Droll Scene in NewburyPort Infuriated Despondency.*

45. Cupboard containing lustreware and other pottery and porcelain pieces, 1790–1825. Above the so-called canary lustre is a shelf of inherited Chinese export teaware and tableware.

46. Corner cupboard with miscellaneous pieces of eighteenth-century English and Continental pottery, including red earthenware, salt-glazed stoneware, and creamware. A salt-glazed pitcher commemorating Admiral Vernon's capture of Portobello, H. 9″, in 1739 stands at the left of the second shelf.

engraving with him and had it transfer-printed on jugs, washbowls, and "vessels of less esteem." He eventually returned home with a large shipment, which he planned to circulate in Newburyport to the obvious discomfiture of Blunt. Outraged by this intended insult, Blunt's friends somehow managed to lay hands on the cargo and, it is said, destroyed almost every piece but the one that continued to remain in the possession of the Brown family.

When I read this colorful legend in an old history of Newburyport, I decided that above all else I must find an *Infuriated Despondency* pitcher, but this seemed a very remote possibility, for not a single example had then been publicly recorded. In December 1936, in the catalogue of the Mrs. Miles White sale at the American Art Association–Anderson Galleries in New York City, I came upon an illustration of the coveted treasure; evidently the significance of the design had gone unnoticed by other collectors, for I was able to acquire the jug with a very reasonable absentee bid. In 1937, the Rodman Nichols collection of Liverpool ware came to the Peabody Museum of Salem, containing a large jug on which the *Infuriated Despondency* cartoon appeared in conjunction with other topical motifs, including the Newburyport ship *Merrimac*, of which Nicholas Brown was later to become the captain. Strengthening the assumption that this piece had been Captain Brown's own pitcher are his initials *N L B* beneath the spout.

Figure 45 illustrates a cupboard containing examples of English earthenware and Chinese export porcelain that typify some of our collecting interests during the 1930s. Lustreware was then very popular, and I inherited a small group of copper, pink, and splashed-pink pieces, of which the glazes all evolved from a basic gold lustre solution.[12] On the center shelf canary-yellow examples contrast pleasantly with Wedgwood and Spode black basalt; below the pink lustre is a miscellaneous group of late-eighteenth-century creamware and stoneware teapots and pitchers.

After I joined the China Students' Club in 1934, my horizons expanded, and I began to investigate the ceramics that had been exported from England to the American Colonies prior to the Revolution, with special emphasis on those passing through the port of Boston. The published sources of specific information on this subject include reports of archaeological excavations on domestic sites, inscribed pieces and those documented by family history, inventories of eighteenth-century estates, and notices of sales and importations found in local newspapers. An analysis of this material revealed that the following categories represent the imported ceramics most widely used in New England homes during the first half of the eighteenth century: English salt-glazed stoneware; Dutch and English delft (including large numbers of fireplace tiles); and blue-and-white Chinese porcelain brought over in English ships. Between 1750 and the outbreak of the Revolution, variegated glazed pieces of Whieldon type, English red earthenware, and cream-colored pottery—plain, printed, and enameled—began to arrive in significant quantities.

The corner cupboard in figure 46 contains examples of several kinds of earthenware used in New England during the eighteenth century. Arranged in the lower section is an assortment of creamware pieces by Wedgwood and other contemporary makers. The second shelf exhibits white salt-glazed ware with enameled and other types of decoration. On the left is a pitcher whose molded reliefs depict the British capture of Portobello, in the Republic of Panama, under the command of Admiral Vernon "with 6 ships only Nov. ye:22:1739." This episode was me-

morialized on some of the first examples of patriotic commemorative china, and this jug was one of our most exciting early finds.

English redware I soon found to be less popular with ceramic enthusiasts than the better-known products of Whieldon and his contemporaries, which we were also collecting (fig. 47). The red pottery on the second shelf of figure 46 was made both in England and on the Continent; its fine body, interesting shapes, and Oriental decoration originally derived from the seventeenth-century Yi-hsing wares of China. The research I did on the subject of redware resulted in my first major article for *The Magazine Antiques*,[13] and also in the discovery in 1938 of the rare seventeenth-century Dutch teapot on the second shelf that is impressed *Ary de Milde*.

It is perhaps not generally known that a brisk trade was carried on in the seventeenth century between the potteries of North Devonshire and the American Colonies. On December 11, 1688, the ship *Eagle* of Bideford arrived in Boston carrying 9,000 parcels of earthenware, and during the following year more than 16,000 pieces came in from the same source.[14] The crowning achievement of the Devonshire potters in the seventeenth century was handsome sgraffito tableware with designs scratched through a white slip to reveal the red body beneath. Shards of a plate, a pitcher, and a mug have been excavated in Jamestown, Virginia. After 1700, presentation pieces in the form of large harvest jugs continued to be produced in Devonshire for local consumption, their naïve folk ornamentation varying but little in feeling during the entire span of the eighteenth century. Figure 48 illustrates two well-preserved slip-decorated jugs dated 1748 and 1801, each featuring a popular version of the familiar British lion.

I have always been more interested in individual pieces of unusual form or decoration than in sets or groups of china, and I have bought marked examples whenever I could, regarding them as valuable keystones in the learning process. Some had slight defects and were not acquired for display but were study pieces used to document the various shapes, borders, and ornamentation of different factories working at the same period. As time went on, I tried to make every ceramic acquisition significant for some special quality that it held for me.

In addition to our pottery collection, I acquired a few individual examples of English porcelain representing the factories that interested me most, including Plymouth, Bow, Pinxton, Chelsea, Caughley, and Coalport (fig. 49). Several Continental pieces are also shown in the secretary with three contrasting sets of children's miniature teaware. Porcelain table ornaments in exotic forms, such as fantastic animal and vegetable shapes, were made by the Chelsea factory in the 1750s. At Coalport, circa 1830, similar "conceits," consisting of delicate dishes piled high with flowers, fruits, or nuts, were so expertly modeled and painted that they could easily fool the eye (fig. 50). Our plate of porcelain walnuts often keeps appropriate company with a small decanter of sherry (a sly joke on an unwary guest), and the dish of flowers provides the center of our dining table with colorful blooms in every season. Our enthusiasm for china collecting did not wane with the close of the 1930s and still continues to parallel our interest in other forms of American decorative arts.

In 1932, we acquired our first important piece of furniture at the auction of New England family heirlooms owned by Mr. and Mrs. Frederick Silsbee Whitwell of Boston (fig. 51). Made of walnut, with bonnet-top, a carved fan, and its original brasses, this highboy had never been out of the owner's family. An accompanying letter from Mr. Whitwell detailed its descent from the Hon. Nathaniel Silsbee, Senior of Salem (1748–1791), through five succeeding generations. From

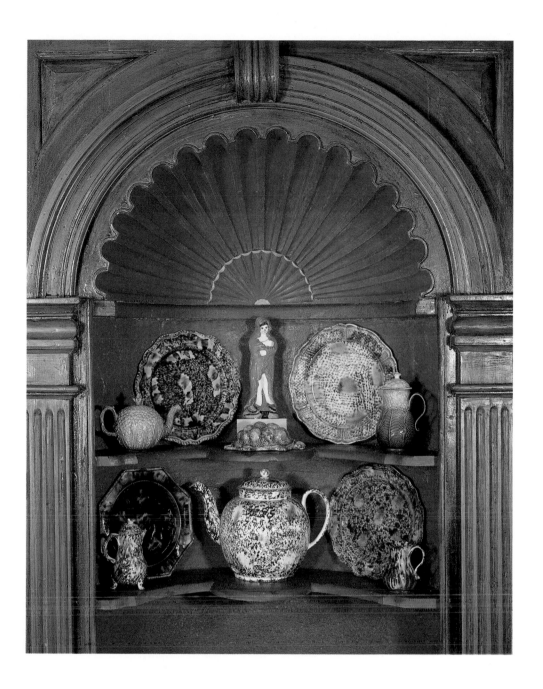

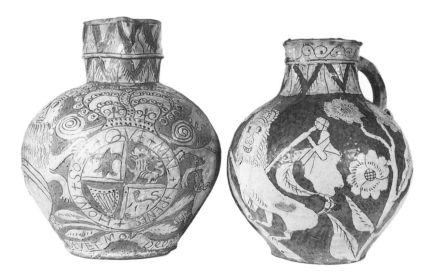

47. Eighteenth-century variegated wares of Whieldon type. A figure depicting *Summer*, H. 9″, one of a set of the four seasons, stands on the upper shelf.

48. Two slip-decorated Devonshire harvest jugs, dated 1748 and 1801, respectively. H. 12½″ and 11½″. Sgraffito (incised) slipware from England was exported to the Colonies as early as the seventeenth century. (Photograph by Hartley and Arnold)

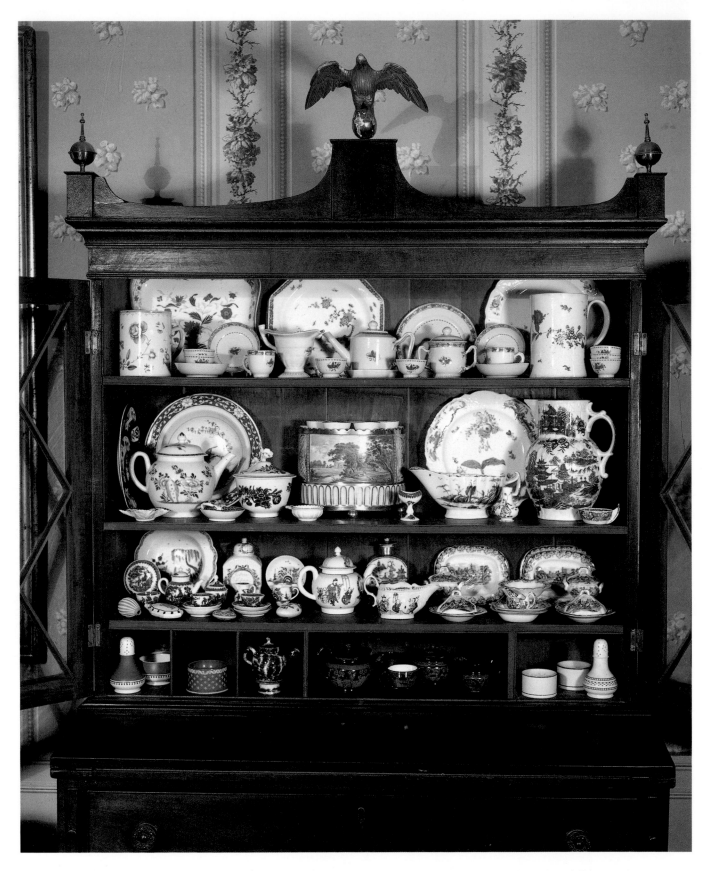

49. Secretary containing miscellaneous examples of eighteenth-century porcelain. The child's tea set (H. of teapot 4½″) on the top shelf was brought home from China in 1820 by one of Bert's ancestors. The bulb pot at the center of the second shelf is English Pinxton porcelain. The miniature tea set (H. of teapot 3″) at the left of the first shelf is Caughley porcelain.

50. Two English porcelain table ornaments, both made at the Coalport factory about 1830. The dish of beautifully modeled flowers is in the manner of those made at Chelsea in the mid-eighteenth century. Diam. 10″. The dish of walnuts is equally realistic. Diam. 7½″.

51. Walnut highboy with original brasses, c. 1780, originally owned by the Honorable Nathaniel Silsbee, Salem, Massachusetts. H. 87″. W. 38″. (Photograph by T. F. Hartley)

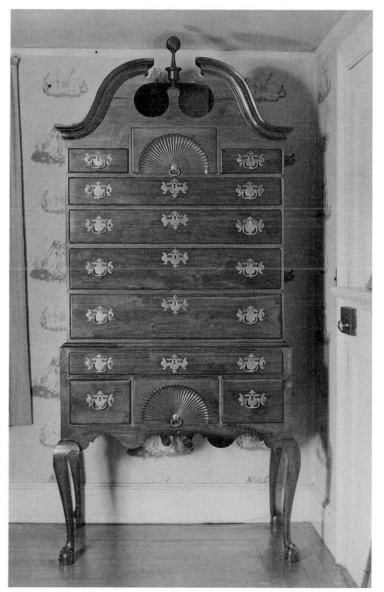

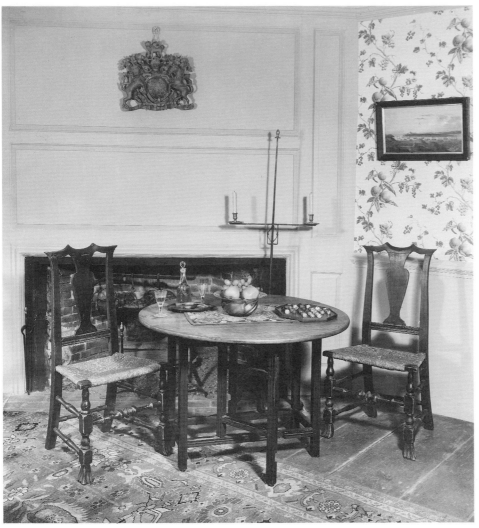

52. Two of a set of six Queen Anne transitional side chairs beside a late-eighteenth-century drop-leaf table. The chairs descended by marriage from the Coker–Thurlow family to George William Adams of Byfield, Massachusetts, in 1848.

53. Side chair, maple and ash, with Spanish feet and grain-painted finish, c. 1760. H. 38½". W. 20". From Highfields, Byfield, Massachusetts, home of George William Adams.

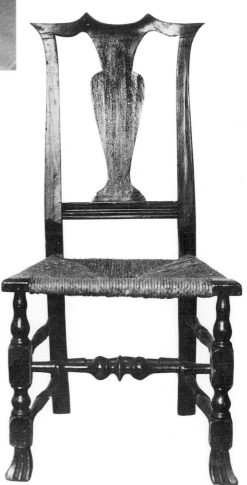

the same source, through a marriage between the Deveraux and Silsbee families, came a graceful early-nineteenth-century chaise longue accompanied with similar documentation. I believe it was at this time that Bert and I had the first premonition of how intensely interested we were to become in the historical background of our pieces, and this interest was to inspire us to obtain, whenever possible, any history available at the time of purchase.

By the mid-1930s, our family had increased by three little Littles, and the country cottage with its lack of heating, lighting, plumbing, and telephone became inadequate for our needs. We relinquished it with the utmost reluctance in 1937 and moved the cherished pieces that constituted our first antique treasures to a larger and more accessible summer home. Our newly acquired farmhouse had dozed in the sun for two hundred years and had mercifully escaped the hand of the ubiquitous "restorer." When we arrived, one old-fashioned bathroom served the entire household; the dirt-floored cellar was (and still is) without benefit of a furnace; and all seven fireplaces were tightly closed to facilitate the use of mid-nineteenth-century stoves. But there was handsome eighteenth-century paneling in the "best" rooms, two closed-string staircases in the front hall, and a deep eight-foot-six-wide fireplace with two ovens hidden behind a brick facing in the old kitchen.

We settled in, happily anticipating a leisurely search for antique furnishings to augment our modest holdings, and in the summer of 1938, we were presented with an unexpected opportunity such as seldom comes in a lifetime of collecting. The impact of this experience was to make an indelible impression on my memory. Even in the 1930s, there were few early-eighteenth-century houses that had been lived in continuously by the same family, and whose descendants had not only cherished their possessions but had kept invaluable records of original ownership. At the time of our visits, Highfields, the 1703 Abraham Adams house in Byfield, Massachusetts, had been periodically overlaid by the usual eighteenth- and nineteenth-century accretions, and the contents exhibited the same pattern of growth and change. There were furnishings of many types and periods living comfortably together as they always had, making the house a veritable document of 235 years of rural New England life.[15] The owner, George W. Adams, was an elderly gentleman with great historical knowledge of his possessions. He was the last of his line, and wishing to move to smaller quarters, he had asked the advice of Charles and Lura Woodside Watkins about discreetly placing some of the family heirlooms in appreciative hands. A few privileged persons, including ourselves, were invited to call and meet Mr. Adams and to make fair offers for anything that we might wish to obtain. Around a large table in one of the 1703 rooms were placed six matching country sidechairs with an old grain-painted finish. Transitional in style from Queen Anne to Chippendale, they had come into the Adams family through the marriage, in 1848, of Mr. Adams's father to Mary Tyler Thurlow, of West Newbury, who was born in 1818. The chairs had been used by Mary's mother, Miriam (Coker) Thurlow, who in turn had inherited them from an earlier generation (fig. 52). The Spanish feet, boldly turned front stretchers, and sharply pointed crest rails make this an unusually stylish set of Essex County chairs (fig. 53).

After his return from fighting in the Revolutionary War, Mr. Adams's great-grandfather, Stephen Adams, purchased the desk in figure 54, presumably in Newburyport, as it exhibits the less academic qualities found in desks from that vicinity, in contrast to those from the Salem–Marblehead area. Part of Byfield was

then a parish of Newbury. Penciled on the side of a small right-hand drawer in the interior is this interesting notation: "Stephen Adams bought this desk in 1783, paying 40 dollars lawful money. This is said to have been his earnings for service during the Revolution." The handles are original, but the brass rail is a nineteenth-century addition that we have seen fit to leave as we found it.

To me, the most exciting part of Highfields was the open attic, which contained a small partitioned room at one end and a slave "bin" built in under the eaves at the head of the steep garret stairs. Whenever possible, I used to slip up there alone, where no flight of imagination was needed to turn the clock back a hundred years. This was the type of attic that one reads about but seldom sees, where everything had been saved by seven generations of a single family. There was early cooking and weaving equipment; homemade snowshoes, straw baskets, and a scrimshaw busk; wooden trenchers; feather beds; handmade blankets, coverlets, and pillows; quilted bonnets, linen nightcaps, wire dress hoops, and padded skirts; plus a large pine drying rack with quantities of hand-dipped candles. In one corner stood a rough, unpainted cupboard; in another hung a pair of hand-wrought pipe tongs. An early-nineteenth-century wallpaper-covered fireboard leaned against a trunk, and a colorful paper bandbox, containing its high-crowned beaver hat, stood nearby. Behind a pile of oddments, one glimpsed a carved and painted codfish that had topped the barn from its installation in 1858 until recently brought indoors for protection against the weather. Many of these treasured bygones, with many others from Highfields, eventually found a place in our own eighteenth-century attic, where, with additions from three generations of Littles, they continue to illustrate the ongoing story of everyday life on a traditional New England farm (fig. 55).

In 1931, we purchased our first American painting. Our interest at that time, however, was not in folk art but in traditional seascapes and ship portraits, which we liked either for their family associations or for their personal appeal. We are both descended from sea-loving ancestors, and our first nineteenth-century pictures depicted family-connected vessels. Several display the red-and-white house flag that distinguished the clippers and merchantmen owned or captained by Bert's great-grandfather, John Bertram of Salem. During the nineteenth century, Bertram ships were engaged all over the world in the Zanzibar, Mediterranean, California, and China trades.

The *Glide* (fig. 56) was a Bertram-owned bark, depicted in Boston Harbor by William P. Stubbs, who was born in Bucksport, Maine, in 1842. Stubbs became a well-known marine painter, distinguished for his crisp representations of schooners and merchant ships plying New England waters. The *Glide* was built in 1861, and she traded off the east coast of Africa in ivory, hides, gum copal, beeswax, coffee, dates, and many other exotic commodities. She was wrecked in 1877 while entering Tamatave, Madagascar, on her thirtieth voyage around the Cape of Good Hope.

The ship *Witch of the Wave* was also owned by John Bertram and associates. Built in Portsmouth, New Hampshire, in 1851, she was captained by his adopted son, Joseph Hardy Millet Bertram, the son of his second wife, the "Widow Millet." The *Witch* was in the China trade, and on one of her early stops at the Philippines, Captain Joseph H. M. Bertram commissioned the watercolor we own to be painted by a local artist, José Honorato Lozano, whose name appears at the lower right of the picture (fig. 57). When seen from a distance, Bertram's name stands out in bold relief, but on close examination, each letter is found to be cleverly composed of miniature Filipino figures and scenes (fig. 58). Although painted in Manila for

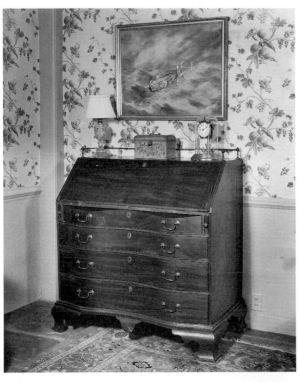

54. Mahogany reverse serpentine desk with original brasses. H. 44″. W. 41½″. Bought by Stephen Adams of Byfield, Massachusetts, in 1783 with forty dollars earned for service during the Revolutionary War. The brass rail is a nineteenth-century addition.

55. Part of the attic in our mid-eighteenth-century farmhouse. The assorted contents include two wooden tobacconist's figures; a rye-straw bee skep; a pair of urn finials, possibly by Samuel McIntire; a fireboard from the Adams house, Byfield, Massachusetts; an early clock housed in a musical instrument case; and a cigar-store Indian signboard.

56. The bark *Glide,* signed at lower left: *Stubbs,* c. 1870. Oil on canvas. 22″ x 36″. Owned by Captain John Bertram of Salem, Massachusetts, the ship engaged in the East African trade. (Photograph courtesy of the Abby Aldrich Rockefeller Folk Art Center)

57. Scenes in the Philippines, c. 1851. Watercolor on paper. 22½″ x 33″. Signed at lower right: *Por Hose Honorato Lozano.* Painted in Manila for Captain Joseph H. M. Bertram of Salem, Massachusetts.

58. Detail of a section of the picture in figure 57, showing Filipino scenes and the native figures cleverly combined to form the letters of the name.

59. The bark *Eliza*, signed at lower left: *B. West* (Benjamin West, Salem), c. 1848. Oil on canvas. 18" x 24". Owned by Captain John Bertram and Associates. In December 1848, she was the second vessel to leave Salem, Massachusetts, carrying supplies for those engaged in the California gold rush.

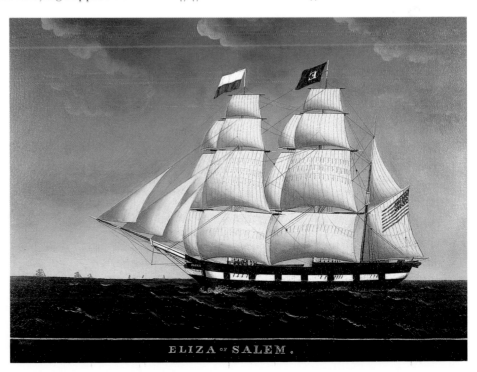

ELIZA of SALEM.

60. Model of the fast clipper *John Bertram*, c. 1851. H. 29½″. L. 39½″. Under the firm name of Glidden and Williams, she sailed from Boston to San Francisco in January 1851 with a cargo to be sold in the California trade.

61. Clipper ship *Adelaide*, signed on mat below picture: *J. F. Huge, Bridgeport, Conn. 1855*. Watercolor on paper. 26¾″ x 40″. The *Adelaide* sailed from Liverpool to New York, bringing my paternal grandfather on his first visit to America in 1863.

Clipper Ship ADELAIDE. J. Hamilton Commander.

62. Packet *Daniel Webster*, mid-nineteenth century. Reverse painting on glass. 10″ x 16″. Built in East Boston by Donald McKay, she carried my maternal Scottish great-grand-parents to this country in 1856.

63. First officer's cabin, clipper ship *Nightingale*, signed: *T. Grob, Special Artist. November 7th, 1866.* Watercolor on paper. 7¼″ x 9¼″. This picture was painted when the *Nightingale* was exploring the laying of a proposed cable across the Bering Strait for the Western Union Telegraph Company.

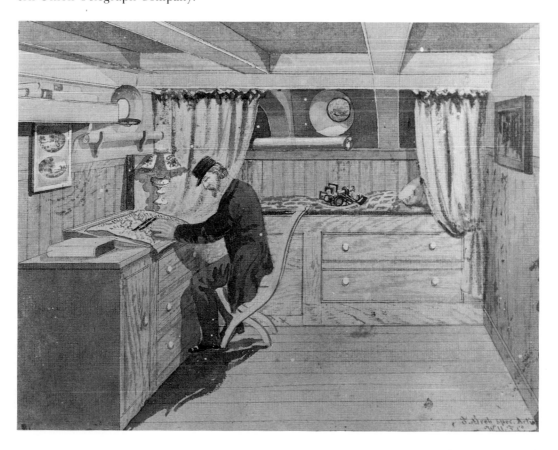

64. Chinese ivory carving, mid-1850s. H. 4″. Daniel McFarland, when second officer of the *Nightingale*, brought this small figure home from China. A mother-of-pearl seal on the bottom is incised to show the ship surrounded by the words SWEET AS THE VOICE OF THE NIGHTINGALE and the initials *DMF*.

65. View of Boston Harbor with Constitution Wharf, attributed to Fitz Hugh Lane. 1841–1842. Oil on canvas. 12½″ x 16¼″.

the American trade, few of these curious compositions seem to have found their way back to America.

In January 1848, gold was discovered in California during the digging of a mill-race for Captain Sutter on land that was to become the site of Sacramento City. Details reached Salem via the Isthmus of Panama early in the following summer. Scarcity of provisions and equipment in the mining area prompted the formation of various companies on the East Coast for the purpose of sending supplies around Cape Horn, and the bark *Eliza,* flying the Bertram house flag, became the second vessel to leave Salem California-bound (fig. 59). In his diary, John Bertram had this to say about the venture:

> We commenced the California business in 1848, the sole object being to assist an unfortunate friend who had, before gold was discovered, asked me to join him in a voyage, but having as much business as I could otherwise attend to I gave him but little encouragement. When the news came in October that gold was discovered, he pressed his application. All the owners of the old bark *Eliza,* willing to assist him agreed to put in her such cargo as he would direct, giving him more interest in the voyage than any other, and found the money.

This supercargo, or foreign agent, was Alfred Peabody of Salem, who in 1874, on the twenty-fifth anniversary of the sailing of the *Eliza,* wrote a fascinating account of her voyage and of the early days of the California trade, which was published in the *Essex Institute Historical Collections* in January 1874. Of his connection with the voyage, Peabody wrote, "About Dec. 1st, 1848, I applied to John Bertram, Esq. to undertake a voyage to California which resulted in himself and 5 other gents. of Salem loading the bark *Eliza* with assorted cargo and I went out to dispose of it."

Sailing on December 23, 1848, the *Eliza* carried six passengers and the supercargo Alfred Peabody in addition to her crew and officers, plus a large assortment of freight. The venture was underwritten by John Bertram and several associates, and the cargo consisted in part of flour, pork, sugar, coffee, butter, figs, dried apples, and meal. Also included were such potentially useful items as boots, shoes, chairs, nails, cook stoves, kettles, axes, picks, shovels, a small steam engine, and the makings of a boat to be built onboard the *Eliza* for use when they arrived at San Francisco.

The *Eliza,* however, has been particularly remembered in history not for her pioneering gold rush venture but because on this voyage was introduced the famous "washbowl" song. Sung in countless versions on every subsequent vessel rounding Cape Horn, as well as by immigrants crossing the plains, it was to become an enduring symbol of the gold rush era. To Stephen Foster's tune *"Oh Susannah"* special verses were composed by friends of one of the *Eliza*'s passengers and struck up as the ship cast off:

> I came from Salem City,
> With my washbowl on my knee,
> I'm going to California,
> The gold dust for to see . . .
> I jumped aboard the 'Liza ship,
> And traveled to the sea,

And every time I thought of home
I wished it wasn't me!
Oh! California
That's the land for me!
I'm going to Sacramento
With my washbowl on my knee.[16]

We also own a handwritten journal kept by Jonathan Nichols of Salem, one of the *Eliza*'s passengers, that gives another colorful day-by-day account of this voyage. On February 8, 1849, the *Eliza* sighted a vessel that proved to be the *Gambia*, out of Salem for Buenos Aires. Of this encounter, Nichols wrote, "We sailed along close together for some minutes and the mischievous fellow captain Bailey paraded a host of satirical washbowls at us which we answered by a like display." Two weeks later, the *Eliza* met up with the *Gambia* anew, and Nichols again recorded in his journal,

> [W]e hoisted 4 washbowls at the main-peak and gave him 3 cheers as he came up. Presently we heard the mellow notes of a bugle playing "Oh Susanna" and getting our full band together on the top of the house (violin, tamborine, accordian and triangle) we gave him our California song.

Shortly before the end of the voyage, Nichols made in his journal the following interesting philosophical observation:

> We all speak slightingly of gold now as if it were the very last thing in the world that we expected to find, but the whole undercurrent of thought with most of the passengers and crew, I am convinced, flows over golden sands and runs more swiftly and eagerly as it approaches its destination. . . . I almost wish that we might be utterly disappointed in this adventure, so clear does it seem that the great desire of the age, which is the fever for wealth, must be alarmingly increased by this sudden acquisition of wealth as it was predicted when we left home. It is not a new thing for a nation (even a republic) to sacrifice the costly blessings of intelligence and religion to this dassling [sic] and alluring ambition, and surely if one has hopes for the land that has been good to him, he may well fear for the effect of this severest trial of human principles.

The *Eliza* arrived in San Francisco on June 1, 1849, after a passage of 160 days. It was decided that a great saving would be made if she could be taken with her cargo up to Sacramento City, the head of navigation of the river, then a town of only seven buildings and a few tents, but nevertheless already a busy trading post. After six perilous days, the *Eliza* reached her destination and was moored to two sturdy oaks at the foot of one of the principal streets. There the vessel remained for many years, used successively as a company store, a boardinghouse, and a landing for steamers until she was broken up in 1868.

Alfred Peabody, the supercargo, remained in California to conduct a profitable mercantile business in basic food and supplies under the name of Flint, Peabody & Co. The glowing reports that he sent back to Salem persuaded Captain Bertram to send out five additional vessels with cargoes for sale, which arrived in San Francisco in the spring of 1850, and also to establish with others the first Boston line of fast clippers for the California trade. Under the firm name of Glidden and

66. Pavilion Beach, 1850–1860. Oil on canvas. 15¼″ x 20½″. Inscribed on reverse: *Early Morning, Pavilion Beach, Gloucester, F. H. Lane fecit.*

67. *Stage Fort Rocks*, Gloucester, Massachusetts, by Fitz Hugh Lane, mid-1850s. Oil on canvas. 13¾″ x 24″.

68. Wreck of the brig *Harriet*. Attributed to Michele Felice Cornè, c. 1800. Gouache and watercolor on paper. 14″ x 18″. Lettered below the scene: *The Brig Harriet of Salem Capn Henry Elkins, cast away on the Texel Island—March 21, 1791.* Captain Elkins was the only survivor of this tragedy.

69. A *Ship Foundering in a Hard Gale,* George Ropes, Salem, Massachusetts, 1809. Gouache on paper. 7¼″ x 9¼″. Ropes, a deaf-mute, was a pupil of M. F. Cornè.

70. U.S. frigate *Washington,* attributed to John S. Blunt, 1814. Oil on canvas. 47¾″ x 57″. A rare view of the launching of a U.S. naval vessel in Portsmouth, New Hampshire, October 1, 1814.

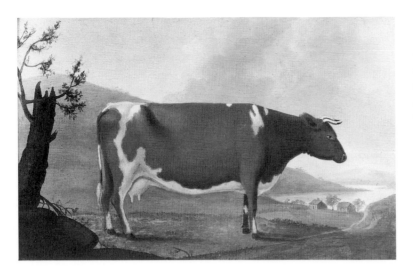

71. *Portrait of Symmetry*, by John S. Blunt, 1823. Oil on wood. 11″ x 17½″. Symmetry was a prize Guernsey cow brought to America in the ship *Harmony* and painted by Blunt against a backdrop of rolling New Hampshire hills.

72. View of the Portsmouth Navy Yard, 1850–1875. Oil on canvas. 27″ x 36″. Looking from the present Gate 2. Many of the buildings in the foreground are still standing and in regular use.

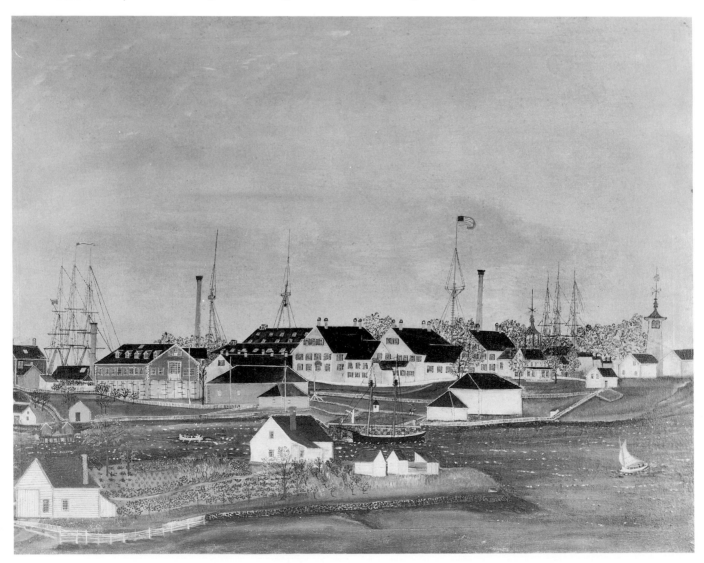

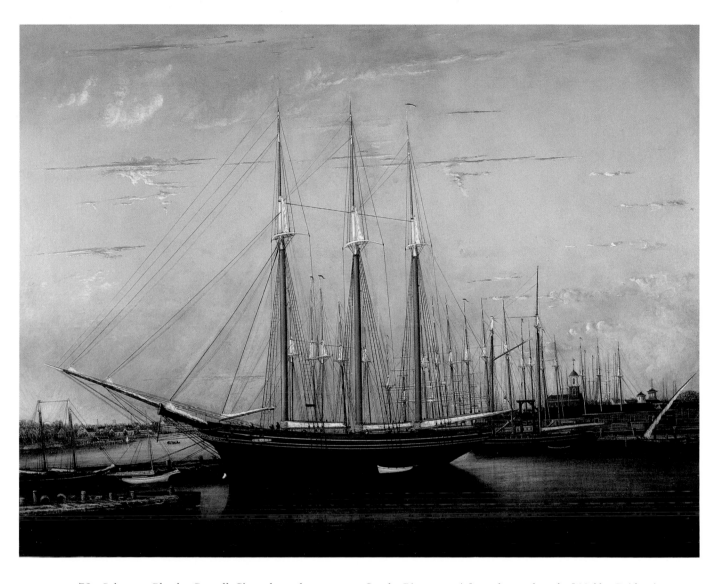

73. *Schooner Charles Carroll.* Signed on the reverse: *On the Piscataqua / from the north end of Nobles Bridge / original / Thomas P. Moses / Portsmouth N.H. / the fall of 1875.* Oil on canvas. 42½″ x 54″. Thomas P. Moses (1808–1881) was a tailor by trade and a painter currently known for his occasional signed marines. He apparently spent much of his life in Portsmouth, N.H.

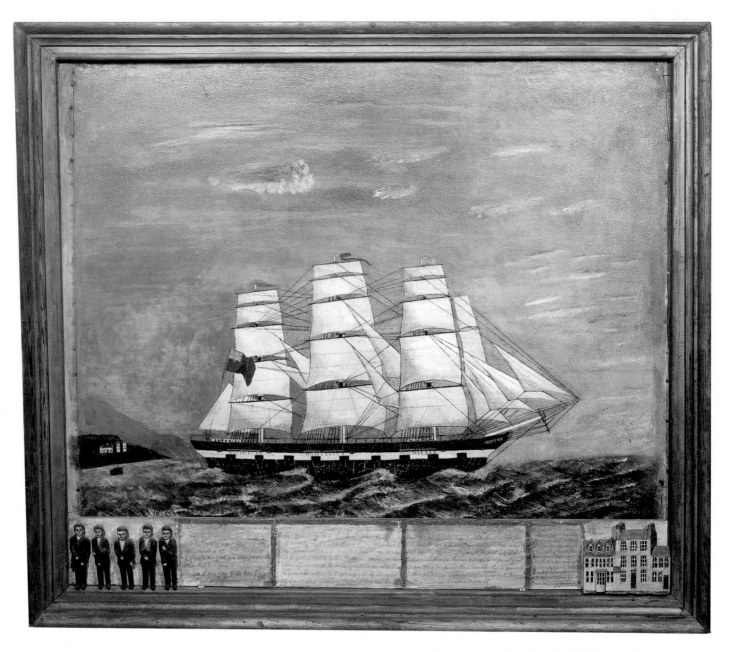

74. Ship *Dredenot* [*sic*] leaving Lands End, England, c. 1850. Oil on canvas. 32½″ x 37½″. The *Dredenot* carried Thomas Wildey, who, in 1817, was the first Odd Fellow to reach America. The carved figures represent the five original members, who in 1819 organized the first lodge at the Seven Stars Tavern in Baltimore, shown at right. The history of the founding of Odd Fellowship in America is written on four sheets of paper below the picture.

Williams, their first clipper ship, the *John Bertram,* sailed for San Francisco on January 10, 1851, carrying among her cargo 10,000 dozens of eggs put up in tins, which on arrival sold for $10,000! In addition to a watercolor painting, we own an old model of the ship *John Bertram* (fig. 60), probably made when she was a famous clipper in the early gold-rush years.

During the period when Bert's ancestors were engaged in various branches of overseas trade, my forebears were leaving England to engage in New England's fast-growing textile industry.

When my paternal grandfather, Charles Fletcher, made his first voyage to this country in 1863, he sailed from Liverpool on the clipper ship *Adelaide.* We are pleased, therefore, to own a spirited watercolor of her painted in 1855 and inscribed with the names of the artist, J. F. Huge, and of the ship's agent, Thomas Wardle, 180 Front Street, New York (fig. 61). Huge came to America from Hamburg, Germany, before 1830 and at various times thereafter was listed in the Bridgeport, Connecticut, directories as "teacher in drawing and painting, and landscape and marine artist."[17] Although his vessels are painted with traditional clarity and precision, Huge's freely rendered treatment of the waves varies in every picture, enlivening the static appearance inherent in so many conventional ship portraits.

In the mid-1850s my maternal great-grandfather brought his wife and children to America on the packet *Daniel Webster,* and this event is remembered in our collection by a reverse painting on glass of the vessel flying the flag of Enoch Train's White Diamond Line (fig. 62). Some nineteenth-century vessels provided unexpectedly spacious passengers' quarters. The *Webster* could accommodate 450 persons in iron berths and was reported to be fitted elegantly in rich deep-veined mahogany, having columns relieved with gold and ceiling of white and gold. Unfortunately, the interiors of merchant ships were not a favorite pictorial subject, but we are fortunate in owning one such picture that was painted under very special circumstances in 1866.

The clipper ship *Nightingale* was built in Portsmouth, New Hampshire, in 1851, and her staterooms and public saloons are said to have been commodious and beautifully fitted up. The vessel was named for the famous singer Jenny Lind, popularly known as the Swedish Nightingale, who was then at the height of her fame. The *Nightingale* had a long and varied career, first as a racing clipper in the tea trade, briefly as a slaver, and later as a part of the Federal Navy in the Civil War. In the mid-1860s, she had an important assignment as the flagship of the Western Union Telegraph Company's fleet of ten vessels operating in the North Pacific to explore a proposed cable from Alaska to Asia via the Bering Strait. In 1866, the telegraph company employed a drawing master, Trautman Grob of San Francisco, in connection with the project, and one of the watercolors he drew pictured the cabin of his friend First Officer John Morton. This sketch (fig. 63) is signed *T. Grob, Special Artist* and is dated *November 7th, 1866.*[18] Several details of an officer's cabin of the period are worthy of note, including the rolled-up charts hung on the walls; the sextant lying on the compact, built-in bunk (which has protecting curtains and convenient drawers); and the tall oil lamp with its stylish floral shade. Mr. Morton himself appears at the left, laying out a course in the North Pacific with his parallel rulers.

In the mid-1850s, when the *Nightingale* was in the China trade, her second officer, Daniel McFarland, procured in Canton or Shanghai the small ivory carving shown in figure 64. Affixed to the bottom of the base is a mother-of-pearl disk

bearing an outline of the ship under full sail and surrounded by the words (in reverse) SWEET AS THE VOICE OF THE NIGHTINGALE, with McFarland's initials *D M F*. Its purpose was to imprint a wax seal on documents and letters. Mrs. McFarland, Daniel's wife, being of strict moral upbringing, did not approve of the figure as a suitable plaything for small children, and it was not until after her death that it became the cherished possession of Daniel's grandson, who always carried it with him as a good-luck charm during his service in World War II and Korea.

Although family ships formed the nucleus of our first marine collection, we soon branched out by adding other maritime subjects. One chilly evening in November 1939, I attended an obscure Boston auction and immediately spotted two attractive pictures, one of Boston Harbor (fig. 65) and the other inscribed on the reverse: *Early morning, Pavilion Beach, Gloucester, F. H. Lane fecit* (fig. 66). I had never heard the name Fitz Hugh Lane, nor had most other people at that time. However, I had summered near Gloucester since childhood, and being well acquainted with the locale of the scene, I purchased it out of nostalgia for less than twenty-five dollars. The view depicts the beach beside the waterfront drive as one approaches the town after crossing the drawbridge at the "cut." A second Gloucester view by Lane depicts the rocky shore of the harbor near the present Stage Fort Park (fig. 67). This scene lies to the right of the drawbridge and cut, and it remains virtually unchanged since it was painted by Lane. Although the artist moved the position of Ten Pound Island to within the viewer's sight, boys still fish from the distant point as they did in the mid-nineteenth century. Lane, a local Gloucester artist of the mid-nineteenth century, has since become famous for his tranquil, luminous coastal scenes, and our painting of Boston Harbor is now also attributed to him.[19]

In 1799, a colorful Neapolitan artist by the name of Michele Felice Cornè arrived in Salem, Massachusetts, aboard the merchant ship *Mount Vernon*. There he remained until about 1807, painting stylish portraits, land- and seascapes, overmantel panels, fireboards, walls of rooms, and countless pictures of local ships rendered in gouache or oil. Cornè is represented in our collection by a landscape, a fireboard, an overmantel, and four marine subjects, one of which is illustrated in figure 68. This painting depicts the wreck of the brig *Harriet*, whose unfortunate master, Henry Elkins, had been several times plundered—and repeatedly cast away—during his previous career on other Salem vessels. On March 21, 1791, came still another disaster when the *Harriet* met her fate on the Texel, one of the West Frisian islands off the coast of Holland. In a violent scene typically dear to the hearts of marine painters, the wreckage of several ships floats over the pounding waves, while a mounted horseman rescues Captain Elkins, who was the only survivor.

One of Cornè's most talented pupils was George Ropes of Salem, a young deaf-mute, some of whose work is almost indistinguishable from that of his master. Although shipwrecks and their tragic consequences were all too frequent in the nineteenth century, they afforded ample opportunities for pictorial melodrama, which were not overlooked by contemporary artists. A particularly dramatic incident is depicted in figure 69, titled, *A Ship Foundering in a Hard Gale*. It is signed *G. Ropes, 1809*, and retains its original repoussé brass frame. It is one of a pair, and its companion piece shows the same vessel still intact, but heading perilously toward the rocky shore.

On October 1, 1814, the U.S. frigate *Washington* was launched with much fanfare from the Portsmouth, New Hampshire, Navy Yard and sailed for the Medi-

75. The Battery and Castle Garden in New York City, attributed to Thomas Chambers, 1835–1840. Oil on canvas. 18″ x 25″. In the center appears the old Southwest Battery, renamed Castle Garden in 1824, after which it became a popular recreation spot. In 1850, it was leased for entertainments by P. T. Barnum, and in 1855, it became the U.S. Immigration Bureau.

76. Ship's figurehead of carved wood from an unknown vessel, mid-nineteenth century. H. 57″.

77. Two miniature figureheads of carved wood from Salem, Massachusetts, first quarter of the nineteenth century. H., left to right, 3″ and 4″. (Photograph courtesy Peabody Museum of Salem)

78. Billethead by Simeon Skillin III of New York. 1810–1825. Wood. H. 17½″. W. 9½″.

62

terranean in October of the following year as the flagship of Commodore Isaac Chauncey (fig. 70). In an eyewitness account of the event, the *Portsmouth Oracle* of October 8, 1814, speaks of the sizable crowd in attendance, and relates that the *Washington* "started from the stocks and glided with the utmost majesty and grandeur . . . the launch is said to have been one of the most elegant and perfect ever witnessed." The unusual composition of this picture shows the vessel emerging from a large "ship house." This particular structure was one of the noted improvements in marine construction during the early years of the nineteenth century, as it not only provided protection from the weather but also furnished cover within which work could progress during the winter season. The building was constructed, beginning in September 1813, at a cost of $5,000, and the ship house was still in use at the navy yard as late as 1876.[20]

This picture has been confidently attributed to John S. Blunt, born in Portsmouth, New Hampshire, on March 17, 1798. Blunt remained in Portsmouth until 1831, during which time various notices in several local newspapers indicated his proficiency in many aspects of the ornamental painter's trade. In the *Portsmouth Directory* in 1827, he advertised, "THE FOLLOWING BRANCHES, VIZ. Portrait and miniature Painting, Military Standard do. Sign Painting, Plain and Ornamented, Landscape and Marine Painting, Masonic and Fancy do. Ship Ornaments Gilded and Painted. . . ."[21] Blunt's land- and seascapes, of which figure 70 must be one of his earliest, exhibit clarity, pleasing colors, and good design, his drawing having notably improved in his later compositions. He was fond of placing small figures in the foreground to bring life to his scenes, and he occasionally experimented with unusual subjects, as in his *Picknick on Long Island*[22] and his portrait *(Symmetry)* of a prize cow brought into Portsmouth by one Captain Woodward on the ship *Harmony* in 1823 (fig. 71). In 1831, Blunt moved his family to Boston, where he opened a studio on Cornhill. If he had lived to develop his talents, he would surely have been recognized today as one of the leading New England artists of his time. During the summer of 1835, however, he embarked on a sea voyage, not to return, for on September 8, the *Boston Daily Advertiser and Patriot* carried the following notice: "Died on board ship *Ohio* on the passage from New Orleans to this port, Mr. John S. Blount [*sic*] passenger, and Avery Gordon, seaman."

A delightfully detailed view of the Portsmouth Navy Yard appears in figure 72, taken from the vantage point of the present Gate 2. Probably painted during the third quarter of the nineteenth century, its flat, photographic quality suggests a possible derivation from a printed source. Wishing to identify the various buildings and to ascertain if any still remained, we presented ourselves one summer day at the entrance to the navy yard, with the painting under an arm. With the naïveté of the enthusiastic collector, we had neglected to arrange an introduction in advance, assuming that our picture would engender enough interest to ensure cooperation in our quest. Unfortunately this was not the case. The officer in charge considered the picture a "map or chart" of the yard, and he questioned us closely about where we had obtained it, apparently quickly deciding that we were "suspicious persons." While he was hastily trying to summon a security guard, three navy yard workers walked into the office—two carpenters and a painter. They had worked on virtually every structure there during their long tenure of employment. They spotted the painting and immediately became fascinated, discussing among themselves the location and current use of every building in the scene. After they had unwittingly supplied us with all possible desired information, we beat a

hasty retreat before a security man could arrive to detain us forcibly! Another Portsmouth, New Hampshire, scene by the little-known painter Thomas B. Moses is taken from a different viewpoint (fig. 73). Here the three-masted schooner *Charles Carroll* lies at anchor in the Piscataqua River with old St. John's Church (which is still standing) dominating the skyline at the right. The Kittery, Maine, shore appears at the left. The morning sun is seen just rising above the tree tops, as it touches the clouds with the first luminous glow of dawn.

Story-telling pictures are always amusing, and that in figure 74 is no exception. The vessel depicted is the English ship *Dredenot* [*sic*], leaving the lighthouse at Lands End. She carried Thomas Wildey, the first Odd Fellow to reach America, to Baltimore, arriving on September 2, 1817. Four handwritten sheets of paper document the organization of the first Odd Fellows Lodge, which took place a year and a half later (according to the narrative) in the Seven Stars Tavern, on April 20, 1819. Carved figures representing the five American founders stand at the left of the picture, and on the right is a three-dimensional model of the historic tavern. Although the painting is unsigned, the artist and author was obviously a devoted and enthusiastic supporter of Odd Fellowship, which, in his words, "is excepted [*sic*] in all civilized countries."

As time went on, we became interested in various marine artists, and I began to do research on Thomas Chambers, about whom I later wrote an article for *Antiques*.[23] Chambers was an Englishman who came to this country in 1832. Between 1834 and 1866, he worked successively in New York City, Boston, and Albany, and his stylish and colorful Hudson River views and harbor and shipping scenes have made him one of the most popular mid-nineteenth-century artists. In figure 75, we see New York Bay and the Battery, with Castle Garden approached by a footbridge, as it looked when it was a fashionable resort, and Jenny Lind made her debut there in four concerts under the management of P. T. Barnum in 1850. Governor's Island appears in the background, and the boats and white-capped waves are recognizable features of Chambers's picturesque style.

All ships' figureheads seem to personify the romance of the sea. Some were works of the professional carver's art whereas others, like that in figure 76, were products of less imaginative artisans. Many seen in public exhibitions have been reconditioned by the filling of time cracks and the application of fresh paint, but our lady, from an unknown vessel, displays her age and bears witness to repeated encounters with wind and wave. Relatively few figureheads have survived, as many were lost or broken up with the vessels of which they were a part. The expertly whittled miniature figureheads shown in figure 77 are only three inches in height and may have been intended as basic models, or more probably as children's toys.

On some sailing ships, figureheads were replaced by billetheads—large, handsomely carved ornaments whose traditional form combines conventional leafage with repeated scrolls. Because they were a stock in trade of most ship carvers, few billetheads can now be traced to their original source, but the example in figure 78 was part of the inheritance of a grandson of Simeon Skillin III of New York City. Son of Samuel Skillin of Philadelphia and grandson of the famous Simeon Skillin of Boston, Simeon III was one of a noted family of ship carvers whose work spanned a seventy-five-year period, starting in the mid-eighteenth century. Simeon III's name first appeared in the New York City directories in 1789 and continuously, thereafter, at various addresses until his death in 1830. For some years in the early nineteenth century, he worked in partnership with Jeremiah Dodge, another well-known carver. Two of Skillin's workbooks (plus other family memo-

79. Masthead figure of carved wood from the *Lottie L. Thomas,* 1883. H. 20″. Attributed to a West Indian carver named Cook, who worked at St. Britton's Bay, Maryland, during the last quarter of the nineteenth century.

80. Model of the *Lottie L. Thomas* after her conversion to a yacht, probably in the 1920s. H. 23″. L. 29″. The *Thomas* was built as a "bugeye," by J. W. Brooks in Madison, Maryland, in 1883 and carried lumber on Chesapeake Bay. A 1″ copy of the original masthead figure (fig. 79) is visible atop the foremast.

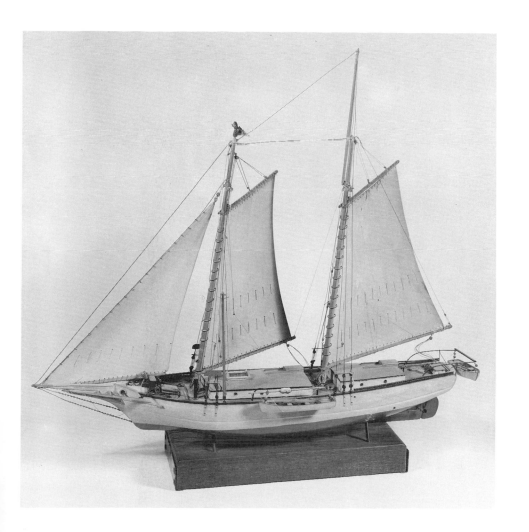

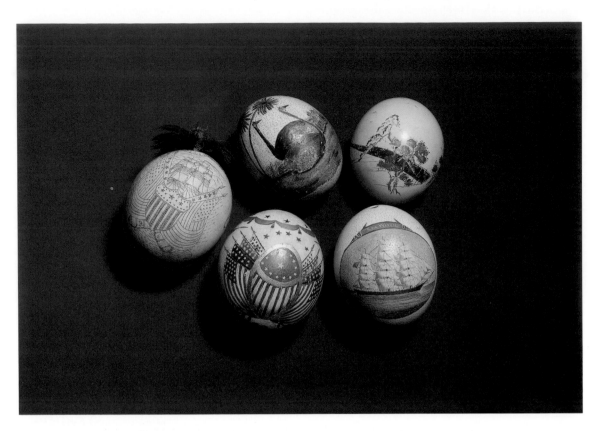

81. Group of decorated ostrich eggs, nineteenth century. Average length 6″. Brought home from African trading voyages, ostrich eggs exhibited all manner of carved and painted decoration. Clockwise from left: Ship with flags and U.S. shield; scrimshaw decoration; pair of ostriches; Japanese-type design; American clipper ship; patriotic arrangement of American flags. The latter came in an especially fitted, protective straw basket.

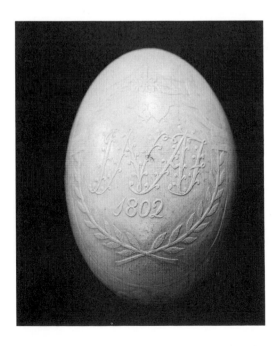

82. Expertly carved ostrich egg, dated *1802*. L. 5½″. (Photograph by Mark Sexton courtesy Peabody Museum, Salem)

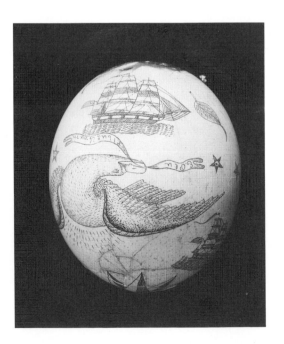

83. Ostrich egg with scrimshaw decoration. L. 6″. The reverse is shown in figure 81. (Photograph by Mark Sexton courtesy Peabody Museum, Salem)

rabilia and three billetheads) are in our possession and contain details of considerable interest concerning his daily transactions. Skillin charged $16.66 for carving a billethead and trailboard in 1817, and $3.00 for painting and gilding the figurehead of the sloop *Fame* in 1810. Our billetheads are obviously small in scale and were no doubt intended as models for full-sized carvings. They are finished with a priming coat of buff paint and display evident marks of age, but they appear never to have "gone to sea."

Certain ship carvings that are quite unfamiliar to New Englanders, but indigenous to Chesapeake Bay, are the masthead figures found on old lumber schooners, or "bug-eyes," built during the last quarter of the nineteenth century. These relatively tiny figures, only about 20″ high, were perched atop the foremast (fig. 79) and were almost invisible from the water below. The *Lottie L. Thomas* (fig. 80) was built by J. W. Brooks in Madison, Maryland, in 1883, and at least three other schooners of her type, one of which was the *Mattie F. Dean,* carried similar masthead figures.[24] George W. Ellis, whose grandfather Captain Edwin Gibson had at one time owned the *Thomas,* believed these figures to have been carved by a West Indian black named Cook, who worked in St. Britton's Bay, St. Mary's County, Maryland. An uncle of Mr. Ellis actually remembered Cook making the similar figure for the *Mattie F. Dean.*[25] By 1932, the *Thomas* had been converted into a yacht by its then owner, Edward G. Jay of Mansfield, Massachusetts. Mr. Jay was Commodore of the Boston Yacht Club in 1932, and the frontispiece of the club book of that year carries a photograph of the *Thomas* in Boston Harbor, complete with the masthead figure that now accompanies the model. The model was evidently made after her conversion to a yacht, for it exhibits a propeller for an engine with which she would not originally have been equipped.

One fascinating aspect of collecting maritime art, particularly the study of nineteenth-century overseas trade, is a realization of the wide range of curios brought home by American seamen from foreign ports. We have a heterogeneous collection of foreign trade items, the most amusing being the large ostrich eggs from Africa, many embellished with carved, painted, and incised decoration (figs. 81, 82, 83). Our first encounter with an ostrich egg was during the early part of World War II, when we used a few precious gallons of rationed gasoline to attend a small house-auction in Gloucester, Massachusetts. There, hanging by a string from a gaslight in the parlor, were two large white eggs brought home by an ancestor of the house's owner in the mid-nineteenth century. After waiting all day for them to be put up, I was the only bidder, and they became mine for forty cents the pair. This event turned out, however, to be only the beginning of a continuing, if spasmodic, search for these elusive collectibles.

Even during the peaceful summer of 1938, distant storm clouds were gathering on the world's horizon and were soon to assume the menacing shape of things to come. On September 3, 1939, England and France declared war on Germany, and scarcely more than two years later, America herself was to be plunged into the darkening tragedy of World War II. I think back on the 1930s, however, as a stimulating decade when money was often scarce and buying frequently curtailed, but opportunities for discovery were unlimited and made "antiquing" a continuously exciting experience for the young in heart.

III
The Busy Forties

We were fortunate during our early collecting years in having several opportunities to acquire good antiques that had descended directly in their original families, all being accompanied with histories of origin and former owners. On a cold, gray Sunday morning in February 1940, we received a telephone call from a friend in Middleboro, Massachusetts, telling us that descendants of an old New Bedford family were preparing to offer some of their inherited things for sale. We went to see them immediately and found that the Charles Tuckers were descended from locally prominent whaling ancestors. Among the cherished family possessions that we took home were a long-handled iron strainer once used on shipboard for the preparation of whale oil; a huge red-and-white worsted flag that had formerly flown from the mast of a Tucker vessel; and a signed and dated ship's checkerboard, complete with its original wooden checkers. The painted lettering around four sides indicated that it was used on the ship *Huzzah* and had been made by Abr^m Tucker of Dartmouth, County of Bristol, January 24, 1824 (fig. 84). A charming view of the old Tucker home in Smith Mills, before the family moved to Padanaram in the nineteenth century, hung on the wall, and, of course, we could not leave this behind. In an upper chamber stood the simple bow-front chest of drawers in figure 85. Constructed of cherry with mahogany veneer and light and dark inlays, this widely popular form was inspired in part by published patterns that appeared in Heppelwhite's *Cabinet-Maker and Upholsterer's Guide* and in *The Cabinet-Makers' London Book of Prices*.[1] The original brass handles bear the unidentified English founder's mark *H·J* on the bail. Mrs. Tucker had found this bureau, accompanied by a gold mirror, many years before in Quechee, Vermont, for the modest price of fourteen dollars for the two pieces. What attracted us, however, was the penciled inscription on the bottom of the top drawer: *Eliphalet Briggs j[r]/Keene January 9th 1810/Made this $19 Doll.* Eliphalet Briggs (1788–1833) was born in Keene, New Hampshire, and his father and five younger brothers are said also to have followed the cabinetmaker's trade. Briggs opened his own shop in 1810, so this chest of drawers must have been one of his first commissions.

In the summer of 1940, we acquired our first examples of Shaker craftsman-

ship after making the acquaintance of Edward and Faith Andrews, whose scholarly book *Shaker Furniture* had gone into its second printing the previous year.[2] General appreciation of the aesthetic quality of Shaker craftsmanship was still in its infancy, its variety and simplicity of design having only recently been brought to public attention by the exhibition of furniture and inspirational drawings held at the Whitney Museum of American Art, New York, in the late fall of 1935. In 1928, 1929, and again in 1933, the Andrews had published articles on the subject in *Antiques,* and the text and illustrations whetted our appetite to see more of these simple functional pieces.

On a fine late August day in 1940, we drove over to the Andrews' home, attractively situated on a quiet back road in the town of Richmond, Massachusetts. There we were entirely surrounded by their wide-ranging collection, acquired during years of perceptive gleaning from various Shaker communities in New England and New York State. At that time, most of the larger pieces of furniture were not for sale, but the Andrews were willing to part with certain duplicates and with many significant smaller items, including woven handkerchiefs, printed apothecary labels, handmade coat hangers, peg boards, colorful oval boxes, and a one-drawer pipe box. We were so obviously delighted with these varied examples of Shaker crafts that before the end of our leisurely visit, the Andrews offered to make available our first important piece of Shaker furniture, the tall combination cupboard and chest of drawers that appears in figure 86. This chest came from New Lebanon, New York, and is documented by an old inscription penciled on the upper surface of the bottom board: *Jan. 29th, 1817. J. B. and G. L.* Mrs. Andrews told us that the initials *J. B.* probably identified either Job or John Bishop, as there were several cabinetmakers among the Bishop family, who produced some of the earlier furniture in the New Lebanon community. Another piece that caught our eye was the red-painted sill cupboard shown in figure 87, which the Andrews had discovered in a subcellar of the First Order dwelling, Church Family, in New Lebanon. A photograph of it *in situ* appears in plate 25 of *Shaker Furniture.* I jokingly asked Mrs. Andrews to put my initials on the back for future reference, and sure enough, she telephoned me in 1947 and said that we might drive up and take the cupboard home! The raised panel doors are an unusual feature and suggest an early example of Shaker craftsmanship.

A few of our smaller pieces of furniture, with accompanying accessories that originated in several different Shaker communities, are shown in figure 88. The wooden coat hanger at the left is from Sabbathday Lake, Maine. From Canterbury, New Hampshire, came the blue-painted stool, the stand with shelf, and the coat hanger with shaped ends. The small table with stretchers was made in Enfield, New Hampshire. From New Lebanon, New York, came the pipe box, the slat-back chair, and the thin, oval box resting on the cupboard top, which is labeled (and still contains) "white silk from Lebanon."

December 1941 saw the entry of the United States into World War II, and for the second time in ten years, our collecting activities were to be temporarily curtailed. Nevertheless, it was during this time that some interesting furniture from our own forebears came into our possession.

Early one evening, an elderly cousin of Bert's telephoned to say that she was considering parting with a few of her inherited pieces, among them a seventeenth-century oak armchair that Bert's uncle had purchased about seventy years before. Although Bert had long been familiar with the chair, we decided to visit the cousin immediately with flashlight in hand, as she lived in an early-

84. Painted checkerboard with original wooden checkers. Lettered around edge: *Abr^m Tucker of Dartmouth, County of Bristol, maker. Jan. 24, 1824. Huzzah.* 13" x 13".

85. Chest of drawers, signed in pencil on bottom of top drawer: *Eliphalet Briggs j[r]/Keene January 9th 1810/Made this $19 Doll.* Cherry with mahogany veneer. H. 33½", W. 41". From the Tucker family of Padanaram, Massachusetts.

86. Shaker chest of drawers with red stain, New Lebanon, New York. Penciled on upper surface of bottom board: *Jan. 29th, 1817. J. B. and G. L.* H. 83″. W. 42″.

87. Shaker sill cupboard, found in the subcellar of the First Order dwelling, Church Family, New Lebanon, New York, first quarter nineteenth century. H. 75½″, W. 21″.

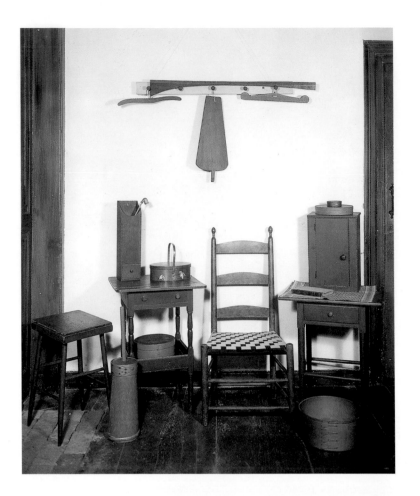

88. Group of Shaker furniture and accessories from various Shaker communities, including Sabbathday Lake, Maine; Canterbury and Enfield, New Hampshire; and New Lebanon, New York.

89. Photograph of furniture in the James Lovell Little house, Brookline, Massachusetts, taken in 1896. The oak armchair stands in the center of the hall. (Photograph courtesy Benno Forman)

90. Oak armchair of Essex County origin, 1670–1700. H. 39″. W. 22½″. Purchased in 1875 for $26.50 from James Moulton, Lynn, Massachusetts, by James Lovell Little. (Photograph courtesy Essex Institute, Salem, Massachusetts)

91. Serpentine desk, from the home of Miss Caroline O. Emmerton, Salem, Massachusetts, 1780–1800. Curly birch with Jefferson brasses. H. 43½″. W. 41½″.

92. Brass drawer-pull with profile of Thomas Jefferson from the desk in figure 91. Diam. 3⅛″. The name *Jefferson* appears below the bust.

93. Birch serpentine chest of drawers with claw-and-ball feet, from 27 Chestnut Street, Salem, Massachusetts, 1770–1790. The brasses are replacements. H. 33″. W. 36″. Chippendale looking glass, 1750–1775. Mahogany and veneer with gilt. H. 42″. W. 20½″.

94. Block-front kneehole dressing table, from 27 Chestnut Street, Salem, Massachusetts, c. 1760. Walnut, with original brasses. H. 29½″. W. 30½″. Mahogany dressing glass from Salem, 1800–1815. H. 21½″. W. 22½″.

nineteenth-century house that was still illuminated solely by oil lamps. There, in its accustomed place in the front hall, stood the chair, just as it had appeared in the 1896 photograph shown in figure 89 (right of center). The back is carved with bands of demilunes, and it exhibits several sets of unidentified initials (fig. 90). Accompanying the chair was the original bill of sale, dated 1875, by the dealer James Moulton of Lynn, Massachusetts, and made out to Bert's uncle James Lovell Little. This was an interesting document, as it listed several purchases of rare historical Staffordshire and an "old oak chest" at $5.00; a "chest of drawers with 8 drops" at $8.00; and eighteen eggs at $1.83. By far the most expensive item, however, was our "old oak chair" at $26.50. This turned out to be one of a small group of similar chairs, of which Winterthur Museum, the New Hampshire Historical Society, and the Museum of Fine Arts, Boston, then each owned one. The exact origin and the maker are at present unknown, although the workmanship indicates that he was an excellent craftsman, probably from East Anglia in England, and that he was primarily a joiner rather than a carver.[3]

During the summer of 1942, following the death of Bert's cousin Miss Caroline O. Emmerton, a large auction was held at her home, a three-story Federal mansion on Essex Street in Salem. As newlyweds, we had been entertained there on various occasions. One of my pleasantest recollections is the delicious lobster bisque soup served in handsome old-fashioned soup plates in Cousin Caroline's formal dining room. In her upper hall stood a serpentine-front curly birch desk, its circular Jefferson-profile brasses polished to a high luster, and I admired this piece on every visit (fig. 91). The Emmerton auction was heavily attended by dealers and collectors from far and near. We drove to Salem for the day, planning to bid on a number of family items. These included a handsome bombé chest-on-chest, for which we were finally outbid by a well-known dealer who had driven from New York City especially for the sale. We did, however, get the desk, and since that time, it has been in continuous use in our living room, its brasses as brightly polished as when we first saw it in Cousin Caroline's home many years ago (fig. 92).

Toward the end of the war, some of the family furniture from the old Little home at 27 Chestnut Street, Salem, came to us by inheritance. Among it was the birch serpentine chest of drawers in figure 93. A simple sturdy piece, it was discovered tucked away in one of the small third-floor maids' rooms in Bert's mother's house, its original finish "beautified" in the nineteenth century by an enveloping mahogany stain that we have since removed. The walnut kneehole dressing table in figure 94 had fortunately fared better. With its original brasses, it is one of a related group of block-front pieces of similar design that perhaps originated in the Salem area. The kneehole table and Federal dressing glass from 27 Chestnut Street have been constant companions longer than anyone in the family can now remember.

During the war, we continued to expand our collection of antique china, but as enemy bombing of the East Coast presented a possible threat to fragile objects, we were advised to pack some of our most valuable ceramics and move them out of Boston. Accordingly, we filled a large wooden barrel with fifteen pieces of our rarest historical Staffordshire and left it temporarily in a small hall that opened off the dining room. A few days later, we discovered to our horror that it had disappeared: it had been put out with the trash and taken to the dump through the mistaken zeal of an overconscientious handyman. Only two pieces were ever

recovered. This was our single casualty, occasioned, as we have said since, by being overcautious.

Early in the 1940s, I made some exploratory purchases of delftware, a type of ceramics that constituted one of the largest importations into Colonial America. Made of a lightly fired earthenware base, the body was coated with an opaque glaze containing oxide of tin, which produced a milky white appearance akin to Chinese porcelain. To this enamel-like surface, painted decoration was subsequently applied. Delftware was manufactured in Holland and England, and in several other European countries. It was known in France as *faïence*, and as *majolica* in Italy and Spain.

One day in December 1940, I found in a small shop in Cambridge a pair of large, covered jars inscribed with Latin names and decorated with designs in purple, blue, and yellow. These, it seemed, were eighteenth-century French apothecary jars, and they are illustrated at either end of the second shelf in figure 95. Following this initial purchase, I became increasingly interested in tin-enameled pieces, and when the famous William Randolph Hearst collection of antiques and works of art was dispersed in New York City in March 1941, I decided to go and have a look. The European pieces were on display at Gimbel's department store and contained a number of rare Continental ceramics that I had read about but never seen. I was able to acquire six examples, among them a German polished red stoneware tankard with silver cover, dated 1736, and a salt-glazed tigerware jug with a silver-gilt mount, marked with London hallmarks for the years 1562–1563. These pieces appear at the extreme left of the two upper shelves in figure 46. I also purchased a handsome tin-enameled plate of Dutch origin, decorated in red, blue, turquoise, and gold, dating to the first half of the eighteenth century (fig. 96).

In May 1946, I received a telephone call from Frank Stoner of Stoner and Evans in New York City describing a large oval English fecundity dish inscribed *Stephen Fortune & Elizabeth* with the date *1633*. Within a few days, Mr. Stoner appeared by train in Boston, carrying the platter wrapped in a brown paper parcel under his arm. I recognized it as one in a group of about twenty known dishes modeled after French lead-glazed pottery made in the sixteenth century in the workshop of Bernard Palissy (fig. 97). Decorated in polychrome with dull gilding, this dish was the earliest dated example that had then been discovered.

After 1730, Boston newspapers began to carry frequent notices of the importation of Dutch and English "Delph" ware. This was shipped from England in hogsheads to be sold in quantity by local shops, and I was constantly on the lookout for delft pieces that had not been recently imported but had family histories tracing them back to early New England owners. Delft bowls, dishes, and plates abound in pre-Revolutionary inventories, but the soft and easily chipped body did not wear well under household use and was finally superceded by the newly perfected cream-colored pottery that flooded the market in the last quarter of the eighteenth century. Two pieces of English delft made in London near the middle of the seventeenth century are shown in figure 98. The lobed dish and standing salt have added interest for me because of their personal histories, which document ownership in New England for at least two hundred years.

Following the end of the war in 1946, antiques collecting resumed with unabated enthusiasm, and in January 1949 occurred an event that was to have lasting repercussions in the collectors' world. This was the first Forum on Antiques and Decorative Arts, sponsored jointly by Colonial Williamsburg and *The Magazine An-*

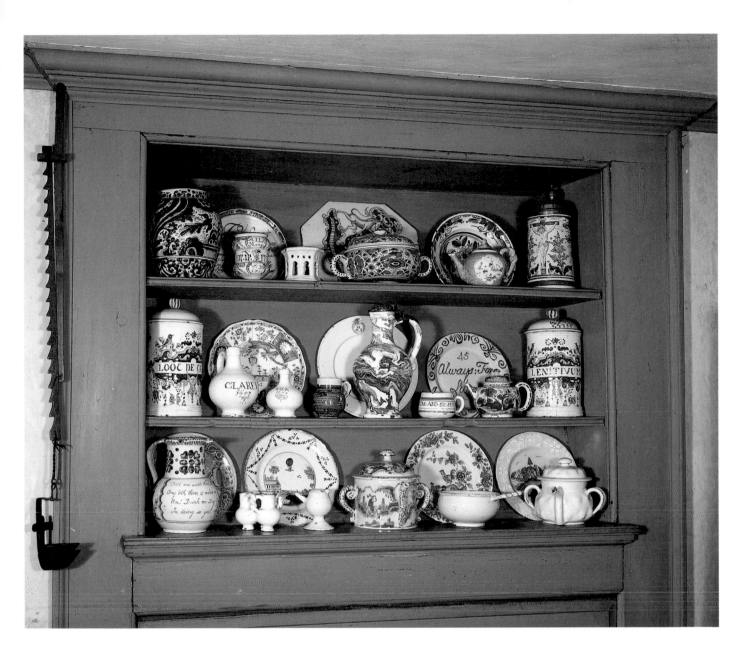

95. Shelves of seventeenth- and eighteenth-century tin-enameled wares, English and Continental. French apothecary jars stand at the extreme left and right of the center shelf. H. of each 10″.

96. Tin-enameled plate, Holland, first half of the eighteenth century. Kakiemon decoration with *grand feu* and muffle-kiln colors in red, blue, turquoise, and gold. Diam. 12¼".

97. English tin-enameled dish, inscribed: *Stephen Fortune & Elizabeth, 1633*. 16¼" x 19½". The subject, known as *La Fécondité*, was copied from examples attributed to the sixteenth-century French potter Bernard Palissy.

98. English delft lobed dish and standing salt, mid-seventeenth century. The dish is documented by an 1876 label as having previously been owned by five generations of one New England family. Diam. 11½". The standing salt descended in a New Hampshire family from before the Revolution. H. 4½". Diam. of base 5".

99. Striped carpeting from Richfield Springs, New York, c. 1825. Warp cotton, weft homespun flax tow. 84" x 84".

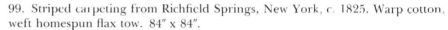

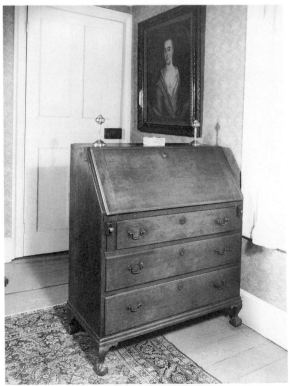

100. Woven coverlet from New York State, c. 1830. 99″ x
81¾″. The yarn was home-dyed with madder, which derived
from the roots of a herbaceous climbing plant chiefly culti-
vated in the Netherlands during the early nineteenth century.

101. Cherry fall-front desk with original brasses, 1760–1780.
H. 42¼″. W. 36¼″. Said to have been brought by settlers from
Connecticut to New York State during the nineteenth cen-
tury.

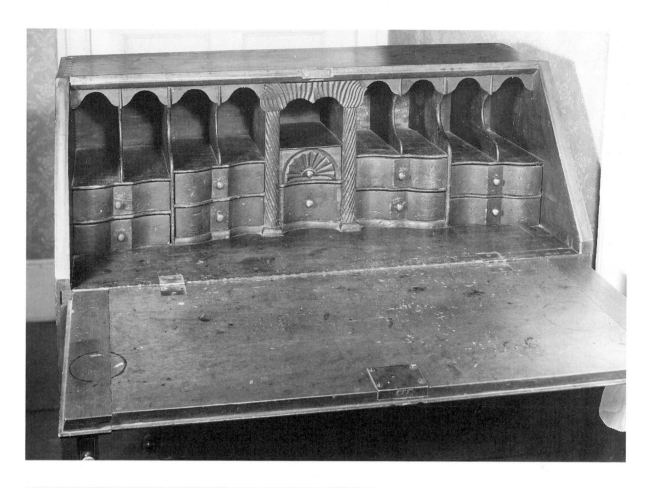

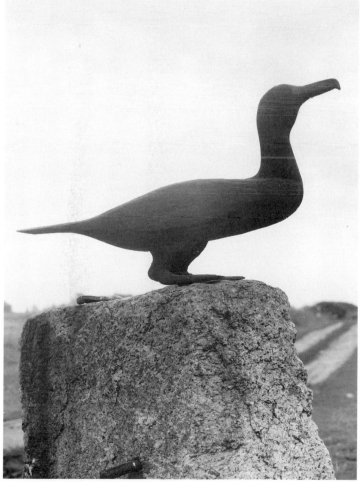

102. Interior of the desk in figure 101. The eight blocked drawers flank a carved section that conceals two secret document compartments.

103. Ornamental carving of a cormorant, probably New England, nineteenth century. H 14" L 27". This bird, posed in an unusual standing position, was found in the Cooperstown, New York, area.

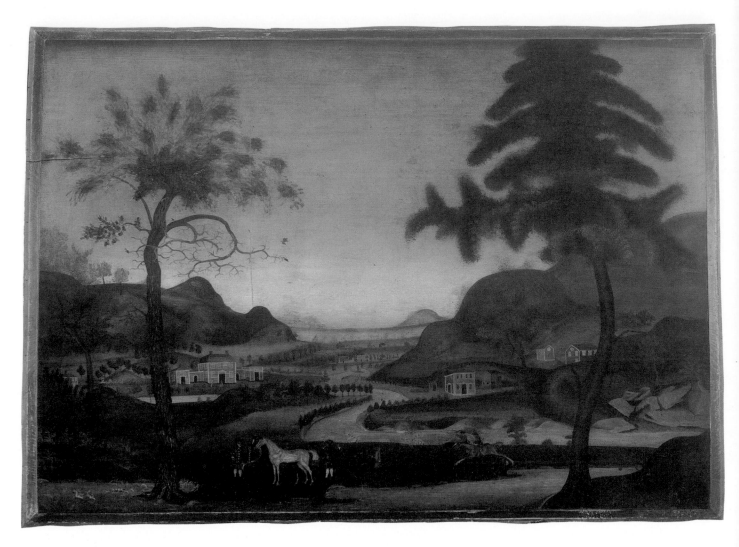

104. Overmantel panel attributed to Winthrop Chandler, from the Elisha Hurlbut house, Scotland, Connecticut, 1767–1769. Oil on wood. 42″ x 59″. The details in the imaginary scene are characteristic of other Chandler landscapes.

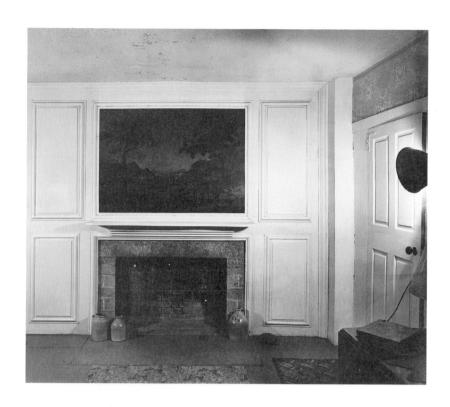

105. Lower northeast room of the Elisha Hurlbut house, Scotland, Connecticut. Photograph taken in 1947, showing the overmantel in figure 104 in its original position. (Photograph by T. F. Hartley)

106. Upper southwest chamber in the old Ebenezer Waters house, West Sutton, Massachusetts, with overmantel attributed to Winthrop Chandler. The grained woodwork was painted over many years ago.

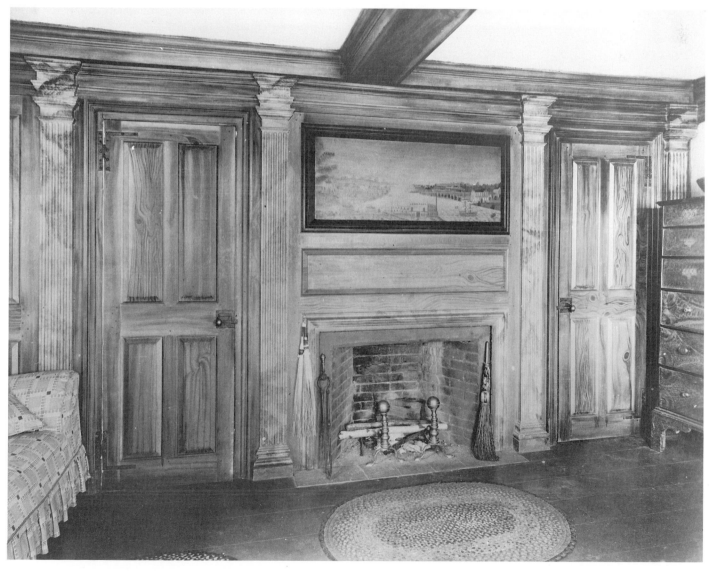

tiques. The program consisted of a series of lectures held in Williamsburg, Virginia, during two concurrent sessions from January 24 through 28, and from January 31 through February 4. In the words of Alice Winchester, editor of *Antiques*, the forum was planned "because we believe it is the best possible way of meeting certain basic needs of collectors. . . . a chance to compare notes, argue about fine points, and exchange collecting experiences." The various speakers were carefully chosen for their expertise and for ability to present their subjects in a concise and informative manner. Among them were Charles F. Montgomery, later Director of Winterthur Museum; John Marshall Phillips, Director of the Yale University Art Gallery; and Joseph Downs, then Curator of the Metropolitan Museum's American Wing. To my surprise, I was asked to speak on "American Pottery and Porcelain in Colonial America."

Each lecturer was allotted exactly fifty minutes, so that the program would proceed promptly according to plan, and a short orientation on the platform the day before his or her talk impressed the time schedule on each lecturer's mind. A Williamsburg staff member courteously showed me the rostrum, the microphone, the light switch, and the signal for changing slides. Then he said in all seriousness, "Five minutes before the end of your program, I will warn you by scratching like a mouse in back of the curtain behind you. I will scratch again in two minutes. If, however, you hear scratchings three times you will know that it *really is a mouse!*" Needless to say, I finished well within the designated fifty minutes! At a later forum, the wife of one eminent collector sat in the front row armed with an alarm clock carefully set to go off if her husband talked beyond his allotted time.

Over the years during which we attended the Forums, it was our privilege to become friendly with many of the well-known collectors of the day, including Mrs. Electra Webb, Miss Ima Hogg, Edgar and Bernice Chrysler Garbisch, Maxim Karolik, and many others, who like ourselves were eager to learn. I lectured at eight of the first ten Forums on various subjects, including ceramics, painted decoration, folk art, and eighteenth-century interiors, topics that reflected some of our collecting interests during the 1940s and 1950s. In January 1969, we lent a group of land- and seascape pictures for an exhibit at the Abby Aldrich Rockefeller Folk Art Collection, and we returned to Williamsburg for the twenty-first Antiques Forum, at which Bert and I spoke jointly on special aspects of our painting collection.

During the summer of 1948, an event similar in some ways to the Forums was (and still is) sponsored in Cooperstown, New York, by the New York State Historical Association. Titled "Seminars on American Culture," the programs differed from the Forums in that they offered either one or two weeks of six-day courses, each course taught by its own faculty of three or more persons. The emphasis was not primarily on collecting but on related subjects, such as writing local history, techniques of historic preservation, genealogy for the amateur, some phases of New York history, and exploration of the newly emerging field of American folk art. Bert and I both taught at Cooperstown, for the meetings came in July, when he could take his summer vacation. Some of the courses in which one or both of us took part included "Preservation of Historic Buildings"; "Tides of Taste in New York State"; "Problems of the Small History Museum"; "Folk Culture of the Northeast"; "Peopling the Past"; and "Historic Housekeeping."

Of course, many amusing incidents took place during these seminars. One that I especially remember happened during a visit to a small village during a course

titled "Reading the Landscape." Stopping on the main street, the leader of the group proceeded, by means of a large bull-horn, to inform his students about the history of the settlement and to call their attention to its patterns of migration and to its architectural and agricultural development. Suddenly, to the consternation of a nearby group of local citizens, the speaker ended with the ringing statement: "Anyone can see that this is a classic example of a dying community!"

Following the evening programs, some of the seminar faculty and students used to gather at the home of the association's director, Dr. Louis Jones, and his wife, Aggie, where stimulating discussions and exchanges of opinions added new dimensions to the day's study. It was at Cooperstown that the whole background of folk culture—its arts, crafts, music, oral history, and folklore—first came to life for me, awakening my interest in a hitherto unexplored territory of collecting and research.

We soon discovered that good country antiques shops were to be found in Upstate New York, and we managed to revisit them year after year. There we bought a large and handsome piece of striped carpeting woven in contrasting shades of rose, blue, rust, and brown (fig. 99). Made in Richfield Springs, New York, this was the first of several old striped carpets that we were later able to acquire. Also from the early Cooperstown years came the woven coverlet shown in figure 100. It is colored with madder, a vibrant orange-red hue derived from the roots of a plant. Here the use of a home dye pot is clearly indicated by the color variations in the woolen yarn.

Many New Englanders came to New York State in the early nineteenth century, bringing with them what few household possessions they were able to carry. Some of these furnishings have remained in the area for well over 150 years, including the cherry fall-front desk in figure 101, which was said to have traveled west from Connecticut many generations before. Notable for its exceptionally small ball-and-claw feet, the desk's interior exhibits bold blocking with a small fan-carved drawer. The center section pulls out to reveal two concealed document compartments (fig. 102). Probably also of New England origin is the life-sized figure of a cormorant (not made as a decoy but as an ornamental carving), a sea bird that we rescued in New York State and returned to its native habitat (fig. 103). One of the picturesque sights to watch for along the Maine coast are the black, hooked-bill cormorants sitting atop a rock or harbor buoy and peering intently for a fish swimming heedlessly below.

In 1945 came the opportunity to embark on my first in-depth research on a little-known New England painter. This study resulted in a definitive exhibition of the work of Winthrop Chandler, an eighteenth-century Connecticut artist, at the Worcester Art Museum in Massachusetts. The study was published in *Art in America* as a catalogue to accompany the exhibit in 1947.[4] Chandler's name was already known to a few art historians in connection with the outstanding pair of portraits of *Reverend and Mrs. Ebenezer Devotion* (owned by the Brookline [Massachusetts] Historical Society), and for six other pictures attributed to him that are owned by the American Antiquarian Society and by the Karolik Collection at the Museum of Fine Arts, Boston. As a result of this investigation into his life and work, he emerged as one of the most important provincial artists of the third quarter of the eighteenth century. Born in Woodstock, Connecticut, in 1747, he combined portraiture, house painting, and other aspects of an ornamental painter's repertoire, most of his patrons being family members and friends. Chandler died in-

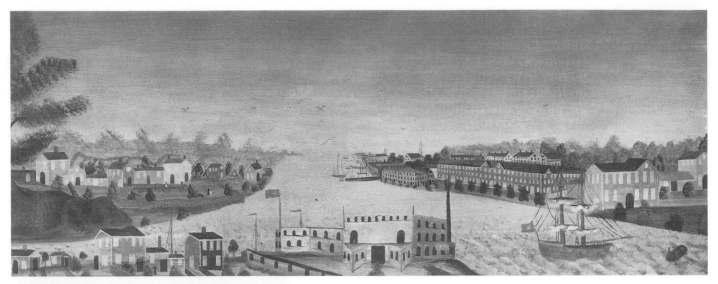

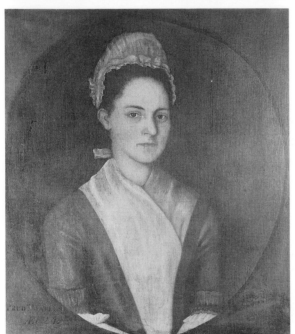

107. Overmantel panel from the old Ebenezer Waters house shown in figure 106, c. 1729. Oil on wood. 18" x 47½". This fanciful composition combines frame houses of a New England type with brick buildings probably derived from a printed source.

108. *Mrs. Samuel Waters* of West Sutton, Massachusetts, attributed to Winthrop Chandler, c. 1779. Oil on canvas. 28¾" x 25½". Lettered at lower left: *Prud^{ce} Waters, AET. 24.*

109. Banister house, Brookfield, Massachusetts. This old photograph shows the house before demolition some years ago.

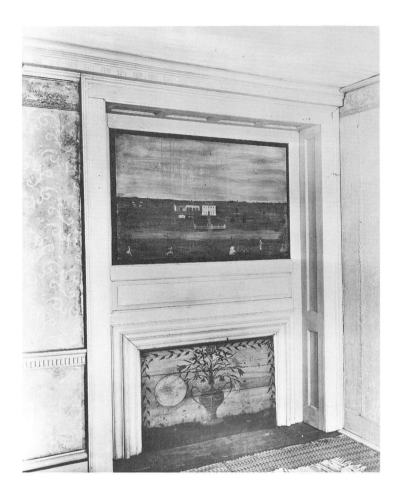

110. Corner of the ballroom of the Banister house showing overmantel and fireboard in original position.

111. Overmantel panel from the Banister house, Brookfield, Massachusetts, c. 1790. Artist unknown. Oil on wood. 31″ x 47″. The house with outbuildings appears in the center. The figures in the foreground were apparently copied from an engraving. (Photograph by George Boyer)

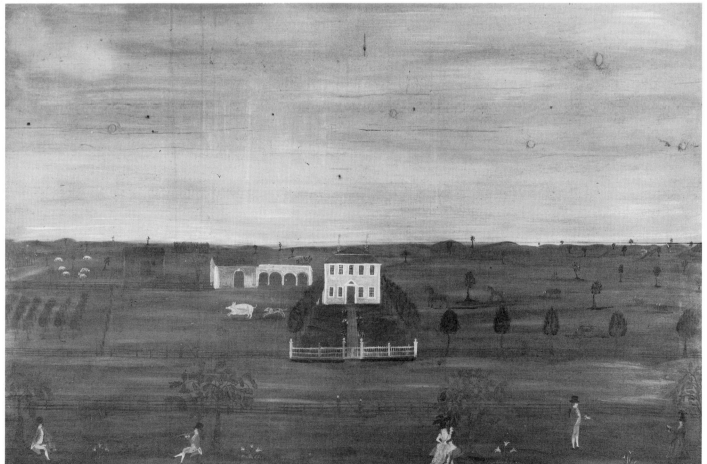

112. Overmantel panel from the Heard house, Wayland, Massachusetts, c. 1800. Artist unknown. Oil on wood. 29½″ x 51″. In the foreground, a hound scents a rabbit that crouches behind a rock at left.

113. Overmantel panel formerly in our collection, c. 1776. Artist and original location unknown. Oil on wood. 33″ x 64″. Inscribed on reverse: *Painted by an Englishman near the year 1776, afterwards being covered with white paint, was removed gently by L. W. B. and Mary H. Hughes. 1854 & 57.* This picturesque composition obviously derives from the same source, probably an engraving, as that shown in figure 112. (Photograph by T. F. Hartley)

114. English engraving, *In Full Chace*, after a painting by James Seymour, 7½" x 11". This subject was the basic source of design for similar hunting scenes painted by several traveling artists.

115. Overmantel panel from East Douglas, Massachusetts, c. 1800. House no longer standing. Artist unknown. Oil on wood. 23" x 43". Based, with variations, on an engraving of James Seymour's painting *In Full Chace*.

116. Overmantel panel said to have come from a house near Franklin, Massachusetts, late eighteenth century. Artist unknown. Oil on wood. 22½" x 58¼". Based, with variations, on an engraving after James Seymour's *In Full Chace*.

117. Overmantel panel from the Damon Nichols house, Sturbridge, Massachusetts, now demolished, c. 1790. Oil on wood. 43" x 58". This panel and a small group of others from the Southbridge–Springfield area are attributed to the anonymous artist who was responsible for the hunting scene in figure 116. (Photograph by T. F. Hartley)

118. Overmantel from an upper room of a house on Salem End Road, Framingham, Massachusetts, late eighteenth century. Oil on wood. 26½" x 54".

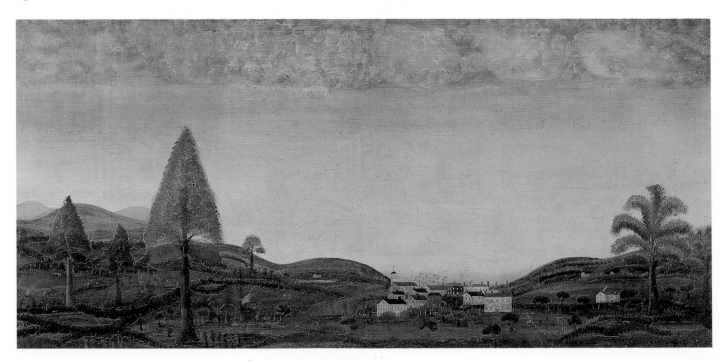

solvent and unappreciated in 1790, not to receive recognition until the exhibition that opened at the Worcester Art Museum to commemorate the two hundredth anniversary of his birth.

While engaged in research on Chandler's portraits, I discovered, to my surprise, that he had also painted decorative landscapes on a number of the large wooden panels that surmounted many eighteenth-century fireplaces. Following English precedent, this type of interior decoration was to be found in many American houses from 1750 to 1800.

In the small town of Scotland, Connecticut, Chandler depicted seven members of the Ebenezer Devotion family, and there in the Elisha Hurlbut house, probably between 1767 and 1769, he painted one of his finest overmantel panels (fig. 104). Although imaginary in subject matter, the arrangement of river, hills, and houses results in a striking composition. The large trees and group of figures in the foreground are characteristic of many of Chandler's landscapes and give added depth to the design. When I first photographed this panel in 1947, it was in its original location above the fireplace in the lower northeast room (fig. 105), and there it remained for some years until its removal by the owner, who subsequently offered it for sale.

On another research trip to West Sutton, Massachusetts, during the same year, I visited the old Ebenezer Waters house to see two unusual paneled room-ends that had once been decorated with a combination of graining and marbleizing in shades of brown and yellow (fig. 106). Although this finish had unfortunately recently been painted over, the overmantel pictures in the upper and lower southwest rooms still survived intact (fig. 107). Having by that time seen several other Chandler landscapes, I recognized his style, often characterized by prim, white-trimmed houses painted in many colors. The two Waters panels came into our collection some years later, after the house had changed hands and they had been removed from their original location. Shortly after my visit to West Sutton, we were offered a characteristic pair of Chandler portraits depicting Mr. and Mrs. Samuel Waters, the brother and sister-in-law of Ebenezer Waters, who had built the house that contained the two overmantels referred to above (fig. 108). The portraits are inscribed on the fronts with the sitters' names and ages, enabling one to verify the date of painting as falling between March and November of 1779. Samuel Waters himself lived in another early house in Sutton, once a tavern, that likewise contains grained woodwork, combined with expert freehand wall-painting. I purchased an unusual fireboard from one of the fireplaces in the Samuel Waters house. It is now in the collection of the Abby Aldrich Rockefeller Folk Art Center.

Following the close of the Chandler exhibit in May 1947, I decided to continue my investigation of overmantel panels with a view toward assembling material for a book on American decorative wall-painting.[5] It had become obvious that the existence of these early American landscapes was virtually unknown, many having been painted over and thus becoming lost to succeeding generations. This research required many trips throughout New England during the late 1940s and necessitated visits to all the old houses where I suspected there might be an existing panel. These overmantels were, of course, in their original locations, although a few others had been at one time removed and were then owned by museums or local historical societies. As my interest in the subject became known, I was apprised of an occasional overmantel for sale through a dealer, or by an owner who had removed it from its surrounding woodwork. I regretted this procedure as I

felt, and still do, that original paneling is an integral architectural feature of a building and should not be separated from it. Nevertheless, long after I had first seen them *in situ*, several overmantels were offered to me through third parties. Thus I unexpectedly acquired a few examples that I had previously discovered many years before.

Near the old road from Fiskdale to Brookfield, Massachusetts, stood, until recent years, a country Georgian mansion known as the Banister house, or the Jennings Tavern (fig. 109). In the upstairs ballroom, a landscape, depicting the house itself, was installed over a recessed fireplace that was closed by a fireboard and surrounded by a wide bolection molding. The photograph in figure 110 was taken while these two features were still in place in the house, some years before both came into our possession.

Most pictorial panels were painted by anonymous traveling artists whose work was inclined to be weak in perspective but strong in color and design. Few of the scenes were taken directly from life. Many derived inspiration, or included elements, from printed sources, such as drawing instruction manuals, book illustrations, or contemporary engravings. The Banister overmantel, probably dating from the 1790s, is no exception; it exhibits across the bottom a decorative series of small figures that are decidedly at variance with the naïve rendering of the rest of the composition. The poses are quite sophisticated and were undoubtedly copied from prints accessible to the painter (fig. 111). Many imported engravings were obtainable in Colonial America, elements of which were freely adapted by provincial artists who combined them with their own native painting traditions.

The panel in figure 112 was removed from an old house in Wayland, Massachusetts, and illustrates work typical of a traveling decorator at his best. The colors are vibrant, the buildings are convincingly drawn, and the design is well balanced and effective. The view might well be an original concept, but it evidently is not, as two other overmantels composed in the same manner are known to me. Each of the three varies in certain details and is obviously by a different hand, but all exhibit the same basic elements: a large house at the left standing beside a river framed in the background by distant hills, with a picturesque dead tree in the foreground, and a hound pursuing a rabbit who crouches behind the shrubbery in the left foreground. Figure 113, formerly in our collection, carries an 1857 inscription on the reverse that reads, in part: *Painted by an Englishman near the year 1776.* Although a common source of design for these three panels was obviously available in New England, it has so far not been identified.

Field sports were a popular pastime in the eighteenth century. Fox-hunting paintings by well-known British artists were engraved and sold in England in large numbers and were also much admired in the Colonies. "Several hunting-pieces under Glass" were advertised for sale at a vendue in the *Boston Gazette* of December 25, 1758. The work of the Englishman James Seymour (1702–1752) was particularly well known in this country, especially his set of four hunting subjects titled, *Going Out in the Morning, In Full Chace, Brushing into Cover*, and *The Death of the Fox*. Engravings of these paintings were incorporated into a handsome Gothic wallpaper hung in the Moffatt–Ladd house, Portsmouth, New Hampshire, presumably in 1763.[6] Over the years, we have found two overmantels, both of which derive quite directly from an engraving of Seymour's *In Full Chace* (fig. 114). Each panel is by a different unknown hand, and it is interesting to observe how each artist modified the original composition to suit his own taste. In figure 115, there are only three horses, and the tall steeple appears prominently in the center, but

119. Paneled room-end from the Van Wagoner house, Warren, Massachusetts, The painting of the rabbit in figure 120 fitted within the left opening.

120. Overmantel panel of a rabbit from the Van Wagoner house, Warren, Massachusetts, c. 1775. Oil on wood. 28″ x 28″.

121. Hare, inscribed on reverse: *Painted by D. B. Franklin in 10 minutes Sept. 6th 1877 for Charles A. Johnson.* Oil on wood. 18″ x 38″.

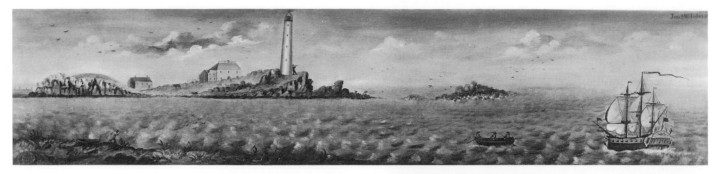

122. Overmantel panel, view of Boston Light, from the Josiah Sanderson house, corner of Lincoln and Lexington streets, Waltham, Massachusetts, now demolished. Signed at upper right: *1789/ Jon.ª W. Edes pin.ᵗ*. Oil on wood. 18″ x 71½″. An early view of Boston Light built in 1783.

123. Signature of Jonathan Welch Edes. This view of Boston Light is the only overmantel known to me that bears the artist's signature on the face of the panel. (Photograph by George M. Cushing)

124. Engraving of Boston Light that appeared in the *Massachusetts Magazine* for February 1789. 5″ x 7¼″.

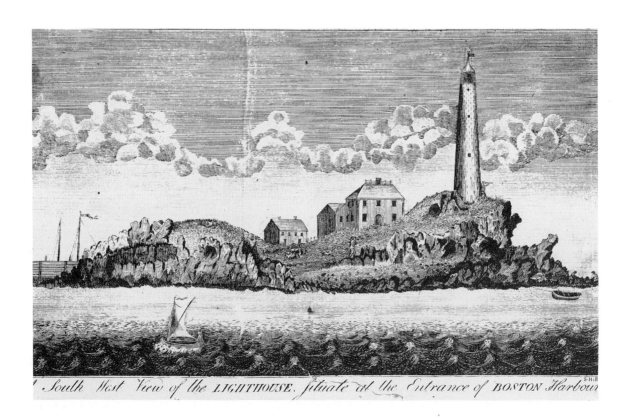

South West View of the LIGHTHOUSE, situate at the Entrance of BOSTON Harbour

125. Pair of small landscapes by William Northey, Jr., Salem, Massachusetts, c. 1785. Oil on wood. 5″ x 7¼″. They are possibly preliminary sketches for large overmantel paintings.

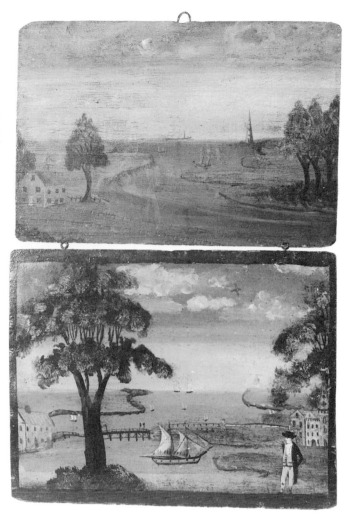

126. Overmantel panel by M. F. Cornè, Salem, Massachusetts, c. 1799–1807. Oil on wood. 27″ x 65½″. Cornè, a Neapolitan ornamental painter, obviously based this picturesque composition on an engraving of a scene in his native Italy.

127. Fireboard, stenciled in black and gray with touches of vermilion on a natural wood background, early nineteenth century. Artist unknown. Oil on wood. 40″ x 59″.

128. Fireboard, urn of flowers, 1825–1835. Artist unknown. Oil on wood. 36″ x 53″. Painted to simulate the pots of leaves and flowers that were often placed before an unused fireplace.

129. Fireboard from Southbury, Connecticut, c. 1820. Artist unknown. Oil on wood. 34″ x 45″. A particularly delicate example of painted decoration. The slots at the base accommodated andirons.

130. Fireboard with pot of greenery and border design suggesting an edging of tiles, 1815–1835. Artist unknown. Oil on wood. 34″ x 39″. This itinerant artist's unmistakable style has been recognized in many other New England fireboards.

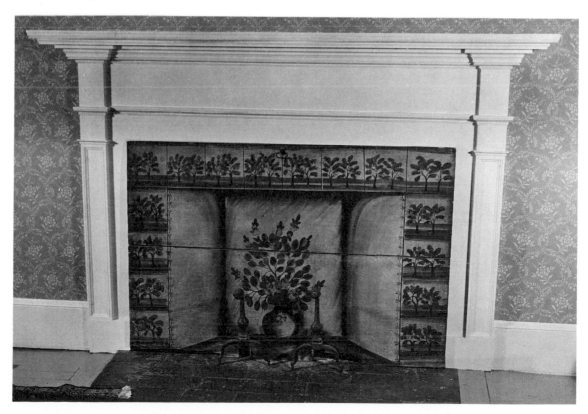

131. Fireboard, *Southwest View of the City of New York in North America,* c. 1790. Artist unknown. Oil on wood. 34″ x 52″. Based on the 1768 Howdell–Canot view, later reissued by Carrington Bowles, London, 1790. The black, gold-beaded frame is painted on the surface of the board.

132. Fireboard, *Contemplation by the Shore,* dated *1790.* Artist unknown. Oil on wood. 36½″ x 59″. Original brass handles assisted in the moving of this large fireboard, which pictures the typical salt marshes of coastal New England.

an entirely new group of buildings replaces the tree at the right. Figure 116 includes four riders of the original five, although their positions are similar to those in the engraved source. Large trees frame the panel at either end, but the distant background is much simplified, omitting both church and steeple. Close observation, however, discloses one detail that remains unchanged in the three compositions: a fleeing fox racing ahead of the hounds at the extreme left end of each picture.

Another group of overmantels exhibits many of the same characteristics as the hunting piece shown in figure 116. Seemingly attributable to the same unidentified artist, the stylized trees, small puffy clouds, and a warm palette are common to all. The hunting panel came from a house near Franklin, Massachusetts. This panel (fig. 117), and several similar to it, originated a short distance directly west of Franklin in the Southbridge–Springfield area of central Massachusetts.

My study of overmantels has clearly demonstrated how many still-unidentified decorative painters were traveling through the New England countryside at approximately the same period, the last quarter of the eighteenth century. Occasionally, as in the work of Winthrop Chandler and the panels just mentioned above, small groups of overmantels can be recognized as having been executed by the same hand. Other examples, however, are entirely different from one another in content and style and may now appear to be one of a kind, although this would have been unlikely, as painters tended to work in a number of houses in the same town. Figure 118 illustrates a charming panel, quite unlike any others I have seen, that came from a house in Framingham, Massachusetts. It features rolling hills accented by several large trees; a small, compact town of brightly colored houses nestling in the center; and a harbor with the tall masts of many ships. The subtle shading of the sky, surmounted by a horizontal band of swirling clouds, is a notable feature that I have not encountered elsewhere.

Sometimes a painter chose a single figure in a wooded setting as a subject for his brush. Figure 119 illustrates an unusual paneled room-end from a house in Warren, Massachusetts, as it appeared when we first saw it. Beneath a dentiled cornice, five small panels surmounted two square landscapes, each framed in bold bolection moldings. The panel at the left depicted a carefully drawn rabbit crouching between two leafy trees (fig. 120). At the right was a hunter in knee britches and a long red coat aiming his gun at a running doe. Judging from the architectural details and the hunter's costume, a Revolutionary-period date for this woodwork would appear to be in order, and this assumption tempts comparison with a similar subject of a hare painted on wood and illustrated in figure 121. This picture exhibits all the recognizable characteristics of an eighteenth-century overmantel, and only the following penciled inscription on the reverse proves how easily one can be misled if an old-style artisan happened to be working in the traditional manner of a hundred years before: *Painted by D. B. Franklin in 10 minutes Sept. 6th 1877 for Charles A. Johnson.*

Prior to 1800, it was not the custom for itinerant artists to sign their fancy-painted woodwork and walls, nor is it the habit of house painters to do so today. Unfortunately, therefore, the names of many individual wall decorators have become entirely disassociated from the surviving examples of their work. This fact makes the overmantel view of Boston Light of particular importance in several respects (fig. 122). First, it appears to be a contemporary picture of this historic Boston landmark, and second, the panel is signed and dated by the artist: *Jona W. Edes pinct. 1789* (fig. 123). Site of the oldest beacon in the United States, the first light was erected "on the Southernmost part of the Great Brewster" at the entrance to

Boston Harbor, following a court order dated November 5, 1714.[7] The wooden portions of the original structure were willfully damaged by American troops to hamper the British during the Revolution, and the light was eventually destroyed by a time charge left by the British when they finally evacuated Boston harbor in June 1776. In 1780, a directive was issued for the erection of a new lighthouse on the same site, and the buildings shown in the panel were completed in 1783 at a total cost of 1,450 pounds.

In February 1789, the *Massachusetts Magazine* printed a piece on Boston Light written by the keeper Thomas Knox, who was also a branch pilot for the Port of Boston. This article, according to the magazine, was "Embellished with an Engraving, representing a South West View of the Light House and of the island on which it is situate." The illustration, which almost duplicates the left half of the overmantel, shows the light with the keeper's house, and a pilot standing with spyglass in hand scanning the horizon for an incoming ship (fig. 124). Samuel Hill was the engraver of this plate, and Jonathan Edes is presumed to have been the artist of the original sketch. Jonathan Welch Edes was born in Boston on February 1, 1750/51, and in 1772, he was listed as "painter" in a deed for a pew in the New North Church. During the 1780s, he lived briefly in Waltham, where, in 1789, he painted Boston Light and at least two other overmantels, one of which (*Eden Vale*) was also used, with his name as delineator, in the *Massachusetts Magazine*.

It is often difficult to discover the original location of an overmantel picture. Sometimes the seller is cooperative in this respect. At other times, the source is artfully obscured, particularly if the panel has been obtained under false pretenses or purchased at less than the fair market value. It took more than two years of patient research, combined with the help of several friends, to dispel the myth that the panel of Boston Light had been removed from a house in Chelsea, Massachusetts, and finally to verify the fact that it had originally been part of the woodwork in the Josiah Sanderson house in Waltham.

It appears likely that Edes's view of Boston Light appeared still a third time when, in October 1789, President Washington paid an official visit to Boston. On that august occasion, a grand procession marched before him and the reviewing stand at the Old State House. The parade was composed of shopkeepers, local tradesmen, and merchants, each division being preceded by a leader carrying a flag symbolic of its trade or craft. Colonel David Mason, one of Bert's great-grandfathers (who, like Edes, was a Boston ornamental painter), led the group of limners. The Marine Society, headed by Captain Dunn, carried a banner deemed worthy of mention in the local press. This was described as having a "ship passing the lighthouse, and a boat going off to her."[8] Although the banner itself has long since disappeared, this contemporary description corresponds exactly with Edes's two previous views, the *Massachusetts Magazine* illustration and the panel of Boston Light, all dating to 1789.

One of my purchases in 1948 was a small pair of eighteenth-century landscapes on wood (fig. 125). They exhibit all the characteristics of full-sized overmantel pictures and could well have been painted as preliminary sketches. An old handwritten label on the reverse identifies them as the work of William Northey, Jr. (1767–1788), son of the Salem silversmith. However, this vogue for painting landscapes on overmantel panels appears to have reached its peak by the close of the eighteenth century. By that time, handsome Georgian room-ends incorporating paneled chimney breasts had gone out of style, to be supplanted by woodwork of the Federal period, whose fireplace mantels were surmounted by plain plaster walls. This

space was then intended as a background for framed oil paintings hung from large handmade nails or suspended on cords from the cornice above.

One decorative painter, however, Michele Felice Corně continued the practice of landscape panel painting during his Salem years, 1799–c. 1807. Two overmantels set in delicate neoclassical moldings were commissioned for the dining and drawing rooms at Oak Hill, the Peabody, Massachusetts, mansion of Mrs. Elizabeth Derby West, and are now in the Museum of Fine Arts, Boston. These scenes are based on engravings after the English artist William Redmore Bigg, but Corně likewise painted overmantels with picturesque views of his native Italy, probably also inspired by printed sources. Figure 126, an overmantel in our collection, is a picturesque example that exhibits typical Corně features: a tall, attenuated figure in the foreground, feathery trees, and puffy clouds in a deep blue sky.

As I continued to research overmantel panels during the 1940s, I discovered evidence indicating that the same type of craftsmen had also produced fireboards, sometimes conforming to the surrounding wall decoration. Figure 127 can be readily recognized as having been painted by the so-called Border Stenciler, whose fine stencil work, comprising a great variety of intricate patterns, has been found in many houses throughout the northeastern states. This fireboard, with its familiar borders and birds, is the largest I have ever seen. Stenciled on five vertical boards, it measures 40″ by 59″ and must have fit into a very large fireplace. It is painted on the natural wood in black and gray, with touches of red in the upper border, and probably matched the decoration of the surrounding walls. Fireboards, however, were more often pictorial, exhibiting a wide variety of subjects that varied from traditional flower arrangements to other delightfully ingenuous concepts.

So-called chimneyboards were well known in Europe during the eighteenth century. They were mentioned in the correspondence of Horace Walpole in 1757, and handsome examples were designed to complement Robert Adam's neoclassical decoration at Osterley Park. Others of the Adam period were especially made for use in four apartments at Audley End.[9] The old English custom (still followed today) of placing a large container of greenery on an unused hearth was no doubt the forerunner of the many American fireboards that exhibit numerous varieties of jars holding flowering sprays. On July 29, 1772, Josiah Wedgwood, the great English potter, wrote to his partner, Thomas Bentley, "Vases are furniture for a chimneypiece, bough pots for a hearth. . . . I think they can never be used one instead of the other." A good, early American reference to this kind of decoration appears in the Letter Book of John Custis of Williamsburg, Virginia, which contains the following instructions written on April 10, 1723:

> Get me two pieces of as good painting as you can procure. It is to put in ye summer before my chimneys to hide ye fireplace. Let them be some good flowers in potts of various kinds and whatever fancy else you may think fitt. . . . I send this early that the painter may have time to do them well and the colors time to dry. . . . I had much rather have none than have daubing.[10]

By the first quarter of the nineteenth century, boards with floral designs such as that in figure 128 were being supplied by the same traveling artists who were also stenciling walls and floors. Sometimes the patterns, like those in figure 129, became more delicate and refined through the incorporation of recessed panels to frame flowering trees, and by the addition of a gold-leaf eagle to beautify the front of the urn. In other cases, a domestic touch was retained by the introduction

133. John Nichols house, later known as Ferncroft Inn, Middleton, Massachusetts. The fireboard in figure 134 came from this well-known building. (Photograph courtesy Essex Institute, Salem, Massachusetts)

134. Fireboard, distant view of Chatsworth, Derbyshire, England, by M. F. Cornè, Salem, Massachusetts, 1799–1807. Canvas mounted on wood. 35″ x 48½″. Based on an English engraving. Cornè altered the figures in the foreground and added the decorative device of the two children holding back the drapery.

135. Engraving, CHATSWORTH IN THE SECOND HALF OF THE EIGHTEENTH CENTURY, after a painting by Paul Sandby. The view on the fireboard in figure 134 derived from this source.

136. High-style fireboard, c. 1800. Artist unknown. Oil on wood. 39¼" x 48½". The tromp l'oeil niches filled with shells give this board a particular air of distinction.

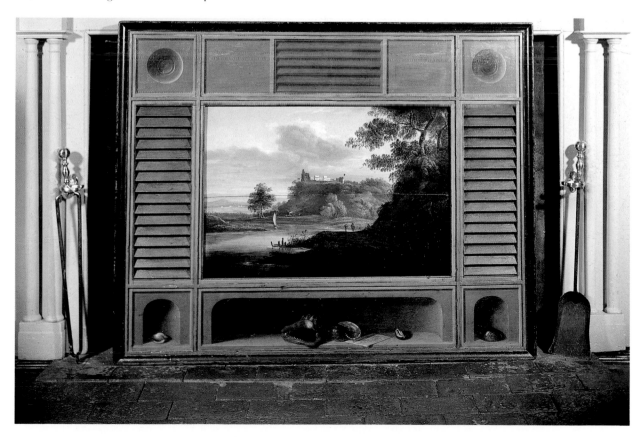

of trompe l'oeil painted fireplaces surrounded by bands of small vignettes to suggest the use of imported delft tiles. Figure 130 is one of a group of very similar fireboards found throughout New England, all recognizable by color and composition as being attributable to the same unidentified hand.

Fireboards were constructed by one of several methods. They were often made of two or more vertical or horizontal boards held together on the reverse by stout battens. The fronts were then planed, and the decoration was applied directly to the surface. At other times, canvas was laid across the face and nailed over the edges as a basis for the paint. A lighter, although less sturdy, type of construction consisted of canvas stretched over a narrow wooden frame in the manner of a picture, with wallpaper or French scenic paper panels applied to the surface. An interesting bill in our possession was presented to Mr. A. Van Allen by one William Carr of Albany on April 27, 1834 (not paid until January 1835); it reads as follows: "to clothing & papering two frames for fire places at 3 shillings each, $.75." A prevailing problem, however, was the difficulty of keeping fireboards upright unless they fitted snugly within the fireplace surround. This difficulty was apparently solved in one of three different ways: (1) a wide molding was affixed to the bottom to keep the board upright; (2) a small catch was installed on the back that rotated behind the wooden facing of the fireplace (the drop handle of such a catch may be seen at the top center in figure 130); or (3) in the most popular method, two slots were cut at the lower edge that allowed the fronts of the andirons to protrude and rest against the face of the board, as shown in figure 130.

Landscapes of every description appeared on fireboards, a few being enclosed within simulated frames obviously intended to give the effect of pictures resting on the hearth. Like the overmantels, fireboards often derived in whole or in part from contemporary engravings, as in the case of the *Southwest View Of the City of New York in North America* (fig. 131). This historical view of the city, painted on two wide boards, was taken from Brooklyn, near the present intersection of Henry and Montgomery streets, and shows the roof of the Rutgers family brewhouse in the center foreground. The original sketch was "drawn on the spot" by Captain Thomas Howdell of the Royal Artillery in 1763, engraved by P. Canot, and issued in London, probably in 1768. The plate was later reissued in reduced size, with the addition of three men in a field, by Carrington Bowles, London, in a series of "Twelve remarkable Views of North America and West Indies." The sales catalogue that accompanied the prints contained this important note: "The preceding sets of demi prints are adapted to be viewed in the diagonal mirror, to frame and glaze for furniture; also designed to instruct, amuse and draw after."[11] This fireboard was certainly copied, or "drawn after," Number 8 in the Carrington Bowles series issued in 1790. The gold-beaded frame is painted in trompe l'oeil against the black wooden background, thereby emphasizing the realistic effect of a framed oil painting resting in front of the fireplace.

Undeniably romantic in feeling is another eighteenth-century board shown in figure 132, which illustrates the increasing interest in the "picturesque." The pensive mood of the young lady is apparently related to the departing ships in the bay, and the salt-marsh banks visible at the water's edge clearly bespeak a New England provenance.

When Bert was a child in Salem, he often accompanied his father on enjoyable excursions to places of interest in the immediate area. One of these expeditions took them to the ancient John Nichols house in Middleton, just beyond the Danvers line. Reputedly built in 1692, and later known as Ferncroft Inn, the house

137. Fireboard, lion in a wood, possibly painted by Harvey Dresser, Charlton, Massachusetts, 1820–1830. Oil on wood. 33″ x 46″. This board closed the fireplace of the main room in the coaching inn owned by Harvey Dresser. (Photograph by George M. Cushing)

138. Engraving, *Let the Weapons of War Perish,* Shelton & Kensett, Cheshire, Connecticut, March 1, 1815. 9½″ x13¼″. Symbolizing peace between England and America, this rendition of the British lion was the source for the painted beast in figure 137. (Photograph by George M. Cushing)

139. Fireboard with two views of a thirty-two-gun frigate. Artist unknown. First quarter of the nineteenth century. Oil on wood. 26″ x 48½″. The andiron slots at the base have been filled in.

140. Fireboard, *Minot's Light*, c. 1860. Artist unknown. Oil on canvas. 37½″ x 49″. This view illustrates the second light, erected in 1860 to replace the first beacon that was washed away in a gale in 1851. The elaborate gold frame is painted on the canvas.

141. Signboard, Center Hotel, Centerdale, Rhode Island, signed: *Brown*, c. 1824. Oil on wood. 51″ x 27″. The eagle was a popular motif on many tavern signs.

had been considerably altered and enlarged in Victorian times (fig. 133). During the eighteen-year ownership by the Walter S. Harris family in the last quarter of the nineteenth century, it became a showplace filled with antiques and curios, some of which remained to serve as intriguing decorations for later patrons of the inn. On September 6, 1899, a large auction was held on the premises accompanied by a descriptive list of the contents for sale. Among these, Number 383 was an "Antique Fireboard, oil painting in gilt frame." On the reverse of the fireboard in figure 134 is an old label identifying it as having come from Ferncroft Inn. Attributed to the Salem artist M. F. Cornè, the painting is on canvas, affixed with large handmade nails to a heavy board support; the gilt frame, however, has long since disappeared. This colorful scene of children holding back a curtain to reveal a landscape beyond is one of Cornè's most stylish subjects. As in most of his compositions, he made good use of an engraved source, this one titled CHATSWORTH IN THE SECOND HALF OF THE EIGHTEENTH CENTURY, taken after a painting by the English artist Paul Sandby (fig. 135). Close comparison with the engraving of this famous English estate will indicate how Cornè adapted the original engraving to his own taste, the most notable difference consisting of the introduction of the figures in the immediate foreground.

A particularly elegant fireboard, said to have come from a house near Philadelphia, incorporates a competently painted landscape of the formal English school (fig. 136). The picture may be removed, if one desires, being held in place by wooden turn buttons on the reverse of the panel. The green-painted louvers on either side were intended to provide ventilation for the room, but the corresponding slats above the picture are painted simulations. The trompe l'oeil recesses in the upper corners, as well as the niches with sea shells below, echo neoclassic motifs that appeared in American decorative arts toward the end of the eighteenth century.

While fireboards of the previous type were being designed for a few high-style homes, humbler dwellings, including some taverns and inns, exhibited decoration aimed toward a different clientele. The fierce lion in figure 137, apparently equipped with a perfect set of dentures, was painted for an old coaching inn on Dresser Hill, Charlton, Massachusetts. Harvey Dresser, the proprietor, may well have been the artist, for in 1817 he did some extraordinary fancy painting for the church in nearby Thompson Village, Connecticut, about which Ellen Larned's *History of Windham County* provides this provocative description: "Harvey Dresser of Charlton, furnished the painting below the lofty pulpit, which so artfully simulated a stairway with curtained drapery that it was a perpetual wonder to children that Mr. Dow [the minister] did not use it." Dresser died in 1837, and the lion that had closed the fireplace in the tavern's main room was eventually sold by his great-great-grandson. But whence, one wonders, came the original concept for such a novel subject to be rendered on a fireboard? In this instance, the source was an unexpected one, brought to my attention by an observant friend. This ferocious beast is no less than the British lion itself, copied in large scale from a prototype depicted in an American patriotic print issued by the Connecticut engravers Shelton & Kensett in 1815, better known for their engravings of the Prodigal Son (fig. 138). Featuring Columbia and Britannia with their respective attributes, the engraving is dedicated to "the memory of departed heroes," memorializing the fallen in the War of 1812.

Marine scenes were evidently not much in demand for fireboards, but one spirited subject (fig. 139) shows two views of a thirty-two-gun frigate under full sail. We had owned the board for many years before I realized that the small black

142. Signboard for J. Bartlett's Hotel, Portsmouth, New Hampshire, 1835–1840. Artist unknown. Oil on wood. 42½″ x 35″. A view of a large three-story house, probably Bartlett's Hotel, appears on the reverse side.

143. Reverse side of signboard for J. Bartlett's Hotel, Portsmouth, New Hampshire, 1835–1840. Artist unknown. Oil on wood. 42½″ x 35″.

144. Fancy painter's sample board, signed: *E. F. Lincoln Falmouth*, 1850–1875. Oil on wall board. 14¾″ x 31½″.

dots visible along the yardarms in the foreground were in reality figures of men poised in readiness to furl the sails! The ocean view in figure 140 gains effectiveness from the rendering of its stylized waves, and from the wide, intricate frame, which is painted directly on the canvas. The scene depicts Minot's Light, situated three miles off Boston's South Shore and erected as an aid to ships entering Boston harbor. The first lighthouse on this spot was an octagonal tower supported on eight sixty-foot wrought-iron piles that were presumably securely attached to the rocky ledge beneath. First lighted on January 1, 1850, this curious structure survived for only fifteen months, being washed away with its two assistant keepers in a great gale on the night of April 17, 1851. The rebuilding of the light began in 1858, and the second and present beacon, pictured here, went into operation at sundown on November 15, 1860.

As early as 1825, a number of fires were supposedly occasioned by the use of fireboards. During that year, a long communication appeared in the *Connecticut Courant* that blamed these mishaps on soot, spiders, and spiderwebs, and stated in part, "This material (very combustible) is concealed from view by the fire-board, and it is not known, or it is forgotten, until, after an accumulation for years . . . it is set on fire by the burning of the chimney, from accident or design . . . we hope the fire-wardens will take up the subject, and remedy the evil." It was, however, the rapid introduction of wood-burning stoves during the 1830s and 1840s that occasioned the permanent closing of many parlor fireplaces. The old fireboards, therefore, became obsolete and were either broken up or relegated to the attic. Hidden away, many remained forgotten until they were rediscovered by a later generation of discerning collectors.

Signboards were also an important part of the ornamental painter's craft, and many men who later became acceptable portraitists began their careers as "sign and fancy painters." In the days when distant identification from the back of a horse or the interior of a coach presented difficulties, business establishments often displayed a pictorial sign. Most interesting, perhaps, are the inn signs, many of which have survived, although some are badly weathered and others have been overpainted with a new design or name, adopted when a tavern changed hands. The piece in figure 141 is unusually well preserved, retaining intact its twisted iron hangers and stylish cutout crest. The Center Hotel in Centerdale, Rhode Island, was built by James Angell during the summer of 1824, and the board, inscribed with the painter's name *Brown*, remained in place until the inn was taken down about 1852. Thereafter it remained in the Angell family until sold by a grandson in 1920.

From Portsmouth, New Hampshire, came the J. Bartlett sign in figures 142 and 143. With a happy disregard for perspective, it depicts in the foreground several large sailing ships rendered in diminutive size. Above is probably a representation of one of Maine's early railroad trains, the first of which made its initial run at six miles per hour from Bangor to Newton in 1836. The engine was built in Newcastle-upon-Tyne, and the three passenger cars were little more than stage coaches that sat on rails. A similar engine and cars built for the Mohawk and Hudson Railroad in 1831 is on exhibit at the Henry Ford Museum in Dearborn, Michigan.

Expertise in lettering, flourishing, and monogramming was an important element in a coach and sign painter's repertoire. We were fortunate, therefore, when we ran across an interesting sample board signed by the decorator himself, *E. F. Lincoln, Falmouth* (probably Maine), which illustrates a number of typical devices used by ornamental painters during the nineteenth century (fig. 144).

IV Pictures: Pictorial Documents of the Past

By 1940, we had acquired the basic household furnishings that we needed for ourselves and three lively children. Our minds then turned to pictures (a subject that had long been of special interest to me) to supplement the marine paintings that we had found during the 1930s. In the early 1940s, the type of pictures that attracted us were still offbeat in conventional antiquarian circles and were variously referred to as *primitive, naïve, unschooled,* or *folk.* By other less enthusiastic art lovers, they were simply regarded as *crude.* There was much discussion at antiques shows and among collectors about these paintings: whether they would eventually find an accepted place in the history of American art, whether the style had a validity of its own, or whether faulty draftsmanship and unconventional presentation rendered the portraits only a second-rate echo of respectable academic art.

By 1941, however, a few discerning dealers, such as Harry Stone of New York City, had begun to insert notices in the pages of *Antiques.* Stone's advertisement read: "WANTED, American Primitive Paintings of Every Description and Subject."[1] Fred J. Johnston of Kingston, New York, under the heading "American Folk Art," offered watercolors, velvets, miniatures, silhouettes, silk pictures, and "exquisitely lovely portraits of children by itinerant painters."[2] In January 1939, Mrs. Lawrence J. Ullman, a perceptive dealer in Tarrytown, New York, had been ahead of her time in offering for sale an overmantel panel of a fox-hunting scene,[3] and in 1941, she illustrated a "primitive painting" in oil of two children in what was later to be designated the Prior–Hamblen School.

During this same year of 1941 appeared one of the first definitive books to be published in New England on the subject of folk portraiture. Titled *Some American Primitives,* it was authored by Clara Endicott Sears of Boston, whose collection had been assembled in a special building on her estate in Harvard, Massachusetts, as part of her Fruitlands Museums.[4] There, for the first time in New England, a permanent museum collection displayed to the public a large group of controversial pictures that had recently been brought out of hiding in local attics and barns. Miss Sears's methods of discovery were basically simple but effective. She inserted

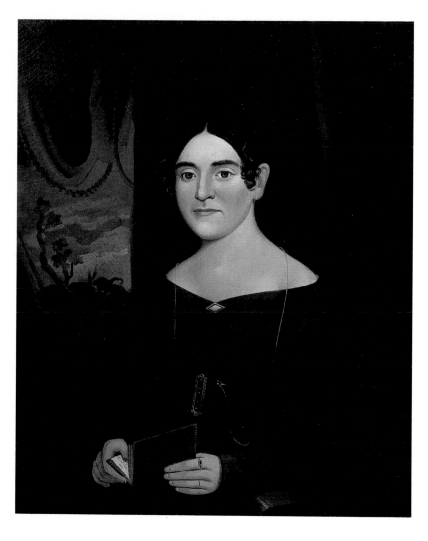

145. *Arobine Sewall*, Bath, Maine, by William Matthew Prior, 1838. Oil on canvas. 34″ x 28″.

146. Inscription on reverse of *Arobine Sewall* in figure 145. (Photograph by Henry D. Childs)

147. Label of W. M. Prior on reverse of figure 148.

148. *Nat Todd*, New England, by William M. Prior. 1837. Oil on academy board. 16½" x 12½". This "flat picture without shade or shadow" cost the client $2.92, frame and glass included. Original frame.

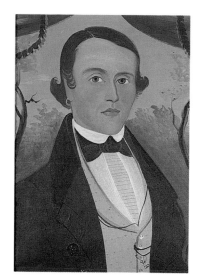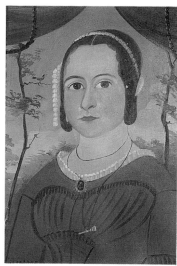

150. Pair of unidentified subjects, attributed to George H. Hartwell, c. 1840. Oil on academy board. 14" x 10". Hartwell died in Auburn, Maine, in 1901, aged eighty-six years.

149. The subject is identified as *Ellen* by an old label on the reverse, c. 1840. Inscribed on the side of the right-hand shoe: *S. J. Hamblen.* Oil on canvas. 27" x 22".

151. *Captain Amasa Wood and Family,* West Millbury, Massachusetts, attributed to John S. Blunt, 1831–1832. Adults, oil on bed ticking. 34½" x 29¼". Children, oil on wood. 15" x 11½".

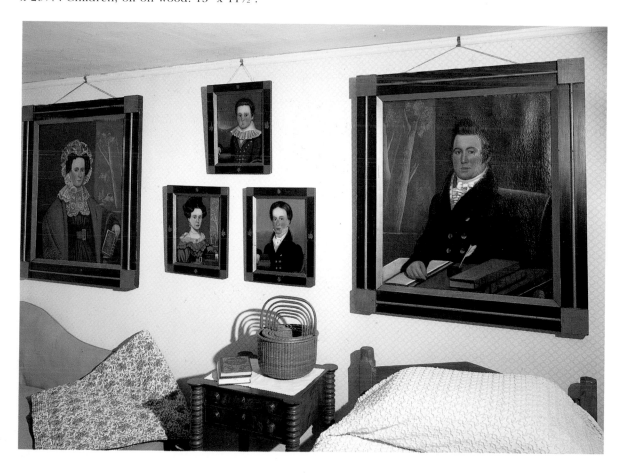

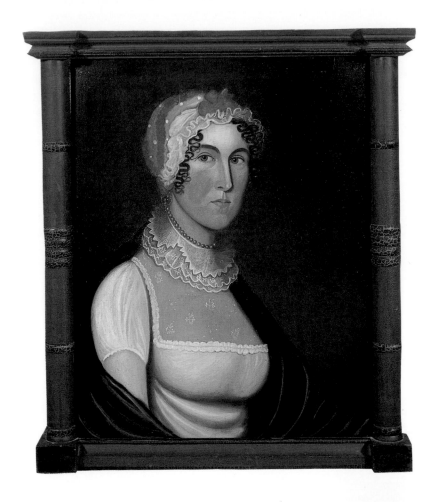

152. Unidentified Woman, New England, by Zede-
kiah Belknap, c. 1815. Oil on wood. 24½″ x 19½″.
Original frame.

153. Unidentified Man, companion to figure 152,
New England, by Zedekiah Belknap, c. 1815. Oil on
wood. 24½″ x 19½″. Original frame.

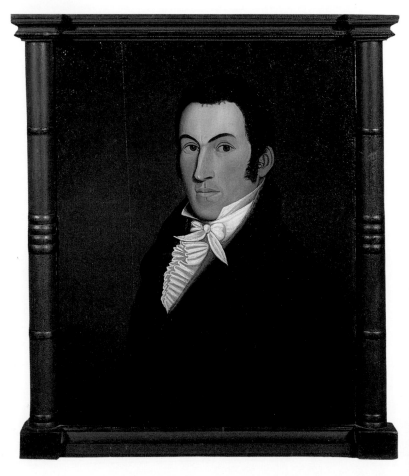

notices inquiring about family portraits in various small-town newspapers and followed up through correspondence or personal visits the numerous replies that she received. This procedure ultimately resulted in the acquisition of many interesting examples, accompanied by family histories and artists' names, that formed a valuable basis for research by her and later students.

In 1941, we became actively involved with the Folk Arts Center in New York City, an organization guided by the Burchenal sisters and dedicated to the study of American folk art "as expressions of the American Spirit, as roots of American Culture, and as a part of American History." One of the center's many activities was the presentation of annual loan exhibitions, coupled with occasional "institutes" featuring recognized experts who discussed such topics as folk customs, song and dance, early vernacular architecture, the decorative use of paint in rural interiors, quilt patterns, and many other subjects related to folk culture. At various times, we lent pictures, rugs, a handsome Philadelphia quilt, and a wool-embroidered coverlet that I later suspected was not considered quite up to the other stylish folk examples on display. At these stimulating gatherings, we had the chance to meet established experts in the folk arts field, an area of Americana in which we were still neophytes. Among the many participants were Alice Winchester, the knowledgeable editor of *The Magazine Antiques,* and Marian Nichol Rawson, author of several widely read books on early country arts and crafts. It is an interesting commentary that for one special meeting of the Folk Arts Center in 1944, no expert on old hooked rugs could be located as a speaker!

As mentioned in Chapter II, our interest in pictures had begun with marine paintings in the 1930s, but it expanded to include other types during the following decade. We never thought of making a "collection," or of acquiring special subjects to fill gaps in our holdings, as more advanced collectors did. From the beginning to the present time, we have bought only what particularly appealed to us, basing our decisions on a number of different considerations. Although artistic appeal is always a prominent factor, documentary background is an important element to me, as my personal interest in folk painting combines both the historical and the aesthetic approach.

Early in a collecting career, one becomes aware of the problems of conservation, and never more so than in the field of painting. The extent to which one wishes to clean, or otherwise restore, one's pictures elicits a very personal reaction, ranging from a preference for complete renovation to a predilection for leaving surfaces untouched as found. Each collector eventually formulates his or her own philosophy. Our policy usually involves light surface cleaning so that a patina of age is retained, plus such basic conservation as is deemed necessary to keep the picture in stable and undeteriorating condition. If, through modern technology, the original canvas can possibly be retained, we definitely prefer it to immediate relining. If the latter is unavoidable, the original stretchers are affixed to the new ones and the old nails are reused if possible.

At times, the reverse of a picture that still retains its original support, nails, and stretchers or strainers can become extremely important in attribution and dating. We feel that the greatest compliment that can be paid to one of our pictures is when a viewer says, "What a beautiful old surface, it looks as if it has never been touched." We enjoy both our furniture and our pictures because they are old and necessarily have acquired the appearance of age, and we do not wish them, through renovation, however expert, to appear as they did when they were initially created. We also prefer not to employ individual spotlights to illumine our pictures

at night as this would seem inappropriate in our old house, and we often remind ourselves that all eighteenth- and early-nineteenth-century paintings were originally observed after dark only by the soft glow of candles or an oil lamp.

As we search for furniture with its original brasses, so we are especially attracted by pictures having their original frames, for they open up a new and absorbing field of study. Unfortunately, many paintings have lost their old enframements, long since reused or thrown away when fashions in framing changed. In this case, three practical alternatives remain, the most feasible being to acquire newly made frames appropriate in period and style. In our early collecting days, many second-rate folk paintings were bought in country shops for trifling prices especially for their desirable frames. After the pictures were disposed of, the frames were refitted to other, better examples with gratifying results. Although for obvious reasons that practice has virtually ceased, good early frames may occasionally still be found, even though the prices may almost equal the value of the pictures themselves. Other alternatives that are sometimes acceptable include hanging portraits unframed or using narrow moldings to give an unobtrusive finish to the edges.

Folk painters have always been of keen interest to me, especially the little-known artists, research on whose work has proved so rewarding. Soon after the close of World War II, I was able to carry out a longtime plan of spending a few days in Bath, Maine, for the purpose of hunting for information about my great-grandfather, John Masters, who had been a clockmaker there during the second quarter of the nineteenth century. I decided to begin my search by consulting the *Maine Inquirer,* beginning in the mid-1820s, so I ensconced myself at a table in the basement of the public library, where the old newspapers were at that time stored. Although I did find a few items of personal value, my eye was immediately caught by a series of advertisements that proved of far greater general interest. These notices appeared from 1827 to 1831 and, as I later discovered, were inserted by a youthful resident of the town who had been born there in 1806 and had painted portraits of Samuel and Susannah Bovey, who were closely connected with my ancestors through marriage. The name of William Matthew Prior was not unknown to me in relation to his later portraits and landscapes,[5] but little had heretofore come to light about his early career in Bath.

Like other young artists of the time, Prior first designated himself as a "fancy, sign and ornamental" painter, advertising "old tea-trays and waiters re-japanned and ornamented in a very tasty style." By 1828, he referred to himself as Portrait Painter, his prices ranging from $10.00 to $25.00, with gilt frames from $3.00 to $10.00 extra. By the 1830s, he was charging $30.00 for a waist-length pose and was receiving important commissions from the Sewalls, one of the most prominent families in Bath. Our painting of their daughter Arobine is executed in Prior's formal style, which he employed in many of his portraits painted before 1840 (fig. 145). He was always prone to informative and amusing inscriptions written on the backs of his canvases, which prove of particular interest to today's collectors. The inscription on the reverse of *Arobine* (fig. 146) gives her age as twenty years and informs us that she was painted after death from a "Cast Relief" by W. M. Prior in 1838. Another portrait formerly in our collection depicts a woman and a child seated side by side in close proximity, with a vertical line drawn on the background between the two figures. On the reverse is the following thought-provoking information, *By Wm. M. Prior Mr. Turner Paid $4.00 Mr. Sawin $4.00 May 1841.* Apparently, two different gentlemen paid jointly for the picture of

154. Inscription *Z. Belknap* on reverse of portrait of Hannah Fisher Stedman (fig. 155).

155. *Hannah Fisher Stedman,* Chester, Vermont, by Z. Belknap, 1836. Inscribed on reverse: *Portrait of Miss Hannah F. Stedman Aged 27 yrs. Aug. 13th, 1836. Painted in her last sickness by Z. Belknap. Augt. 13, 1836.* Oil on canvas. 28″ x 24″.

156. *Mrs. Joseph Dorr* (Sarah Bull), Hoosick Falls, New York, by Ammi Phillips, 1814–1816. Oil on canvas. 40″ x 33″.

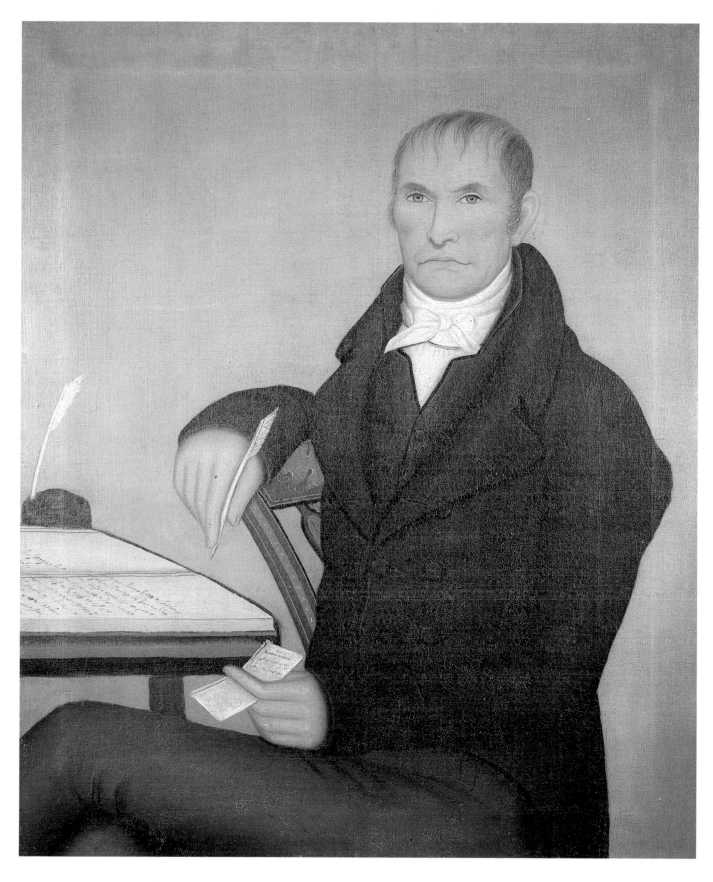

157. *Colonel Joseph Dorr,* Hoosick Falls, New York, by Ammi Phillips, 1814–1816. Oil on canvas. 40″ x 33″.

158. *The Reverend Jonas Coe*, Troy, New York, attributed to Ammi Phillips, c. 1820. Oil on canvas. 48″ x 38½″. Coe was pastor of the First Presbyterian Church in Troy, 1793–1822.

159. Miniature of *The Reverend Jonas Coe*, Troy, New York, nineteenth century. Artist unknown. Oil on ivory. 3″ x 2½″.

160. *The Reverend Eli Forbes*, Gloucester, Massachusetts, by Christian Gullagher, c. 1786. Oil on canvas. 45¾″ x 40⅛″. Forbes was pastor of the First Church, Gloucester, 1776–1804.

mother and child, but which gentleman paid for which subject and why are still unanswered questions.

By the time Prior was twenty-five years old, he had obviously decided that there was a market, at least in rural Maine, for inexpensive and rapidly drawn likenesses. He advertised in the *Maine Inquirer* on April 5, 1831: "Persons wishing for a flat picture can have a likeness without shade or shadow at one quarter price." In 1947, we found one of his "flat pictures," which not only fits this description but was accompanied by documentation in the form of a printed label pasted on the original wooden backboard (fig. 147). The label has been frequently quoted but seldom illustrated with the picture to which it refers (fig. 148). Prior used this flatly painted cardboard medium more and more as time went on. Some of the results (especially in the case of children) are quaint and appealing, while others are of slight artistic merit, but their popularity has persisted and is still increasing at the present time.

Several of the elements that appear in Prior portraits are repeated in the work of some of his contemporaries. They were not copyists, but their compositions typify a style in vogue during the 1835–1850 period. A few of the artists were related to Prior through his first wife, Rosamond Hamblen. In fact, the technique of Rosamond's brother Sturtevant J. Hamblen, seen here in a signed picture of *Ellen* (fig. 149), is often so like Prior's that this whole group of portraits has become known as the Prior–Hamblen School. Crisper in drawing, yet similar in their flat delineation, are the stylish pair of unidentified subjects painted on cardboard and illustrated in figure 150. They are confidently attributed to George H. Hartwell, a Hamblen relative by marriage, on the basis of several signed examples in the collection of Fruitlands Museums, Harvard, Massachusetts. Window views with picturesque trees, sometimes featuring a small perching bird, are characteristic of the Prior–Hamblen School.

During the 1940s, I engaged in active research on the lives and works of several other little-known artists,[6] one of whom was John S. Blunt, who was born in Portsmouth, New Hampshire, in 1798 and died at sea in 1835. From an advertisement in the Portsmouth Directory in 1827, and many entries in his account book for decorating numerous items, including firebuckets, fancy chairs, and signs from 1819 to 1827, it is apparent that, like Prior, Blunt carried on a career as an ornamental painter while he was also producing landscapes and marines. During the winter of 1976–1977, an in-depth study by Robert Bishop resulted in an exhibition of an outstanding group of portraits also attributed to Blunt[7] under the name of the Borden Limner. To the several Blunt landscapes already in our possession, we eventually added a group of five portraits of the Captain Amasa Wood family of West Millbury, Massachusetts (fig. 151). In at least ten related portraits painted in Millbury, Blunt used similar window views with stylized trees as a background device. He delineated the trees in a vibrant yellow, which is effectively echoed by the striping on the handsome original frames. Believed to have been painted in 1831–1832, the Wood family pictures are competent and colorful examples of a considerable body of work attributed to a man who, had he not met an untimely death at the age of thirty-seven, would undoubtedly have gone on to make a significant contribution to nineteenth-century art.

While I was writing the catalogue of the Abby Aldrich Rockefeller Folk Art Collection in the mid-1950s, I became acquainted with a handsome pair of portraits of Major and Mrs. Harrison, attributed to Zedekiah Belknap (working c. 1810–1850). A resident of Wethersfield, Vermont, where we visited his grave in a small

country cemetery, Belknap spent his long career as an itinerant, painting count-less likenesses in the small towns of northern New England. His style is easily rec-ognizable through his individual manner of facial painting, characterized by partly turned faces with prominent, heavily shadowed noses. His pictures vary in merit: some subjects are uninteresting, others of children delightfully naïve, and a few, such as the unidentified pair in figures 152 and 153, are stylish and well drawn. Signed examples are relatively rare. A typical inscription in Belknap's handwrit-ing (fig. 154) appears on the reverse of the portrait of Hannah Fisher Stedman of Chester, Vermont (fig. 155).

Also while doing research on the Rockefeller Folk Art Collection, I became aware of a group of homogeneous portraits dating to the 1830s. The artist had been dubbed the Kent Limner because of a 1924 exhibit in Kent, Connecticut, at which eight portraits were exhibited by this distinctive but then unknown hand. The only clue I found to his possible identity was the name Phillips contained in a reference to portrait illustrations found in an 1897 publication of the *Ten Broek Genealogy*. Shortly after the publication of the Rockefeller Folk Art Collection catalogue in 1957, I came upon a portrait of young George C. Sunderland in an antiques shop in Silvermine, Connecticut, which I immediately recognized as one of the Kent Limner group. On the reverse of the canvas, apparently in the artist's hand, was the name Ammi Phillips and the date 1840. Although the subject of this picture did not attract me, the documentary interest of the signature did, and I carefully noted it before leaving the shop. It was no surprise, therefore, when in 1965 Bar-bara and Lawrence B. Holdridge organized the first definitive exhibition of Ammi Phillips's work at the Connecticut Historical Society, to find that the Sunderland portrait occupied a place of honor as the frontispiece of their catalogue.[8]

Phillips's early painting years, from 1811 to 1820, seem to us the most vibrant period of his long career, and it was some time before we found what we were looking for in the portraits of Colonel Joseph and Sarah (Bull) Dorr illustrated in figures 156 and 157. We acquired them from a direct descendant in Hoosick Falls, New York, where a number of likenesses of the Slade, Spicer, and Dorr families had been painted about 1814. Joseph Dorr, who established many mills in Hoos-ick, was very prominent in the town: Justice of the Peace, County Judge, and Col-onel of Militia in the War of 1812. The pictures are large and bold in concept, capturing personality by means of flat planes emphasized by strongly delineated lines that in form and shape betray a notable lack of anatomy and perspective. Soon after 1820, the artist's early technique began to evolve into his later Kent Limner style.

The portrait of the Reverend Jonas Coe (also attributed to Phillips) was proba-bly painted several years before his death in 1822 and illustrates the transition from the artist's earliest work to his slightly later style (fig. 158). In 1793, Jonas Coe was ordained as the first pastor of the First Presbyterian Church in Troy, New York, a position that he was to occupy until his death in 1822 at the age of sixty-three years. Accompanying the portrait, preserved by Coe descendants, from whom the picture came, was a group of personal memorabilia that included Coe's folding spectacles, the clerical bands worn at times during his ministry, and a ledger that records his salary (entered at first in pounds, shillings, and pence) for the entire thirty years of his ministry in Troy. Coe began his pastorate to the United Congregations of Troy and Lansingburgh on December 1, 1792, at an agreed-upon stipend of 240 pounds per annum, of which each congregation was to pay one half. In 1804, the congregations separated, and from 1805 to 1822, Coe was

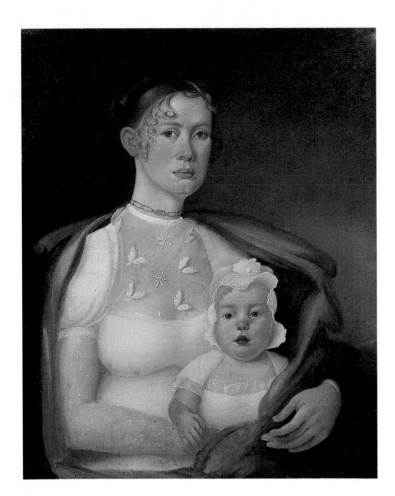

161. Unknown Lady, by Asa Park, Lexington, Kentucky. Inscribed on reverse: *Painted by Asa Park 1814*. Oil on canvas. 34" x 27".

162. Unknown Man. Inscribed on reverse: *Painted by Asa Park 1814*. Oil on canvas. 34" x 27".

163. *Mrs. Robert Dean*, New York City, 1818–1819. Artist unknown. Pastel on paper. 25¾″ x 21½″. Original frame.

164. *Robert Dean*, New York City, 1818–1819. Artist unknown. Pastel on paper. 25¾″ x 21½″. Dean was a boot crimper in New York. A framer's label on the back of the gold frame indicates that it was made by Ambrose Crane, carver and gilder, New York, 1818–1819. Original frame.

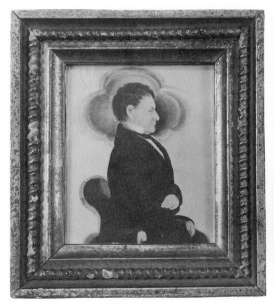

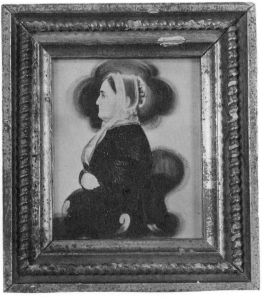

165. Pair of miniatures, New England, by James Sanford Ellsworth, 1840–1850. Signed on backs of both chairs: *J. S. Ellsworth, Painter*. Watercolor on paper. 3¾″ x 3¼″.

retained by the trustees of the Presbyterian Congregation of Troy, his yearly salary then being permanently fixed at one thousand dollars.

From another line of the Reverend Coe's direct descendants came a well-painted miniature on ivory (fig. 159), traditionally ascribed to the same hand that created the large portrait. Although many of Ammi Phillips's contemporaries advertised profiles and miniatures at reduced prices, there is no present proof that Phillips was one of them. Accompanied also by early-nineteenth-century family memorabilia, the attribution of the miniature presents one of those intriguing quandaries that make collecting such a stimulating pursuit.

A majestic yet personal quality is often evoked by a painting of a pastor in the act of exhorting his flock. This compelling quality is abundantly evident in the commanding portrait of the Reverend Eli Forbes (fig. 160) standing in the pulpit of the First Church in Gloucester, Massachusetts. Forbes was the Revolutionary period minister in the town, serving his congregation from 1776 until his death in 1804. Here is an outstanding example of the early work of Christian Gullagher, a Danish-born artist whose presence in Massachusetts is verified by his marriage to Mary Selman in Newburyport in 1786. A few portraits of Essex County people, including Reverend Forbes, are credited to Gullagher during 1786–1789, before he settled in Boston to pursue an expanding painting career.

A happy contrast to the dour Dorr pictures is presented by the lighthearted portraits in figures 161 and 162. Both are signed by Asa Park and, like the Dorrs, date to 1814. Park, a Virginian by birth, became one of the pioneer painters of Lexington, Kentucky, when he settled there, before 1800. Although he was better known for his fruit and flower pieces than for his likenesses, one senses his acquaintance with the academic style which is expressed by surrounding the baby in swirling blue drapery and providing the man (said to have been his brother) with a five-keyed classical clarinet.

Dating about five years later are the high-style New York City pastels depicting Mr. and Mrs. Robert Dean painted by an unknown hand (figs. 163 and 164). Dean was a boot crimper (leather worker) by trade, listed in the New York City directories for the years 1812–1821. Affixed to the heavy blue paper covering the back of Mr. Dean's picture is a printed label of Ambrose Crane, carver and gilder, that reads as follows: AMBROSE CRANE/Importer & [Manu]-fact[urer] of Looking-Glasses./No. 135/Broadway, New-York/Tenant the City Hotel/Carving & Gilding of every description done in the neatest manner. As Crane was listed at 135 Broadway in the city directories only during 1818 and 1819, these years suggest the probable date of the pictures. They represent two of an especially prized group of pastels in our collection, acquired over the years because pastel portraits are seldom dull and often surpass, in characterization and style, those found in other media.

Old people were often among the most appealing subjects to come under the folk artist's brush because their care-worn faces frequently mirrored the tranquillity of advancing years rather than the grim realities of middle life. James Sanford Ellsworth is well known for his distinctive miniatures, the prim profile figures painted in watercolor and backed by scalloped clouds (fig. 165). Although he occasionally painted in oil, few of his large portraits have come to light, and most of them lack the crisp style of his miniatures. The unknown woman in figure 166, her luminous face and shadowy figure silhouetted against a high-backed rocking chair, evinces a curious aura of otherworldliness that is not easy to define. In flourishing script on the reverse of the canvas is the signature: *James S. Ellsworth Portrait Painter* (fig. 167).

George Gassner, who came to this country from Germany in 1811, painted in 1834 the striking image of an unidentified woman seen in figure 168. Little is known about Gassner beyond his advertisements for portrait painting that appeared in the Bristol, Rhode Island, *Gazette and Family Companion* from January 31 to March 2, 1835.[9] He also executed miniatures and in 1839 signed a less interesting picture of a woman in Chicopee Falls, Massachusetts,[10] where he eventually died in 1861.[11] Like other folk artists, Gassner occasionally painted an outstanding portrait that far surpassed the regular run of his work.

In 1957, a Maine itinerant entirely unknown to me came to my attention through a group of five McArthur family portraits signed: *Royall B. Smith*. Arthur McArthur was a lawyer in Limington, Maine; in the local cemetery seven matching marble headstones mark the graves of seven members of the McArthur family (fig. 169). His house and small law office were still standing when we visited the town, and in a closet of the former, the portraits had remained hidden until sold by the nephew of little Harriet McArthur (fig. 170).

Royall Brewster Smith, who inscribed the McArthur pictures in 1836, was a native of Buxton, Maine, where he was born on August 7, 1801. He was the son of John McCurdy Smith and his wife, Elizabeth McLellan, a descendant in the third generation of Hugh and Elizabeth McLellan of Gorham, Maine. Also in Buxton lived Dr. Royall Brewster (brother of the portraitist John Brewster, Jr.), and it is evident that the eleventh child in the Smith family was named in honor of the physician who officiated at his birth. Relatively little has been learned about Royall Smith himself or his painting career, although several letters from his younger brother, George, written during 1831–1833 from Orono and Bangor and addressed to Royall in Gorham Corner, indicate that money was scarce in the Smith family. On August 13, 1832, George wrote the following letter:

> I left Kennebec a week ago last Thursday and left the folks all well. I went to Uncle Bryce's and I talked to him about some money. He said he hadn't any now but he would get some for me and I expect to get it next month and I think you had better come down as soon as you can. I think this is as good a place for your trade as you can find anywhere. I think you had better not engage any more work now. If you come down we can look around and find a place to work at painting until we can get a shop that will suit you.[12]

Several portraits signed by Royall B. Smith were painted during this period, including the matching canvases in figure 171, with the signature illustrated in figure 172. Although his face painting was still quite naïve, he had certainly mastered the illusion of transparent lace, and these vigorous likenesses heralded the more accomplished work to come in Standish and other Maine towns.

John Greenwood, a mid-eighteenth-century portrait painter, left Boston for Surinam in 1752. Several years previously, about 1748, he had painted the imposing portrait of Mrs. Mary (Fitch) Cabot of Salem (fig. 173). Characteristic of Greenwood's manner is the stiffness of the figure and his obvious ineptitude in attaching the head to the body. But the conventional pose and gracefully painted hands bespeak New England pre-Revolutionary portraiture that was firmly rooted in English academic style.

In the early 1950s, I became increasingly involved with New England provincial portraits of the last quarter of the eighteenth century, and with increasing interest, I have continued to the present my collecting and researching them.[13] Break-

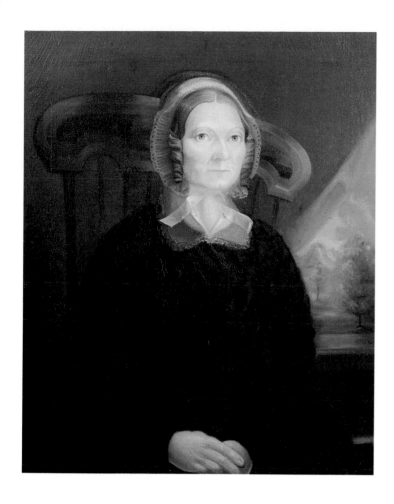

166. Old Lady, New England, by James Sanford Ellsworth, c. 1845. Inscribed on reverse: *James S. Ellsworth Portrait Painter*. Oil on canvas. 32″ x 26″.

167. Inscription by James S. Ellsworth on reverse of portrait of an old lady in figure 166.

168. Unidentified Woman, New England, by George Gassner. Signed at lower left: *Taken by Gassner 1834*. Oil on canvas. 34″ x 27″.

169. Seven marble gravestones of the McArthur family, Limington, Maine.

170. *Harriet McArthur*, Limington, Maine, by Royall B. Smith. Inscribed on band at bottom of canvas: *Harriet McArthur, born January 29th, 1834. Painted June 1836, by Royall B. Smith.* Oil on canvas. 50″ x 27″.

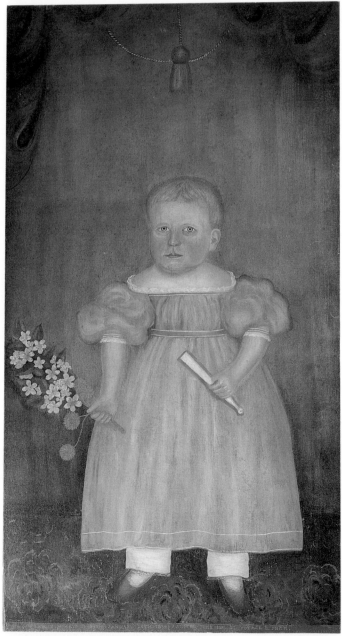

171. Unidentified Man and Woman, New England. Pair of portraits, signed on reverse: *Painted by Royall B. Smith March 1831*. Oil on canvas. 30″ x 25″.

172. Inscription by Royall B. Smith on reverse of portraits in figure 171.

173. *Mary (Fitch) Cabot,* Salem, Massachusetts, attributed to John Greenwood, c. 1748. Oil on canvas. 36″ x 28″. Mary Fitch became the first wife of Francis Cabot of Salem in 1745. She was born in Ipswich, Massachusetts, in 1723–1724 and died in 1756. Original frame.

174. *Ezra Weston*, Duxbury, Massachusetts, by Rufus Hathaway, 1793. Oil on canvas. 38″ x 25″. The calipers and gauging rod seen in the portrait were listed in Weston's inventory at four dollars.

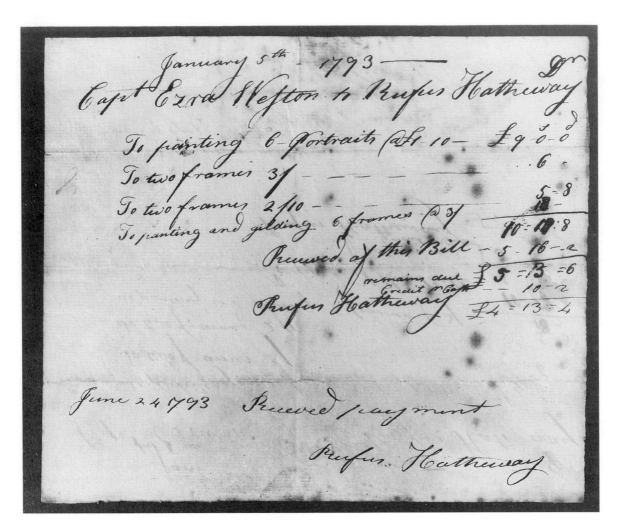

175. Bill of sale, signed by Rufus Hathaway, January 5, 1793, for painting six portraits of the Weston family at nine pounds. Included is the portrait of Ezra Weston (fig. 174) and the cost of the frame, three shillings.

176. *Thomas Winsor*, Duxbury, Massachusetts, miniature by Rufus Hathaway, 1797. Engraved on back of gold frame: *Thomas Winsor born July 22nd 1780. Died March 12th 1832. Painted when he was 17 years of age by his brother-in-law Dr. Rufus Hathaway.* Oil on cardboard. Diam. 2⅜".

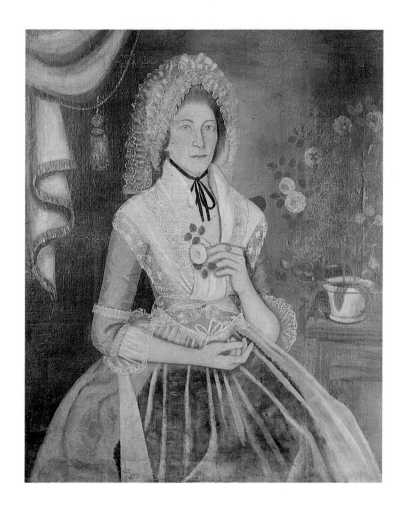

177. *Mrs. James Blakeslee Reynolds* (Mary Thomas), West Haven, Connecticut, attributed to Reuben Moulthrop, c. 1789. Oil on canvas. 45″ x 36″. This picture typifies the flair for decorative design seen in the work of many post-Revolutionary provincial artists.

178. *James Blakeslee Reynolds*, West Haven, Connecticut, attributed to Reuben Moulthrop, c. 1789. Oil on canvas. 45″ x 36″. A brass snuff box rests on the table beside him.

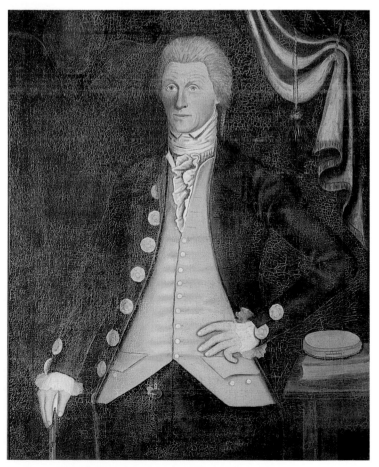

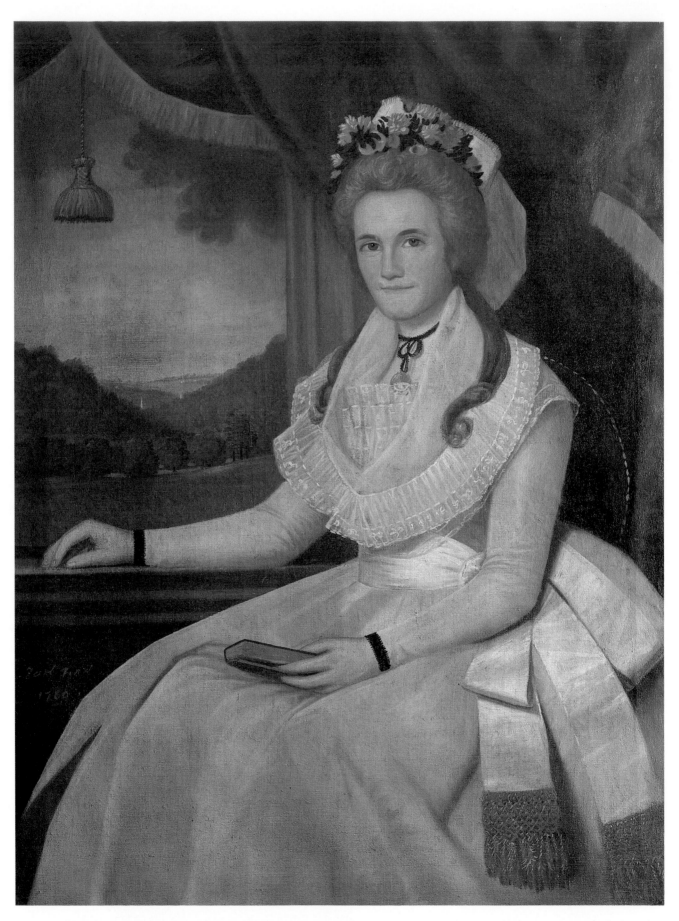

179. *Mrs. Homer Boardman* (Amaryllis Warner), New Milford, Connecticut. Signed at lower left: *R. Earl Pinx 1789*. Oil on canvas. 49″ x 37″.

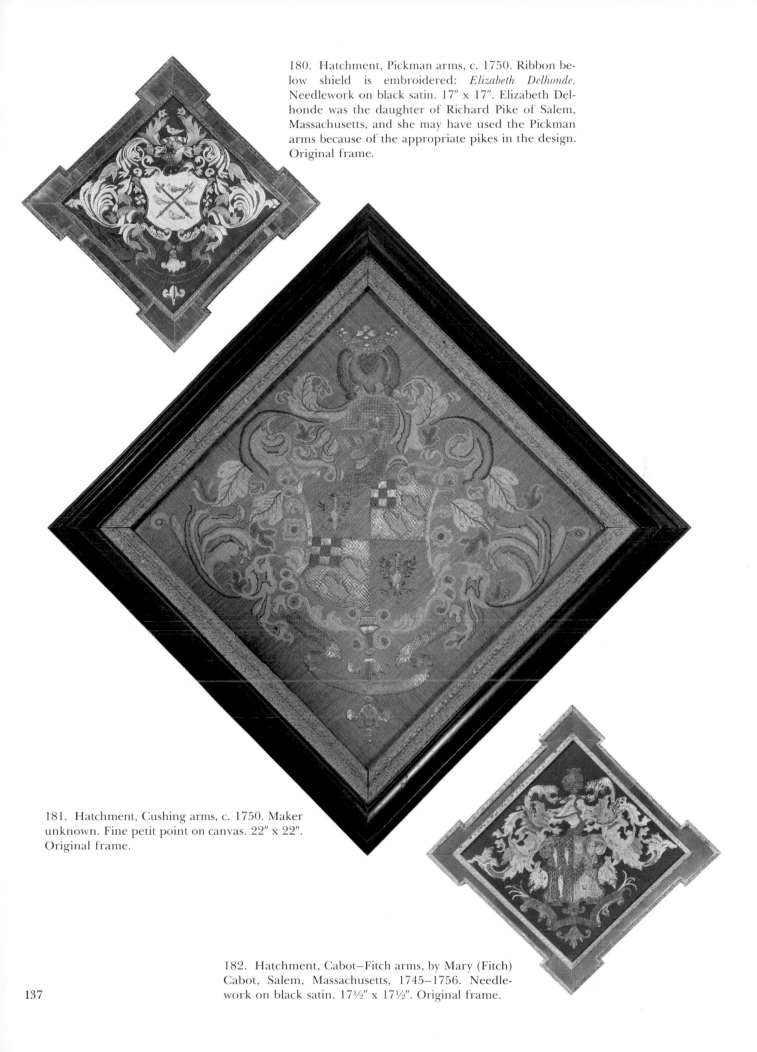

180. Hatchment, Pickman arms, c. 1750. Ribbon below shield is embroidered: *Elizabeth Delhonde*. Needlework on black satin. 17″ x 17″. Elizabeth Delhonde was the daughter of Richard Pike of Salem, Massachusetts, and she may have used the Pickman arms because of the appropriate pikes in the design. Original frame.

181. Hatchment, Cushing arms, c. 1750. Maker unknown. Fine petit point on canvas. 22″ x 22″. Original frame.

182. Hatchment, Cabot–Fitch arms, by Mary (Fitch) Cabot, Salem, Massachusetts, 1745–1756. Needlework on black satin. 17½″ x 17½″. Original frame.

183. Howard and Hancock coats of arms, John Coles, Sr., 1806–1807. Watercolor on paper. 14″ x 10″. Painted on ribbon below left shield: *By the name of Howard.* In this rendition, Coles used the arms of Catherine Howard, fifth queen of Henry VIII, the crest being surmounted by an American flag. Hancock coat of arms (right), John Coles, Sr., c. 1800. Watercolor on paper. 14″ x 10″. Lettered below shield: *By the name of Hancock.* These were English arms appropriated by Thomas Hancock of Boston, Massachusetts, in 1739. Original frames.

184. Two coats of arms. Dobel coat of arms (left), attributed to George Searle, Newburyport, Massachusetts, 1775–1790. Watercolor on paper. 14″ x 10″. Lettered below shield: *He beareth Sable a Doe . . . Between three Bells . . . by the Name of Dobel.* Stewart coat of arms (right), possibly by Robert Cowan, ornamental painter, Salem, Massachusetts, c. 1790. Watercolor on paper. 12½″ x 9½″. Lettered on ribbon below shield: SPERO, MELIORA.—*By the name of Stewart.* This shield depicts the English arms of Stewart of Blackhall. Cowan's wife was Elizabeth Stewart. Original frames.

ing away from the academic precepts that had predominated in Anglo-American portraiture of the Colonial period, these forthright likenesses reflect a refreshingly new approach by virtually untrained artists. They painted with unabashed reality the faces of the men and women whose lives had spanned the uneasy years of the Revolutionary period and who were facing the uncertainties of the new Republic that was to follow in its wake.

Rufus Hathaway, whose work I began to explore in 1952,[14] intended to become a traveling artist until his future father-in-law, Joshua Winsor, a prosperous Duxbury, Massachusetts, merchant, persuaded him to follow the more respectable profession of medicine, if he wished to marry Winsor's daughter. Hathaway became the only physician in Duxbury until his death in 1822. Previous to his marriage to Judith Winsor in 1795, he had painted a small number of remarkably powerful likenesses of local people, including three generations of two prominent Duxbury families, the Westons and the Winsors. Many of these sitters were delineated in three-quarter length, a prevailing eighteenth-century style. Through Hathaway's ability to handle color and mass, despite the usual limitations of anatomy and perspective, he was able to create compositions of striking linear design. Ezra Weston (fig. 174), whose wealth was derived from large shipping activities, was known locally as "King Caesar." During the early 1790s, Hathaway painted portraits of at least ten members of the Weston family, of which Ezra's own likeness, and that of his grandson Church Sampson, remained with direct descendants until coming into our possession in 1974. The pictures were accompanied by the original bill of sale signed by Rufus Hathaway and dated January 5, 1793 (fig. 175). The bill lists six family portraits at a charge of 1 pound, 10 shillings each. Four frames were variously priced at 3 shillings and 2 shillings, 10 pence each. Hathaway also painted a few miniatures, at least two of which are unlocated. A third example is in our collection, and it depicts Thomas Winsor, the younger brother of Hathaway's wife, Judith, painted in Duxbury in 1797 (fig. 176).

In the late 1940s, we heard about a large pair of late-eighteenth-century portraits still owned by a descendant who, regrettably, could ill afford to keep them in her possession. Eventually we forgot all about the pictures, so we were surprised and pleased when, some years later, they were offered for our consideration (figs. 177 and 178). James Blakeslee Reynolds of West Haven, Connecticut, married Mary (Kimberly) Thomas about 1788, and they were painted, perhaps by Reuben Moulthrop, shortly after that date. In his own day, Moulthrop was best known as a modeler in wax, although in 1793 he advertised portrait and miniature painting. Variations in style and scarcity of signed pictures create uncertainty in attributing much of Moulthrop's work.

We had never been particularly desirous of owning a portrait by Ralph Earl, feeling that the work of less well-known artists was more challenging to discover and study. Some of Earl's ladies are imposing rather than endearing to live with, and all his compositions were influenced to some extent by the formative years he spent in England. Mrs. Homer Boardman, however, immediately won our hearts by her unpretentious grace and charm (fig. 179). Wife of the third Boardman brother of the prominent New Milford, Connecticut, family, all painted in 1789, Amaryllis Warner had married Homer Boardman in 1787. After her death in 1839, the portrait descended through her daughter Laura, who married the Reverend Aaron Darick Lane of Waterloo, New York, and it remained in the Lane family until shortly before we purchased it in 1966.

In addition to the larger categories of pictures, we have collected in several specialized fields of American naïve art. One group comprises various types of pictorial records pertaining to New England families that began with hatchments in the mid-eighteenth century and ended about 1830 with the typical schoolgirl family registers and mourning pictures.

It was during the 1720s that two English books—John Guillim's *A Display of Heraldry*, reprinted in 1724, and Samuel Kent's *The Banner Display'd*, published in 1726 and 1728—made easily available to American painters, designers, and carvers many family coats of arms that had not previously appeared in the English publications that dealt primarily with arms of the peerage. One or both of these treatises are known to have been used as heraldic sources by Nathaniel Hurd, silversmith; John Coles, Sr., heraldry painter; and George Searle and Edward Bass of Newburyport.[15]

The term *hatchment* signifies a coat of arms emblazoned on a square panel that is designed to be hung from one corner. Wooden hatchments for funeral display were accepted status symbols in both England and the Colonies. Eighteenth-century examples painted on black backgrounds were carried in funeral processions or were hung on the exterior of the residences of the deceased as a sign of mourning. Sometimes lozenge-shaped panels were embroidered on black satin by a member of the family. These were obviously not for exterior display but were ornamental memorials to be hung inside the house.

The hatchment in figure 180 displays the Pickman coat of arms. Embroidered within the ribbon below the shield is the name Elizabeth Delhonde. Mrs. Elizabeth (Pike) Delhonde was the daughter of Richard Pike of Salem. Sometime following his death in 1747, she apparently worked these arms in colored silks on a black background, perhaps as a memorial to her father. This device of pikes and birds was actually the arms used by Benjamin Pickman of Salem in 1723 and found on a silver cup belonging to him that is now in the collection of the Essex Institute. Perhaps the arms were appropriated by Elizabeth (Pike) Delhonde because of the pikes in the design. Numerous similar needlework hatchments that descended in old New England families have now found their way into museum collections, unfortunately seldom accompanied by information about their origin or maker.

In the shop of Thomas Johnston of Boston (1708–1767), a house painter, japanner, engraver, and painter of coats of arms, many skilled artisans were trained during the Colonial period. At Johnston's death, his inventory listed a "Book of Heraldry, 48s," and one of his hatchments painted in watercolor on paper is illustrated in Bowditch's article on painted coats of arms.[16] In the administrator's accounts of the estate of the wealthy Bostonian William Clark, who died in 1742, appears the following entry: "Pd Johnson for Escutcheon and Coat of Arms and stock do [ditto] for House 57 [pounds]." This relatively large sum may have been a charge for painting the bold escutcheons that were emblazoned on several of the vertical panels that embellished the walls of Clark's north parlor in his house on the corner of Garden Court and Prince Street, built about 1712.[17]

Another of Boston's pre-Revolutionary ornamental painters was John Gore (1718–1797), proprietor of the shop Sign of the Painters' Arms on Queen Street. Gore was the owner of an important book known as the *Gore Roll of Arms*, which contains paintings of early-eighteenth-century arms and crests with the names of the bearers. These arms appear to represent heraldic devices that had especially attracted Gore's attention and that he used in his local decorating business. Gore

185. Coat of arms of the Little family, Newburyport, Massachusetts, c. 1800. Signed on paper backing: *Wrought by Abigail Little*. Needlework on white satin. 18″ x 13″. Embroidered on ribbon below shield: *By the Name of Little*. Apparently based on a design by John Coles, Sr. Original frame.

186. Coat of arms of the Dummer family, c. 1800. Embroidered at bottom: *Wrought by Abigail Little*. Needlework on white satin. 18″ x 14″. Embroidered on ribbon below shield: *By the Name of Dummer*. Original frame.

187. Mourning picture, in memory of Levi and Simon Davis, c. 1815. Watercolor on paper. 13¾" x 15½". Lettered in gold on black glass mat: *Rebecca Davis.* This view of Faneuil Hall, Boston, Massachusetts, was copied from an illustration in the *Massachusetts Magazine* of March 1789. Original frame.

188. Family record, Miner and Perley families, Lempster, New Hampshire, attributed to Maria Perley, c. 1845. Watercolor on paper. 21" x 21". The three vignettes across the bottom contribute to the originality of this unusual composition. (Photograph by George M. Cushing)

189. Mourning picture, in memory of the Perley family, attributed to Maria Perley, c. 1845. Black watercolor on paper. 21″ x 23″. The hearse house with its black doors stands at left. (Photograph by George M. Cushing)

190. Family record, Burnham–Channel Family, Ipswich, Massachusetts. Inscribed below picture: *Gloucester July 10, 1795. Drawn by William Saville.* Watercolor on paper. 12½″ x 10¾″.

191. Mourning picture, in memory of Mrs. Abigail Channel, Ipswich, Massachusetts, c. 1795. Signed on lower right: *Drawn by William Saville.* Watercolor on paper. 13¼″ x 10″.

192. *Waiting for the Kettle to Boil.* Signed at left: *Edward Hill, 1885.* Oil on canvas. 14″ x 20″.

193. Painting of Vermont cupboard. Signed at left: *T. W. Wood, 1885.* Oil on canvas. 19″ x 15″.

had a son, a son-in-law, two grandsons, and a nephew, George Searle, who all continued to follow the ornamental painting trade in Boston or Newburyport.

Apprenticed to John Gore in 1740 was fourteen-year-old David Mason (1726–1794), one of Bert's direct ancestors. He was later to become a colonel of artillery and to see service in both the French and Indian and the Revolutionary wars. Mason also worked under Thomas Johnston, and a payment due him in excess of twelve pounds is recorded in the previously mentioned Clark accounts, probably for assistance in painting the coats of arms in the Clark house. Following Mason's escape from capture at Fort William Henry, he advertised in the *Boston Gazette* on December 18, 1758: "this is to inform the Publick, That David Mason, Japanner, has open'd a Shop . . . where all sorts of Painting, Japanning, Gilding, and Varnishing are done; Coats of Arms, Drawings on Sattin or Canvis for Embroidering; also Pictures fram'd after the neatest manner." Mason not only supplied painted coats of arms but drew designs for making them in needlework, which he was also equipped to frame. In 1757, the following notice appeared in the *Boston Gazette:* "To be taught by Jean Day . . . Embroidery with Gold and Shell Work, Coats of Arms, Tent Stitch, and a Variety of other Work, all in the neatest and newest Fashion."

Embroidered hatchments were worked in two different styles, either in long stitch on black satin backgrounds, usually enhanced by metal threads, or, more rarely, in tent stitch (petit point) on canvas, with needlework backgrounds that were often in color. Figure 181 illustrates the most expertly stitched hatchment in our collection. Still protected by its original eighteenth-century frame and glass, it depicts the arms originally used by Matthew Cushing of Hingham, Massachusetts, in 1638.[18]

The Connecticut Historical Society owns an interesting hatchment exhibiting the arms of the Pitkin family of East Hartford, Connecticut, worked in 1750 by Jerusha Pitkin. This is a significant study piece because the embroidery, being incomplete, reveals some of the unfinished design beneath, suggesting that many needlework patterns were originally outlined in white on the black satin grounds. Although black backgrounds derived from the traditional painted funeral escutcheons, some hatchments were made to signify a marriage rather than to memorialize a death. The piece in figure 182 descended in the family of Mary Fitch of Ipswich and Francis Cabot of Salem, married in 1745. It displays a combination of the Fitch and Cabot arms and is said to have been worked by Mary (Fitch) Cabot before her death in 1756. (Her portrait is illustrated in figure 173.)

As the eighteenth century progressed, embroidered hatchments were gradually superseded by ornamental coats of arms painted in watercolor on laid paper. Rectangular in shape, they, like the hatchments, were frequently enhanced by handsome carved and gilt frames. From a heraldic point of view, these painted emblems seldom have any authenticity although they are now prized as family heirlooms. A few of the designs were fabricated by the artists from whom they were commissioned. Many others were variations of English armorial devices found in Guillim or Kent and offered to New Englanders with corresponding surnames, although the owners often belonged to a family branch that did not have the hereditary right to bear those particular arms.

John Coles, Sr. (1749–1809), a printer and publisher of engravings, was also listed in the Boston directory of 1796 as a "Heraldry Painter" and was the most prolific of the post-Revolutionary heraldic artists. His shields are sometimes surmounted by a closed, side-facing helmet, and outside the four corners of the shield appear two branches, variously designated as palms or cornstalks. On the scroll,

instead of the traditional motto, is usually inscribed the surname of the family who commissioned the painting. Coles frequently adapted armorial designs or took them out of Guillim, and a typical example of this practice appears in the Howard family coat of arms illustrated on the left in figure 183. In this ingenuous adaptation, Coles appropriated the arms of Catherine Howard, fifth queen of Henry VIII, and used as a crest the American flag![19] Although an occasional coat of arms will be found signed on the front with the artist's name, Coles usually affixed a paper label to the backboard of the frame. The Howard arms bears such a label announcing Heraldry Painting at 61 Newbury Street, Boston, where Coles's shop was located during 1806 and 1807. Also shown in figure 183 is Coles's Hancock arms, combining three cocks with an upraised hand. Actually these were the arms granted to the Hancock family of Combmartin, Devonshire, England, who were the progenitors of Richard and John Hancock, patentees of New Jersey in 1675. Thomas Hancock, and his more famous nephew John of Boston, began to use these arms in 1739, but there is little reason to believe that they were rightfully entitled to bear them.[20]

Watercolor arms were produced by a number of New England painters, some of whom have been identified through documented examples of their work, although a predilection for borrowing elements of design from one another often causes confusion in attributing unsigned examples. George Searle of Newburyport (c. 1751–1796), nephew of John Gore, owned a small hand-stitched notebook containing paint formulas, prices for chaise painting, and other similar items, including an armory of eighty-five names and arms of local gentry.[21] The left side of figure 184 illustrates a handsome coat of arms of the Dobel family attributed to Searle on stylistic grounds. Between 1775 and 1789, three marriages were recorded in the Vital Records of Marblehead, Massachusetts, under the name of Thomas Dobel (or Doble). As this is not a common name in Essex County, it seems probable that these arms, featuring a doe and three bells, were commissioned by Thomas Dobel of Marblehead. Behind the wooden backboard of the original carved frame, we discovered a handwritten account kept in pounds, shillings, and pence dated 1760, also a pen-and-ink version, probably in the artist's hand, of the wording that appears below the shield. Searle obviously copied the arms from a heraldic source available to him.

The second painting, shown at the right in figure 184, bears the Stewart arms. This version is actually the coat of arms of Stewart of Blackhall, registered in the office of the Lord Lyon at Edinburgh in 1672. Although the artist has not been definitely identified, an attribution is possible to one Robert Cowan, who was born in Scotland in 1762, married Mary Stewart in Salem, and lived and died there in 1848. Like his fellow townsman Samuel Blyth, several of whose coats of arms are in our collection, Cowan was a competent ornamental painter who decorated furniture, picture frames, "sleys," and landscape fireboards. For one of the latter, he billed John Derby 1 pound, 9 shillings, and 7 pence in 1791.[22]

By the closing years of the eighteenth century, traditional embroidered hatchments had gone out of fashion as ladies turned their attention to other forms of pictorial needlework. A few family arms, however, were still being stitched by young women in local academies. Such a pair is in our collection, one of which is inscribed: *Wrought by Abigail Little*. These pictures depict the arms of two families and signify the marriage in 1786 of Abigail's parents, Moses Little and Elizabeth Dummer of Newburyport, Massachusetts. The pictures were worked by their daughter while she was a student at nearby Bradford Academy. The Little arms

194. Photograph of Peter Cushing house, Hingham, Massachusetts, c. 1885. Ella Emory, who painted interiors of several rooms in the house, is seated in the foreground.

195. West Parlor, Peter Cushing house, Hingham, Massachusetts, by Ella Emory, 1878. Oil on canvas. 12¾" x 17½".

196. East Parlor, later the dining room, Peter Cushing house, Hingham, Massachusetts, by Ella Emory, 1878. Oil on canvas. 15½″ x 21½″. (Courtesy *The Magazine Antiques;* photograph by Helga Photo Studio)

197. East Chamber, Peter Cushing house, Hingham, Massachusetts, by Ella Emory, 1878. Oil on canvas. 15½″ x 26¾″.

198. Old Laundry, Peter Cushing house, Hingham, Massachusetts, by Ella Emory, 1878. Oil on brass stovepipe cover. Diam. 12″. In 1945, the little building was moved and attached to the main house, and the chair-table was stored in the barn. (Courtesy *The Magazine Antiques;* photograph by Helga Photo Studio)

199. Parlor in Mrs. Smith's Boardinghouse, Philadelphia, by Joseph S. Russell. Inscribed below picture: *Mrs. H. W. Smith's Parlor, Broad & Spruce St. 1853.* Watercolor on paper. 8½″ x 11″.

200. Sitting Room of the Russell Daughters, by Joseph S. Russell. Inscribed on lower margin: *Sarah & Eliza Russell's room at Mrs. Smith's N.E. Broad & Spruce Philad' 1854.* Watercolor on paper. 8½″ x 11″. Joseph S. Russell, the artist, stands at right. (Courtesy *The Magazine Antiques;* photograph by Helga Photo Studio)

Sarah & Eliza Russell's room at Mrs Smith's N.E Broad & Spruce Philad' 1854

201. Interior in the House of Moses Morse, Loudon, New Hampshire, by Joseph Warren Leavitt, c. 1825. Watercolor on paper. 7″ x 9″. The stenciled wall patterns are typical of examples found in Loudon and other central New Hampshire towns.

202. *Thomas and Betsey Thompson*, Durham, New Hampshire, attributed to Joseph H. Davis. Written below picture: *Thomas Thompson Æ 66. Nov. 13ᵗʰ 1837. Betsey Thompson Æ 56. Nov. 1ˢᵗ 1837.* "I'm glad I ever see the Day, / We met to sing, and preach and Pray. / There's Glory, Glory, in my Soul, / Which makes me praise My Lord so Bold." Watercolor on paper. 10½″ x 15″.

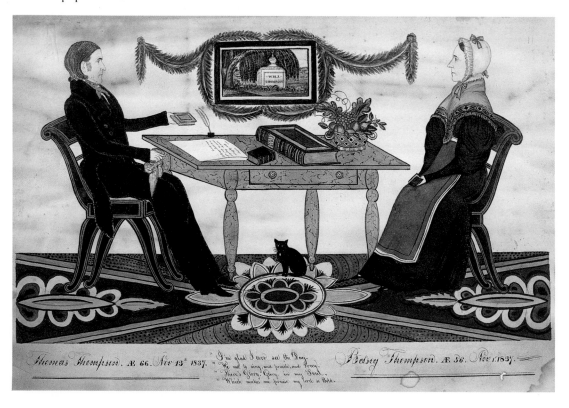

(fig. 185) have been used by various branches of the Newburyport Littles, the design being typical of the style adopted by John Coles, Sr. The Dummer coat of arms (fig. 186) appears to be a curious rendition that may have derived from the arms belonging to Edmund Dummer of Swathling, Southampton County, England, as recorded in Guillim, page 22 of the Second Part. Regarding this design, a humorous letter to me from the late Dr. Harold Bowditch reads in part: "Abigail's design is something new and strange in my experience; her rendition of fleurs-de-lys is, to say the least, novel—and better not be imitated."

During the 1790s, two quite different types of family records began to supersede the conventional coats of arms that had flourished during the preceding fifty years. The painting or embroidering of so-called mourning pictures and family registers gradually became an accepted part of a genteel education, the majority being the work of schoolgirls and intended for display on the parlor walls. The death of President Washington in 1799 added impetus to the creation of memorial subjects. Mourning pictures often included a tomb bearing the name of the deceased, one or more mourners, a river, a weeping willow tree, and a church, all recognized symbols of bereavement. In these pictures, frequently created as exercises in academy art, young ladies memorialized deceased relatives, even grandparents who had departed life before the young artists were born. Therefore, the death dates inscribed on the tombs seldom coincide with the actual date of the painting of the pictures.

Family registers, as the name implies, were pictorial genealogical charts. Designed in many decorative patterns, they customarily recorded the date of a marriage with the names, births, and sometimes the deaths of the persons listed thereon.

Although we own a number of conventional registers and mourning pictures, we are always searching for those that exhibit originality of design. The watercolor in figure 187 memorializes the deaths of Levi Davis, who died as a baby on February 4, 1796, and of Simon G. Davis, who died at age two and a half years in 1813. The black glass mat was inscribed by Rebecca Davis, who was probably the sister of the two little boys. Although her composition includes several typical elements, one unusual feature may be seen in the background. In place of the usual church or meeting house is a large structure that is a precise representation of Boston's Faneuil Hall. This view shows the building as it appeared in an engraved illustration in the *Massachusetts Magazine* of March 1789, before enlargement by Charles Bulfinch in 1805.

Occasionally one finds a mourning picture and a family register that have descended together in the family for whom they were made, and such was the case with the pictures in figures 188 and 189. The double register is quite original in its decorative details and is unusually complete, as it records the marriages of two different couples with the births, marriages, and deaths of their offspring. On the left side of the double tablet appear the names of B. A. Miner and Amanda Carey of Lempster, New Hampshire, married in 1811, with their five children below. On the right are Edmund Perley and his two wives of Haverhill, Massachusetts, with their ten children born in Lempster between 1798 and 1826. Across the bottom are painted three small scenes: a tomb with mourners; a house, probably the Perley home; and the ubiquitous weeping willow. In the mourning picture that accompanies this register (fig. 189), the same girl with long black scarf is featured, probably the artist Maria Perley, standing beside the tomb of her parents, Edmund and Sarah Perley. Unusual elements here are the hearse house with black painted door (one still survives in Essex, Massachusetts) and the elaborate Gothic

Revival church in the background. Curious to discover if this handsome edifice was merely symbolic, or whether it represented an actual structure in Lempster, we visited the town one summer day and were not surprised to find that the old Congregational church, built in 1835, did not resemble at all the one in the picture, being a typical example of the unadorned New England architecture of its period.

Two other family records, drawn by a professional artist, descended together in the Channel family of Ipswich, Massachusetts, and are shown in figures 190 and 191. They are significant because of their early date, 1795, and the signature of William Saville of Gloucester, Massachusetts. Saville (1770–1853) was a schoolmaster when he drew these watercolors in early life. He later became a so-called trader in Sandy Bay, now Rockport, where he was Town Clerk for twenty years. Several similar registers by him are owned by the Sandy Bay Historical Society. Although the tree design is a familiar genealogical device that appears also on samplers, it is drawn with exceptional delicacy here (fig. 190). Entwined hearts beneath the branches contain the 1779 marriage dates of Abigail Burnham and Abraham Channel and his second wife, with the names of their children on round discs above. On the margin below appears the legend: *Gloucester, July 10, 1795. Family Record. Drawn by William Saville.*

The design of the memorial in figure 191 is a decided departure from the conventional amateur compositions of the nineteenth century and betokens a more innovative professional hand. The tall monument is effectively silhouetted against a wide black band and is inscribed, *To the memory of the late Abigail Channel this inscription is dedicated by her friends and relations. Drawn by William Saville.* Abigail "departed this life June ye 24th, 1794." Abigail Channel's grave is in the old burying ground in Essex, Massachusetts, which was, until 1819, the South or Chebacco Parish of Ipswich. A visit to her grave proves again that the monuments in mourning pictures were designed by the artists as conventional symbols of death and seldom, if ever, bore any resemblance to the actual tombs of the deceased.

It has recently been said that if a pre-Revolutionary housewife with a talent for drawing had stood in the doorway of each room in her home and set down on paper exactly what she saw before her, those paintings would today be visual documents of the utmost value and importance. Unfortunately the appearance of eighteenth-century domestic interiors, with their everyday arrangements of furniture and accessories, were seldom deemed of sufficient interest or artistic appeal to warrant the attention of a serious artist. How many of us have ever depicted our own kitchens for posterity, complete with utilitarian stove, dishwasher, refrigerator, and all the other familiar gadgets so dear to the hearts of modern homemakers? Early interiors are usually seen only as backgrounds for portraits of people. Valuable as these glimpses are, they were seldom the main object of the artist's concern. In fact, until the middle of the nineteenth century, relatively few American rooms were painted solely for their own intrinsic interest.

During the last quarter of the nineteenth century, patriotic fervor occasioned by the 1876 Centennial celebration resulted in the painting of numerous picturesque compositions that re-created imaginative aspects of the "good old days." In other cases, however, a few genuine early interiors were executed by persons who could actually remember the homes of the 1820s. The pleasant room in figure 192 is signed by an artist named Edward Hill and dated 1885. Titled on the reverse, *Waiting for the Kettle to Boil,* it depicts, apparently truthfully, a country kitchen

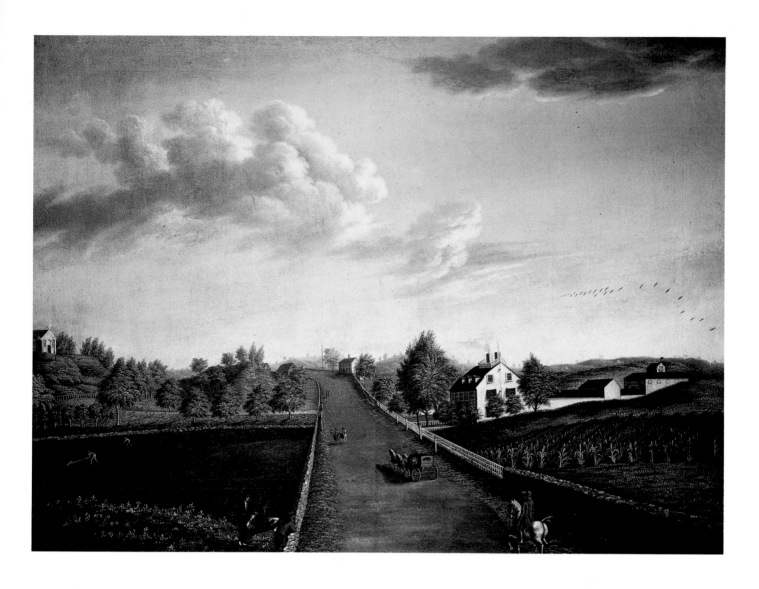

203. *Ezekiel Hersey Derby Farm*, Salem, Massachusetts, attributed to Michele Felice Cornè, c. 1800. Oil on canvas. 40″ x 53½″. One of Cornè's rare topical views, most of his landscapes having been based on engravings.

204. Estate in Kentucky, by Dupue. Written on backboard of frame: *Mr. Jas. Raglan and Wife Taken August 1820 in Clark Co. Kentucky by Dupue.* Watercolor on paper. 13″ x 15¾″.

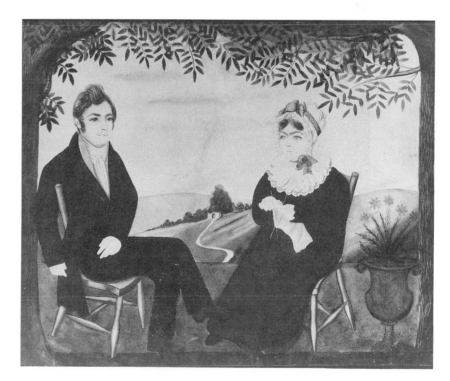

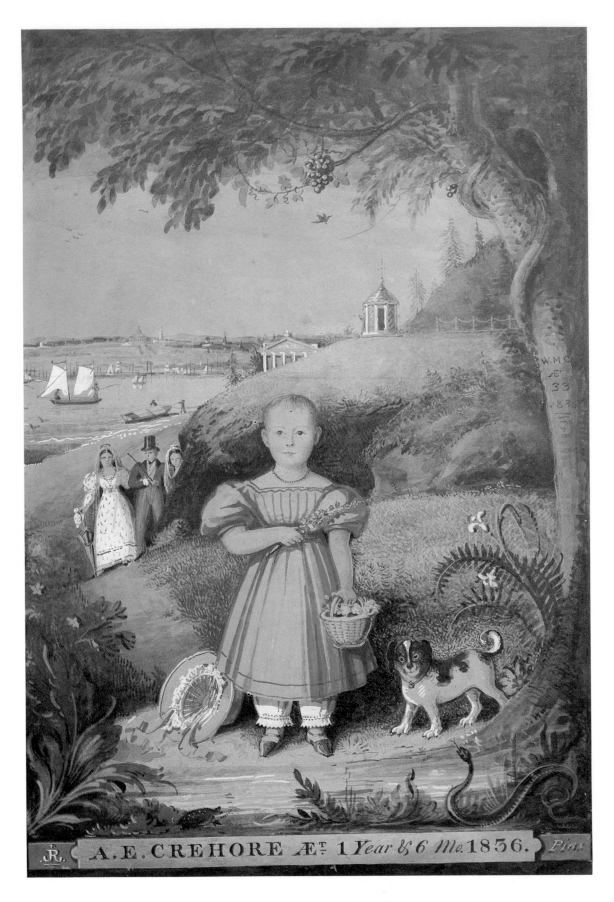

A.E. CREHORE Æᴛ 1 Year & 6 Mo. 1836. *Pinx*

205. *Ann Elizabeth Crehore*, Milton, Massachusetts, by John Ritto Penniman. Inscribed below picture: JRP [Monogram] A. E. CREHORE AEᵀ *1 year & 6 mo. 1836 Pinx.* Watercolor on paper. 12″ x 8⅝″. The view looks north toward Boston from Milton Hill.

of perhaps fifty years before. It is the small details that are particularly notable here: the absence of window curtains, the wooden lift latch on the batten door, a candle snuffer hung conveniently by the fireplace, and the hand-whittled turn catch on the door at the right. In the far corner may be seen a large step-back cupboard typical of those to be found in many eighteenth- and early-nineteenth-century kitchens. Fitted with paneled doors that concealed the shelving within, they were used for the household storage of pewter, crockery, woodenware, and all manner of cooking and eating utensils.

Figure 193 shows a picture of a similar cupboard, also painted in 1885 and signed by the Vermont artist Thomas Waterman Wood (1823–1903). The open doors reveal a varied assortment of nineteenth-century ceramics, but the outstanding feature of the composition is the artist's ability to convey to the viewer an almost tactile impression of the patina of the worn green paint. In his later years, Wood became well known for his genre subjects, sometimes using Vermont interiors as backgrounds for these scenes. Our visit to the Thomas W. Wood Art Gallery in Montpelier, Vermont, in 1967 revealed another painting that included the same large cupboard. That picture, the librarian told us, depicted the artist's grandmother, painted in the old Wood family home.

In 1878, the child Alice Cushing, accompanied by her mother and her Aunt Ella Emory, went to spend the summer in the venerable Peter Cushing house in Hingham, Massachusetts. "Aunt Ella," shown in a late-nineteenth-century photograph (fig. 194), was an amateur artist and occupied herself by painting the interiors of four of the rooms as they appeared during her visit. Built about 1678, the house was "refurbished" during the mid-eighteenth century, which resulted in the casing of some of the original beams and the addition of paneling to several of the principal rooms. For the ensuing one hundred twenty-five years these interiors remained virtually unchanged, and in 1878, they still retained an interesting combination of seventeenth- and eighteenth-century architectural elements. At the time the pictures were painted, the majority of the furnishings dated back to the eighteenth century, although a few Victorian pieces had begun to creep in. All these features were duly observed and carefully recorded by Ella Emory, and her canvases are not only charming examples of their period but also visual documents recording the changes in life-style that took place in the life of one family over a span of two hundred years. Further restoration has again changed the eighteenth-century aspect of at least one of the rooms, but most of the furniture that appears in the four Emory pictures is still in use in different parts of the house.[23]

Figure 195 pictures little Alice Cushing in what was then the west parlor, shown as it looked after "updating" in the mid-eighteenth century. At that time, the seventeenth-century beams were boxed and the walls furred in to create extra space for the deep windowseat, and for insertion of the corner cupboard at the right. The ceiling and walls have since been restored to their seventeenth-century appearance, but many of the furnishings, including the cupboard, were still in evidence in other rooms of the house when we visited it in 1957.

The east parlor, later the dining room, now retains its eighteenth-century paneled chimney breast, although the later mantel shown in figure 196 has been removed. The tiled fireplace had not changed in 1957, and the same tall brass andirons, fire tools, jam hooks, bellows, and fender were then still in place. The kittens on the hearth were named Tweedledum and Tweedledee. In the east chamber (fig. 197),

the straw matting has disappeared, but the large seventeenth-century fireplace, the early wing chair, and the vertical sheathing with batten door remain the same. The handsome toile bed hangings have been carefully preserved but were replaced some years ago for daily use by a new set made by Mrs. Matthew Cushing. The long cover on the center table was a typical Victorian touch, by pulling on which the playful kittens have overturned the large vase of flowers. The laundry, or washroom, with its pine trim, its white-washed walls, and heavy chair-table, is painted on a brass stovepipe cover (fig. 198) and is the most unusual of the four Cushing house interiors. This room, formerly located in a small detached building, no longer survives in its original form, having been moved and attached to the main house, where it served as a later kitchen.

We also own a second group of six interior views, painted during the mid-nineteenth century by Joseph Shoemaker Russell, a native of New Bedford, Massachusetts, who, about 1818, moved to Philadelphia and became a dealer in New Bedford whaleoil. His drawings of New Bedford, his lamp store in Philadelphia, and the boardinghouse in which he lived are illustrated later in this chapter. In figure 199, we meet some of his landlady's other guests with Mr. Russell himself seated on a fashionable horsehair settee. Many details are of interest here: the figured carpet, the mantel ornaments, and the tall green folding shutters that protected the occupants from the glare of the summer sun. Most notable, however, is the piped-in gas table-lamp at the right, domestic illumination by gas having been a relatively recent innovation in Philadelphia houses in the early 1850s. Figure 200 depicts Mr. Russell again, this time in the company of two of his daughters in their sitting room at Mrs. Smith's in 1854.

We acquired our first picture of an interior in the fall of 1940, a colorful view of a room in a farmhouse in Loudon, New Hampshire (fig. 201). This watercolor caught our attention because it presented several special features and was documented by an old label written by a member of the family in which it had descended through four generations. According to this information, Moses Morse, owner of the house, was a cabinetmaker in Loudon who made the secretary-desk seen in the illustration, as well as the inlaid frame on the picture.[24] The painted floor is typical of the first quarter of the nineteenth century, but the stenciled walls are recognizable as the work of a traveling artist whose patterns are still to be found in other New England towns.[25] Although our visit to Loudon failed to locate the Morse home, another house nearby exhibits the same bird on branch with accompanying border designs, which prove that this decorator definitely worked in the town. Moses Morse, his back modestly turned toward the viewer, was born in Loudon in 1788. His wife, Sally Emery, warming her feet at the fire, was born in 1790, and both are buried in the old Loudon Hills cemetery. The artist was Joseph Warren Leavitt of nearby Chichester, a cousin of Sally Emery Morse, but even though Leavitt was a prominent name in southern New Hampshire, we have not been able to find any further reference to this particular man.

It is, however, the prominent figure in the foreground that immediately rivets the eye, although his identity cannot be verified by known historical fact. Family tradition avers that this gentleman was no less a personage than General Lafayette himself, who reputedly stopped in Loudon to dine with a schoolmaster named Gleason at the time of the general's visit to New Hampshire in June 1825. Unfortunately, historical accounts indicate that Lafayette did not pass through Loudon on his trip between Concord and Portsmouth during the last week of June. However, his presence in the vicinity must have caused great excitement in the neighboring towns, so this figure may have been inserted by the artist to personify "The

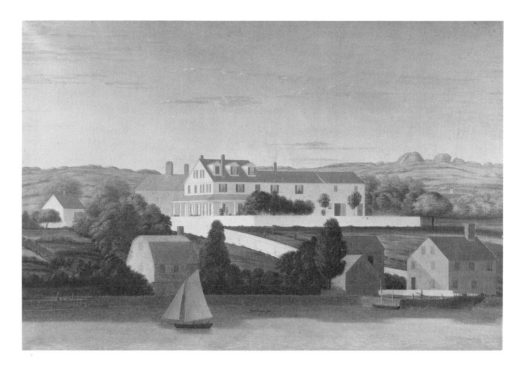

206. *Captain Oliver Lane House*, Annisquam, Massachusetts. Written on back of canvas: *Painted by Alfred J. Wiggin, Oct. 1859.* Oil on canvas. 28″ x 40″.

207. *Tucker Family Home*, Smith Mills, near New Bedford, Massachusetts, by William Allen Wall, c. 1870. Signed in lower right corner: *W. A. Wall.* Watercolor on paper. 9″ x 13¾″.

View of Union or Main Street New Bedford taken from the S Story Window of Abm Russell's house at the head of the Street 1812

208. Union Street, New Bedford, Massachusetts, by Joseph Shoemaker Russell. Inscribed below picture: *View of Union or Main Street New Bedford taken from the S[econd] story window of Abm Russell's house at the head of the Street 1812.* Watercolor on paper. 8½" x 11". Probably painted from memory in the 1850s.

209. J. S. Russell's Oil & Lamp Store, Philadelphia, by Joseph S. Russell, c. 1853. Inscribed below picture: *N. E. corner of Chestnut & Strawberry Streets 1818 Philadelphia. J. S. Russell's Oil Lamp store. No. 55. Chestnut St. his place of business.* Watercolor on paper. 8½" x 11". (Courtesy *The Magazine Antiques;* photograph by Helga Photo Studio)

N. E. corner of Chesnut & Strawberry Streets 1818 Philadelphia

S Potter & Co, original publication Office of the Episcopal Record

J S Russell's Oil-Lamp Store, No 55. Chesnut St, his 1st place of business

Nation's Guest and Our Country's Glory." If this is a portrayal of Lafayette, he is dressed as Lafayette would have looked as a young man at the time of his first visit, and not as he appeared on his second visit in 1824–1825.

An entirely different type of interior is pictured in the work of the itinerant watercolorist Joseph H. Davis (fig. 202). Davis's style has long been familiar to collectors, being easily recognized through his large profile figures, which often face one another across a grain-painted table, and by the boldly patterned floor coverings that form the bases of his fanciful compositions. At this writing, Davis himself continues unidentified among several other men of the same name who are recorded as living in the area of southeastern Maine and the adjacent towns of northeastern New Hampshire, where the artist painted so many of his subjects. His working years appear to have been short, about 1832–1837, but during that time, he created a successful formula for many often-repeated stylized designs. Various accessories in each picture differ, however, and it is these personalized touches that endow Davis's scenes with individual interest. The couple depicted here are Thomas and Betsey Thompson, painted at ages sixty-six and fifty-six in November 1837, probably in Durham, New Hampshire, where the Reverend Thompson was a minister. The focal point in many of Davis's compositions are the swag-draped pictures prominently displayed above the tables. Here our eye was immediately caught by the traditional mourning picture (the tomb inscribed *W. H. J. Thompson*), which is the only memorial that we have happened to see in a Davis interior.

Naïve views featuring people and buildings in their original surroundings have always held a special appeal, as landscapes are to be found in many styles wrought by both professionals and amateurs. Whether depicted in oil on canvas, watercolor on paper, paint on velvet, or needlework on fabric, each medium exhibits its own characteristics of workmanship and design. We began to collect these pictures in the 1940s and still continue to do so. We enjoy them because of our interest in early New England architecture, because they are stimulating to the imagination, and above all because they provide important visual documentation of certain aspects of the American scene that none of us has ever witnessed.

Although country houses were often subjects for the English artist's brush, formal house portraits have always been less common in America. One important example is the farm and country home of the shipping merchant Ezekiel Hersey Derby (brother of the famous Elias Hasket Derby), whose winter residence in Salem, Massachusetts, was scarcely two miles distant from his summer estate! Derby purchased the buildings and the surrounding land early in 1800. Shortly thereafter, he commissioned the well-known architect and carver Samuel McIntire to embellish the house and barn, and a local artist, Michele Felice Cornè, to paint this picture of his farm, which was located on the present Lafayette Street in Salem (fig. 203). To his view of the Derby farm Cornè added several personal details, which add greatly to the interest of the picture. The family coach, with coat of arms painted on the door, approaches the house, followed by a single outrider. Within the coach, the group of five ladies probably includes Mrs. Derby with friends arriving for a pleasant day in the country. Beside a nearby stone wall stands a gentleman, apparently intended to represent Samuel McIntire, who holds a roll of plans in his hand as he points toward the house on the opposite side of the road. Beside him sits the artist Cornè, presumably recording this view on the sketch pad held on his knee. A similar instance of the artist's including himself in a land-

scape occurs in Ralph Earl's *View of the Town of Bennington, Vermont,* painted 1796–1798. The third figure in our picture must be the traditional "innocent bystander."

Entirely different in style, and an unusual subject for an American watercolor, is the view of a large estate shown in figure 204. Despite the naïve rendition, the scene echoes English conversation pieces that depict the owners of a country house formally posed in a far-flung landscape setting. Here the Raglans are seated in yellow-painted side chairs while Mrs. Raglan engages in the homey occupation of knitting a stocking. A conventional urn of flowers, combined with two leafy shade trees, forms a sylvan frame for the rolling Kentucky hills, where a winding drive leads to a large building partially obscured by trees. Written in ink on the frame's wooden backboard is the following inscription: *Mr. Jas Raglan and Wife Taken August 1820 in Clark Co Kentucky by Dupue.* One would like to see more examples from the brush of the currently unidentified Dupue.

The portrait of a child in figure 205 illustrates yet another example where a figure is placed prominently in the foreground of a landscape. This is a signed piece identified by Carol Damon Andrews as the work of John Ritto Penniman, an expert ornamental painter who worked in Boston and Roxbury during the first three decades of the nineteenth century.[26] Ann Elizabeth Crehore, pictured here, was born in Milton, Massachusetts, and was depicted in 1836 when she was eighteen months old. The Boston State House is seen in the distant background as it appeared looking north from Milton Hill, and in the middle distance is a representation of the summer house, with the Greek Revival entrance later added to the 1743 mansion of Royal Governor Hutchinson. The symbolism in this composition is particularly interesting. It includes the grapevine that entwines the elm, which may refer to the Diana Grape, the first seedling grapes grown in this country, raised by Mrs. John Crehore in Milton. The serpent and the lilies are probably biblical references to the innocence and purity of childhood.

Many of the houses featured in early topical views have passed into oblivion. Others have been so altered in appearance, either structurally or through the encroachment of modern surroundings, that a painting is the only record left to show their original aspect. Fortunately this is not the case with the Captain Oliver Lane house, built in Annisquam, Massachusetts, in 1833 and occupied by the captain's descendants for 130 years (fig. 206). We visited the house several times in 1962, and it had remained quite unchanged except for a thick growth of trees that then obscured the former view of the Annisquam River, where a wharf and buildings once witnessed the departure of many Lane vessels engaged in the China trade. The picture is signed and dated October 1859 by a Cape Ann artist, Alfred J. Wiggin, who painted portraits and a few topical scenes during the 1840s and 1850s. Still hanging in the Lane home at the time of our visit, the picture was surrounded by many Oriental pieces acquired through overseas trade, and by other ships' portraits depicting Lane vessels in Chinese waters. We were privileged to acquire a number of the family treasures to augment our increasing collection of objects brought home by travelers from foreign parts.

In February of 1940, when we visited the Tucker family in New Bedford and acquired their chest of drawers (fig. 85), we saw two charming watercolors hanging on the parlor wall. One pictured their former home in Padanaram, the other (which we purchased) their farm at nearby Smith Mills, signed at the lower right: *W. A. Wall* (fig. 207). William Allen Wall was born in New Bedford on May 19, 1801. At first his reputation was largely a local one; but from the 1830s through

210. Mrs. Smith's Boardinghouse, Philadelphia, by Joseph S. Russell, c. 1853. Inscribed below picture: *Mrs. A. W. Smith's Broad St. corner of Spruce. Montgomery & Shinn's Store.* Watercolor on paper. 8½″ x 11″.

211. *Samuel Chamberlain in Market Square*, Salem, Massachusetts, 1850–1860. Artist unknown. Pastel on paper. 20″ x 29″. Lettered on the shop fronts are names of local grocers and fruit, vegetable, and produce dealers.

212. Cambridgeport, Massachusetts, by Charles Mason Hovey, 1822–1828. Watercolor on paper. 13¼″ x 18½″. Hovey Tavern is at left. Universalist Church, corner Massachusetts Avenue and Main Street, in background.

213. Framingham Common, Massachusetts, by General Gordon, c. 1840. Old label on back of frame reads: *Picture of Framingham Common in 1808 taken by Daniel Bell . . . This is a copy by Gen Gordon.* Oil on canvas. 15″ x 22″. The 1807 meetinghouse still stands at the head of the common.

the 1870s, he is credited with painting many noteworthy pictures that include portraits, landscapes, narrative subjects, and a number of watercolors mostly done in his later years. Although Wall lacked formal training, except what he may have received from his talented father, he did spend parts of 1832 and 1833 observing the art scene in England and Italy, and his subsequent landscapes are certainly not in the New England folk tradition. Some of his watercolors of houses were no doubt executed on commission from the owners, as was probably the picturesque view of the Tucker home and land.[27]

Another local artist, Joseph Shoemaker Russell, may have received early instruction from William Allen Wall. Born in New Bedford in 1795, Joseph was the fifth son of Abram Russell, a descendant of a prominent Quaker whaling family, whose three-story mansion stood at the head of Union Street.[28] From a second-story window of his father's home, Joseph later painted the view down Union Street, with the trim houses and rows of poplar trees as he remembered them in 1812. The only chaise in the town, owned by William Rotch, is shown in the foreground, with the Acushnet River and the town of Fairhaven in the distance (fig. 208). When Joseph Russell was about twenty-two years old, he left home to live in Philadelphia, where, in 1818, he perpetuated the family business by opening a shop for the sale of oil lamps and New Bedford whale oil. The white clapboard building in figure 209 was situated on the northeast corner of Chestnut and Strawberry Streets, and beneath a colorful signboard depicting a large whale on a blue ocean may be seen the Russell oil and lamp store. On the window shelves are displayed brass and pewter lamps of many sizes and shapes, casks of whale oil marked with an *R* stand outside, and two customers approach the door carrying containers for purchases of oil. Rounding the corner appears Joseph Russell himself, driving his delivery cart, identified by the slogan *New Bedford Lamp Oil*. In 1853, the Russell family was boarding with Mrs. A. W. Smith at the corner of Broad and Spruce Streets, and Joseph Russell executed a detailed series of watercolors showing the arrangement and furnishings in various rooms of the house. He also painted a meticulous view of the exterior of the building, which included the family carriage at the left and several of the other boarders sewing, chatting, and neighbor watching from the parlor windows above (fig. 210). The first floor of the house accommodated the drugstore of Montgomery and Shinn, and we can glimpse the shelves of glass vials inside the door. The bay window is filled with old-time blown bottles and footed globes containing liquids in vibrant shades of canary, blue, and rose. This is a fine pictorial document of a mid-nineteenth-century chemist's shop.

Other views in our collection illustrate street scenes in coastal Massachusetts. Figure 211 pictures Samuel Chamberlain driving his stylish rig in Salem's Market Square as it looked in the 1850s. This area was the city's market district, and the old Market House, with fan-lighted doorway and lunette window beneath a dentiled cornice, stands in the background. The names of various produce merchants are lettered on the surrounding buildings, all of which appear in the Salem directories during the third quarter of the nineteenth century. The old square has now been renovated by the Salem Redevelopment Authority, and the exteriors of the buildings that survive have been returned to their former appearance.

An area formerly known as Cambridgeport is the subject of the scene in figure 212. Once comprising a large tract of open land along the north bank of the Charles River, where sailing vessels docked before the Back Bay section of Boston was filled in, this locality long ago lost its identity by being absorbed into the closely built

city of Cambridge. Through this watercolor, however, we may still visualize the tranquil residential neighborhood, which included a part of Massachusetts Avenue looking toward the Universalist Church, built in 1822 at the junction of Main Street. At the left stands the Hovey Tavern, with swinging signboard, which was burned in 1828. Adjacent to it, a group of occupational buildings includes N. Child's store, a soap factory, and hay scales. Beyond them appears the large two-family home of Nathaniel and John Livermore. The picture now provides the best visual record of this particular area as it looked in the 1820s, for none of these buildings now remains. It was painted by a young horticulturalist, Charles Mason Hovey, who with his brother Phineas opened his first small plant nursery in Cambridgeport in 1832. Hovey was later to become famous as a nurseryman, hybridizer, writer, and editor and to be remembered as an important figure in the history of American horticulture.[29]

Occasionally, a folk artist tried his hand at painting an entire village or town, with results that varied greatly according to his ability to handle a complicated scene. In 1808, Captain Daniel Bell, standing prominently in the foreground, painted a panorama of Framingham Common, Massachusetts, probably taken from the adjacent Bear (or Bare) Hill (fig. 213). This first picture has now disappeared, but a lithograph based on it was later printed in Boston, on the back of which the names of all the people and buildings were carefully identified by three old residents of the town. A written inscription on the reverse of the picture illustrated here describes this view as a copy of the original 1808 landscape. It was probably painted about 1840. In the doorway of the three-story tavern at the center stands the proprietor, Abner Wheeler, waiting to greet the incoming stage, and behind the tavern is the red schoolhouse with children playing. The Larabee shoe shop stands at the left, and driving past it is Mr. Brewster in his two-wheeled chaise. The handsome facade of the third meeting house, raised in 1807, dominates the green, and at the far left, the 1792 brick Academy building and gun shop are almost hidden behind a grove of "20 ornamental trees" planted by vote of the town in 1808. Ingenuous pictures such as this one impart more vividly the character of a typical country town than do most of the scholarly descriptions compiled for modern history books.

Quite a different style of topographical view shows the town of Freeport, situated slightly to the northeast of Portland, Maine (fig. 214). Incorporated in 1789, it boasted 3,812 inhabitants by 1804. Freeport prospered during the ensuing seventy-five years, and by the mid-1880s, the central area was built up with substantial wooden-frame houses. The high school, visible at the extreme right, was constructed in 1873–1874, after Francis Fassett, an architect from Portland, drew the plans, as he did also for the large shoe factory at the left, which was built in 1885. To the immediate left of the high school appears the Greek Revival town hall, dating to 1849, behind which run the Central Maine railroad tracks, where old-fashioned "up" and "down" trains of cars have just passed one another as the engines emit plumes of smoke. The impressive Congregational church atop the hill burned in 1894, and near this site now stands the well-known store of L. L. Bean.[30] In the 1880s, a grist mill, sawmill, brickyard, and quarry brought added employment, and in the fall of 1886 a house painter by name of G. J. Griffin climbed to the top of Torrey's Hill, constructed a platform in a tree, and proceeded to paint the colorful picture, correct in every detail, that is illustrated here. Many years later, the painting emerged from a local attic, at last to be appreciated as a valuable record of Freeport's past. Although the scene painted by Griffin had

214. *Freeport, Maine, from Torrey's Hill,* by G. J. Griffin. Inscribed on frame: *Painted by G. J. Griffin.* On back of canvas: *Oct. 1886.* Oil on canvas. 21″ x 39″. The Congregational church on the hill burned in 1894, and L. L. Bean's store now stands near this site.

215. Saint Joseph's Academy, Maryland, by Anna May Motter, 1825. Lettered in gold on the glass: *View of St. Joseph's near Emmitsburg, A. M. Motter, 1825*. Needlework and watercolor on silk. 17¾″ x 24″. The old house shown here is still standing.

216. View of Boston from Heath Hill, Brookline, Massachusetts, by Susan Heath, 1813. Written on old label on back of frame: *View of Boston from the East Chamber window of the residence of Mr. Ebenezer Heath on Heath Street, Brookline. Painted by his daughter Miss Susan Heath. Begun Sept. 16, 1813*. Watercolor on paper. 16″ x 22″.

become obscured by trees the last time we visited the hill, some of the buildings, although altered, still remain.

Painters of landscape scenes were by no means all men, nor were they always professional artists. Some of the most charming watercolor views were executed by the many young ladies who were taught painting and drawing as a requisite of a genteel education. Miss Sarah Pierce, founder and headmistress of the Litchfield (Connecticut) Female Academy, expressed to her pupils the prevailing attitude toward schoolgirl art in 1820:

> If you have any natural taste for drawing I wish you would indulge it. I think it an accomplishment very adapted both to the taste and delicacy of your sex. It will agreeably exercise your ingenuity and intention and will teach you to discover a superior finish in all the varied landscapes and scenery of nature. . . . When nature howls with wind or is covered with snow you will be able to call a fancy spring upon the canvas of which the blossoms will be ever fragrant and the trees ever green.[31]

Although carefully trained in the precepts of conventional art, schoolgirls seldom painted "from nature"; they derived their compositions from printed sources. These might include lithographs and other prints supplied by the school, or illustrations contained in drawing-instruction books published as manuals for the guidance of amateurs. After 1800, watercolor and needlework were often combined, an accomplishment that resulted in decorative pieces to be suitably framed and proudly displayed on parlor walls.

Sometimes pupils depicted the schools that they attended, and a particularly pleasing example shows St. Joseph's Academy near Emmitsburg, Maryland (fig. 215). The background and sky are delicately painted in watercolor on silk, and the large house, trees, and nearby fields are embroidered in a combination of long stitch and chenille. Lettered in gold on the lower edge of the covering glass are the names of the Academy and of the young artist, *A. M. Motter*, with the date, *1825*. The school was established by Elizabeth Ann Seton, later to become the first American-born Roman Catholic saint. Gifts from friends financed the building of St. Joseph's House, shown here, and Mother Seton and her followers moved in on February 20, 1810. During the 1820s, at least four of the pupils worked very similar embroideries, followed by views painted by later students that provide a chronological record of the new, larger buildings eventually added at the right. This expansion necessitated moving the original house in 1845, with further alterations being undertaken in 1917. Despite the steady growth that eventuated in its becoming, during the twentieth century, a modern liberal arts college, the old academy was forced by economic problems to close in 1972. However, St. Joseph's House still remains standing, a symbol of 160 years of continuing development in women's education.[32]

On September 16, 1813, Susan Heath, then thirteen years old, undertook what must have been for her a very important project. On that day, she began work on a panorama of what she could see as she sat in the rear east-chamber window of her father's house on Heath Hill in Brookline, Massachusetts. This was not to be the usual schoolgirl copy of a printed view, but a more ambitious undertaking that resulted in an important record of Boston and the intervening land as they appeared from the present Ebenezer Heath house in the early nineteenth century (fig. 216). Boylston Street, as it is designated today, was incorporated as the

Worcester Turnpike in 1806. This old toll road and the eighteenth-century Zab-diel Boylston house appear in the left foreground, looking much as they still do today. The steeple of the second building of the present First Parish Church is silhouetted against the sky, but the open land visible at the right became a reservoir in about 1850. On the far horizon atop Beacon Hill looms the Boston State House, and at the distant right is Boston Neck. This road was the city's only connection with the mainland in Roxbury until the Mill Dam (Beacon Street to what is now Kenmore Square) was opened in 1821. In later years, when Susan was asked, "Could you see the Old Elm on the Common so distinctly as that in those days?" she made the classic schoolgirl reply, "No, but I knew it was there so I put it in." The Old Elm was believed to predate the settlement of Boston and was a familiar landmark on Boston Common until blown down in a severe storm in February 1876.

John Orne Johnson Frost was born in Marblehead, Massachusetts, on January 2, 1852, and since his death on November 23, 1928, he has gradually become recognized as a unique self-taught painter who preserved in his pictures the history and daily activities of his native town. The vibrant colors of his busy scenes, many done on wallboard, are laid on in flat, solid masses, entirely lacking in shading, modeling, or perspective. John went to sea when he was sixteen years old, and some of his later marines were based on these never-to-be-forgotten experiences. As a child, he remembered vividly the difficult years of the Civil War and recollected the outbreak in one of his most stirring historical panoramas (fig. 217). Signed *J. O. J. Frost,* it is also inscribed: *1861, April 16th at 7 o'clock these men left town for Boston . . . the first to reach Faneuil Hall in the State.* Written on a cloud floating in the sky above is the ringing statement, *There shall be no more war.*

Frost married and gave up the sea in 1870 and went into the restaurant business while his wife, Amy Lillibridge, raised and sold sweet peas and other garden flowers from their home at 11 Pond Street. It was only after her death in 1919 that Frost began to paint the brilliant, colorful scenes in which he recorded from imagination, memory, and daily experience historical incidents and everyday life in the town he loved. His efforts were ridiculed by his neighbors and friends. Appreciation of American folk art had not yet reached Marblehead. In 1952, 11 Pond Street passed out of the ownership of the Frost family. Renovations were in progress when it was discovered that pieces of wall boarding in several parts of the house had been at one time reversed, and displayed on the back sides were about twenty of Frost's largest and finest scenes. In 1954, these were exhibited at Childs Gallery in Boston, and pending opening of the public sale, they were hung in several rooms on an upper floor. There, in complete seclusion, I had the unique opportunity of spending many fascinating hours with Frost's wonderful paintings. I finally narrowed my choice to three of what seemed to me the most exciting pictures: *Washington Crossing the Delaware, View of the Town of Marblehead,* and *Troops Marching from Marblehead to Boston in the Civil War,* which is illustrated here in figure 217.

217. *Troops Marching from Marblehead to Boston in the Civil War*, 1919–1928. Signed at lower left: *J.O.J. Frost*. Written on front: *1861, April 16th at 7 o'clock these men left town for Boston . . . the first to reach Faneuil Hall in the State . . . There shall be no more war.* Oil on wall board. 31½" x 72".

V Folk Carvings: Decorative and Useful

So-called folk sculpture is not represented by a large number of pieces in our collection, perhaps because the term seems to suggest a formality of design inappropriate to the appearance of many of the simple, three-dimensional objects that played a useful part in early American domestic life. This point was brought home to me on one humorous occasion when I showed a spirited metal horse to an old-time New England farmer with the enthusiastic comment, "Isn't this a wonderful piece of early folk sculpture!" to which he replied in some bewilderment, "It appears to me to be a beat-up but still useful weathervane." We enjoy the sympathetic quality of wood, so the majority of our pieces are in the form of carvings. They include a variety of examples in many different categories, of which a few are illustrated here.

In the mid-1940s, decoys were not the popular collectibles that they have since become. Our introduction to these bird carvings occurred at the auction of the early-eighteenth-century Little homestead in Marshfield, Massachusetts. The house had once held many cherished family heirlooms, including a tall clock installed by Simon Willard himself, but these had already been distributed to other relatives, and only the miscellaneous odds and ends of an old country home remained to be dispersed. When five hand-carved shorebirds were put up along with several eighteenth-century account books, we bought them all as memorabilia of bygone generations of the Little family.

There is an indefinable quality inherent in the pose and the expression of some decoys that endows them with comical individuality and this, together with original paint, is what attracts us rather than date, rarity of maker, or conventional elements of design. The black duck in figure 218 certainly has a personality of its own. The body is made of painted canvas stretched over a wooden frame, and this decoy also came from Marshfield. Most ducks are designed to rest on the water as a lure to their counterparts flying overhead, but this decoy was planned as a stickup, which makes it unusual and much more fun. Underwater feeding is a well-known attribute of certain ducks, and various ingenious devices, such as half bodies that float tail up, were used by sportsmen to simulate a duck in diving position. The streamlined decoy in figure 219 exhibits such a graceful feeding pos-

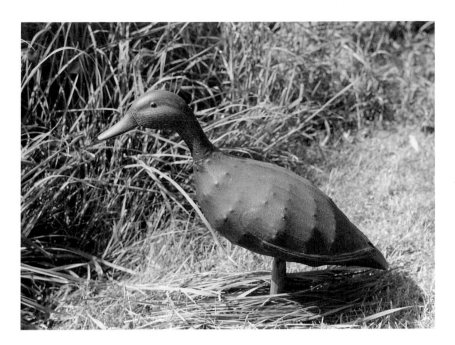

218. Decoy, black duck, Marshfield, Massachusetts, L. 21″. The body is made of canvas stretched over a wooden frame.

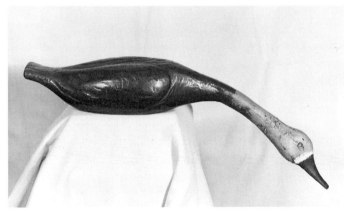

219. Decoy, feeding black duck, L. 22″. The body is carved and painted, and its outstretched neck submerges, when the duck is floating, to simulate a feeding bird.

220. Two heron decoys, used in the late nineteenth century at Hay Bay, near Picton, Ontario. Left: L. 35″; right: L. 29″. They are posed beside a marshy pool where live herons often sun in late summer. The neck of bird at right is formed from a root, with body shaped from a log.

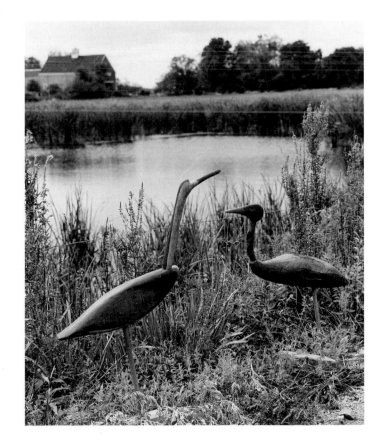

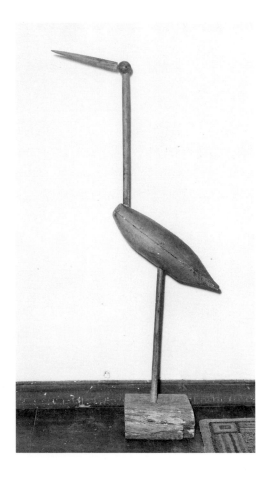

221. Decoy, crane assembled from five parts. Written in pencil beneath tail: *George Martin's crane, Barnegat, June 1907.* L. 40½". (Photograph courtesy Adele Earnest, *The Art of the Decoy*)

222. Crane in figure 221, taken apart for easy carrying. (Photograph courtesy *The Art of the Decoy*)

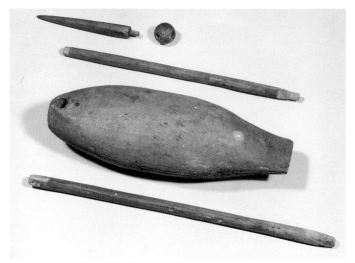

223. Group of decoy shorebirds, chosen for their diversity of pose and carving. The yellowlegs at left is by Tom Wilson of Ipswich, Massachusetts. L. 12½".

224. Pair of shorebird decoys, attributed to Bill Bowman, late nineteenth century. L. 13″ and 12″. The stands of the miniatures that accompany the Bowman pieces are impressed with a rectangular stamp containing: *A. E. Crowell Maker East Harwich, Mass.* Twentieth century. L. 2¾″ to 3″. (Photograph courtesy *The Art of the Decoy*)

225. Group of assorted miniature wooden birds, late nineteenth century. Rectangular stamp of *A. E. Crowell*. 3″ to 5″. On top shelf, two pheasants and a woodcock.

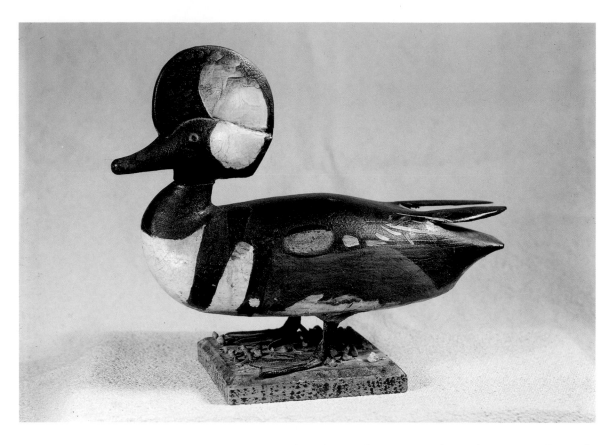

226. Ornamental carving of a hooded merganser, late nineteenth century. Maker unknown. Wood. L. 13″.

227. Weathervane, cock, from vicinity of Bethel, Maine, late eighteenth century. Wood. L. 34″. The body is fully carved on both sides.

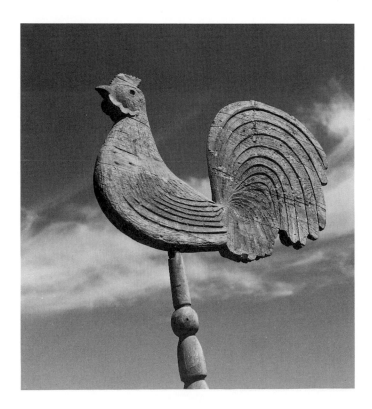

228. Weathervane, cockerel, said to have been used on a church in Dover, New Hampshire, nineteenth century. Wood. L. 17½″.

ture that his slender neck is always decorated with a jaunty red bow in honor of Christmas.

Herons are frequently seen on lake shores or in coastal areas of New England. Their wooden counterparts are known as *confidence decoys*, because herons standing quietly beside a marshy pool, as they do in late summer in our Flaggy Meadow, convey a sense of security to wildfowl sighting them from above (fig. 220). Herons are interesting to collect, as each carving differs greatly in form according to the whim of its creator. A recurring decoy legend describes numerous herons swallowing good-sized fish, which may be observed passing slowly down their long, thin throats. Certainly the neck of the bird at the right, made from a tree root, is formed to illustrate this popular concept. I was always skeptical of the fish-swallowing story until I actually saw it happen at close range, when a heron perched on a nearby rock devoured a fish, whose slow downward progress could actually be clocked by the moving bulges in its throat.

Whoever designed the decoy in figure 221 was a practical gunner who constructed his bird with a minimum of fuss. When assembled, it presents a recognizable silhouette of a crane. It can be quickly taken apart, however, and the five pieces easily transported and reassembled at any desired location (fig. 222). The decoy probably originated in the New Jersey area; a penciled inscription beneath the tail reads: *George Martin's crane, Barnegat, June 1907.*

In figure 223 are shown several similar species of shorebirds chosen to illustrate the varieties of pose and carving employed by four different makers. The bird at center is streamlined and aristocratic, whereas the Connecticut example at right, with its iron bill and hand-whittled body, is primitive in shape and execution. The yellowlegs on the left, however, is true to life in form and plumage and is an example of the work of an accomplished maker. It is one in a group of thirteen unused decoys comprising several species of shorebirds, ducks, and a Canada goose, all acquired in 1951 and made by Tom Wilson of Ipswich, Massachusetts. The variety of Wilson's output had not been generally recognized until recent research revealed that he was born in England in 1863 and, while employed in a hosiery mill in Ipswich, began to carve decoys for his own use, probably in the 1880s. He worked as a market gunner and a sportsmen's guide and subsequently operated two gunning camps and a blind in Portsmouth, New Hampshire, which he sold in 1920. He died in Ipswich in 1940.[1]

When we found the two fine shorebirds in figure 224, no one had a clue to the maker's name. Later their distinctively shaped underbodies were recognized as a characteristic of the little-known work of a "character" named Bill Bowman, who carved during the summers on the south shore of Long Island near Brosewere Bay. For an interesting comparison with the rare Bowman stickups, we show three similar species in miniature, each bearing the familiar rectangular impressed stamp of A. Elmer Crowell (1862–1951) of East Harwich, Massachusetts. Although principally a decoy maker, Crowell also fashioned many types of miniature birds that delighted both adults and children. Bert owns a group of six gaily colored songbirds by Crowell, purchased for him by his mother when he was a teenager, as mantel ornaments for his own small cabin.

One evening many years ago, we attended a dinner party at the family home of Miss Marguerite Souther, a well-known dancing teacher to generations of young Bostonians. As postprandial entertainment, she brought down from the attic an ancient cardboard box in which some long-forgotten playthings that had once belonged to her small brother had been stored for well over fifty years. As she unpacked the box, there emerged before our unbelieving eyes a group of forty-six

miniature Crowell shorebirds in perfect condition, of which a small selection appears in figure 225. We stayed on long after the other guests had left, trying to convince our hostess that the collection had value and should not be given away either to us or to certain acquisitive friends. Still unpersuaded, she reluctantly accepted the reasonable check we offered, but she always felt guilty about it, although she was happy to know that the little birds had finally found an appreciative home.

Decoy makers and other carvers also fashioned large "ornamentals," which, as the name implies, were intended for display on mantelpiece or table. We own three marked Crowells: a woodcock, a yellowlegs, and a tern, all standing on typical wooden mounds. Not as expertly formed or painted, but nevertheless a vigorous carving by an unknown hand, is the hooded merganser in figure 226, which is mounted on a rough segment of plank liberally sprinkled with small seashells. Good-sized ornamentals such as this were usually one of a kind, made to special order for a particular client.

There is a special quality about time-worn wooden weathervanes that tells its own story, evoking many years of battling the elements on church steeple or barn. Unless produced commercially, weathervanes are usually anonymous and individual, depending for desirability on their originality of design. Generally speaking, a cock was the symbol of a church or public building, and cocks are found in many styles. The dignified bird in figure 227 is an eighteenth-century form and is fully carved on both sides, having a red wattle and comb and a yellow beak. Obviously repainted many times, the body is now mostly a weathered white. When we heard that the vane had supposedly graced a steeple in West Bethel, Maine, we lost no time in visiting the region to see if anyone remembered the cock or the church. This turned out to be one of our unsuccessful quests, although we met many kind people who tried to be of help. The perky cockerel in figure 228 was said by its former owner to have come from a church in Dover, New Hampshire. Hand-carved with elaborate tail feathers, the body has been strengthened, where cracked, by old strips of iron, and it still retains some of the yellow paint that was used in the country to simulate gold leaf.

Few weathervane makers' names have been remembered, as wooden examples were often whittled at home or fashioned by a local artisan. Fortunately this is not the case with the fish in figure 229, as it and two companions are known to have been made for three neighboring farms in East Kingston, New Hampshire, during the middle of the nineteenth century. The maker, one Alonzo Parker, known as a "seafaring" man, carved the bodies in the round from one piece of wood. Incised, red-painted gills and eyes, coupled with large black metal fins, impart an unmistakable character that is easily recognizable as Parker's work.

Although ducks and geese were abundant along the New England coast, A. Elmer Crowell used them as models for only a few weathervanes, but these perpetuated the fine carving and painting apparent in his decoys. The goose in figure 230 hung for years in our attic until we discovered the interesting fact that a counterpart had been purchased by a neighbor directly from Mr. Crowell himself in the 1920s. The mallard duck with outstretched wings (fig. 231) is also by Crowell. Shortly before his death, he told a mutual friend that he had made only seven or eight full-bodied ducks and about the same number of Canada geese weathervanes, and that many of these had never been used outside, having been displayed indoors as ornaments.

For those who live adjacent to the coast, late-nineteenth-century ship weathervanes are both appropriate and appealing. They vary considerably in form, some

229. Weathervane, fish, East Kingston, New Hampshire, by Alonzo Parker, mid-nineteenth century. Wood. L. 44½″. One of three made for neighboring farms.

230. Weathervane, flying Canada goose, attributed to A. Elmer Crowell, c. 1922. Wood. L. 28½″.

231. Weathervane, mallard duck, by A. Elmer Crowell, c. 1925. Wood. L. 30″.

232. Weathervane, square-rigged ship, from Martha's Vineyard, Massachusetts, late nineteenth century. Wood with metal shrouds and sail. L. 36″.

233. Cigar-store figure, Indian maiden from vicinity of Amesbury, Massachusetts, second half of nineteenth century. Wood. H. 61½″. Also shown is an old-time wooden coffin and an adult cradle used for rocking invalids and old people.

234. Tobacconist's figure, cut in silhouette, late nineteenth century. Wood. H. 78".

236. Portrait bust, nineteenth century. Maple. H. 6½".

235. Portrait bust, probably from New York State, nineteenth century. Pine. H. 12".

237. Portrait bust of Abraham Lincoln. Lettered around base: ABRAHAM LINCOLIN (sic). Incised on bottom: *C O Feb 3 1909*. Pine. H. 19″. Dated near the anniversary of Lincoln's one hundredth birthday.

238. Pair of portrait plaques, c. 1800. Painted in blue, red, and yellow on pine. Man, 8¼″ x 6″. Woman, 9″ x 6″.

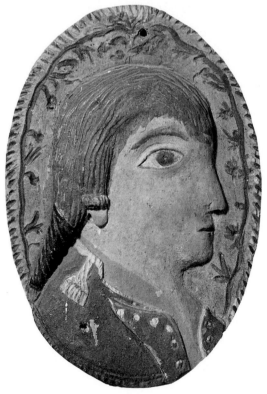

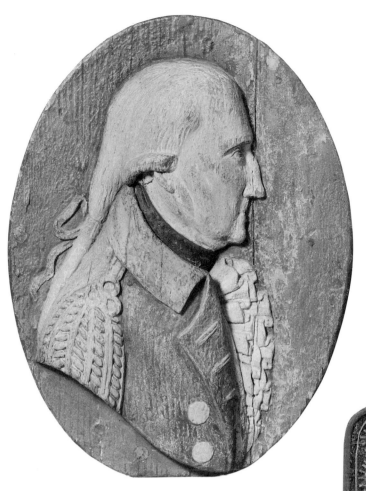

239. Portrait plaque, General Washington, attributed to Samuel McIntire, Salem, Massachusetts, early nineteenth century. Painted on pine in blue and yellow against a red background. 15″ x 11″.

240. Sample gravestone, by Noah Pratt, Freeport, Maine, 1787. Slate. 14″ x 7″. Pratt's distinctive faces are found on stones in several cemeteries in the Freeport area.

241. British coat of arms, by Winthrop Chandler, Woodstock, Connecticut, c. 1773. Pine. 16″ x 17″. Carved for his first cousin, Gardiner Chandler of Worcester, Massachusetts. Originally painted in polychrome, the wood was refinished many years ago.

square-riggers even displaying as many as five masts with a full set of sails. At one time, these vessels could often be seen silhouetted against the sky as they swung atop a summer cottage, shed, or barn. But like other vanes, they have now become collectibles, so many have ceased to serve their original function. A hull of wood with metal sail and rigging distinguishes our piece (fig. 232), which began life in Edgartown on the island of Martha's Vineyard.

In England, Indians have been used as shop figures for generations, holding rolls or packages of tobacco, strings of tobacco leaves, or bundles of cigars. In America, by 1860, the cigar-store Indian was a familiar sight. Some were expertly fashioned by recognized makers, and others were the work of less accomplished ship-carvers' apprentices. Life-sized figures are not easy to display in a domestic setting, and our only example, stored in the attic, is shown in figure 233. Said to have come from a shop in the vicinity of Amesbury, Massachusetts, the young squaw presents an unusually simple yet dignified image. Proprietors who did not employ expert craftsmen sometimes used figures cut in silhouette from a flat board, painted realistically, and mounted to hang or stand before the shop. Inexpensive, light in weight, and convenient to move or store, these profiles were prone to pilfering by pranksters, so relatively few genuine old examples now survive (fig. 234).[2]

Portrait busts form one of the most fascinating groups of folk sculpture because, although often unidentified as to sitter or maker, each expresses by the simplest means the personality of the subject. Most small busts were whittled from a single block of wood. If the carver's ability was limited, he might produce a rudimentary yet humorous likeness (fig. 235); if he was more skilled, a truer portrait was likely to emerge (fig. 236). There is no question, however, concerning the identity of the man shown in figure 237, although he might not be quickly recognized if the name ABRAHAM LINCOLIN(sic) were not carved in raised block letters around the base. Incised by means of small punch marks on the bottom of the pedestal is the inscription: C O Feb 3 1909. Beyond surmising that the initials referred to the carver, it was some time before I realized that Lincoln was born in 1809, and that therefore, this was a memorial piece carved in honor of his hundredth birthday.

Equally interesting, and seen less often than freestanding figures, are the portrait plaques that were carved in relief and painted in naturalistic colors (fig. 238). In the tradition of the wax and ceramic medallions of the last quarter of the eighteenth century, such naive carvings were intended to be hung on a wall by means of small nails inserted through a hole in the top of each piece. Various surmises as to the identities of these particular subjects have proved inconclusive, the most obvious being Captain John Smith and Pocahontas, or George and Martha Washington.

Another plaque, also rendered in wood (fig. 239), depicts General Washington in uniform. This is a much smaller version of the large medallion now in the collection of the Essex Institute, Salem, which was carved by Samuel McIntire in 1802–1805 as part of the decorations for the west gate of Salem's Washington Square. The source of the design is said to have been an engraving by Joseph Hiller, Jr., based on the profile by Joseph Wright.[3] Hiller was a Salem youth who made his copy in 1794, one year before he was lost at sea at age eighteen. The Washington medallions in our collection are two of three facsimiles known to me, the third being owned by Old Sturbridge Village. Ours are carved in high relief, fastened back to back, and painted in polychrome colors, the surface showing signs of much weathering. A long, tapering hole bored into the base indicates the one-time presence of a pole for outdoor display. These plaques are believed to have been two

of the "8 medallions of Washington" that were listed in McIntire's shop at the time of his death in 1811. The modest value of two dollars for the eight pieces suggests that they were small counterparts of the large original and were probably intended for sale to the general public.

The art of the gravestone cutter produced some of the most striking symbolic portraits to be found in early New England. Following the fearsome skeletons and death's-heads of the seventeenth century, the winged cherubs and fanciful faces that supplanted them heralded a less stern approach to human translation into eternity. The stonecutters who designed and executed this funerary art often supplied stones to the residents of many surrounding communities. Therefore the characteristics of their individual borders, ornaments, and stylized faces may be recognized in a number of different graveyards, even when the identities of the carvers themselves have been lost to posterity.

From the old Bicknell family home on Pleasant Hill Road, Freeport, Maine, came the stone in figure 240. This appears to be a sample gravestone by Noah Pratt, illustrating his numerals, his two styles of lettering, two types of borders, and a pair of incised faces, of which the male wears a wig, the female a close-fitting cap. On a trip to Maine in April 1962, we stopped in Freeport to research Noah Pratt, and there were put in touch with a Pratt descendant: "Shorty" Pratt (over six feet tall, incidentally). He could not locate Noah in the family genealogy but kindly guided us to the small First Parish Cemetery, where we quickly recognized more gravestones with the distinctive Pratt faces. Although other stones by Pratt are located in the Mast Landing Cemetery in Freeport, and in the Mere Road Cemetery in Brunswick, Noah himself remains something of a mystery. His name appears twice in the Cumberland County Registry of Deeds, where he is designated as having been a stonecutter of Freeport in 1791. We feel that this sample grave marker is an important piece, as it documents the work of a hitherto unrecognized carver of many of the eighteenth-century portrait stones found in the Freeport area.[4]

Our oldest and most significant historical carving is the British coat of arms that appears in figure 241. Now natural pine, it bears evidence of having once been painted in polychrome in contrast to its surrounding woodwork. Previous to the outbreak of the Revolution, the American Colonists signified their loyalty to the King by displaying royal emblems within public buildings, courtrooms, churches, and executive mansions, and also by mounting them on the facades of shops, inns, and taverns. The arms of the House of Hanover decorated the courthouse in Worcester, Massachusetts, as late as July 1776, when "the Arms of that Tyrant in Britain, George III of execrable memory, which . . . of late disgraced the Court house in this town were committed to the flames and consumed to ashes."[5]

Our coat of arms was carved by Winthrop Chandler to be displayed above a fireplace in the handsome home of his first cousin Gardiner Chandler, located on Main Street in Worcester. The latter was a prominent Tory, but his recantation in 1774 saved his property, including the royal arms, from being molested. After his death, the arms were given to Mrs. Henry Paine, whose husband presented them to the American Antiquarian Society in the mid-1820s. About 1838, Mrs. Mary (Chandler) Ware, a great-grandniece of Gardiner Chandler, was able to repossess the carving in exchange for some books bearing Gardiner Chandler's bookplate.[6] Thereafter it descended in her family until coming into our possession with other Chandler heirlooms in 1956. It represents one of the few surviving royal arms known to have been carved for domestic use before the Revolution.

VI *Furniture: For Use, Comfort, and Convenience*

Because of the Depression in the 1930s, followed by World War II (coupled with the practical hazards of raising a young and lively family), we did not invest in much noteworthy furniture during those busy years. By the mid-1940s, however, we were becoming increasingly interested in the construction of early pieces crafted by joiners working outside the large centers of population. One significant trend had been gradually evolving that fortunately resulted in a reversal of the desire to refinish everything, regardless of its age or type. On this subject, we learned our lesson the hard way. I had purchased at an auction a simple country Queen Anne fiddle-back chair then covered with old red paint. As this time-worn surface was unacceptable to my unpracticed eye, I lost no time in having the paint removed, only to discover that several woods, including maple, mahogany, and oak, had been thriftily combined in the chair's original construction, all intended to be concealed with the unifying painted finish that I had been at such pains to remove! As time went on, we realized that the mellow reds, blues, greens, and even blacks remaining on old chests, tables, and chairs were warm and colorful to live with. If patterned surfaces survived, so much the better from our point of view, although popular demand for painted decoration was still some years in the future.

In this discussion of our own collection, I have tried to focus on the furniture that might be of greatest interest to others and have therefore chosen a cross section of some of our favorite pieces. Most of them are shown as found, or exhibiting only a minimum of necessary repair. If major restoration is required to return an item to its original condition, we usually pass it by. But reasonable wear and the minor repairs incurred during years of honest use we regard as an acceptable part of the ongoing history of a genuine antique. Recently applied surface paint we are inclined to remove, but a grained finish added in the first half of the nineteenth century to update an earlier piece, such as the New Hampshire lowboy in figure 242, we leave intact as evidence of the changing taste of progressive generations. On eighteenth-century chests of drawers, we look hopefully for original hardware. If any of the old escutcheons, backplates, or handles remain intact, we try to augment them with old matching examples whenever pos-

242. Lowboy descended in the Hartshorn family of Amherst, New Hampshire, mid-eighteenth century. Pine. W. 34″. H. 32″. The grained finish was probably added to update the piece during the 1830s. Brass drawer pulls replace the first wire bail handles.

243. Chest with drawer, Boston area, c. 1670. Oak, maple, and pine. L. 45½″. H. 31½″. Paneled sides and back, split spindles, and remnants of applied moldings. Used at one time to store grain, the chest is in "as-found" condition, with remains of original red paint.

244. Chest lacking drawer, Matthews family, 1650–1700. Oak, pine, and white cedar. L. 53¾″. H. 23″. Gray paint over original red. The Matthews family settled in Yarmouth, Massachusetts, in 1638, and the construction and design of this piece follow the furniture-making traditions of the Barnstable–Yarmouth area. (Photograph by Robert B. St. George)

245. Storage box, probably Marshfield, Massachusetts. *S 1696 F* are carved on the lid of the till. Oak and pine. W. 30″. H. 8¾″. (Photograph by Robert B. St. George)

246. Six-board chest, Deerfield, Massachusetts. *I S* and date *1699* are carved on the front. Pine with original red paint. L. 51½″. H. 23¼″. Geometric arabesques and scalloped projecting bootjack ends are distinctive features. By tradition, the chest belonged to John Sheldon and stood in his Deerfield, Massachusetts, home during the Indian Massacre of February 1703/04.

247. Storage box, with initials *M E* and date *1683*, New England. Pine. W. 28″. H. 10″. Old refinish, with traces of black paint remaining in the interlaced scrolls. The escutcheon is a replacement.

248. Chest of drawers, New England, last quarter seventeenth century. Oak. W. 38″. H. 35¾″. The drawers slide on side runs. The surface paint had been brightened and the feet replaced before our acquiring the chest.

249. Small storage chest, New England, 1680–1710. Oak, pine, and maple. W. 23½″. H. 21″. The original colorful decoration was preserved in good condition under a later painted finish. The brasses are replacements following evidence of the first set. The chest descended in the Patch family of Hopkinton, New Hampshire.

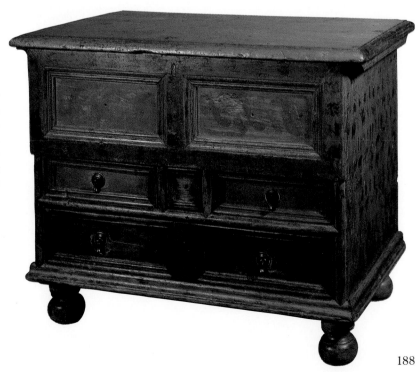

188

250. Chest of drawers on frame, New England, c. 1710. Pine. W. 38″. H. 48½″. Shown as found, with remains of the second and third sets of hardware. (Photograph by William Putnam)

251. Chest in figure 250 after the original red paint on the upper section had been revealed, and the old hardware had been replaced with the same design as the originals. (Photograph courtesy Old Sturbridge Village)

252. Blanket chest, New England, 1710–1740. Pine. W. 36½″. H. 43″. Old black over the first red paint. The key escutcheons are original, the other brasses were replaced before our ownership. The heavy beaded skirt and the turnip feet applied to the ends of the front posts are characteristic of several similar chests by this unknown maker.

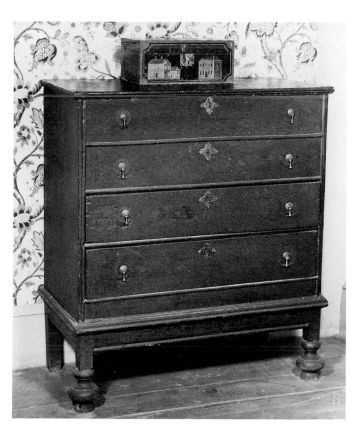

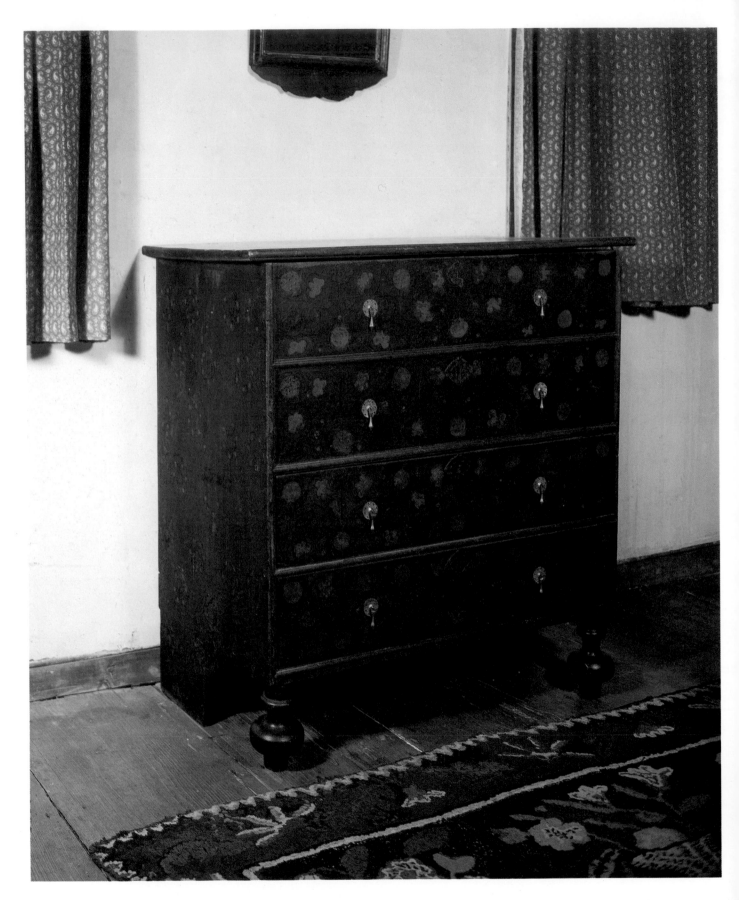

253. Blanket chest, New England, 1710–1740. Pine, with painted decoration. W. 36½". H. 38¾". The end boards were shaped to provide the back supports, but bold turnip feet were applied to the bottoms of the front posts, creating an example of unusual construction. One brass is original, the others are copies.

sible. It is becoming so difficult to find period brasses, however, especially of the teardrop variety, that carefully made reproductions are often the only solution.

Our first purchase of a significant example of seventeenth-century furniture was made in 1939 at one of the early Boston antiques shows. I had been studying illustrations in several standard reference books, and in one of the booths, I glimpsed a chest that I thought looked exciting, although it was placed in the rear of the booth, almost concealed by nineteenth-century trivia (fig. 243). With considerable trepidation, I asked the dealer to uncover it for my inspection, and there stood a once-splendid oak, maple, and pine chest probably made in the Boston area about 1670.[1] It was original in every remaining detail, although many of the front moldings had unfortunately disappeared through years of protracted usage in somebody's barn. On the underside of the lid, in large black letters, appeared the word GRAIN. Suffused with a warm glow of discovery, I purchased the chest, having been encouraged by a substantial reduction in price offered by the friendly dealer, who, I later suspected, realized that its "rough" condition might inhibit a sale to a more experienced client. Reaction from seventeenth-century furniture buffs was not long in coming, it being duly noted that small sections of all the missing decorative elements were still *in situ*, making perfect rehabilitation eminently feasible. This situation presented three questions and brought us face to face with our first quandary in the philosophy of restoration: (1) Had the chest in its current condition been worth acquiring in the first place? (2) If yes, should it now be expertly restored? (3) Or should it continue to remain as found, a mute witness to 250 years of rigorous survival? We decided with little hesitation on the third course.

Some years later, we acquired our second seventeenth-century spindle chest, illustrated in figure 244. Constructed of oak, pine, and white cedar, it dates from between 1650 and 1700 and displays an old coat of gray paint over the first red. Almost all the original moldings are still present, although a lower drawer has long since disappeared. The construction and design fit stylistically into the seventeenth-century furniture-making traditions of the Barnstable—Yarmouth area south of Boston, and this provenance is substantiated by an accompanying history of descent in the Matthews family, who settled in Yarmouth, Massachusetts, in 1638. Produced also by South Shore artisans, probably in Marshfield or Scituate, was the large oak-and-pine box illustrated as figure 245. The front exhibits interesting half circles combined with trefoil motifs enclosed by two bands of chisel carving, and the lid of the till is inscribed *S 1696 F*.[2] Large containers of this type have been known as *Bible boxes* since the nineteenth century, but the term does not commonly occur in seventeenth- or eighteenth-century records, and it appears that these boxes were used for general storage, including that of wearing apparel, household linens, and miscellaneous books, papers, and currency.[3]

The red-painted six-board chest from Deerfield, Massachusetts (fig. 246), presents an unusual geometrically carved and punched facade with three decorative motifs consisting of triple-line squares with double-line corners. The end boards extend beyond the front of the chest to form two double-scalloped protruding feet. The chip-carved corners are edged by a vertical band of lunettes. In the center design appear the initials *I S*, with the digits *16* and *99* carved within the flanking scrolls. The chest descended in the Sheldon—Hawks family of Deerfield, Massachusetts, and traditionally belonged to John Sheldon, in whose home it witnessed the fearful massacre that took place on the night of February 29, 1704, when the stockade was stormed by the French and Indians and John's wife, Hannah, his daughter Mercy, and his three grandchildren were killed—Hannah by a bullet fired through a gash cut in the door of the house.[4] The chest was rediscovered in 1941

hidden beneath the eaves of the eighteenth-century house built by John Sheldon III, a heritage of eight generations in the Sheldon–Hawks family.

The box in figure 247 illustrates the use of interlaced straps or scrolls, a design that, in one form or another, appears on a number of seventeenth-century pieces. Included in the center is the six-petaled motif so popular in both seventeenth- and eighteenth-century work, here coupled with the initials *M E* and the date *1683*. The paint was apparently removed a long time ago, as the present surface bears evidence of hard wear. The hinges and escutcheon are replacements, but otherwise the piece is all original, and boxes dated in the early 1680s are relatively rare.

In his *Colonial Furniture of New England*, Dr. Irving Lyon stated that chests of drawers appeared in New England records as early as 1643, and thereafter they became increasingly popular because of their obvious convenience. Fortunately, a number have survived from the late seventeenth century, embellished with various arrangements of applied split spindles and moldings. The four-drawer piece in figure 248 is one of a group of quite similar design. It is made entirely of oak, the drawers are grooved to accommodate side runners, and the front and ends are ornamented with combinations of moldings surrounding raised panels. The front posts terminate in small ball feet, which we believe to be replacements, and although the surface color is old, it appears to be a rebrightening of a previous finish.

Somewhat similar stylistically is the small chest-over-drawers illustrated in figure 249. This piece had never left the ownership of the Patch family of Hopkinton, New Hampshire, until it came into our possession through a dealer in 1982. Patches have lived in the old family home since shortly after 1800 and apparently brought the chest with them, presumably from Duxbury, Massachusetts. The chest is only 21″ high. The frame is made of pine, the drawers are riven oak, and the ball feet are maple. Following the recent removal of a coat of Victorian green paint, the first colorful finish was revealed as seen here with no retouching. Apart from its completely unrestored condition, the little chest is of particular interest because of its several ingenious locking devices, which indicate that it was once used as a repository for valuables. The cover could be secured when closed by a sturdy iron lock with a key, both of which have now disappeared. In the bottom of the center front of the deep well is a slot shaped to accommodate a thin wooden rod that fitted down into a hole in the front board of the small square secret drawer beneath, rendering the drawer immovable from the outside. Wooden pegs, or perhaps rose-headed nails, likewise ran through the bottom board of the well down into holes in each of the two short drawers below, making them also impossible to open without access to the well above. Although these locking devices have been lost over the years, we have had replacements made, as clear evidence remains of their original position and purpose.

Stored in the cellar of an ancient house south of Boston the chest-on-frame of around 1710 in figure 250 came to light in the 1960s. As is often the case, the top and bottom had long ago been separated. The top, when used alone as a chest of drawers, had been repainted three times and equipped with cheap modern hardware. The heavy six-legged base, however, was untouched and retained its old red finish. Two sets of brasses, teardrops and early bail-handles, had preceded the tin replacements, and three escutcheons of the second set still remained in place. The outlines of the original teardrops, however, were still visible beneath the modern gray paint. Fortunately we had recently acquired at the auction of a friend a set of period backplates and drops, and these were installed on the chest after the later paint was removed, as shown in figure 251.

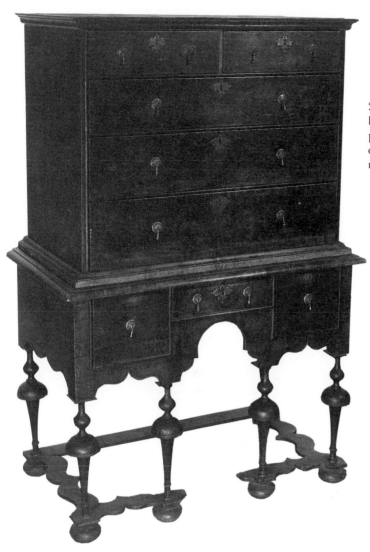

254. Trumpet-legged Queen Anne highboy, from the Howland family of Westport, Massachusetts, 1690–1710. Maple and pine. W. 40″. H. 61¼″. All the key escutcheons and the four drop brasses on the two upper drawers are original. The remainder are copies. (Photograph by Zaharis)

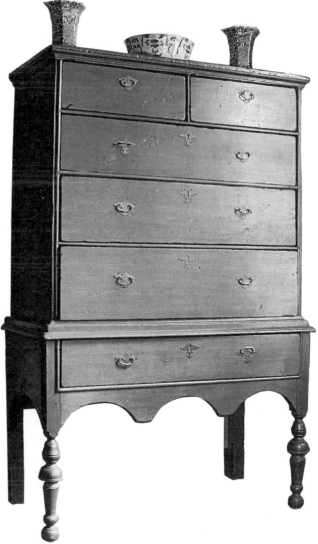

255. High chest of drawers on frame, Marsh family of Cornwall, Connecticut, 1720–1740. Poplar. W. 39″. H. 61″. A transitional piece. The design of the base is a modification of the earlier Queen Anne style. Original brasses. (Photograph courtesy Old Sturbridge Village)

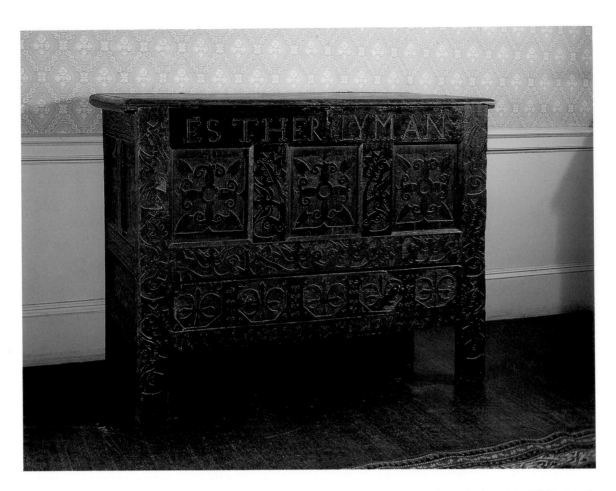

256. Chest with drawer, Northampton, Massachusetts, 1700–1720. Oak and hard pine. W. 45″ H. 34⅛″. Esther Lyman was born in Northampton in 1689 and was married in 1724. This piece was probably made as her future dower chest.

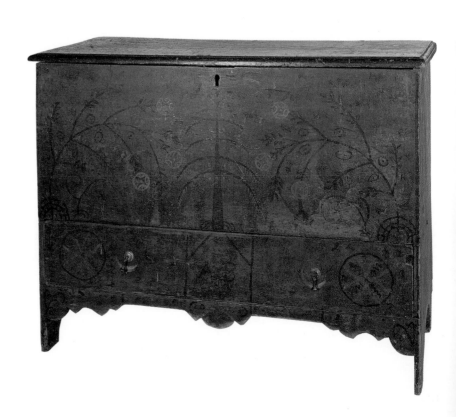

257. Chest with drawer, initialed *A B*, 1710–1740. Pine. L. 43½″. H. 33″. Attributed to a maker in the vicinity of Hampton Falls, New Hampshire.

Plain chests having lift tops and two simulated drawers, with two actual drawers below, were also made at the same period. The one in figure 252 has single arch moldings and its original feet. The drop brasses have been replaced, although the engraved key escutcheons have never been changed. Two distinctive features of this piece are its heavy skirt molding, which surmounts a board with a boldly beaded edge, and its large turnip feet, which are attached to the square front posts. During the last twenty-five years, five other chests have come to our notice that exhibit the same unmistakable characteristics.

The construction of another two-drawer blanket chest (fig. 253) exhibits one unusual feature. Instead of the back posts' acting as supports for the rear of the chest, the wide end boards are cut to serve this function. The vine-and-blossom decoration is painted in black and coral on a dark reddish ground, but the ends exhibit a different design of scalloped and dotted circles. When a chest of drawers such as this was raised on a six-legged base, it became the upper section of a Queen Anne highboy.

The trumpet-legged Queen Anne highboy in figure 254, dating from 1690–1710, exhibits the same form of upper section as the chest-on-frame illustrated in figure 251. The escutcheons and the four drop brasses on the two top drawers have never been off the piece, the missing ones having been copied from the originals. This highboy descended in the Howland family of Westport, Massachusetts, and as was true of the chest-on-frame, the upper and lower sections had been separated for many years. The case of drawers had been stored in the attic while the base was in use downstairs. It eventually received a rejuvenating coat of new brown paint, which we subsequently removed. It appears that at one time there was possibly a break in the front stretcher, although by a strange coincidence a mate to this highboy exhibits a stretcher of identical form.

An interesting comparison with the foregoing piece is illustrated by the high chest in figure 255. Always owned, until it came to us, by the Marsh family of Cornwall, Connecticut, it is constructed throughout of poplar, with single-arch moldings separating the drawers, as well as original bail handles of the 1720 period. The traditional form of six-legged base has here evolved into an updated four-legged version, but the scalloped outline of the skirt still suggests the presence of six legs, and the small, modified trumpet turnings echo the earlier Queen Anne style.[5]

In 1935, the Reverend Clair Franklin Luther, minister of the Second Congregational Church of Amherst, Massachusetts, published his well-known book, *The Hadley Chest*, which recorded in detail the many richly carved chests that originated in the upper Connecticut River Valley during the late seventeenth and early eighteenth centuries. Several of these pieces, with others found subsequently, form a separate category known as the *Northampton type* because of original ownership in Northampton or its vicinity. Each exhibits the initials or the full name of the owner across the top of the front, and three recessed panels enclosing distinctive four-petaled ornaments appear on several of the chests, as do fleurs-de-lis in five octagons on the drawer fronts. Family histories relate this group to one unidentified early-eighteenth-century carver in the Northampton area, where the various owners were born between 1695 and 1702. These pieces were presumably dower chests, made for the girls whose names or initials they bear while they were still young children.[6] Esther Lyman, whose chest we now own (fig. 256), was born in Northampton on February 15, 1698. On August 26, 1724, she married Benjamin Talcott of Bolton, Connecticut, where she died on August 23, 1736. Tradition maintains that the piece descended to her unmarried daughter Esther Talcott, who

died in 1808, and from her to an unnamed nephew. The chest reappeared, said to have been still in the family's possession, in Framingham, Massachusetts, in the late 1960s. The exterior retains some of its colorful original finish, the name *Esther Lyman* being picked out in red on the black top rail. Many eighteenth-century chests bear tantalizing names or initials, painted on the backs or on drawers, that would seem to designate one-time owners. This chest is no exception. Painted on the drawer bottom in bold black letters of obviously early vintage is the name *Erastus Banks,* to whose identity no clue now remains.

During the first half of the eighteenth century, many country-made chests and cupboards were painted with various forms of meandering or geometric designs, and we have been fortunate in finding several early decorated examples to add to our collection. Among them is the chest in figure 257, which is one of a small group of pieces that has been traced to a maker working in the vicinity of Hampton Falls, New Hampshire, during the 1720s. The designs are naïvely drawn on a dry red background, and in the center is a stylized pine tree in black flanked by blossoming sprays of coral-colored blooms. Circular motifs were added where needed to fill up space, and the initials *A B* are painted in a cut-cornered square at the center of the drawer. Decoration by the same hand appears on a cupboard from Hampton Falls now owned by the Yale University Art Gallery.[7]

Country press cupboards are among the rarest forms of early-eighteenth-century New England furniture, being descendants of the heavy oak cupboards patterned after English prototypes that were to be found in wealthy homes during the second half of the seventeenth century. Although the latter had gone out of fashion by 1700, the traditional form persisted, at least in New Hampshire, for the next quarter century. Our cupboard (fig. 258) is of board construction, made of pine with drawer sides of maple, all joined by large handwrought nails. The upper section displays the usual sloping sides flanking a central door hung on cotter pin hinges, the top being supported by boldly turned, black-painted balusters. Below is a paneled section that surmounts a long drawer. The interiors of both top and bottom are fitted with two long shelves, 7″ in width, that rest on wooden supports nailed to the insides of each end. The end boards are undecorated and are painted red. As on other cupboards of its type, the brasses are of the drop variety. The front is stained reddish brown over a base coat of vermilion and retains an old coat of varnish. The decoration is painted in white and black and includes an artless variety of leaves, stylized flowers, small blossoms, and vines topped by shapes resembling carnations and thistles (fig. 259). The cupboard spent many years during the twentieth century as a prized possession of an older generation of the Freese family of Deerfield, New Hampshire. It is now surmised by a present family connection that it may have been brought from Epping, New Hampshire, by Andrew Freese (born there in 1747) when he moved to Deerfield in 1773, although there is no proof of this fact.

One of a small group of painted pieces associated with the Milford–Woodbury area of Connecticut is a chest with drawer, one end of which is illustrated in figure 260. It is decorated with motifs embodying three-petaled flowers terminating in fleurs-de-lis. The ground is reddish brown, and the designs are in white with accents of green and vermilion. A similar chest in the collection of the Pocumtuck Valley Memorial Association in Deerfield, Massachusetts, was referred to in their old catalogue as a "Lily chest . . . An old and odd affair."[8] Although our chest, like many another outdated household relic, was finally discarded, it was eventually rescued from a dump in Woodbury, Connecticut, with part of the lid broken and the surface obscured by a later coat of white paint.

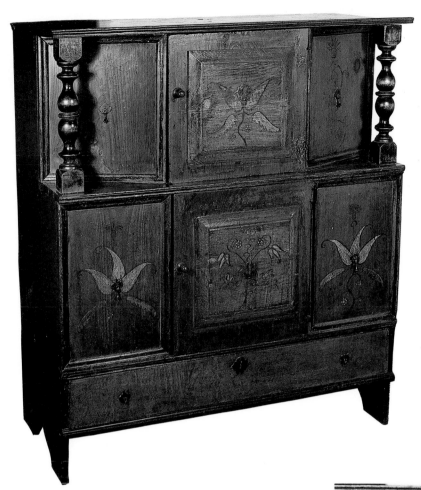

258. Press cupboard, 1710–1730. Pine and maple. W. 42″. H. 50½″. All brasses are original except those on the sides of the upper sections. Believed to have descended in the Freese family of Epping and Deerfield, New Hampshire.

259. Detail of floral decoration on the press cupboard in figure 258. The front is painted in reddish brown over a vermilion base coat; the flowers are white with black accents. The turned knobs are replacements, and the raised panels were once framed by moldings.

197

260. End of a chest with drawer, from the Milford–Woodbury area of Connecticut, 1720–1735. Pine. W. 17¼″. H. 33″. The decoration is painted in white with touches of green and vermilion on a red-brown background.

261. End of an early-eighteenth-century chest of drawers, with decoration possibly intended to suggest tortoiseshell, New England, 1710–1730. Poplar. W. 18½″. H. 41½″.

262. Octagonal trinket box, probably from Vermont, c. 1830. Pine. W. 8¾″. H. 4½″. Rectangles of bright streaks of color applied freehand are surrounded with dainty bronze motifs stenciled on a dark green ground.

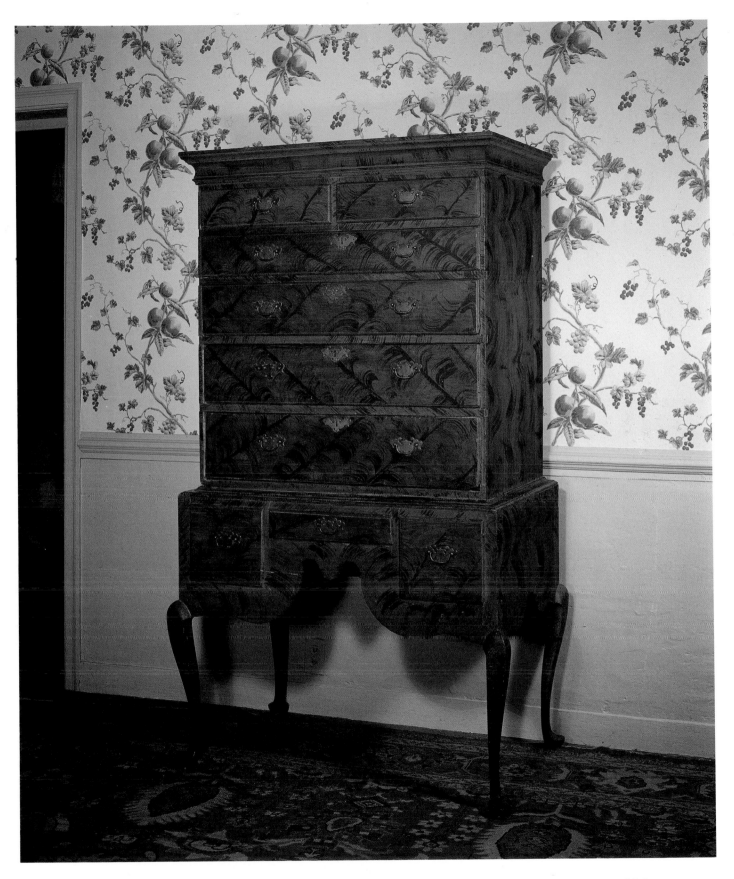

263. Highboy, probably Maine, 1740–1765. Maple and pine. W. 38″. H. 68″. Grained to suggest high-style burled-walnut veneer. The brasses are original.

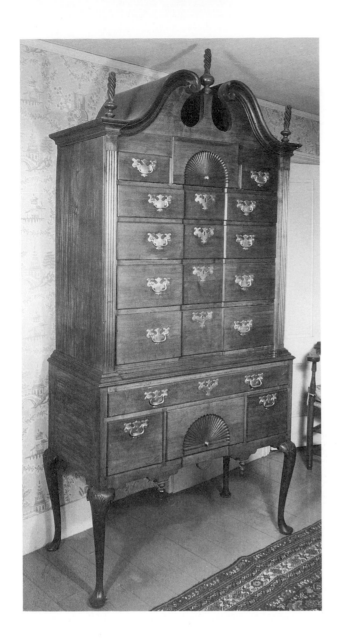

264. Highboy, c. 1760. Maple, with original brasses. W. 42¾″. H. 90½″. Owned by the Honorable John Chandler of Petersham, Massachusetts. The blocked upper section and apron are unusual features. (Photograph by George Boyer)

265. Lowboy, or dressing table, 1750–1760. Cherry, brasses and pendants replaced. W. 33½″. H. 31″. A companion piece to the highboy in figure 264. The shell-carved knees and center drawer with fan are similarly carved, as is the blocked apron. Owned by the Honorable John Chandler of Petersham, Massachusetts, before 1779. (Photograph by George Boyer)

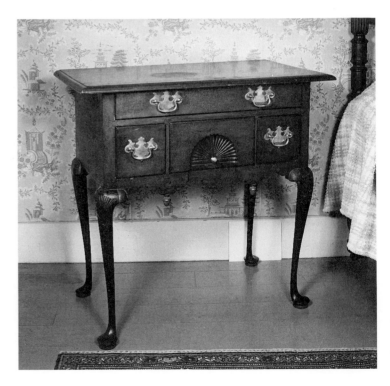

Designs seen on the ends of chests and boxes sometimes differ slightly from those appearing on the fronts, and the colors are usually in better condition owing to lack of wear. The end of the early-eighteenth-century chest of drawers in figure 261 is a good example of what an American country decorator might have considered a simulation of tortoiseshell, for which directions to "imitate and counterfeit" were enumerated in *A Treatise of Japanning and Varnishing* published in England in 1688.[9] Three sides of an octagonal trinket box dating a hundred years later (fig. 262) provide an interesting comparison with the two eighteenth-century pieces in figures 260 and 261.

The flat-topped highboy in figure 263 dates to the middle years of the eighteenth century. It was found in private possession in Maine, where it probably originated, its simply designed skirt and lack of ornamentation suggesting the hand of a rural joiner. Although the majority of eighteenth-century grained furniture received such decoration at a later date, this highboy exhibits its first painted surface. The free-form swirled patterns were applied over a dark ocher ground, being evidently intended to disguise the maple wood by simulating a more desirable burled-walnut veneer.

Another highboy and an accompanying lowboy, or dressing table, are more sophisticated in concept (figs. 264 and 265). The maker is unknown. Both pieces belonged to the Honorable John Chandler (1720–1800), a loyalist who was prominent in Worcester County, Massachusetts, before the Revolution. He was later known as the "Honest Refugee" after his property was confiscated following his departure from Boston with the British in March 1776. In a record of the ensuing auction of his personal estate in 1779 appears the following pertinent entry: "1 case of drawers at 3 pounds, 1 toilet table at 18/ 3-18." It is believed that these items were bought in by the family. Although they were eventually separated, each passed down through six generations of Chandlers in Petersham and South Lancaster until they were finally reunited in the ownership of John's great-great-great-grandson Herbert H. Hosmer, from whom we acquired them with other family heirlooms in 1956. The maple highboy, with its fluted pilasters and unusual blocked upper case, has cabriole legs terminating in pad feet. The brasses, finials, and pendant drops are all original to the piece. The companion lowboy, however, has both similarities and differences. It is made of cherry, and its descent in a different branch of the family accounts for the replaced brasses and drops. Nevertheless, the outline of the shaped, blocked apron and the form of the feet and legs are the same on both pieces, and the shell and bellflower carving on the knees of each is identical.[10]

For many years, we have been enthusiastic admirers of the stylish furniture made by Major John Dunlap in Goffstown and Bedford, New Hampshire, from 1768 until his sudden death in 1792. The chest-on-chest-on-frame in figure 266 exhibits all the distinctive elements of the Dunlap style, including short, squat cabriole legs with pad feet, flowered ogee moldings around three sides of the top and bottom, double S-scrolls on the base, and characteristic "spoon-handled" shells on the cornice and the lower drawer. Although the first name of the original owner is not known, the chest descended in the George family, early residents of the Bedford area of New Hampshire, later of Worcester, Massachusetts. In the eighteenth century, there were two large and prominent families of this name: Joseph and Timothy George and their descendants, who lived, respectively, in Goffstown and Weare, New Hampshire. One Stephen George served in the French and Indian Wars, and this name appears again on the Weare tax list in 1764. The only person with the surname of George to be found in Major John Dunlap's account

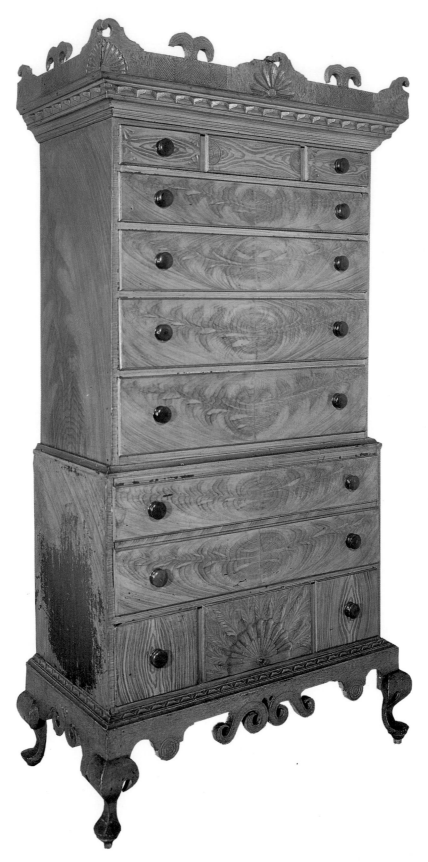

266. Chest-on-chest-on-frame, attributed to John Dunlap, Bedford, New Hampshire, 1775–1790. Maple. W. 36¾″. H. 76″. Made for a member of the George family and owned by descendants until acquired by us. The grained finish and the wooden knobs were evidently added to update the piece in the 1830s.

267. Armchair, New England, 1680–1720. Maple and ash, old red paint. H. 46″. W. 24″. The bottoms of the original posts were slightly shortened when rockers were added at a later date.

268. Banister-back armchair, New England, 1725–1735. Birch, maple, and ash, original brown paint. H. 49″. W. 23½″. The unusual crest and the bold turnings of the front stretcher give this chair an air of distinction. The adjustable unpainted candlestand, which dates from the late eighteenth century, has an oak shaft with maple top and base, and it accommodates two big hog-scraper sticks that slide into grooves cut in the center of the top. New England. H. 36″.

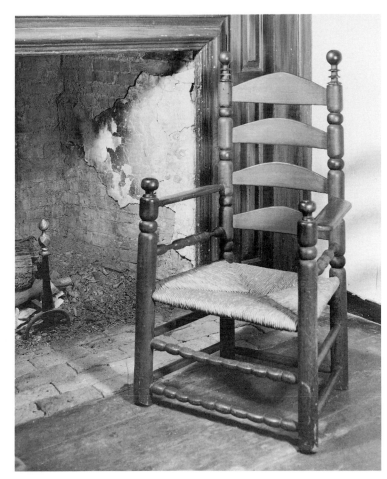

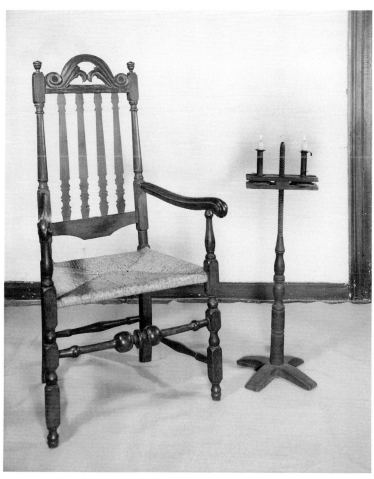

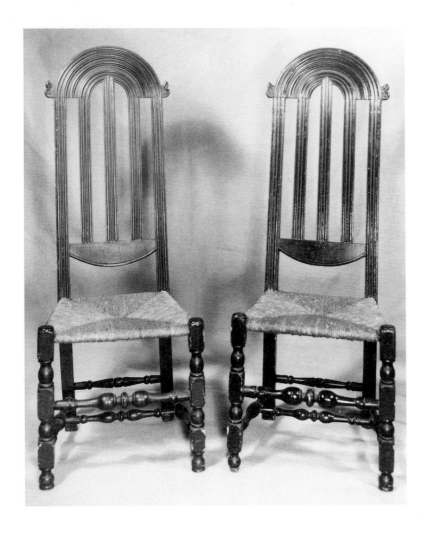

269. Pair of maple side chairs with reeded splats and conforming arched cresting rails, each with two carved ears, c. 1730. H. 49½". W. 17½". These chairs, together with a Hadley chest, descended in a western Massachusetts family.

270. Detail of the back of one of the chairs in figure 269.

book occurs in the following entry: "Aprile the 14 1775 Stiven george [*sic*] Credet to 90 feet of Clear Board 3 6 0."[11]

Maple and birch were predominant in John Dunlap's furniture, and it is probably because of their superior appearance (particularly the handsome curly maple) that a majority of the case pieces have been stripped of their original paint and returned to natural wood. However, many of Dunlap's pieces received colorful finishes, as proved by his following references to decorative stains: "To Japan or Varnish on Wood, To stain wood Green, To stain wood an orange Color, To stain wood to Resemble Mahogany."[12] In figure 266, the expertly grained finish in soft yellow and brown simulates the appearance of crotch veneer and was obviously added to update the chest about 150 years ago. Beneath this surface, where the graining has worn away, the original mahogany stain is apparent, and tiny spots of greenish blue are discernible on the top and base moldings where the present paint has chipped. The chest was first fitted with bail handles; the present knobs are concurrent with the graining, the whole reflecting the "high-style" appearance of some pieces of country furniture as they evolved in the 1830s. This handsome finish, we feel, should never be removed but should remain as an example of the changing taste of ongoing generations.

From the "Country Auction" of the Hartshorn Farm Homestead in Amherst, New Hampshire, owned by the Hartshorn family for over 150 years, came the mid-eighteenth-century lowboy previously shown in figure 242. Like the Dunlap highboy, this piece was updated about 1830 by the addition of a red-and-black-grained finish and the substitution of small brass knobs for the original bail handles secured by wires to the insides of the drawers. It could easily be refinished and period hardware installed, but its distinctive character would disappear.

An early-eighteenth-century date for the maple-and-ash armchair shown in figure 267 is indicated by its heavy slats, its ring-turned posts with ball finials, and its horizontal spindles placed below the flattened arms. The worn sausage turnings on the front stretchers bespeak generations of welcome foot support, and the backs of the rear finials show considerable wear where the chair at one time either rested or was tilted against the wall. The lower posts were slightly shortened and split for the insertion of rockers, which had disappeared before the piece came to us in November 1942 from the New York auction of Mrs. Luke Vincent Lockwood. The chair had been found in Connecticut by Mr. Lockwood.

Banister-back chairs derive their name from the split-baluster form of their vertical splats, and a boldly carved crest of rhythmic design adds an air of distinction to this example (fig. 268). The chair retains its first coat of mellow brown paint, and the rush seat, which is old but not original, has been painted white. A virtually identical example, also with white-painted seat, was once owned by General Samuel Strong of Vergennes, Vermont.[13] Illustrated with the chair is an interesting form of adjustable stand. Wooden candlestands have always been one of our preferred lighting accessories, and we own several different types, this one being made of oak with maple top and base. It was fashioned to accommodate two hog-scraper candlesticks, whose bases slide into a space between the upper and lower sections of the top of the stand.

Another type of chair akin to the banister-back has straight, reeded, vertical slats (figs. 269 and 270). The half-round molded crest with shaped ears is an unusual form in New England and occasioned a query to me from Joseph Downs of the Metropolitan Museum (later Curator in charge of Collections at Winterthur Museum), as to whether the chairs were perhaps of Pennsylvania origin. As they were also included in the 1942 Lockwood sale, I wrote to Mr. Lockwood concerning

their history. He replied that he had acquired them from a Massachusetts lady whose family had also inherited a Hadley chest, and he felt confident that the chairs were of the same New England provenance.[14]

The hoop-back Windsor armchair with its added comb crest came from an old family in Kent Hollow, Connecticut, and retains much of its first red finish (fig. 271). This particular combination of Windsor forms, enhanced by well-turned legs and arm supports, makes an effective silhouette against a whitewashed plaster wall. Shown beside it is a ratchet lighting stand, equipped with its original graduated set of five hog-scraper candlesticks. The tallest rests on the small oval top, on the edge of which are four thumbnail grooves carved to fit the handles of the four hanging sticks. These are of two sizes, so that their bases are cleverly prevented from overlapping.

Above the chair hangs a red-and-black Queen Anne country looking glass that evokes vivid memories of a summer day in 1950 when the contents of the venerable Dean–Barstow house in East Taunton, Massachusetts, were sold at an outdoor auction on the premises. The Deans had been a prominent family in this area since before 1750, and the property, with the house and many of its original furnishings, had never left the descendants' possession. Still set up in the garret was an ancient loom on which all the blankets and household linens had been woven for generations. We purchased it *in situ*, together with a pair of hand-woven rose-embroidered blankets, but the loom had to be laboriously taken apart before it could be brought down from the attic. The hand-whittled pegs that held it together were then piled on the grass nearby, but when we came to pack the loom, all but two of the pegs had been picked up as "souvenirs."

Placed with other odds and ends in a corner of the Barstow yard, I spied what turned out to be one of the rarest examples of American marked bell metal, a three-legged skillet, its long handle cast with the name L. LANGWORTHY 1730 (fig. 272). Lawrence Langworthy, pewterer, brazier, and iron founder came to Newport, Rhode Island, from Exeter, England, and the date that appears with his name may signify the year in which he started to work in America. He died in Newport and is buried there in Island Cemetery, his will having been probated in 1739. Illustrated with the Langworthy skillet is another example almost identical in size and form. This bears the mark COX TAUNTON and could conceivably be another American piece, but it is more likely to have been an English import.

Strangely enough, considering the quality of the merchandise, the Barstow sale was little advertised and sparsely attended, but thirty years ago, mixed auctions of family household goods did not create the interest they do today. In any case, this event was attended mostly by neighbors, a few collectors, and a handful of small dealers, with the exception of one man from Duxbury, Massachusetts, whom I knew quite well. He was the only person, as far as I could see, who had spotted the skillet. Deciding to take the bull by the horns, I approached him and said I wanted very much to bid on that particular item. He graciously withdrew, and later I refrained from bidding against him on a set of six fiddle-back chairs, which we later acquired from him at a modest markup. In the meantime, on the wall of one of the rambling sheds behind the house, I had seen the early mirror shown in figure 271. Minus its glass, it was hanging dejectedly by one corner of its frame from a large nail, as it was not considered of sufficient merit to be included in the sale. I persuaded the auctioneer to put it up, and we eventually took it home, together with other Dean–Barstow treasures, the loom and its appurtenances being tied precariously on top of the car.

One of our prized pieces of early-nineteenth-century furniture (fig. 273) was

271. Bow-backed Windsor armchair with comb crest, 1780–1800. Maple and ash, traces of original red paint. H. 49″. W. 24½″. Ratchet lighting stand from Bristol, Connecticut, late eighteenth century. Maple and ash. H. 29″. Four of the matched set of five hog-scraper candlesticks hang from grooves carved in the edge of the top of the stand. Red-and-black-painted country Queen Anne looking glass, c. 1725. From the Dean–Barstow family, Taunton, Massachusetts. Pine. H. 21½″. W. 11″.

272. Two bell-metal skillets. On the handle of the upper piece is cast the name COX TAUNTON. It is probably English, 1650–1750. L. 17″. The handle of the lower skillet bears the maker's name L. LANGWORTHY 1730. Langworthy, a pewterer, brazier, and iron founder, came from Exeter, England, to Newport, Rhode Island, presumably in 1730, where he worked until his death in 1739. L. 16¼″.

273. Side chair, 1808–1815. Branded on bottom of front seat rail S. GRAGG BOSTON PATENT. Ash and hickory, painted yellow with brown striping and peacock feather decoration. H. 34¾". W. 17½". Gragg also included armchairs, settees, and benches in his output.

274. Samuel Gragg's brand, located on the bottom of the front seat rail of the chair in figure 273.

275. Windsor rocking chair with writing arm and original dark green paint, 1830–1840. H. 43½". W. 30". An old handwritten label, accompanied by a group of family letters, gives the history of ownership of the chair. Originally the property of the Reverend Seth Chapin of Mendon, Massachusetts (1783–1850), it descended in four generations of the Chapin family. The particularly wide seat and the method of supporting the writing arm are unusual features.

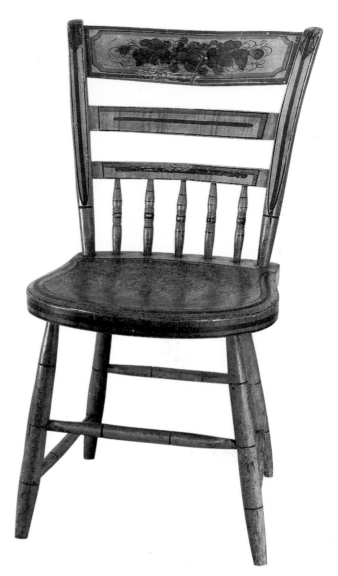

276. Windsor side chair made by the Newburyport Chair Factory, Massachusetts, c. 1829. Yellow, with bronze freehand decoration. H. 33¼". W. 18¼". (Photograph courtesy Old Sturbridge Village)

277. Label of the Newburyport Chair Factory pasted beneath the seat of the chair in figure 276. (Photograph courtesy Old Sturbridge Village)

278. Table, New England, 1680–1710. Oak and pine, old black paint. H. 25½". W. 29". Drawer and two drops missing. The form and arrangement of the stretchers are early features.

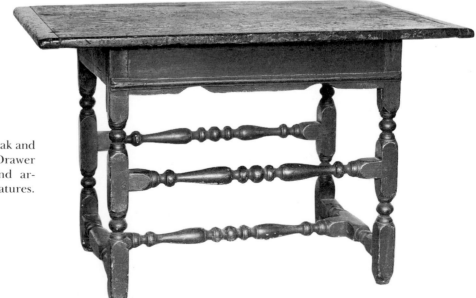

made by Samuel Gragg (1772–1815), a Boston chair-maker whose chairs embody an advanced application of the bentwood technique in which continuous members curve from the crest rail downward to the bottoms of the front feet. This is a simple interpretation of the ancient Greek *klismos* chair, featured by Thomas Hope in *Household Furniture and Decoration* (London, 1807).[15] Branded on the bottom of the front seat rail S. GRAGG BOSTON PATENT (fig. 274), the chair is made of ash and hickory, painted yellow with shaded brown striping, and decorated with peacock feathers that radiate from the middle splat along the center of the top rail.

Windsor chairs with large attached writing arms were one of the most useful and ingenious forms of eighteenth- and early-nineteenth-century furniture. The backs of the earliest examples often featured an added comb, later ones having straight or stepped-down crest rails similar to that in figure 275. Perhaps the most interesting elements of these Windsors is the design and construction of the writing arms, particularly the different ways in which they were attached to the seats of the chairs. In the majority of cases, the arms had a supporting member that rested on a small platform built out from one side of the seat. A shallow drawer usually fitted below the large, flat writing surface, with a second drawer sometimes suspended on runners beneath the seat.[16] Because our chair differs from the general pattern, we feel it must have been made to order, in this case for the minister who was its longtime owner. It was originally the property of the Reverend Seth Chapin, born in Mendon, Massachusetts, in 1783. After attending Phillips Academy, Andover, and Brown University, he served his first pastorate in Hillsborough, New Hampshire, from 1812 to 1816. Other parishes followed until his death in Providence in 1850, after which date the chair descended through three more generations of the Chapin family. The Reverend Seth's chair is certainly an unusual concept, as the writing arm is constructed above the end of the wide, rectangular seat and is supported from the front rather than by a brace positioned on a small added platform. Adding to the interest of the design are the number and arrangement of drawers beneath the arm, which include a small one in which, judging from the ink stains, the owner kept his writing materials. Only the runners now remain of a fifth drawer, which was once suspended below the seat.

At first glance, the traditional Windsor side chair in figure 276, with its soft yellow paint and conventional spray of bronze freehand decoration, does not seem particularly outstanding. However, we were attracted enough to acquire it because of the printed label affixed to the underside of the seat (fig. 277). Hoping to find further reference to this unfamiliar manufactory, we scanned the pages of the *Newburyport Herald* and were rewarded by an informative advertisement that ran from April 13 to May 26, 1829:

> Chairs, of every description, made
> at the *Newburyport Chair Factory*
> viz:—Cane bottom Chairs, of a superior
> quality, worth from $2.50 to $4 each—
> Fancy Chairs, Windsor Chairs, and Box
> Chairs for Shipping. Any pattern
> or color, made to order.
> WASH-STANDS, CHAMBER-TABLES
> Bureaus, and Work stands, of every description, always on hand, at wholesale
> or retail.
> N. HASKELL, *Agent for the Prop's*
> Chair Factory. April 13, 1829.

Tables of every sort seem to gravitate toward us as if drawn by a magnet, even when we have no convenient space in which to put them. In earlier days, when we were not seeking to enrich our collection but merely trying to furnish a home, we occasionally asked a dealer to find us a needed piece, such as a desk or a chair. Inevitably, it seemed, he would be unable to locate the desired object but would say ruefully, "Sorry about this, but I have just found the most *wonderful* table." We could not, of course, resist this temptation, so we continued to live without the utilitarian desk or chair, as it must be admitted that, apart from their usefulness, we are obviously partial to tables as an antique furniture form.

The table in figure 278, with oak base and pine top, has long since lost its drawer but is notable for the late-seventeenth-century arrangement of the boldly turned stretchers, and also for the fact that it was once fitted with two drops, for which elliptical cutouts at the lower edge of the skirt are still visible. At the top of each cutout is a hole that accommodated the neck of the wooden drop. In cases such as this, where a significant early feature has disappeared, it is a great temptation to replace the lost element if it can be correctly copied from an existing original on another piece. We discussed this possibility but finally decided against any restoration.

A rare, early table with a medial stretcher is illustrated in figure 279. The trestle base provides the type of foot appearing on pieces of furniture that would not remain upright without a wide bottom support. This table bears some resemblance to a small group of related examples that seem to have Connecticut connections.[17]

One of the most convenient forms of the mid-eighteenth-century gateleg table was the so-called tuckaway style. These tables are held upright, when closed, by means of two trestle feet. When open, the two gates swing out and support the semioval leaves (fig. 280). Tuckaways are distinguished by their unusually narrow center sections combined with two deep leaves that, when folded down, produce a very narrow table that fits easily behind a door or in other restricted spaces (fig. 281). The top of our piece, when closed, is only 5½" wide. The base has old red paint, the top is stained, and the leaves are hung on large iron hinges, the rose-headed nails of which are backed by leather washers.

The formal serving of tea was one of the most important social customs in eighteenth-century America. As it became a fashionable pastime, tea tables were to be found in both well-to-do homes and rural farmhouses. Frequently placed against a wall when not in use, they often remained set up with the basic equipment of silver and china. This could have included a teapot, tea cannister, sugar bowl and tongs, milk jug, cups, saucers, and spoons. Even children played at serving tea. In the 1780s, one fortunate young lady, at age five, was allowed to invite "by card . . . 20 young misses" to her own "Tea Party and Ball."[18] Her equipage might have resembled the doll's-sized table and miniature porcelain set shown in figure 282. Although tea drinking was curtailed during the Revolutionary period because of the English tea tax, it was resumed after the war and continued to be an important social custom well into the early twentieth century.[19]

Judging from contemporary paintings, prints, and inventories, large, round tripod-based tea tables were the most popular, although four-legged tables with rectangular tops are often designated today as tea tables. They undoubtedly had many other uses and appear in different styles, a few country examples still retaining their original grain-painted tops. The piece in figure 283 came out of an old collection in West Hartford, Connecticut, although it may not have originated there. The delicate and shapely cabriole legs support a tray top painted to simulate marble above a deeply molded apron. In "as-found" condition, the maple base is grained to resemble mahogany.

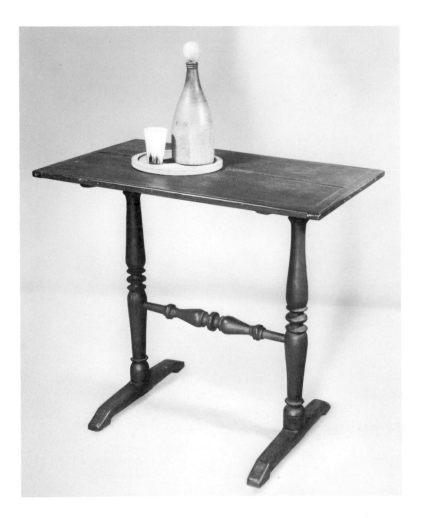

279. Table with medial stretcher, New England, 1710–1730. Ash and maple, red paint. H. 27″. W. 29″. The turned wooden bottle on the table has a stopper made from a dried gourd.

280. Folding or "tuckaway" table, New England, 1720–1740. Old red paint. H. 25″. L. 31″. The ends of the leaves had been cut off and replaced. The leaves are hung on large wrought-iron hinges backed by leather washers. (Photograph courtesy Old Sturbridge Village)

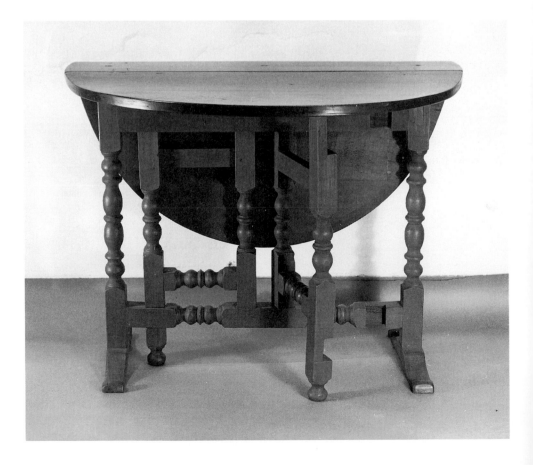

281. Table in figure 280, with leaves down, tucked behind a door. The center section measures only 5½" wide.

282. Miniature tea table, made by Samuel Newman, Andover, Massachusetts, c. 1880. Mahogany. H. 11½". Diam. of top 11½". Miniature tea set from the Caughley factory, Shropshire, England, late eighteenth century. Marked *S* for "Salopian" (the term means *from* or *relating to* Shropshire), the name by which the porcelain was generally known. H. of teapot 3½".

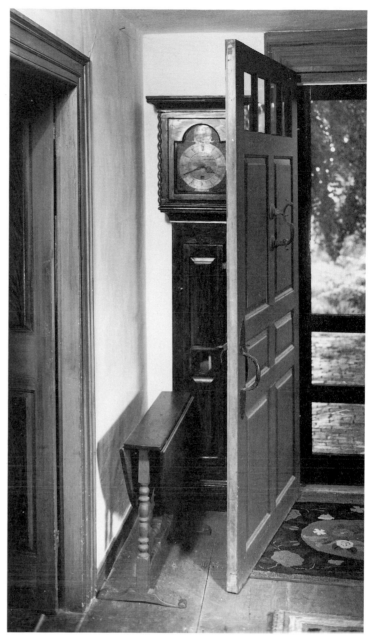

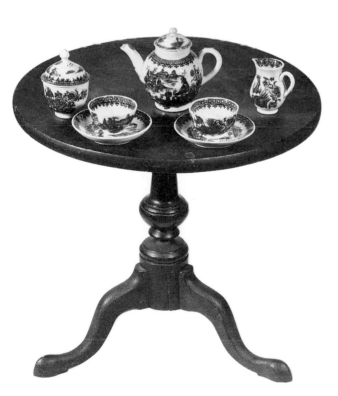

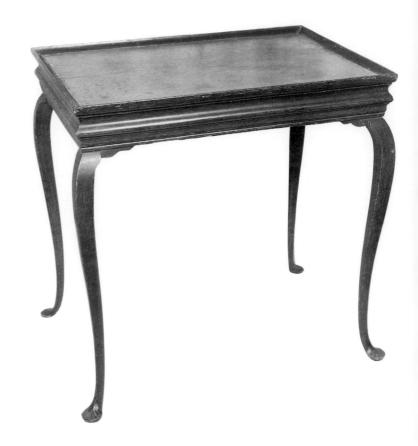

283. Tea table with marbleized top, probably Connecticut, 1740–1760. Maple and pine. H. 26½″. W. 26¾″. The table is distinguished by a strongly molded apron and unusually shapely cabriole legs.

284. Maple tea table with grain-painted top, from Hampstead, New Hampshire, late eighteenth century. H. 26½″. W. 30½″. Maple black-painted side chair from Hampstead, New Hampshire, c. 1780. H. 42″. The English delft punch bowl, with reserves on a "powdered purple" ground, is accompanied by a brass spice shaker and two long-stemmed punch glasses.

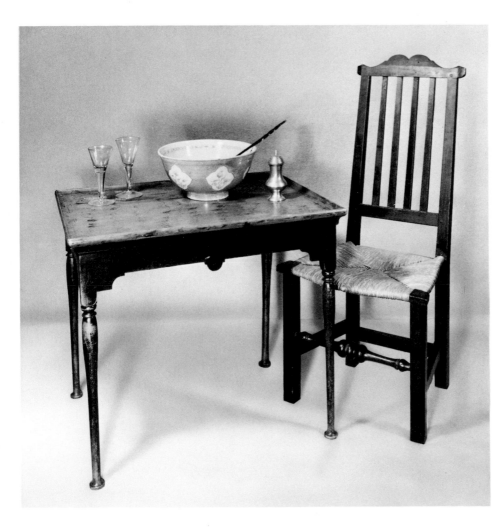

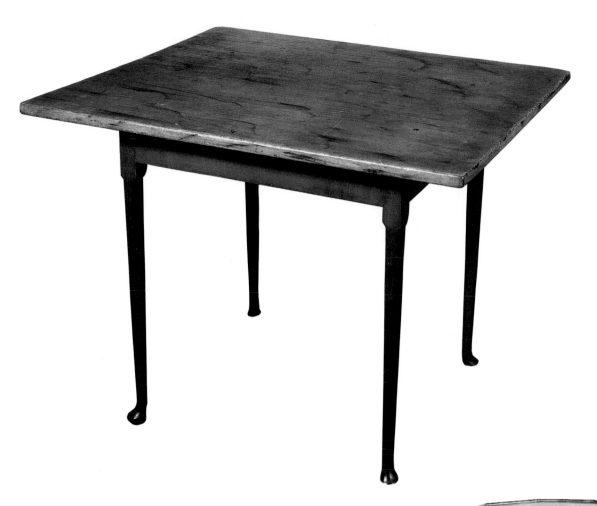

285. Tea table, New England, 1740–1780. Maple and pine. H. 27¼". W. 26½". Base has the original red paint; top is marbleized in black on gray.

286. Candlestand, possibly American, c. 1700. Unpainted, maple base, curly maple top. H. 29½". W. of top, 12¾". The turnings of the shaft terminating in a drop, the flat scrolled base, and the octagonal galleried top are features found on English examples of the late seventeenth century.

287. Mahogany fire screen with hinged candle shelf, probably of Salem, Massachusetts, origin, 1800–1810. H. 58″. W. of screen 11¾″. In 1802, Jacob Sanderson, cabinetmaker, charged Captain John Derby of Salem eight dollars for a "Fire Screen with a leaf to sett Candlestick on."

288. Tripod stand with drawer, unpainted, 1780–1790. H. 26¾″. Diam. of top 18½″. From Simsbury, Connecticut, made by the former owner's grandfather from trees grown on his land.

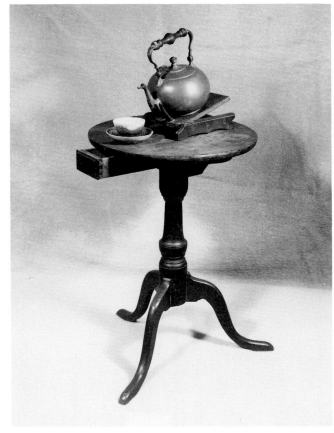

289. American birch tip-table with spade feet, New England, 1800–1825. H. 30½″. W. of top 15″. Still-life decoration of this quality is seldom found on the top of a small stand.

290. Worktable, bag missing, c. 1810. Cherry and maple with bird's-eye and curly maple veneers. H. 28½″. W. 38″. The decoration was painted by Sarah Eaton of Dedham, Massachusetts, when she was a pupil at Mrs. Rowson's Academy.

291. Top of worktable in figure 290. The picturesque English landscape scene was probably derived from an illustrated drawing-instruction book.

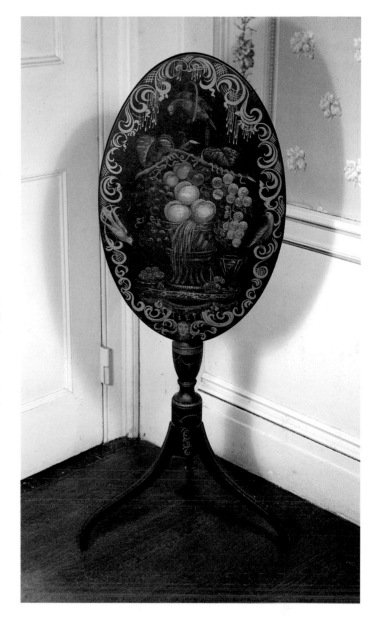

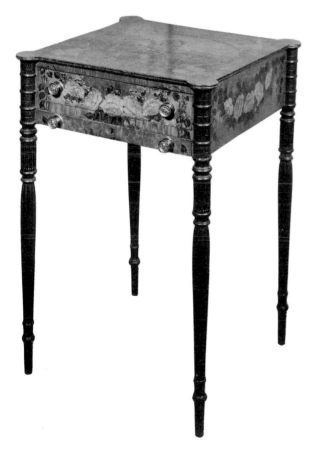

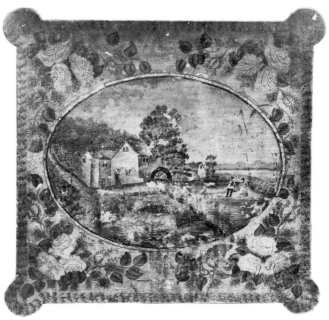

From a two-hundred-year-old house in Hampstead, New Hampshire, we were fortunate in purchasing several outstanding examples of eighteenth-century furniture that included a ball-foot four-drawer chest with its original drop brasses. The owner was a descendant of the Coffin and Little families of Newbury, Massachusetts, one of whom, Daniel Little, became an incorporator of the town of Hampstead in 1749. With the chest, we acquired the black-painted side chair (one of a pair) and the maple tea table illustrated in figure 284. The shaped apron on the table is enhanced by two center pendants, the base retains its original red-brown stain, and the surface of the galleried top is ornamented with black, random brush strokes on a blue-gray ground. The sturdy character of the table, with its straight legs terminating in button feet, results in an unusually pleasing example of country craftsmanship.

A third table that also falls into the tea table category appears in figure 285. The straight apron and the turned legs terminating in pad feet retain their unusually bright red color, and the grain-painted top is in excellent condition. As all our tables are in daily use, we find it expedient to protect the grained surfaces with small mats (hooked, sewn, or Oriental) and have been fortunate in finding suitable examples of approximately the proper size. We also use small rugs on chests and low chests of drawers when the tops are damaged or disfigured with age, thus making it possible to display and enjoy certain textiles that are too fragile for use on the floor.

So-called candlestands come in many styles, some with small fixed tops, others of the tip variety that fit unobtrusively into a corner of the room. Because of their convenience and availability, most homes furnished with antiques are liberally supplied with several types and sizes, but we have chosen to illustrate four that are quite different from one another. The stylish stand in figure 286 has been assigned an American provenance and a confident early-eighteenth-century date by the late Benno Forman of Winterthur Museum. Since 1956, Winterthur has owned a piece with a similar pedestal and drop, having the same tripod base with curious thin, flat legs terminating in scrolled feet. The museum's stand, however, has lost the raised molding that originally encircled the top. The turnings of the shaft, the octagonal galleried top, and flat scrolled legs are typical of English candlestands of the Charles II period, two comparable examples of which are illustrated in Ralph Edwards's *Shorter Dictionary of English Furniture*. A drawing of a stand of the same form is also shown on a page from a seventeenth-century English household inventory that was reproduced in Randle Holme's 1688 *Academy of Armoury*.[20] As in the Winterthur example, the base of our stand is maple, but it has a curly maple top. Beyond a history of Rhode Island ownership, there is no specific documentation; thus we are left with an intriguing problem of provenance.

It is seldom that one finds a standing fire screen included in a discussion of candlestands, and only a very few warrant this designation (fig. 287). Intended to serve as adjustable shields to protect the face from the heat of the fire, the screen portions were usually embellished with examples of ladies' work done in silk, embroidery, or ornamental painting. However, several examples are known that are made entirely of mahogany and fitted at the tops of the columns with small, hinged trays intended to support a candlestick. Two very similar examples are in the collections of Winterthur Museum and the Essex Institute, Salem, Massachusetts, each differing from ours only in the form of the base. Under the date of December 24, 1802, Thomas Hodgkins, the possible maker, charged the cabinetmaker Jacob Sanderson of Salem two dollars for "one fire Screene with a flap." Three days

later, Sanderson charged Captain John Derby eight dollars for a "Fire Screen with a leaf to sett Candlestick on."[21] Both our screen and the Essex Institute piece have early Salem histories, raising the speculation that these distinctive mahogany candlestands may have been a specialty of Salem cabinetmakers.

Tripod stands with drawers have always appealed to me, and they must have been very useful over a long period, as one associates them particularly with Shaker craftsmanship, always eminently practical in concept. Figure 288 is not, of course, a Shaker piece; we acquired it in 1942 with a family history of early ownership in Simsbury, Connecticut. The drawer spans the entire width of the table, sliding through the upper section of the pedestal beneath the top so that it may be easily drawn out at either side. Because of their long, narrow shape, these drawers are popularly believed to have held candles, and well they may have, but many other convenient uses come readily to mind.

When we first encountered the small tip-table illustrated in figure 289, we immediately admired its colorful decoration but felt that it might be of English origin. Further investigation, however, indicated that the wood is birch, and antiquarians have confirmed our belief that it is an American piece. Pictures of still-life subjects were very popular during the 1820s and 1830s and embellished the walls of many New England homes. Still-life compositions are found less often on furniture, although a somewhat similar arrangement of fruit in an urn appears on a high-style American fireboard that was formerly in our possession.[22] More delicate versions of this type of painting are associated with the large tin and papier-mâché trays that were made in Birmingham and Wolverhampton and imported from England in large numbers during the first half of the nineteenth century. To create the graceful and complex designs on a tray required the services of three different craftsmen: a striper; a borderer, who designed and executed the elaborate scrolls and "drips"; and an artist to paint the birds, fruits, and flowers.[23] This table is apparently the work of only one competent ornamental painter, but it is hardly a utilitarian piece because of the fragile nature of its surface, although its decorative quality outweighs any other possible drawbacks.

Worktables, or sewing tables, were to be found in almost every household, and many different kinds have survived. They were usually made with one or two drawers, sometimes with a plain or scalloped shelf below. At other times, a silk bag hung on a sliding frame that pulled out at the front or side. High-style examples were made of mahogany or other richly figured woods and were ornamented with inlay, contrasting bands, or veneer. Simpler pieces provided excellent subjects for the painted decoration executed by young ladies either at home or in school. In figure 290 is shown a table of stylish design that is constructed of cherry and maple, with bird's-eye and curly maple veneer. Garlands of roses and leaves adorn the front and sides and enframe a picturesque scene probably derived from a drawing instruction book (fig. 291). A handwritten note is affixed to the bottom of the drawer stating that the painting was done about 1810 by Miss Sarah Eaton of Dedham, Massachusetts, while she was a pupil at Mrs. Rowson's Academy, a well-known private school in the vicinity of Boston. A second table with similar decoration, also by Sarah Eaton, is still owned by an old Dedham family.

Because of the obvious problem of display, beds, beyond those in current use, are not usually looked on as convenient collectibles. Nevertheless we must admit to having several tucked away in the attic. One is red-painted with low posts, scalloped headboard, and large, removable ball feet—a curious feature that we have

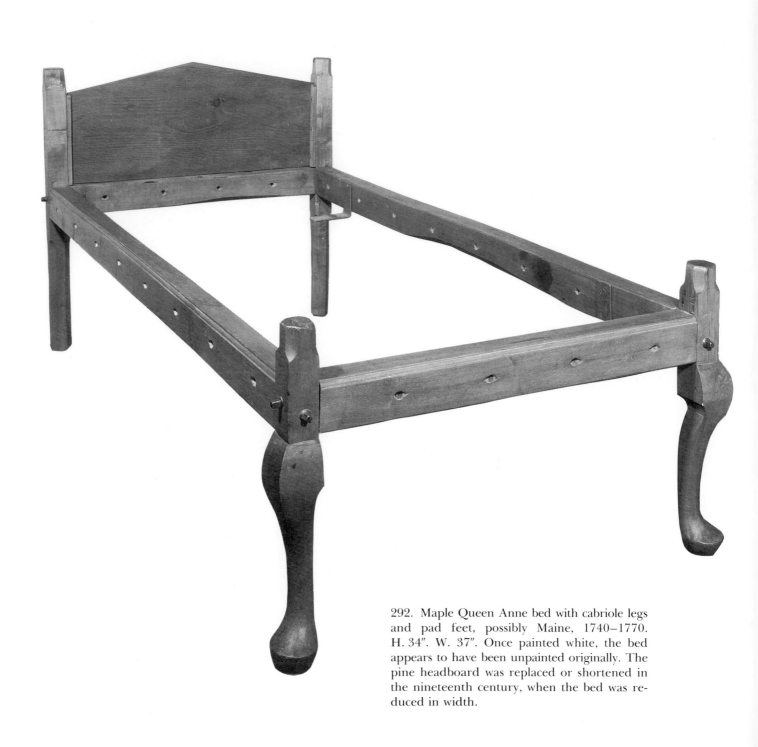

292. Maple Queen Anne bed with cabriole legs and pad feet, possibly Maine, 1740–1770. H. 34″. W. 37″. Once painted white, the bed appears to have been unpainted originally. The pine headboard was replaced or shortened in the nineteenth century, when the bed was reduced in width.

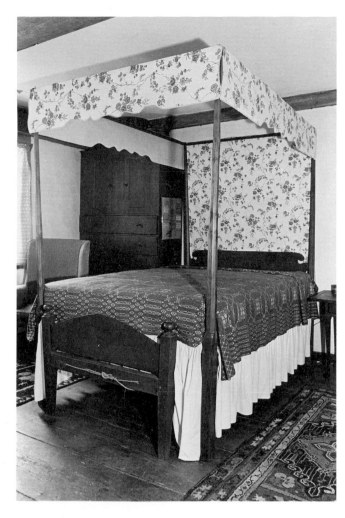

293. Birch pencil-post bed from Swansea, Massachusetts, 1780–1800. H. 80½″. W. 54″. The wallpaper tester valances are copied from an eighteenth-century paper pattern. A child's low-poster fits conveniently beneath the large bed. A tall Shaker chest of drawers stands in the background. (Photograph courtesy Old Sturbridge Village)

294. Set of paper tester valances lined with newspaper dated 1780, from which the valances in figure 293 were copied. Side pieces: L. 76½″, W. 11″. End piece: L. 54″, W. 11″.

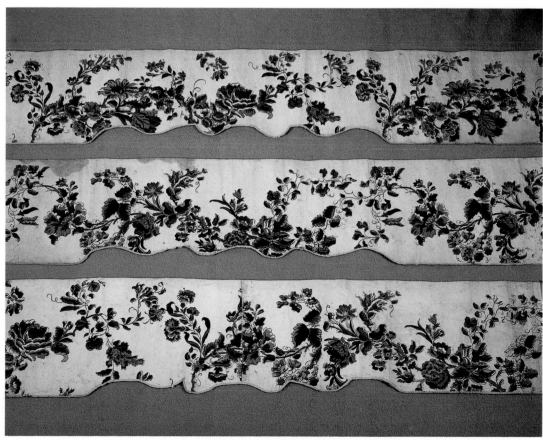

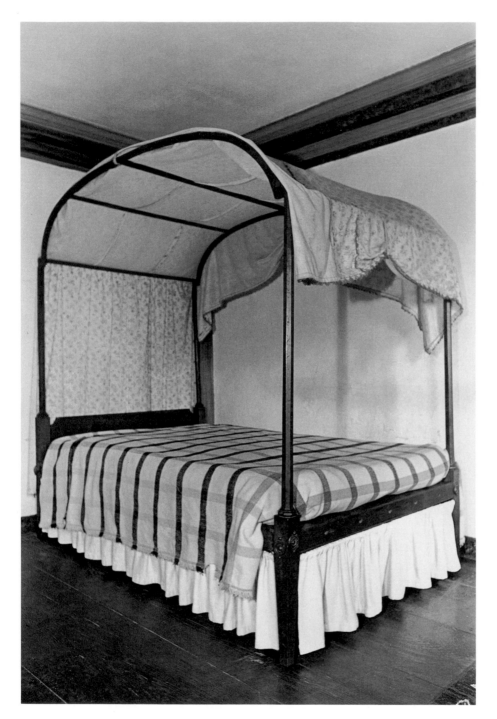

295. Maple pencil-post field bed from Connecticut, 1790–1810. H. 60½". W. 47½". The canopy frame is contemporary with but not original to this bed. (Photograph courtesy Old Sturbridge Village)

296. One of four carved rosettes, this one on a foot post of the bed in figure 295. These ornaments mark the transition between the upper and lower sections of each post. (Photograph courtesy Old Sturbridge Village)

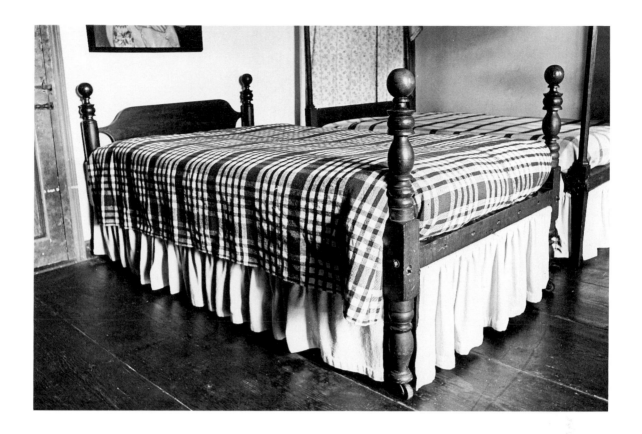

297. Maple low-post bed, original red paint, c. 1830. H. 37″. W. 43″.
Made by Luther Metcalf of Medway, Massachusetts, and acquired from
his great-granddaughter. The feet have been shortened to accommo-
date castors. (Photograph courtesy Old Sturbridge Village)

298. Wooden pattern for two profiles of "cannonball" bedposts, 1825–
1840. H. 48¼″. Inscribed in pencil: *Alfred B. Sanborn, Brookfield, N.H.*
(Photograph courtesy Old Sturbridge Village)

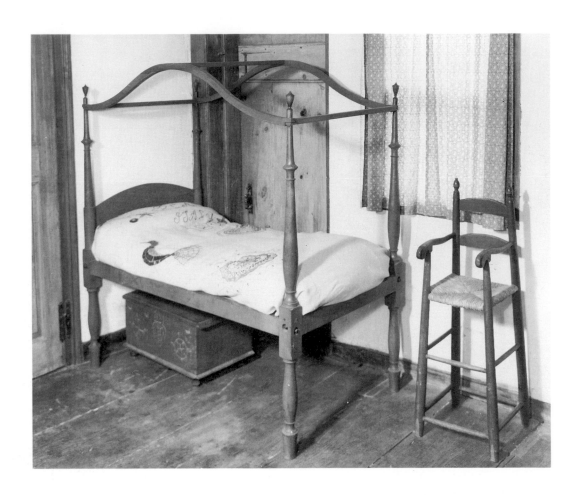

299. Child's maple canopy bed, New England, 1790–1810. Original red paint, tester frame, and urn finials. H. 54½″. W. 30″. The red-painted child's high chair is 36¾″ high. Under the bed is a decorated marriage box attributed to a maker in Hampton Falls, New Hampshire, c. 1730.

300. Folding bed, New England, 1780–1820. Maple and oak, original blue-green paint. H. of back posts 33½″. W. 52″. The front legs swivel down when the bed is open. (Photograph courtesy Old Sturbridge Village)

not happened to come upon before. Another favorite is a Shaker bed from New Lebanon, New York. It retains its soft yellow stain and the typical wooden wheels that were designed to roll it away from the wall to facilitate making up by the Sisters in the morning. We think this feature should be perpetuated, as it is equally convenient for present-day sisters!

Queen Anne beds with cabriole legs and pad feet that date to near the middle of the eighteenth century are considered rare, one being in the collection of Winterthur Museum,[24] a second at Colonial Williamsburg,[25] and a third illustrated in *Antiques* in September 1967.[26] In common with the others, our bed is maple with a headboard of pine, and the outer edges of the side and bottom rails have well-defined moldings (fig. 292). When found stored away in a small house near Thomaston, Maine, this example had evidently undergone some adaptations in the nineteenth century. It appears to have begun life as a double bed and was at one time covered with white paint, vestiges of which still lingered at the time of our purchase. There was no color discernible beneath the white, and the warm tone of the wood suggested that originally it had not been painted. Although the tops of the posts are now well worn, they may have been cut down or were perhaps finished with small caps, as is the case with the Williamsburg low-poster. The bold cabriole legs have sharply pointed knees that quickly become round in form before terminating in large pad feet raised on well-defined discs. These features are said to be associated with furniture forms originating on the Massachusetts North Shore.[27]

High-post beds came in two different styles, either made with straight canopy frames that rested on the tops of the tall posts, or having shorter posts fitted with serpentine or arched canopies. The latter were known as *tent* or *field beds*. Of the former type, we own a majestic "pencil-post," with the original canopy frame, that came from Swansea, Massachusetts (fig. 293). Following its acquisition, we faced the problem of finding suitable hangings and finally decided to try an experiment based on an eighteenth-century document. Some years before, we had purchased three rolled-up strips of heavy, flowered wallpaper, late-eighteenth-century in date (fig. 294). Because of their dimensions, combined with their asymmetrically shaped lower edges, these pieces appeared to have been side and end valances made for use on a tall, flat-top bed. One piece was lined with an old Boston newspaper dated 1780, the set having been found in Medford, a town adjacent to Boston. What pleased us was finding this visual proof that contemporary wallpaper had on occasion been substituted for more expensive fabric hangings. We found a reproduction paper that conveyed the feeling of the flowered original, and upon this Bert laid the old pieces, and penciled around the scalloped lower edges and shaped ends before doing the final cutting to size. I rebelled at trying to reproduce the fragile hand-sewn paper binding found on the edges of the originals, so I cheated a bit and used narrow gummed tape, which, from a distance, gives virtually the same effect. As no other pieces accompanied the valances, we added a matching paper back curtain, but we omitted the top panel, which would probably have been included in an original fabric set. The result is quite effective and re-creates a type of "make-do" substitute hanging that must have dressed at least one eighteenth-century bed.

The late-eighteenth-century Connecticut field bed in figure 295 has delicate pencil posts at both the head and the foot. In the illustration, the tester has been laid back to reveal the structure of the canopy frame, which is contemporary with but not original to the bed. What distinguishes this piece from many others of its type are the four carved octagonal rosettes that mark the transition between the square

members of the lower posts and the tapered upper sections (fig. 296). When we acquired this distinctive bed, the owner told the dealer that another matching it was in his attic and it would soon be for sale. Months of eager waiting ensued, until it became apparent to all that this alluring tale was only a myth. Unfortunately we needed a second bed in the room, but as it seemed unlikely that matching beds were often paired in early New England farmhouses, we decided not to follow twentieth-century taste, so we used the low-poster shown in figure 297.

In 1936, Bert became secretary of the "Harvard Tercentenary Exhibition of Furniture and the Decorative Arts of the Period 1636–1836." At that time, he and I called on several descendants of early Harvard graduates in connection with loans for this exhibition, and among them was one Mrs. Bertha Hunt. As we were leaving her home one day after a pleasant visit, she called our attention to an oversized child's bed that had lain for many years unassembled and stored under the eaves in her attic. It had been made in the early 1830s by one of her great-grandfathers, Luther Metcalf (1756–1838) of Medway, Massachusetts, who had been a major in the Revolution and an expert country cabinetmaker.[28] When we admired the bed, she was more than happy to part with it, and after our young daughter outgrew it, we had the side rails lengthened and now use it as a compatible companion to the aforementioned field bed. Some years later, we came upon the odd-looking wooden piece illustrated in figure 298. Close scrutiny revealed that it exhibits two different profiles used as patterns for the posts of "cannonball" beds. Penciled along one side is the name *Alfred B. Sanborn, Brookfield, N. H.* He was probably the local furniture maker in this small town, which happens to be located next to Sanbornville in the southeastern part of the state.

In the days when floor space in sleeping chambers was limited because of the numbers of adults and children to be accommodated, beds of all sizes and types were often used together in one room. A cradle took care of the youngest, and a trundle bed, or a low bed that slipped beneath an adult bed when not in use, could sleep one child or, in a pinch, two (fig. 293). Occasionally, an especially privileged older child was allowed a high-poster that was a carefully scaled-down model of a full-sized canopy bed. One is owned by Winterthur Museum,[29] and ours, which is quite similar but slightly smaller, is illustrated here in figure 299. What seems amazing is that this bed retains all its original elements still in good condition, including the red-painted finish, tester frame with finials, and the old linen sack-bottom secured to the rails with handmade nails. Also, it is a pleasure to see feet, especially on a child's bed, that have not been cut down.

Another convenient space-saver was the folding bed, which could be quickly pushed up out of the way when more floor space was needed (fig. 300). The side rails were hinged near the back, and a second pair of plain, slanted legs gave needed support when the bed was folded up against a wall. Usually the short front legs do not fold, but this bed is noteworthy because of its unusual design. Two turned legs conforming to the back ones are attached to a wooden bar that spans the front of the side rails. The ends of the bar revolve within the rails, allowing the legs to drop down to the floor as supports when the bed is open, but they fall flat, as shown in the illustration, when it is folded back.

VII Textiles: The Housewife's Legacy

Over the years, we have picked up a varied assortment of textiles that, for one reason or another, we have found interesting to own. Some are handmade rugs, some are coverlets acquired for use on our old-fashioned beds, which we alternate from time to time. Other fabrics are accessories that were used by housewives for domestic purposes, or that were fashioned at home as wearing apparel. In the 1940s and 1950s, one could still find at country auctions mixed lots of hand-loomed sheets, pillowbeers (pillowcases), tablecloths, and towels that had been woven on the very farms where they were currently being sold. Buyers then were not very plentiful, as kitchen equipment in good repair was more desirable than worn linen sheets or old patchwork quilts disgorged from musty blanket chests and mellowed by time.

On several occasions when friends have disposed of their heirlooms, no one but ourselves has been interested in preserving the remnants of their hand-woven linens, all lovingly initialed or numbered by ancestors whose names and dates we have carefully recorded. At other times, handmade textiles, because of their personal associations, have often been stored away and passed down in families who have inherited no other tangible relics of their past. For this reason the original owners of wedding dresses, bed coverlets, and needlework accessories are frequently more identifiable than the early makers of furniture or other types of antiques.

Crewelwork (embroidery done with woolen yarns) was a special accomplishment of the Colonial housewife, the art being taught to young ladies in many eighteenth-century needlework schools such as that of the famous Mrs. Condy, who advertised in the *Boston News-Letter* on April 27, 1738, that she sold "cruells of all sorts" with copies of needlework patterns from London.

Large folding pocketbooks were used by both men and women during the second half of the eighteenth century. The outsides were covered with decorative needlework, often in flame stitch patterns, the linings being of contrasting-colored wool. Sometimes the names or dates of the owners were worked on the upper edge of one of the inner flaps, as on the flame stitch example in figure 301 (right), where the name B WATER is embroidered on a green horizontal band. Benjamin

301. Two crewel-embroidered pocketbooks, second half eighteenth century. Left: 15¾″ x 10″; right: 17″ x 10¾″. Example at left bears the name of B WATER, who operated the Salem-to-Beverly ferry from 1769 to 1784. At right, pocketbook that descended to Bert from the Marble–Morrison family of Danvers, Massachusetts.

302. Crewel-embroidered coverlet, mid-eighteenth century. 90″ x 90″. Said to have been worked by Esther (Meacham) Strong of Coventry, Connecticut.

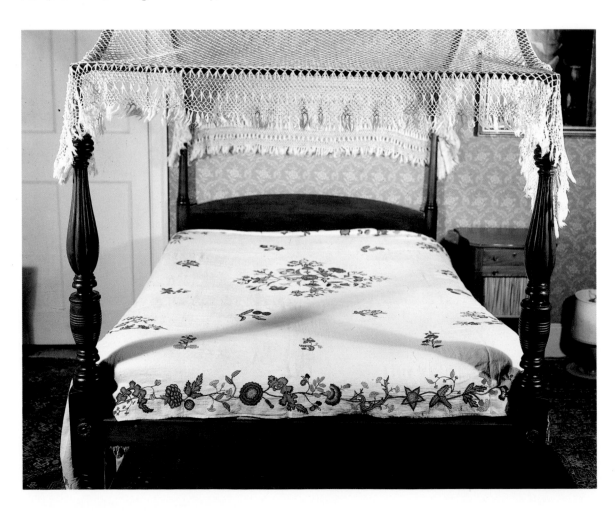

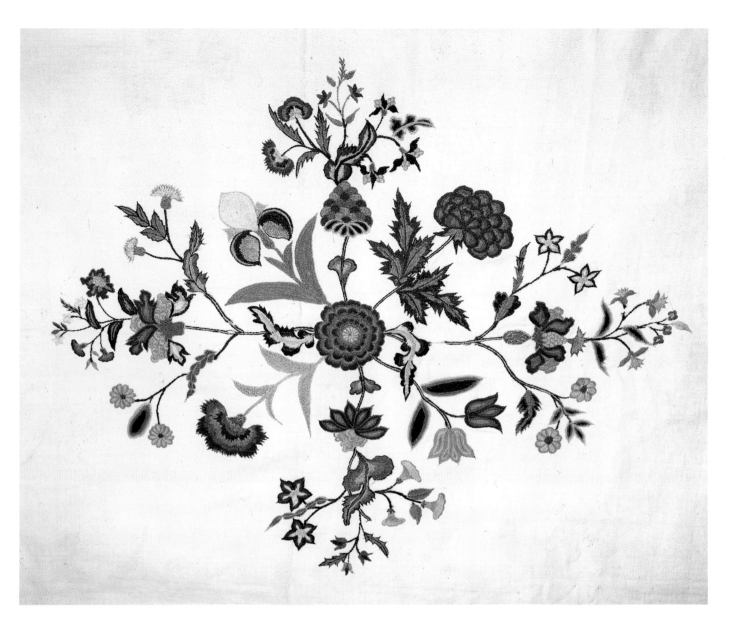

303. Central medallion of coverlet in figure 302. 26″ x 22½″.

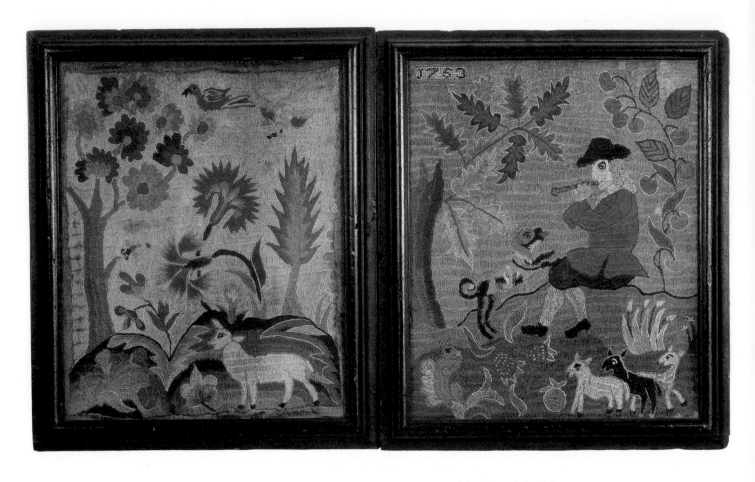

304. Pair of crewel-embroidered landscapes from New Hampshire, in original frames. The date *1753* is embroidered in petit point in the upper left corner of the picture at right. 10″ x 8″. Original frames.

305. Linen crewelwork coverlet in shades of
blue, green, and yellow, Essex County, Massa-
chusetts, second half of eighteenth century.
76″ x 6″. Several of the designs make an inter-
esting comparison with similar motifs found on
New England furniture and decorated walls.
(Photograph by Helga Photo Studio)

306. Two crewelwork linen "pockets" meant to
be tied around the waist of a busy housewife,
late eighteenth century. L. 15¾″ and 17″.

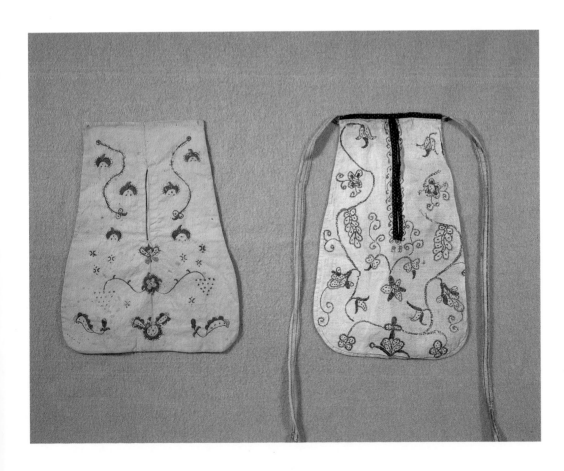

307. Oak tape loom. Attributed to Thomas Dennis, Ipswich, Massachusetts, 1668–1700. H. 33¼″. W. 10″. The loom has been mounted on a heavy maple block, probably because of an old break at the end of the handle.

308. One of a pair of heavy linen bedcovers embroidered in deep blue woolen yarn, probably New England, first quarter nineteenth century. 86″ x 72″.

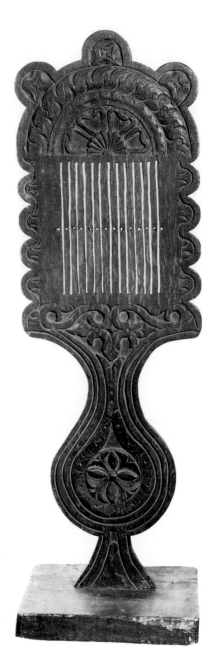

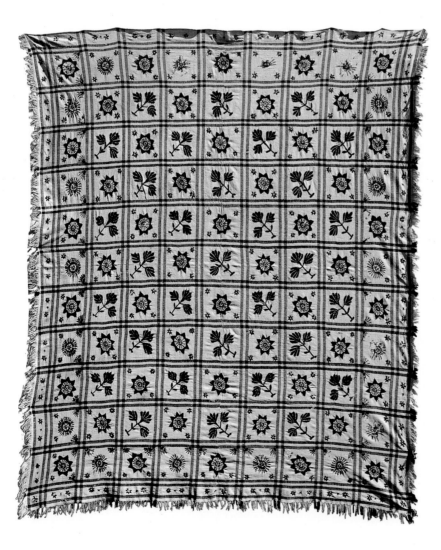

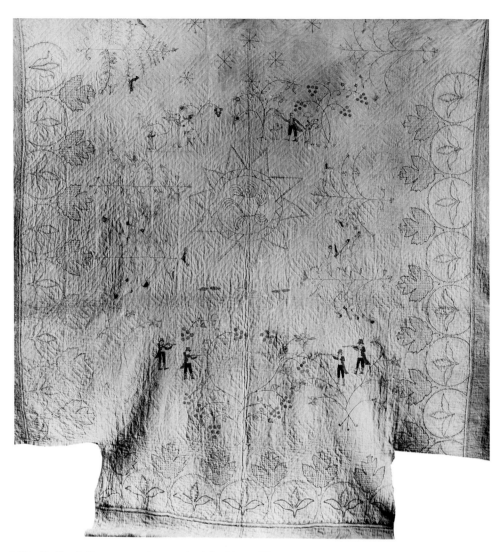

309. Quilted linen coverlet worked in blue silk outline stitch, c. 1800. 97″ x 93″. The four men in knee britches are aiming guns at a dragon that was drawn in outline but never completed in needlework. Made in the home of Mary (Beebe) Strong (1759–1834), wife of Elisha Strong of Windsor, Connecticut.

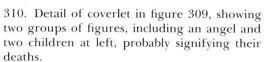

310. Detail of coverlet in figure 309, showing two groups of figures, including an angel and two children at left, probably signifying their deaths.

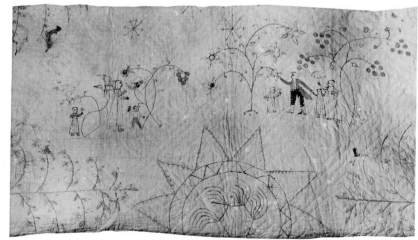

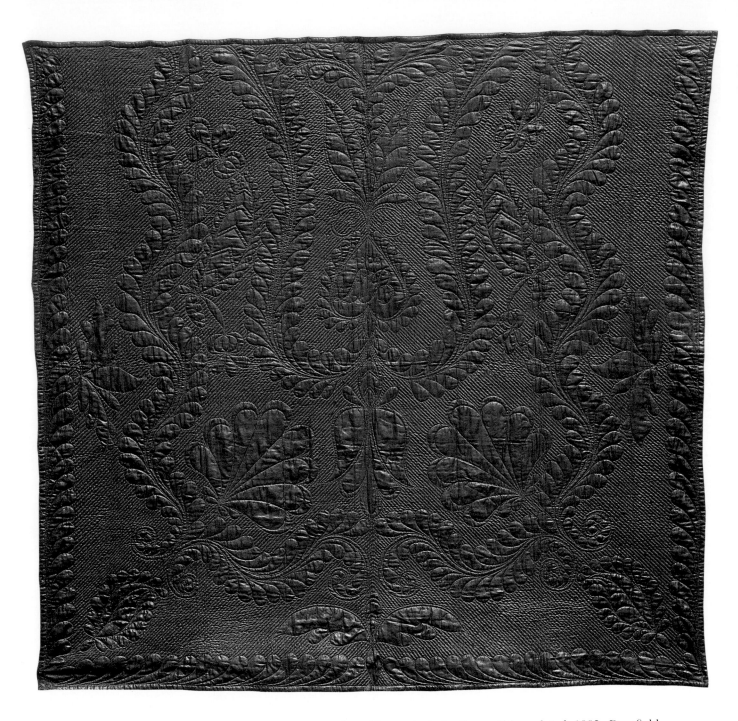

311. Exceptionally large linsey-woolsey coverlet with particularly fine quilting, dated *1803*, Deerfield, Massachusetts. 129″ x 123″.

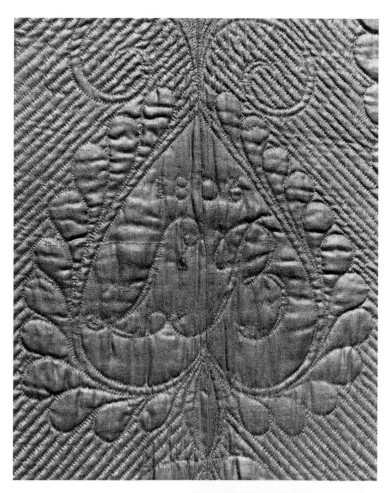

312. Detail of coverlet in figure 311, with the date *1803* quilted within a heart. The initials *L B* identify Lydia Batchelor of Deerfield, Massachusetts.

313. Blue linsey-woolsey coverlet, the weave of which exhibits a small repeat pattern, probably New England, early nineteenth century. 110″ x 98″.

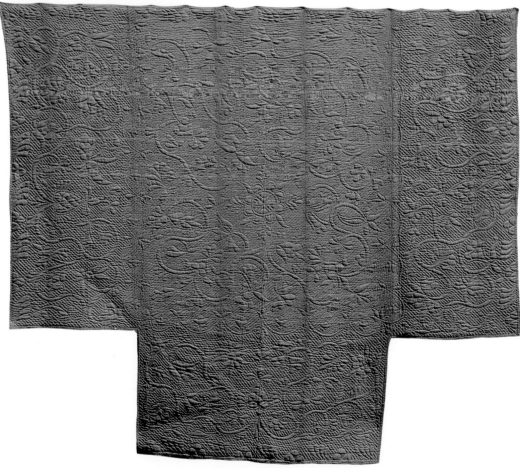

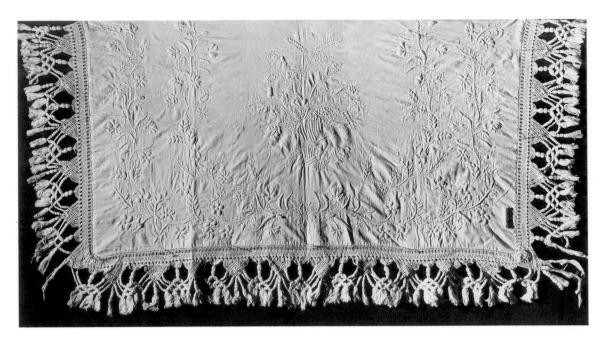

314. Section of a cotton pillow sham with hand-knotted fringe, made by Deborah Keston, New England, late eighteenth century. 56″ x 29″. The delicate raised designs are padded with cotton wicking. (Photograph by Helga Photo Studio)

315. Candlewick spread worked by Olive Hobbs of Ipswich, Massachusetts, c. 1836. 83″ x 68½″.

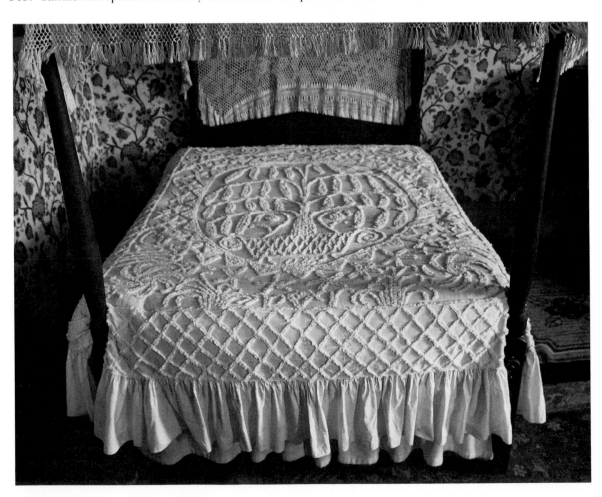

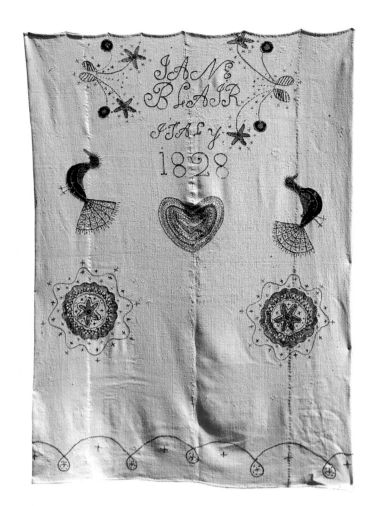

316. Woolen blanket embroidered with the name *Jane Blair, Italy [New York] 1828.* 72″ x 70″. The sides have been turned under to fit the child's bed shown in figure 299.

317. Stenciled cotton coverlet with colors mellowed by many years of home laundering, c. 1825. 109″ x 109″.

318. Cotton table cover with stenciled design and finely knotted fringe, c. 1825. 29½″ x 22½″.

Waters (1721–1784) operated the ferry from Salem to Beverly, Massachusetts, between 1769 and 1784. Another handsome example, because of its unusual stitchery and intricate floral design, descended to Bert from the Marble–Morrison family of Danvers, Massachusetts, along with an uncut crewel petticoat border (fig. 301 [left]).

Sets of bed hangings, sometimes with matching coverlets, were at times made for the best chamber. Although the hangings have often worn out or have been recut for other uses, many of the coverlets have been carefully saved. The mid-eighteenth-century crewel spread in figure 302 is by tradition the work of Esther (Meacham) Strong of Coventry, Connecticut. Her mother, Esther (Williams) Meacham, was taken into captivity and scalped by the Indians. Her grandfather was the Reverend Mr. Williams of Deerfield, Massachusetts. The aesthetic appeal of the crewel embroidery, stitched on a thin homespun-linen sheet, derives from the artistic arrangement of the scattered floral motifs and the still-bright, contrasting colors of the yarns (fig. 303). Decorative crewelwork pictures, their subjects inspired by contemporary prints, were also made at this time to hang on the wall, and a small pair of New Hampshire origin is shown in figure 304. The red-coated piper, with the embroidered date of 1753, is a familiar figure in eighteenth-century bucolic art.

Sometimes graceful meander patterns resulted in bedcovers of quiet distinction, like the one in figure 305. On this crewel spread from the vicinity of Ipswich, Massachusetts, freehand scrolls terminate in leaves and blossoms in shades of dark blue, greens, and yellows. On first seeing this coverlet, I was struck by its similarity to freehand painted designs that I had seen on an early-eighteenth-century press cupboard and also on the later plastered stair hall of an old house in southern Massachusetts. This repetition emphasizes the close relationship that existed between motifs on fabrics, on furniture, and in painted wall decoration. Much the same feeling is evident in the two "pockets" illustrated in figure 306. Bound with handmade tapes that also tied around the waist, these commodious bags accommodated all manner of useful items for the daily convenience of the busy housewife. Narrow tapes of this sort were widely used for binding and edging on eighteenth-century fabrics and were woven on small, upright tape looms shaped to be held between the weaver's knees (fig. 307). This late-seventeenth-century example is attributed to Thomas Dennis of Ipswich, Massachusetts, because of its similarity to an almost identical loom that has descended in the Dennis family, and because it exhibits several carved motifs from Dennis's recognized repertoire.

Much time and care must have been expended on the pair of embroidered linen bedcovers, one of which is shown in figure 308. It is worked in deep blue wool, and the double squares alternate in framing traditional serrated circles and graceful flower sprays. A raveled fringe provides a pleasing finish to the edges.

A very different style of coverlet, from Windsor, Connecticut, appears in figure 309. There is nothing conventional about this ingenuous design with its freely drawn flowers and trees, large perching birds, and small, animated human figures, all worked in blue silk outline stitch on a closely quilted linen ground. A strip of coarse homespun fabric is stitched around three sides to form an edging, and on it is written with pen and ink the initials *M S* (for Mary Strong) with the following note: *this quilt is 125 years old. Made at grandmother Strong's house.* The quilt came to us with an old handwritten genealogy detailing four generations of the descendants of Elisha Strong (1745–1826) and his wife, Mary (Beebe) Strong (1759–1834), the above legend having been written by Mary (Beebe) Strong's great-granddaughter, Anna Elizabeth Holbrook. Family histories such as this add very personal dimensions to the study and collecting of old textiles. Toward the top of this

quilt, a man in tailcoat, accompanied by a lady with a parasol and a small child, plucks blossoms off a tree. Opposite them stands a winged angel with a little girl and boy, perhaps suggesting the death of these children (fig. 310). At the lower center, four little men in knee britches and tall hats point guns at a legendary dragon, the outline of which was drawn in ink but never completed in needle-work.

Another popular type of bedcover that provided warmth as well as beauty was the so-called linsey-woolsey, woven with wool combined with cotton or linen. They are found today in many warm shades attained by the use of home dyes, and their decorative effect is enhanced by their intricate quilted patterns, which differ in each example. Among several in our collection is a very large quilt with glazed finish, in a vibrant shade of deep blue (fig. 311). Made by Lydia Batchelor of Deerfield, Massachusetts,[1] it bears her initials, *L B* and the date *1803* within a heart in the center of the design (fig. 312). A second linsey-woolsey quilt with cut corners (fig. 313) is a clear bright blue, the unusual weave exhibiting small repeat patterns.

Several types of "white work" were popular during the late eighteenth and the first half of the nineteenth centuries. Cornucopias and baskets filled with flowers surrounded by flowering vines are among the handsome patterns found on coverlets and other household items. Figure 314 illustrates a pillow sham identified by an early label as having been made by one Deborah Keston, presumably in 1774. The designs on the fine cotton top are raised by means of wicking held in place by tiny running stitches that are sewn through from the surface to the hand-woven cotton backing on the reverse. An intricate homemade fringe completes three sides of this attractive piece.

The majority of all-white candlewick spreads were made during the second quarter of the nineteenth century, the patterns being formed by raised loops of cotton cording stitched through to the surface from the reverse side. The loops might be left uncut; if cut, they produced a soft, shaggy pile, as shown in figure 315. This coverlet bears the initials *O.H.* for Olive Hobbs. About 1810, in Kennebunk, Maine, Olive Curtis and her two sisters lost their ship-captain father, and soon thereafter, their mother also died. The three little girls were subsequently raised by the Shakers, probably at the Alfred, Maine, community, which Olive left to marry Jonathan Hobbs of Ipswich, Massachusetts, in 1836. No doubt benefiting from her Shaker training, Olive became an expert spinner and weaver, and in addition to the spread, we are fortunate in owning three of her blankets, the ends of which are embellished with colorful rose stripes. We also have three tablecloths, each woven in a different fancy pattern.

Blankets not only were woven in many colorful checks and stripes but also served as backgrounds for various forms of needlework. We came upon two pairs of "rose" blankets, carefully stored away in the Dean–Barstow house in Taunton, Massachusetts. We had no competition in acquiring them at the family auction in 1950. They are worked with long, loose stitches in varying shades of worsted yarn. Many similar, large wheel designs embroidered in each corner date to the 1820s, these blankets having sometimes been intended as wedding gifts. Other blankets display informal embroidered patterns obviously designed by the individual maker. One feels that the needlework in figure 316 must have been executed by a child. Large irregular letters in flowing script spell the name *Jane Blair* with the place name *Italy* (New York) and the date *1828* below.[2] Circles, peacocks, and a delightfully meandering border make this blanket a universal favorite.

319. Velvet fichu with intricate stenciled border, 1825–1830. 47½″ x 23½″. Stenciling on velvet was being taught in young ladies' schools during the 1820s.

320. Velvet picture with stenciled design of fruit and flowers resting on a tin tray, 1825–1835. 20″ x 28″.

321. Reverse of a yarn-sewn rug showing the separate stitches whose loops on the surface were often cut to form a thick, soft pile.

322. Bed rug, woolen yarn sewn through a wool background support, New England. Dated within yellow serrated circle at top center, *L M / 1821.* 98″ x 92″.

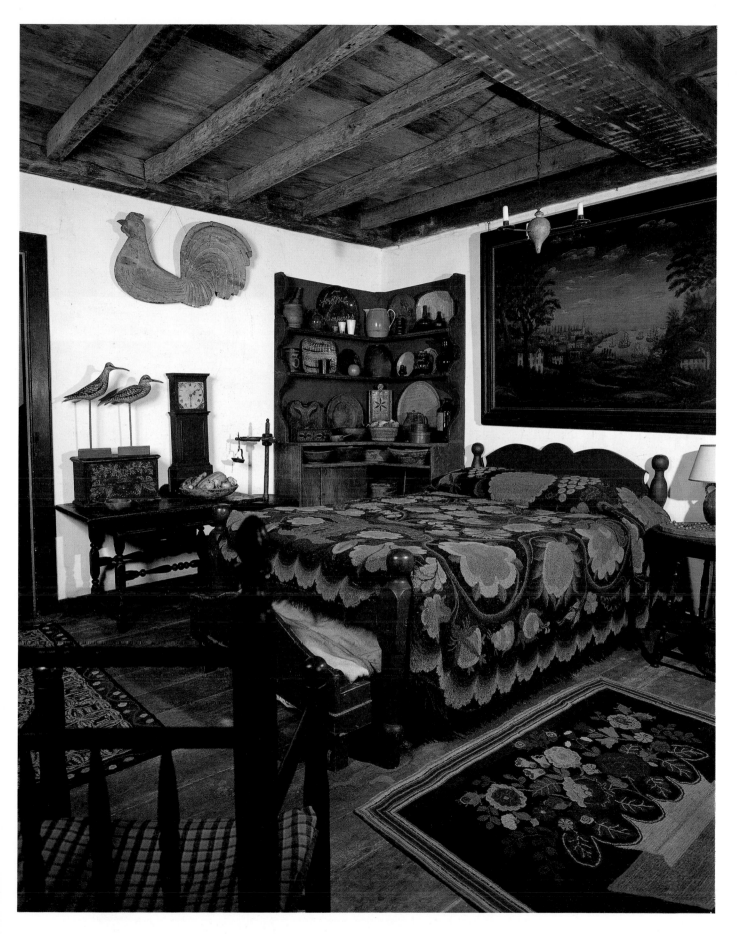

323. The bed rug illustrated in figure 322 as seen in the first-floor chamber of our early-eighteenth-century farmhouse.

324. Yarn-sewn hearth rug with tow support, Maine, 1825–1830. 76″ x 32½″.

325. Yarn-sewn rug on linen, 1825–1840. 75″ x 45″. It features blue and brown natural dyes.

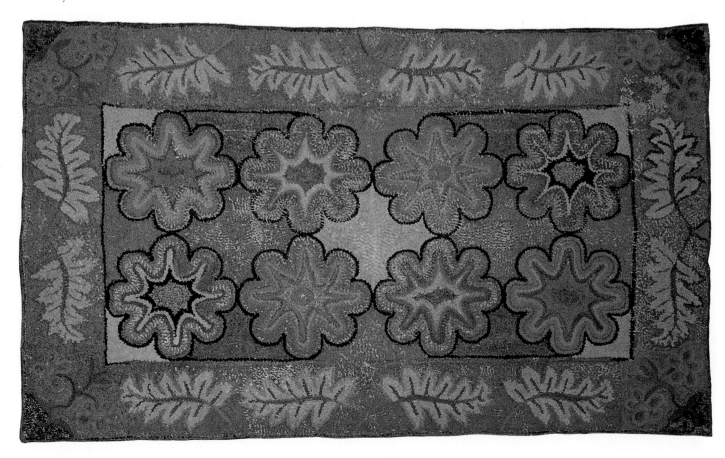

Toward the end of the eighteenth century, ladies began to introduce painted backgrounds into needlework pictures, and during the first quarter of the nineteenth century, individual embroidery stitches were cleverly imitated in watercolor. Pin pricking was used to raise the surface of the paper in simulation of french knots, and the use of theorems became increasingly popular as a quick means of decoration. Walls of rooms were stenciled as an alternative to wallpaper, and fabrics also began to exhibit stenciled patterns as substitutes for the time-consuming needlework of the previous generation. Early stenciled coverlets in good condition are relatively scarce because of the exigencies of repeated launderings and years of wear. One of our stenciled quilts (too faded to photograph) exhibits large baskets of flowers and other motifs reminiscent of the designs used in still-life pictures and also worked into homemade rugs of the period. Another stenciled bedcover, in figure 317, retains its mellow colors, the repeated medallions and graceful border resulting in an overall pattern of delicate charm.

The fine cotton table cover in figure 318, with its nineteenth-century knotted fringe, had evidently been carefully used and thus escaped the hand of the laundress. Although age has produced some slight discoloration in the background fabric, the patterns are as fresh and bright as when they were stenciled, perhaps 150 years ago. The velvet fichu, embellished with an intricate stenciled border (fig. 319), is an example of decorative wearing apparel that might well have exhibited needlework decoration if made in the previous generation. As early as 1822, the art of theorem painting (stenciling) on velvet was being taught in young ladies' schools.[3] Seen most often today are the pictorial still lifes that were framed and hung as room decoration. Although many velvet pictures exhibit formal arrangements in baskets or vases, other compositions are wonderfully naïve, such as figure 320, in which several fruits, a fruit knife, flowers, nuts, and a perching bird are all artlessly combined on a painted tole tray, without benefit of perspective.

We had purchased a few hooked rugs for use in the country during the 1920s. It was not until the early 1950s, however, that we became seriously involved with floor coverings, both because of their design and because of our interest in the various techniques used in their making. In the interim, we had learned that most small, early rugs were worked with a needle on a cotton, linen, or tow support,[4] and that after 1850, the majority were hooked through a burlap foundation.[5]

During the eighteenth century "bed ruggs," used as warm bedcovers, were made by a method now known as *yarn-sewn*. This process consisted of sewing loops of woolen yarn through a linen or tow background in a series of short separate stitches. Figure 321 illustrates a section of the reverse of a yarn-sewn piece. When the individual loops on the surface were cut, they formed a thick, soft pile. The bed rug in figures 322 and 323 is initialed *L M* and dated *1821*. It exhibits a traditional asymmetrical design that was colored, as were all early handmade yarns, with natural dyes. These pigments were derived either from local sources, such as the wood and bark of certain trees, or, in the early nineteenth century, from substances available through foreign trade. Some of the most widely used colors included *madder*, which produced reds and cinnamon browns and was derived from the roots of a plant cultivated by the Dutch in Zeeland. Madder could also be propagated in the United States. *Turmeric* gave a rich, fugitive yellow from the curcuma, a tuberous-rooted tropical plant. *Indigo* produced the best of all blues, the highest quality from a so-called drug originating in Bengal, the East Indies, and South America. *Cochineal*, which gave beautiful scarlets and crimsons, came from an insect that fed on the juices of the South American prickly pear. *Verdigris* was used

in greens, chrome, and black and was made in Europe from the rust of copper. *Sumac* was a native American shrub, the stalks giving a yellow dye, and the leaves affording drab and slate colors.[6]

Yarn-sewn rugs display a soft surface enhanced by the subtle irregularities of homemade dyes. Although difficult to date, they are considered the earliest group of handcrafted rugs, as the yarn-sewn technique was used in bed rugs from before the mid-eighteenth century through the first quarter of the nineteenth century. An unusual geometric pattern appears on the Maine hearth rug in figure 324. It is sewn through a tow ground to produce a very soft, flexible textile. A larger example drawn through linen employs the same shades of sky blue combined with vibrant yellows and browns that have been noted in other rugs that originated in Maine (fig. 325). Bark, chips, and shavings of wood from various trees were often used as dyes, butternut being a favorite that produced the rich tans and browns so often noted in homemade fabrics. A rare variant of yarn-sewing is seen in figure 326, where the expertly drawn design is executed in tightly clipped woolen yarn that is slightly raised above the surface, resulting in a pleasing sculptured effect. The background, however, is not yarn-sewn, being filled in with long even rows of needlework stitches.

A second method of rug making, popular from approximately 1835 to 1860, was accomplished by gathering strips of cotton fabric with needle and thread and sewing them onto the surface of the supporting foundation. In this technique, known as *shirring*, only the strong linen stitches are visible on the back of the rug (fig. 327). Sometimes narrow strips of woolen cloth were stitched widthwise to the base, then folded upward to form pleats, and stitched down again. When packed tightly against one another, the tops of the pleats formed a hard, even pile (fig. 328). At other times, fabric strips were stitched lengthwise, forming gathered folds when the thread was tightly pulled. Many of the shirred designs are very clear and precise, such as the prim house with fruit trees (fig. 329), whose support is a coarse linen grain bag initialed *J.D.P.* in large black-painted letters. The richly colored rug in figure 330, with its wide border of leaves and intricate center motifs, was stitched onto linen and has become thin and soft from many years of use underfoot. A third method of shirring is illustrated by the rug in figure 331, where small circular strips of fabric were folded and secured to the foundation by their apexes. The raveled edges of the individual rosettes create a loose, shaggy surface that is attractive to the eye but has not resulted in good wearing qualities on the floor.

Hooked rugs form the largest and most varied group of homemade nineteenth-century floor coverings. Although an occasional example exhibits a cotton or linen support, the majority were fabricated from remnants of used store-bought materials (both wool and cotton) cut into long strips and drawn with a hook through a coarse burlap backing. The dating of individual examples may be problematical, but the presence of commercially made fabrics and brightly hued synthetic dyes suggests a post-1850 date, as does the use of burlap, whose component of jute, derived from the fibers of an East Indian tree, was not imported to this country until soon after the middle of the nineteenth century. A hooked rug is easy to distinguish from a yarn-sewn or shirred piece, as the reverse of the foundation exhibits solid rows of flat loops that correspond in color and pattern to the designs on the surface of the rug (fig. 332).

Even though the fabrics and the dyes of hooked rugs were seldom of domestic origin, most of the ingenuous early patterns were drawn in the home, usually directly on the foundation, to facilitate the work of the hooker. Pictorial, geometric,

326. Yarn-sewn rug on a tow support, second quarter nineteenth century. 68½" x 25½".
The background surface is embroidered in long stitch.

327. Reverse of a shirred rug utilizing a combina-
tion of several fabrics. The stitches of linen thread
fasten the surface strips to the background support.

328. Shirred rug with vine pattern, 1840–1860. 87½″ x 40¾″. Strips of woolen felt are stitched across their width onto the foundation, then pleated and stitched again to form tightly packed surface rolls.

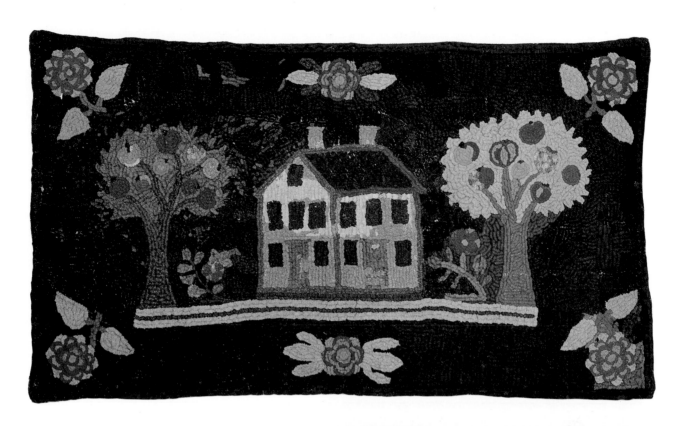

329. Shirred rug, second quarter nineteenth century. 58¾″ x 34″. The woolen strips are gathered lengthwise and sewn onto a heavy tow grain bag, initialed *J.D.P.*

330. Shirred rug on linen, whose central section is reminiscent of the design of an Oriental rug, 1850–1860. 71½″ x 42″.

331. Shirred rug on cotton, c. 1840. 64″ x 31½″. Circular patches of cotton fabric have been sewn by their centers onto the background support, their roughly cut edges creating a loose shaggy surface.

332. Reverse of a hooked rug. The flat loops on the back closely approximate the appearance of the surface design.

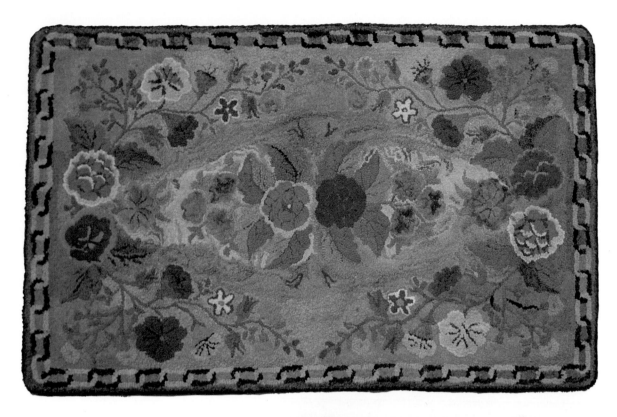

333. Hooked rug with a colorful floral pattern, probably New England, late nineteenth century. 53″ x 33″.

334. Hooked rug based on an Oriental design, by Edward Sands Frost, c. 1870. 72″ x 37½″. Frost peddled his stenciled rug patterns from door to door in Maine from 1864 until his retirement in 1876.

335. Hooked rug with stag, a favorite motif in the late Victorian period, 1880–1900. 76″ x 67″.

336. Needlework rug, 1825–1835. Woolen yarn on hand-spun linen. 57″ x 34½″.

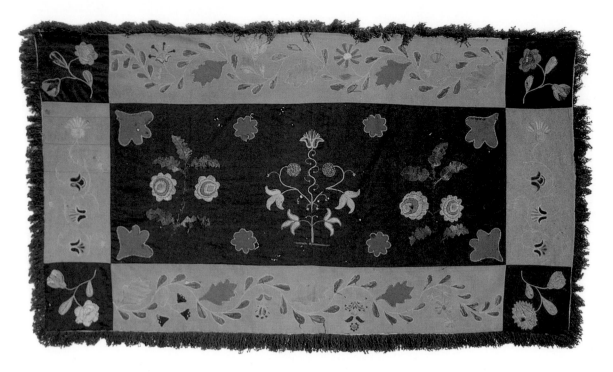

337. Appliqué and needlework rug, New England, c. 1830. 57″ x 37″. Patches of homespun woolen fabric are combined with embroidered motifs to create this well-designed piece worked on a woolen background.

338. Striped carpeting of New Hampshire origin, first quarter nineteenth century. 13″ x 8″. Each strip is 32″ wide. Woolen warp, cotton weft. The natural dyes and homespun yarn result in a pleasing irregularity of texture and color.

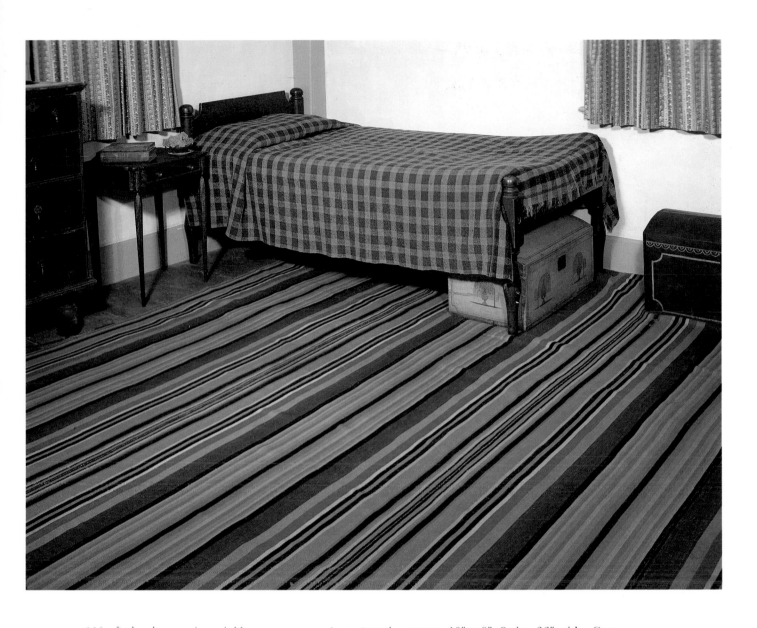

339. Striped carpeting of Maine origin, mid-nineteenth century. 18" x 9". Strips 36" wide. Cotton warp and weft. Probably factory-made with chemical dyes.

and floral designs were favorites, the latter deriving their decorative quality from combining gay colors with artistic arrangements of leaves and flowers (fig. 333). Edward Sands Frost, born in Lyman, Maine, in 1843, specialized in the stenciling of hooked-rug designs, which he sold from a peddler's cart beginning in 1864. Before his retirement in 1876, he had cut some 750 stencils, and these are now owned by the Henry Ford Museum and Greenfield Village, Dearborn, Michigan. Perhaps Frost's most original contribution was designing a group of patterns copied or adapted from Oriental imports, of which figure 334 is a good example.[7] During the last quarter of the nineteenth century, animals, such as friendly lions, tigers, leopards, and domestic pets, became popular at a time when numerous stamped patterns were offered through catalogues or peddled from door to door. The magnificent stag and his admiring companion, surrounded by flowers and enhanced by a period enframement, must have lent elegance and dignity to some late Victorian parlor (fig. 335).

In addition to the groups mentioned above, various individual needlework rugs were designed and made by industrious housewives. Reminiscent of the patterns employed in ladies' art of the second quarter of the nineteenth century is the embroidered piece in figure 336. It was worked on hand-woven linen in two-ply woolen yarn, and its surface colors have now faded to soft shades of rose, beige, blue, and green.

Rugs embellished by the method known as *appliqué*, whereby small pieces of contrasting fabrics were stitched onto the surface of the background material, were in use in the early nineteenth century, when Charles M. Hyde reminisced as follows about his youth in the small town of Brimfield, Massachusetts: "The first carpets were introduced about 1802. They were made of square pieces of cloth sewed together, ornamented with various patterns cut from differently colored cloth, and sewed on."[8] The rug in figure 337 exhibits a background of buff and blue wool, onto which were sewn contrasting homespun patches, combined with needlework motifs worked in buttonhole, satin, chain, and cross stitch.

A considerable quantity of factory-made carpeting was imported from England during the second half of the eighteenth century and used in the homes of the well-to-do. Commercially made carpets of American manufacture were available in New England by 1825. In many small country homes, however, strips of striped carpeting 32″–36″ wide were sewn together to make the desired size. We have been on the lookout for pieces of different types and patterns for a number of years, but good examples are becoming increasingly hard to find. Much of the striped carpeting that dates to the early nineteenth century was made from wool that was spun and woven at home and colored with natural dyes, a method that resulted in a noticeable irregularity of surface and color. The New Hampshire carpet in figure 338 combines soft greens and browns accented with an occasional thread of bright blue. The warp is wool and the weft is cotton. A different range of equally vibrant colors was used in the example illustrated in figure 99, which originated in Richfield Springs, New York, probably about 1825. This has a cotton warp and a weft of homespun flax tow. Cotton was factory-spun—and also woven on an experimental basis in New England—as early as the 1790s. By the middle of the nineteenth century, striped carpeting was being factory-made and displays a tighter and more even surface combined with the brighter colors derived from the use of artificial dyes. The handsome carpet in figure 339 was found in the closet of a house in South Paris, Maine, and is probably a mid-nineteenth-century factory-woven product.

VIII
The Children's World

There are probably few collectors of American antiques who have not been beguiled into acquiring at least a few children's pieces. Miniature items, either toys or objects actually made for use by little folks, are almost irresistible to most antiques lovers and are to be found in many related fields. Eighteenth-century doll's furniture and china are often sold as early "tradesmen's samples," although there is little contemporary documentation known to me that substantiate this designation.[1]

Attitudes toward youth have changed over the years, and this change becomes evident in the children's portraits that form one of the most delightful groups of early American art. From children filling the dignified roles of small adults during the seventeenth and eighteenth centuries, to the child as an accepted part of the average nineteenth-century family, youngsters were portrayed from the cradle to adolescence with an unconscious humor and an ingenuous reality that make each picture a minor masterpiece.

About 1820, an unidentified artist painted a typical group comprising five members of the Charles Richardson family of Boston. The parents were taken in traditional bust-length poses, but each child was depicted with his or her own personal attributes. Young *George Richardson* is shown in figure 340, hat in hand, walking to school, a neat white clapboard building that may picture Groton (now Lawrence) Academy, Groton, Massachusetts, Groton having been his mother's native town.[2] George's younger sister, Louisa, presents an extraordinary image of a tall two-year-old child who has apparently just stepped out of the baby's cradle resting on the floor behind her (fig. 341).

Cradles, made either for infants or to be played with as toys, still survive in many forms; a typical example of the latter now holds an eighteenth-century "Queen Anne" doll (fig. 342). A similar doll of larger size sits comfortably in the small Windsor armchair in figure 343. On the right is a much-worn slat-back to which rockers were probably added a long time ago. This little chair, with its ring turnings, heavy slats, and shaped finials on the front and back posts, is constructed entirely of oak and may predate the mid-eighteenth century.[3] A blue padded bon-

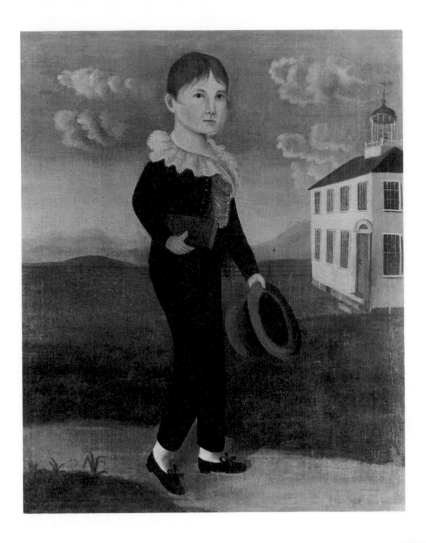

340. *George Richardson*, Boston, c. 1821. Artist un-known. Oil on canvas. 21″ x 17″. The school in the background may represent the 1793 building of Groton (later Lawrence) Academy.

341. *Louisa Richardson*, Boston, c. 1821. Artist un-known. Oil on canvas. 21″ x 16″. We own one of Louisa's schoolbooks, inscribed in her own hand: *So. Boston, April 4, 1826.*

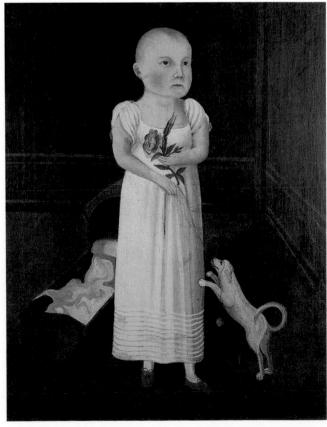

342. Doll's cradle with Queen Anne doll, New England, first quarter nineteenth century. Pine. L. 17″. W. 12″.

343. Two children's chairs, New England. Windsor chair, c. 1800. Maple, oak, and pine; black paint. H. 24″. W. 22¼″. Legs cut down. Slat-back chair, 1700–1750. Oak, unpainted. H. 20″. W. 16¼″. The rockers have been added.

net hangs within easy reach, and two homemade rattles lie on the seat. The straw example is especially intriguing as it is so cleverly woven, probably around a dried nut, that there is no way of gaining access to the rattling sound inside.

Although many old-time dolls, and endearing portraits of children holding them, are available today, the watercolor of the young Indian girl Denny Soccabeson, with her own counterpart depicted as a doll, would appear to be unique (fig. 344). *Denny Soccabeson,* wearing the traditional peaked cap and silver disc jewelry of the Passamaquoddy tribe, was the daughter of Francis Joseph Neptune, last hereditary governor of the Passamaquoddy Indians of Pleasant Point, Eastport, Maine. During the War of 1812, Eastport was occupied by English troops from 1814 to 1818. The town was garrisoned by the British, and this scene was painted in one of the barracks buildings in 1817. Beyond the window may be seen a sentinel with a sword and a British officer in a red tunic. The artist is unknown but below the picture is the partly illegible inscription: *Denn . . . on, daughter of Francis Joseph— Governor of the Passamaquoddy tribe Eastport Sept. 18th 1817.*

An unusual combination of a child's desk with a stand is illustrated in figure 345. Both pieces are grain-painted to produce the same red finish, and the center section of the stand lifts up to reveal a writing space with pigeonholes whose shaped tops match exactly those of the desk's interior (fig. 346).

Sometimes the accessories or backgrounds of nineteenth-century children's portraits "steal the show," thereby distracting the eye from the main theme of the composition. This effect is illustrated by the portrait of little *Sarah Benham,* who sits composedly on what appears to be an oddly tilted carpet (fig. 347). But it was the prim red Connecticut house, with its country Greek Revival facade, that made this picture impossible for us to resist.

A generation earlier, during the 1790s, Joseph Steward of Hartford, Connecticut, was also using scenes with small buildings in some of his portrait backgrounds. When we first saw five-year-old *Maria Malleville Wheelock* (fig. 348), I noticed that the large house behind her at the right displayed a prominent hanging signboard, and I immediately surmised that Maria was a tavernkeeper's daughter. This was far from the case, however, as she was the child of no less a personage than John Wheelock, second president of Dartmouth College. The picture was probably executed by Steward around 1793, when he received the commission from Dartmouth to paint a portrait of the Reverend Ebenezer Wheelock, Maria's grandfather.[4] Another late-eighteenth-century Connecticut artist, whose identity has not been definitely ascertained (although it may have been Steward himself), used similar distinctive backgrounds. A typical example is the small boy in figure 349, painted by the "Denison Limner," so-called because of the artist's many portraits relating to the Denison family of Stonington, several of which display buildings similar to Steward's as settings for the sitters.

Children's portraits were frequently painted as part of a larger family group. If their pictures later became separated from those of their parents, the identity of the subjects was often lost. Fortunately this was not the case with the portraits of Harriet Goodnow and her mother, which, through an odd set of circumstances, have always remained together (figs. 350 and 351).

During the mid-1850s, a political struggle was in progress in the recently opened Territory of Kansas between the friends of freedom and others who were determined to make Kansas a slave-holding state. In March 1855, William E. Goodnow of Norway, Maine, with his brother Isaac and two hundred other New Englanders, set out to found a town, soon named Manhattan, where they joined other

Free State forces already working in Kansas. The town prospered and grew, but Goodnow became so deeply involved in his duty toward the others, who were also endeavoring to accomplish their joint mission, that he never returned, except for short visits, to his affectionate family in Maine. Nor could Mrs. Goodnow, who was not in good health, face the prospect of leaving a comfortable home to lead the life of a western pioneer. However, the portraits of his wife and his daughter Harriet were taken by Goodnow to his Kansas home, where they remained together until after his death in 1876, following which they were eventually returned to New England.

Attributed to the little-known Maine artist John Usher Parsons, these colorful likenesses, through their freedom of expression and bold, untutored style, epitomize the spirit of true folk art as rendered by an intuitive, although untrained, hand.

Countless children's playthings are still to be found, the categories being too varied and numerous to mention here. Many particularly fascinating toys were imported from Europe during the nineteenth century. We have only a few examples, but we like the little building titled on its signboard BEEF BUTCHER (fig. 352). With its many different hanging cuts of meat, this is a toy version of the larger glass-encased models that were made for display in the windows of English butcher shops during the 1840s. Miniature hand-whittled shorebirds, perhaps simulating full-sized decoys, were also children's favorites, judging from the various well-worn examples we have seen. A small sampling of painted gulls and ducks is illustrated in figure 353, arranged in a sort of collage against the background of a nineteenth-century painting of Little Good Harbor Beach and Salt Island at Bass Rocks, Gloucester, Massachusetts, where four generations of my family have spent many happy summers.

A red-painted toy cupboard is shown in figure 354, its shelves filled with diminutive American earthenware utensils, none exceeding 3½″ in height. One of the most varied and interesting categories of children's toys comprises the eighteenth- and early-nineteenth-century ceramic miniatures that were imported from England. Creamware toy tea sets like that illustrated in figure 40 were popular to such an extent that their arrival in this country was heralded by notices in the local press. One such advertisement appeared in the *Boston News-Letter* of November 28, 1771: "To be Sold at the Three Sugar-Loaves in Cornhill . . . the following articles: a fine assortment of Tea-pots . . . a great Variety of Mugs, Pitchers, Bowls and Basons . . . several compleat Table-sets of Children's cream-coloured toys."[5]

A rare black-glazed tea set, probably by Thomas Whieldon about 1760, is displayed on a footed creamware stand in figure 355. Unusually complete for a toy set, this one contains tea- and coffeepots, milk jug, sugar bowl, hot-water kettle, and a cup and saucer and must have delighted some lucky child, as much as it now warms the heart of this fortunate collector. At the same period, tiny pieces were being made in white salt-glaze, a type of stoneware that had been brought into the port of Boston as early as the 1740s. The large 14″ dish in figure 356 is accompanied by its 3″ counterpart, in company with a tiny mug and teapot.

Part of a large blue-printed dinner service is shown in figure 357, and it illustrates the variety of forms (including a soup tureen with ladle) that were included in a single miniature set. This one is decorated with Josiah Spode's "Tower" pattern, which he also used on comparable full-sized tableware.

The years following Queen Victoria's accession to the English throne occa-

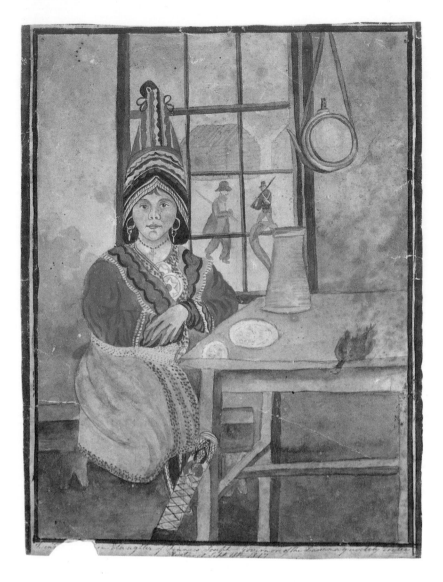

344. *Denny Soccabeson*, Eastport, Maine. Artist unknown. Written below picture: *Denn . . . on, daughter of Francis Joseph—Governor of the Passamaquoddy tribe Eastport Sept. 18th 1817.* Watercolor on paper. 7¾″ x 6″.

345. Child's desk with stand, c. 1800. Grain-painted in red. Desk: H. 17¼″. W. 17¾″. Stand: H. 27″. W. 26½″.

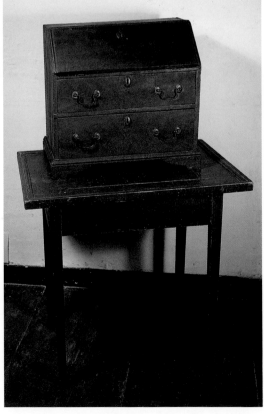

346. Desk-stand. The pigeonholes match those in the interior of the desk in figure 345. The underside of the lid reveals the brightness of the original grained finish.

347. *Sarah Benham*, Connecticut, c. 1840. Artist unknown. Oil on canvas. 35½″ x 34½″. The tilted carpet suggests that Sarah is about to "take off."

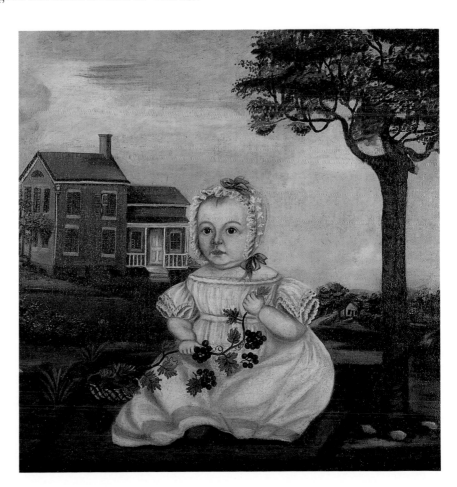

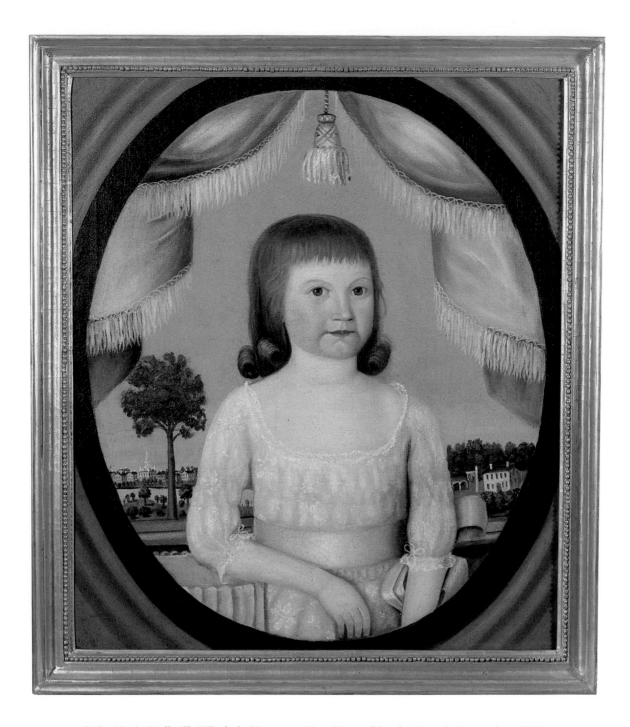

348. *Maria Malleville Wheelock,* Hanover, New Hampshire, by Joseph Steward, c. 1793. Oil on canvas. 28¾″ x 24½″.

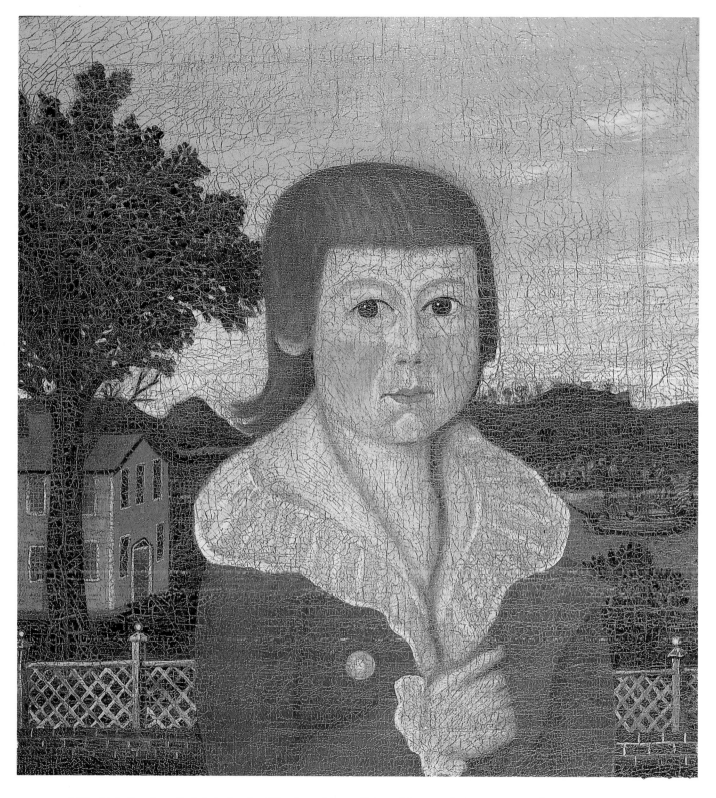

349. *Little Boy in a Red Suit,* by the "Denison Limner" (possibly Joseph Steward), c. 1790. Oil on canvas. 19″ x 17″. Descended in the Coit family of Norwich, Connecticut.

350. *Harriet Goodnow*, daughter of William and Harriet (Paddleford) Goodnow, Norway, Maine, attributed to John Usher Parsons, c. 1837. Oil on canvas. 33½″ x 20″. Harriet was a fine musician and a member of the church choir. She died in 1845 at age fourteen.

351. *Mrs. William E. Goodnow* (Harriet Paddleford), Norway, Maine, attributed to John Usher Parsons, c. 1837. Oil on canvas. 33½″ x 26½″. The portraits of Mrs. Goodnow and her daughter Harriet were taken to Manhattan, Kansas, by Mr. Goodnow and have always remained together since his death in Kansas in 1876.

sioned the issuing of many patriotic souvenirs to be purchased and treasured by her devoted subjects. The little folks were not forgotten, and for them were made doll's dinner sets (fig. 358) colorfully decorated with a scene of two of the royal children riding in a goat cart in the grounds of Windsor castle (fig. 359). Victoria's first child, the Princess Royal, was born on November 21, 1840, and Edward, Prince of Wales, arrived just a year later, so this appealing little set probably appeared in the early 1850s.

Most social historians are well aware of the continuing influence on local education provided by individual writing masters during the eighteenth and nineteenth centuries. Surviving examples of superior penmanship, unique pictorial memorials, and cleverly illustrated family records attest to professional expertise that went beyond the rudiments of basic instruction routinely provided in community schools. Teachers of penmanship were often itinerants. They opened writing schools for brief periods wherever scholars could be obtained and then moved on to the next town. They found patronage in large cities as well as in the rural areas through which they passed. Their equipment was frequently carried in a convenient wooden box that contained paper, pens, penwipers, bottles of homemade ink, and various other appurtenances of their craft.[6]

James Guild, born in Halifax, Vermont, was in 1797 a traveling peddler, tinker, penmanship teacher, and likeness and miniature painter who kept a pungent diary covering his travels from 1818 to 1824. In this unique and detailed journal, Guild recounted both the sad and the happy experiences of itinerancy in America during the first quarter of the nineteenth century.[7] Following brief attendance at a writing school in Royalton, Vermont, the ambitious young man called himself a Writing Master and professor of penmanship, and after only thirty hours of instruction, he started his own writing school in Hancock, New Hampshire. Such was the interest in learning calligraphy that twenty pupils enrolled for a period of two months, after which he continued his travels, arriving eventually in Skaneateles, New York. There, practicing his "New System," he "engaged in inventing a New Stile of writing for business," and in the ensuing five years, the teaching of penmanship became one of his major sources of income. At some time in his career, he posed for what may have been a self-portrait, complete with quill pen and paper, on which, in fine calligraphy, appears the appropriate legend: *James Guild Penmanship* (figs. 360 and 361).

As time went on, Guild began to paint profiles and miniature portraits. He studied for three months in New York City, and when "improved enough," he went on to try his luck with miniatures in Baltimore, where he described his visit in part as follows:

> I drew up a subscription paper and went round the City stating if I could get 12 engaged I would take them for half price in order to get started. I soon got the number and meet with very good success . . . I then went to painting and after a little time I made money enough to pay my debts and have $60, in my pocket. . . . The people in Baltimore are generally familiar and hospitable, take much notice of strangers, particular if they have a genteel appearance. The ladies are fond of parties.[8]

It seems curious that Guild's work has generally remained unrecognized, perhaps because few of his small likenesses were signed. One, at least, has recently appeared depicting a child with toy horse and whip in hand (fig. 362) and signed at

the lower right: *James Guild Baltimore 1820.* In 1824, Guild sailed out of New York for London and "commensed his profession as an artist." While abroad, he is said to have engaged in superior portrait and miniature painting. His last years were spent in the West Indies, but he died in New York City about 1841.

The eighteenth-century copy sheet illustrated in figure 363 was penned by Betsy Drake of Epping, New Hampshire, in 1791. Appropriately titled THE WRITING MASTERS INVITATION & INSTRUCTION, it reads in part:

> Come youth this charming sight behold,
> With laurel plum'd a pen of gold,
> If you would win this glorious prize,
> Do as your master shall advise,
> Till you from learners masters grown
> Make both the bags and gold your own.

Further moral maxims are set forth ON CARE, INDUSTRY, HOPE & FEAR. Within the circle headed ON A WATCH appears this succinct verse:

> Time flies
> Man dies,
> Eternity's at hand
> What's best
> My rest
> In the Emmanuels land

An unusually informal and surprisingly humorous schoolmaster's tribute occasioned the watercolor drawing shown in figure 364. It is enclosed in a paper wrapper inscribed, "A present to Miss Katy Newton from her teacher, in 1794, Marlborough Depot, N.H." Catherine Newton was born in Marlborough in 1786, her brother Artemus (at right) in 1785. The whimsical rhymes below the figures appear to be original, in contrast to the stilted verses that often accompanied children's exercises. At the left are written the following lines:

> Here's Katy Newton, here she stands
> A spelling book within her hands
> She's reading to her master dear
> How well she reads do only hear
> She learns her lessons very well
> She can both read and also spell
> She may be called a scholar bright
> In learning she takes great delight
> I do admire how well she reads
> Tho she's but eight years old indeed . . .

A more humorous verse appears at the right:

> Artemus Newton with his glass
> Of wine stands drinking to his lass
> My health to you Madam says he
> Will you drink a glass of wine with me? . . .

352. Toy butcher shop. Sign reads: BEEF BUTCHER. A nineteenth-century import from England. Wood. H. 7″. W. 6½″.

353. Toy gulls and ducks, New England, late nineteenth or early twentieth century. Painted pine, homemade. L. 1¾″ to 3¾″.

354. Toy cupboard, New England, late nineteenth or early twentieth century. Pine. H. 18″. W. 8″. Miniature American red pottery. H. 1½″ to 3½″.

355. Toy tea set, England, attributed to Thomas Whieldon, c. 1760. Black-glazed earthenware. H. of teapot 3″.

356. Salt-glazed stoneware, England, c. 1760. Large plate, Diam. 14″. Miniature plate, Diam. 3″.

357. Miniature blue-printed dinner set, England, by Josiah Spode, first quarter nineteenth century. H. of large tureen, 3″.

358. Miniature dinner set picturing Queen Victoria's children, England, c. 1850. Maker unknown. Deep dish at left, 3" x 3¾".

359. Two of Queen Victoria's children are pictured in a goat cart at Windsor Castle.

She takes the glass and drinks the wine
Another glassful stands behind
And one good turn deserves another
So therefore go and bring me t'other.

Ha ha ha

As mentioned in Chapter IV, mourning pictures in memory of President Washington proliferated during the first quarter of the nineteenth century. Those made by children that date to 1800, or shortly after, tend to be less conventional, and therefore more interesting, than the later ones. The ink-and-wash drawing in figure 365 is signed *Sir William Plumer. Æ 13, August 26th 1802*, and bears, in part, the following appropriate verse:

Where shall our country turn its eyes
What help remains beneath the skies
Our friend protector strength and trust
lies low and mould'ring in the dust . . .

William Plumer of Epping, New Hampshire, was the son of Governor William Plumer, a lawyer and statesman who was elected to the U.S. Senate in 1802 and later became the first president of the New Hampshire Historical Society. William, his son, was equally prominent, an accomplished speaker and writer, an ardent abolitionist, and a member of the U.S. Congress from 1819 to 1825. It is not known why the prefix *Sir* appears before his name, but one suspects that the young man was (as the saying goes) "giving himself airs."

Many handwritten exercise books were illustrated with children's naive watercolor drawings, but journals were more often the work of adults who had received basic instruction as part of their primary education. Among our historical manuscripts are three handwritten, paperbound volumes titled *Family Records*, one of which is a fascinating account of eighteenth- and early-nineteenth-century life in the tiny settlement of Lempster, New Hampshire, which in 1775 boasted 128 inhabitants. To this "inconsiderable Township," the author, Alfred Abell, moved with his parents in 1774, when he was two years of age. Among the pastimes of a typical country childhood, Abell, reminiscing in 1837, described catching grasshoppers, chasing butterflies, climbing trees after birds' eggs, hunting squirrels, and assisting his father in building dams, making waterwheels, erecting windmills, and setting up liberty poles.

The writer was much concerned with the depredation of bears and wolves on farmers' sheep and cattle: "Bears and Wolves were plenty in the early settlement of this new world and were very mischievous; but Bears were much easier traped [*sic*] and destroyed than Wolves as they do not possess half the sagacity nor are they half so mistrustful." Large bear hunts were organized in the neighborhood, and on one horrifying occasion, young Abell recorded,

As I plodded on I happened to raise my eyes a little, and casting a glance fowards, and to my unutterable surprise a Monstrous Bear sat in my path . . . looking straight at me, so I could feel the hair crawl under my hat as I had no weapon of defense. But he manifested no displeasure at my approach and after a moment of profound silence he modestly rose up and civilly made off.

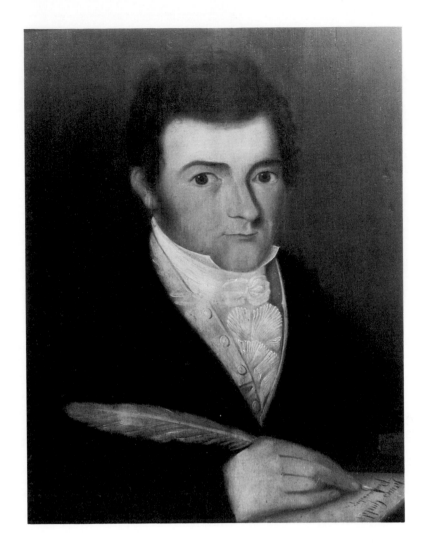

360. *James Guild*, 1820–1824. Inscribed at lower right: *James Guild / Penmanship*. Oil on panel. 18½″ x 14½″. Guild was an itinerant writing master and also a portrait and miniature painter. This picture may have been a self-portrait.

361. Detail of inscription, probably in Guild's calligraphy, on portrait in figure 360.

274

362. Miniature portrait of a child. Signed at lower right: *James Guild / Baltimore 1820*. 6¼″ x 4¾″.

363. Children's writing exercise. Inscribed: *Betsy Drake's, Epping* [N.H.] *Nov. 4th 1791*. Pen-and-ink and watercolor on paper. 15¾″ x 12¾″.

364. Schoolmaster's tribute, Marlborough Depot, New Hampshire, 1794. Artist unknown. Watercolor on paper. 12″ x 14¾″. At left, Katy Newton and her teacher. At right, her brother Artemus Newton and his "lass."

365. Memorial to Washington. Inscribed: *Sir William Plumer. Æ 13, August 26th, 1802*. Pen and gray wash on paper. 15¾″ x 12½″.

366. Illustration from the journal of Alfred Abell, Lempster, New Hampshire, c. 1837. Ink and water-color on paper. 6½″ x 6¾″. Titled: *Dea. Shepherd Shooting the Bear In October 1808.* The bear is pictured as described in the journal, with trap, chain, and hook attached to her foot.

This scene and similar incidents are illustrated in amusing small pen-and-ink and watercolor sketches throughout the journal, and on one occasion in 1808, a community bear-trapping expedition was organized that occasioned a detailed description accompanied by the half-page illustration that appears in figure 366. The leading hunter "planted his trap in the bear's path. In the morning he found to his great joy that he had taken the Bear. She had no less than 40 or 50 pounds of weight of trap and chain attached to her foot and was gone into the forest." The men tracked her for some distance, carrying the trap in her teeth until the hook finally caught in some bushes. Then they found and shot her. After she was carried home slung on a pole, "Shepherd treated us with as much new Rum as we could drink, and plenty of good Bread and cheese." Thus closed with conviviality one successful hunt.

The Chronicle of our collection happily still continues, for the joys of collecting never end.

Notes

CHAPTER I

1. N. Hudson Moore, *The Old China Book* (New York: Frederick A. Stokes, 1903).

2. W. C. Prime [The Youngest Member], *The China Hunters Club* (New York: Harper & Brothers, 1878).

3. *The Old China Magazine* (New York: Ceramic Studio Publishing, October 1901–September 1904), vol. I, no. 1, to vol. III, no. 12.

4. Lura Woodside Watkins, *Early New England Potters and Their Wares* (Cambridge: Harvard University Press, 1950), p. 15.

CHAPTER II

1. Guy S. Rix, comp., *Genealogy of the Foss Family in America* (Concord, N.H., n.d.), pp. 15, 20.

2. William D. Knapp, *Somersworth: An Historical Sketch* (Somersworth, N.H., 1894), p. xxxiv.

3. Joseph Tate, *Journal 1769–1778* (in the New Hampshire Historical Society), p. 86.

4. *Ibid.*, p. 95.

5. Rix, *Genealogy of the Foss Family*, pp. 15, 20.

6. Madeline Hampton, "Riley Whiting—Clockmaker," *The Decorator*, vol. 17, no. 1 (Fall 1962), p. 18.

7. Robert S. Dodge, "A Grandmother Clock with Wooden Works," *Antiques* (March 1938), p. 133.

8. Charles S. Parsons, "G. G. Brewster, Watch-Maker and Dentist" (typescript).

9. James Rindge Stanwood, *Direct Ancestry of the Late Jacob Wendell* (Boston: David Clapp & Son, 1882), pp. 30, 31.

10. Jean Gorely, *Old Wedgwood* (Wellesley, Mass.: Wellesley Press, 1941), pp. 82, 84, 100.

11. Nina Fletcher Little, "The Cartoons of James Akin upon Liverpool Ware," *Old-Time New England*, vol. 28, no. 3 (January 1938), pp. 103–108.

12. W. D. John and Warren Baker, M.D., *Old English Lustre Pottery* (Newport, England: R.H. Johns, Ltd., 1951), pp. 21, 22.

13. Nina Fletcher Little, "European Redware and Its Chinese Ancestors," *Antiques* (January 1938), pp. 14–19.

14. C. Malcolm Watkins, "North Devon Pottery and Its Export to America in the 17th Century," *U.S. National Museum Bulletin*, vol. 225 (Smithsonian Institution, Washington, D.C., 1960), p. 27.

15. For an excellent description of Highfields and its history, see Lura Woodside Watkins, "Highfields and Its Heritage," *Antiques* (August 1966), pp. 204–207.

16. For this first version of the "California Song," and for other details of the 1849 voyage of the *Eliza*, see the account of the supercargo Alfred Peabody of Salem, written on the occasion of the twenty-fifth anniversary of her sailing. Alfred Peabody, "On the Early Days and Rapid Growth of California," *Essex Institute Historical Collections*, Part I (January 1874).

17. Jean Lipman, *Rediscovery: Jurgan Frederick Huge* (New York: Archives of American Art, 1973), p. 4.

18. Trautman Grob, artist and drawing master, is listed in George C. Groce and David H. Wallace, *The New-York Historical Society's Dictionary of Artists in America, 1564–1860* (New Haven and London: Yale University Press, 1957), p. 276.

19. John Wilmerding, *Fitz Hugh Lane 1804–1865: American Marine Painter* (Salem, Mass.: The Essex Institute, 1964), p. 54.

20. Linda Mitchell McKee, "Capt. Isaac Hull and the Portsmouth Navy Yard," Excerpt from her doctoral dissertation, St. Louis University, 1968.

21. Robert Bishop, "John Blunt: The Man, the Artist, and His Times," *The Clarion* (Spring 1980), pp. 21–39.

22. Nina Fletcher Little, "J. S. Blunt, New England Landscape Painter," *Antiques* (September 1948), pp. 172–174.

23. Nina Fletcher Little, "T. Chambers, Man or Myth?," *Antiques* (March 1948), pp. 194–196; Howard S. Merritt, "Thomas Chambers—Artist," *New York History*, vol. 37, no. 2 (April 1956), p. 222.

24. The masthead figure of the *Mattie F. Dean* and other masthead figures are illustrated in M. V. Brewington, *Shipcarvers of North America* (Barre, Mass.: Barre Publishing Company, 1962), p. 108, figs. 105, 107.

25. Letters to me from Philip Chadwick Foster Smith, Peabody Museum, Salem; and from George Ellis, Silver Springs, Maryland, dated August 22 and December 17, 1969.

CHAPTER III

1. *Plain & Elegant Rich & Common: Documented New Hampshire Furniture, 1750–1850*. Exhibition catalogue (Concord, N.H.: New Hampshire Historical Society, 1979), p. 128.

2. Edward Deming Andrews and Faith Andrews, *Shaker Furniture: The Craftsmanship of an American Communal Sect* (New Haven, Conn.: Yale University Press, 1937).

3. Letter to me from Benno Forman, Winterthur Museum, June 10, 1970.

4. Nina Fletcher Little, "Winthrop Chandler," *Art in America*, vol. 35, no. 2 (Issue of April 1947).

5. Nina Fletcher Little, *American Decorative Wall Painting, 1700–1850* (Sturbridge, Mass.: Old Sturbridge Village, in cooperation with Studio Publications, 1952). New enlarged edition (New York: E. P. Dutton, 1972).

6. Nina Fletcher Little, "English Engravings as Sources of New England Decoration," *Old-Time New England*, vol. 54, no. 4, series no. 196 (April–June, 1964), p. 96.

7. Edward Roe Snow, *The Islands of Boston Harbor* (Andover, Mass.: Andover Press, 1935), pp. 79–108.

8. *The Essex Journal and New Hampshire Packet* (October 28, 1789).

9. Letter to me from John Hardy, Victoria and Albert Museum, London, July 20, 1972.

10. The John Custis Letter Book is deposited in The Library of Congress.

11. I. N. Phelps Stokes and Daniel C. Haskell, *American Historical Prints: Early Views of American Cities, Etc.* (New York: The New York Public Library, 1933), p. 21.

CHAPTER IV

1. *Antiques* (February 1941), p. 87.

2. *Ibid.*, p. 96.

3. *Antiques* (January 1939), p. 8. This panel, described and illustrated in Chapter III, is now in our collection.

4. Clara Endicott Sears, *Some American Primitives* (Boston: Houghton Mifflin, 1941).

5. Grace Adams Lyman, "William M. Prior, The 'Painting Garrett' Artist," *Antiques* (November 1934), p. 180; Sears, *Some American Primitives*, pp. 31–43.

6. Articles on William M. Prior, Thomas Chambers, John S. Blunt, and Thomas Thompson were published in *Antiques* in January, March, and September 1948, and in February 1949.

7. *The Borden Limner and His Contemporaries*. An exhibition organized by Robert C. H. Bishop, The University of Michigan Museum of Art, November 14, 1976–January 16, 1977.

8. Barbara and Lawrence B. Holdridge, "Ammi Phillips, 1788–1865," *The Connecticut Historical Society Bulletin*, vol. 30, no. 4 (October 1965), pp. 197–245.

9. I am indebted to Mrs. Stephen Hill for her kindness in bringing these advertisements to my attention.

10. This portrait was advertised for sale by Joy Piscopo, *Maine Antique Digest* (April 1976), p. 31A.

11. The few details concerning Gassner's life are contained in a letter from his great-granddaughter that is quoted in Sears, *Some American Primitives*, p. 289.

12. George Smith's letters to his brother Royall Brewster Smith are quoted in Claude R. Wiegers and Rosalie Trail Fuller, *Andrew M. and O. S. Smith, Sons of Maine . . .* (privately printed, 1979), pp. 17, 19.

13. Nina Fletcher Little, *Paintings by New England Provincial Artists, 1775–1800*. Exhibition catalogue (Museum of Fine Arts, Boston, July–October 1976).

14. Nina Fletcher Little, "Dr. Rufus Hathaway, Physician and Painter of Duxbury, Massachusetts, 1770–1822," *Art in America* 41, no. 3 (Issue of Summer 1953).

15. Harold Bowditch, "Early Water-Color Paintings of New England Coats of Arms," *Publications of The Colonial Society of Massachusetts*, vol. 35 (December 1944), pp. 172–209.

16. *Ibid.*, fig. 1.

17. One of the wall panels from the Clark–Frankland house that displays an escutcheon bearing the Hubbard arms is illustrated in Nina Fletcher Little, *American Decorative Wall Painting* (New York: E. P. Dutton, 1972), p. 32.

18. These arms are described in William Armstrong Crozier's *General Armory* (New York: Fox, Duffield, 1944) and are illustrated in the manuscript *The Gore Roll of Arms* (copy of Harold Bowditch, 1926, no. 150.2).

19. Walter Kendall Watkins, "John Coles Heraldry Painter," *Old-Time New England* (January 1931), p. 136.

20. Harold Bowditch, "Heraldry and the American Collector," *Antiques* (December 1951), pp. 539, 540.

21. Bowditch, "Early Water Color Paintings," p. 86.

22. Bill from Robert Cowan to John Derby, December 7, 1791, *Essex Institute Historical Collections*, vol. 81 (January 1946), p. 94.

23. Through the courtesy of Mr. Robert Cushing and Mrs. Matthew Cushing, we visited the Peter Cushing house in 1957. At that time, we were able to identify and photograph most of the furniture and accessories that appeared in the Ella Emory paintings. My remarks on the interior of the house are based on our 1957 visit.

24. Although Moses Morse has not been recorded as a cabinetmaker in Loudon, New Hampshire, a very similar secretary-desk is in the Colonial Williamsburg collections. This piece has no definite provenance. Two other pieces, however, a pine tavern table and a fine inlaid chest of drawers, are still owned by a descendant of the

Osborne family of Loudon and suggest the probability that a competent cabinetmaker (perhaps Moses Morse) was working in the neighborhood. See Barry A. Greenlaw, *New England Furniture at Williamsburg* (Williamsburg, Va.: The Colonial Williamsburg Foundation, 1974), no. 102.

25. Janet Waring, *Early American Wall Stencils* (1937; reprint, New York: William R. Scott, 1942), pp. 50–56, figs. 46, 49, 50.

26. Carol Damon Andrews, "John Ritto Penniman (1782–1841): An Ingenious New England Artist," *Antiques* (July 1981), p. 164.

27. Richard C. Kugler, *William Allen Wall: An Artist of New Bedford.* Exhibition catalogue, November and December 1978 (New Bedford, Mass.: Old Dartmouth Historical Society, 1978).

28. A second group of J. S. Russell's local watercolors, including his view of the Abram Russell house, is in the collection of the Old Dartmouth Historical Society, New Bedford, Massachusetts.

29. B. June Hutchinson, "A Taste for Horticulture," *Arnolda* (The Arnold Arboretum of Harvard University), vol. 40, no. 1 (January/February 1980), p. 46.

30. I am grateful to Mrs. John W. Rand for providing the foregoing information about old buildings in Freeport, obtained during a "Historic Survey of Freeport" undertaken during the 1970s under a grant from the Maine Historic Preservation Commission.

31. Emily Noyes Vanderpoel, comp.; Elizabeth C. Barney Buel, ed., *Chronicles of a Pioneer School from 1792 to 1833* (Cambridge, Mass.: The University Press, 1903).

32. Betty Ring, "Saint Joseph's Academy in Needlework Pictures," *Antiques* (March 1978), pp. 592–599. This valuable article includes many fascinating pictures recording the appearance of the academy as it grew and expanded during the nineteenth century.

CHAPTER V

1. For information concerning Tom Wilson, I am indebted to John Nove, former Curator of Natural History, Peabody Museum of Salem.

2. Frederick Fried, *Artists in Wood* (New York: Clarkson N. Potter, 1970), pp. 18, 19.

3. Fiske Kimball, *Mr. Samuel McIntire, Carver The Architect of Salem* (Portland, Me.: Southworth-Anthoensen Press, 1940), p. 140.

4. I am grateful to Mrs. John R. Rand, formerly of Freeport, Maine, for valuable information about Noah Pratt and for notes on gravestones carved by him in the Mast Landing Cemetery.

5. *Massachusetts Spy* (July 24, 1776).

6. The history of this carving is documented by an old label affixed to the back and written by William Lincoln, Librarian of the American Antiquarian Society, 1836–1837.

CHAPTER VI

1. Letter to me from Benno Forman, Winterthur Museum, June 3, 1969.

2. The chest and box were both included in the exhibit and catalogue by Robert Blair St. George,

The Wrought Covenant: Source Material for the Study of Craftsmen and Community in Southeastern New England, 1620–1700 (Brockton, Mass.: Brockton Art Center, Fuller Memorial, 1979), nos. 8, 58.

3. Nina Fletcher Little, *Neat and Tidy: Boxes and Their Contents Used in Early American Households* (New York: E. P. Dutton, 1980), pp. 1–13.

4. John Sheldon's "Indian House" was taken down in 1848, but the ancient oak door with a gash made by the Indians is on exhibit in Memorial Hall, Deerfield.

5. A six-legged highboy with a similar scalloped skirt is in the Winterthur Museum and is illustrated in Jonathan L. Fairbanks and Elizabeth Bidwell Bates, *American Furniture, 1620 to the Present* (New York: Richard Marek Publishers, 1981), p. 55.

6. Preston R. Bassett, "Collectors' Notes," *Antiques* (May 1959), pp. 460, 461; Edith Gaines, "Collectors' Notes," *Antiques* (August 1962), p. 172.

7. Esther Stevens Fraser, "Pioneer Furniture from Hampton, New Hampshire," *Antiques* (April 1930), pp. 312–316.

8. Dean A. Fales, Jr., *American Painted Furniture, 1660–1880* (New York: E. P. Dutton, 1972) p. 43, fig. 52.

9. John Stalker and George Parker, *A Treatise of Japanning and Varnishing* (1688; reprint, London: Alec Tiranti, 1960), p. 79.

10. A set of six Chandler-family side chairs, not in our possession, bears the same carved ornamentation.

11. Charles S. Parsons, *The Dunlaps & Their Furniture.* Exhibition catalogue (Manchester, N.H.: The Currier Gallery of Art, 1970), p. 175.

12. *Ibid.*, p. *57.

13. The General Samuel Strong Historical Collection was sold at auction at the Hotel Plaza, New York City, by the National Art Galleries Inc., on December 3, 4, and 5, 1931. The Strong chair was illustrated in *The Fine Arts* (December 1931).

14. A chair that is similar to these in almost every respect is illustrated in Robert Bishop, *Centuries and Styles of the American Chair 1640–1870* (New York: E. P. Dutton, 1972), p. 52.

15. Fairbanks and Bates, *American Furniture*, p. 223.

16. Illustrations of four typical writing-arm Windsor chairs appear in Edgar G. Miller, Jr., *American Antique Furniture* (Baltimore: The Lord Baltimore Press, 1937), vol. 1, p. 271.

17. For further examples of trestle-foot stands, see Wallace Nutting, *Furniture Treasury* (New York: Macmillan, 1948), vol. 1, nos. 1205, 1208; Barry A. Greenlaw, *New England Furniture at Williamsburg* (Williamsburg, Va.: The Colonial Williamsburg Foundation, 1974), no. 112.

18. Rodris Roth, *Tea-Drinking in 18th-Century America: Its Etiquette and Equipage* (Washington, D.C.: United States National Museum, Bulletin 225, 1961), p. 72.

19. *Ibid.*, p. 68.

20. Rupert Gentle and Rachel Field, *English Domestic Brass* (New York: E. P. Dutton, 1975), Section 26.

21. Charles F. Montgomery, *American Furni-*

ture: The Federal Period (New York: Viking Press, 1966), p. 246.

22. Nina Fletcher Little, *Country Arts in Early American Homes* (New York: E. P. Dutton, 1975), fig. 166.

23. Ziller Rider Lea, ed., *The Ornamented Tray* (Rutland, Vt.: Charles E. Tuttle, 1971), p. 66.

24. Joseph Downs, *American Furniture: Queen Anne and Chippendale Periods* (New York: Macmillan, 1952), fig. 1.

25. Greenlaw, *New England Furniture at Williamsburg*, p. 11, no. 1.

26. Edith Gaines, "The Robb Collection of American Furniture," *Antiques* (September 1967), p. 324.

27. Greenlaw, *New England Furniture*, p. 152, no. 1.

28. For an account with illustrations of Luther Metcalf and his work, see Mabel M. Swan, "Some Men from Medway," *Antiques* (May 1930), pp. 417–421.

29. Montgomery, *American Furniture*, p. 67, no. 10.

CHAPTER VII

1. Lydia Batchelor was born April 19, 1776, daughter of John Batchelor of Conway, Massachusetts. She married Simon DeWolf on December 1, 1803, lived in the Deerfield area, and died July 22, 1847.

2. Italy is a small town south of Canandaigua, New York.

3. Advertisement of Mrs. Saunders and Miss Beach's Academy, *Columbian Sentinel* (March 23, 1822). Quoted in Betty Ring, "Mrs. Saunders and Miss Beach's Academy," *Antiques* (August 1976), p. 306.

4. In tow, the shives (the woody scales left from breaking the flax) still remain in the fabric, which appears to the eye as a very coarse linen cloth.

5. The presence of burlap as a foundation usually connotes a post-mid-nineteenth-century date because of its component of jute, an East Indian fiber not generally imported to this country until about 1850.

6. This list of dyes and their origins has been abstracted from the book, *The Family Directory, in the Art of Weaving and Dyeing* (Utica, N.Y., 1817).

7. *Edward Sands Frost's Hooked Rug Patterns* (Dearborn, Mich.: Greenfield Village and Henry Ford Museum, 1970). An illustration of this design appears as pattern no. 108, p. 55.

8. Charles M. Hyde, *Historical Celebration of the Town of Brimfield* (Springfield, Mass., 1879).

CHAPTER VIII

1. I am indebted to Richard H. Randall, Jr., for the following interesting reference: James Hardie, *Description of the City of New York* (New York: Samuel Marks, 1827). During a procession in New York City in 1827, "the cabinet Makers exhibit many beautiful miniature specimans of their wares, decorated with flowers, etc., born of members of the Society."

2. The 1793 building of Groton (later Lawrence) Academy is discussed and illustrated in Harriet Webster Marr, "The Four-Square School," *Antiques* (June 1954), pp. 476, 477.

3. For a comparison with an early-eighteenth-century adult chair, see Chapter VI, figure 267.

4. Nina Fletcher Little, *Paintings by New England Provincial Artists, 1775–1800*. Exhibition catalogue (Boston: Museum of Fine Arts, 1976), p. 162.

5. George Francis Dow, *The Arts and Crafts in New England, 1704–1775* (Topsfield, Mass.: The Wayside Press, 1927), p. 94.

6. The penmanship box of writing master Nelson J. Smith of Newport, New Hampshire, still containing its original fittings, is owned by the New Hampshire Historical Society.

7. "From Tunbridge, Vermont, to London, England—The Journal of James Guild," *Proceedings of the Vermont Historical Society*, new ser. vol. 5, no. 3 (1937), pp. 249–314.

8. *Ibid.*, pp. 299, 300.

Selected Bibliography

The following books and periodicals have proved useful because they contain specialized information relative to certain fields of our collecting.

Andrews, Carol Damon. "John Ritto Penniman (1782–1841): An Ingenious New England Artist." *Antiques* (July 1981).

Andrews, Edward Deming, and Andrews, Faith. *Shaker Furniture: The Craftsmanship of an American Communal Sect.* 2d ed. New Haven: Yale University Press, 1937.

Bassett, Preston R. "Collectors' Notes." *Antiques* (May 1959).

Bishop, Robert. *The Borden Limner and His Contemporaries.* Exhibition catalogue. Ann Arbor: The University of Michigan Museum of Art, 1977.

———. *Centuries and Styles of the American Chair 1640–1870.* New York: E.P. Dutton, 1972.

———. "John Blunt: The Man, the Artist, and His Times." *The Clarion* (Spring 1980).

Bowditch, Harold. "Early Water-Color Paintings of New England Coats of Arms." *Publications of The Colonial Society of Massachusetts* 35 (December 1944).

———. *The Gore Roll of Arms.* Albany, N.Y.: Joel Munsell, 1926.

———. "Heraldry and the American Collector." *Antiques* (December 1951).

Brewington, M. V. *Shipcarvers of North America.* Barre, Mass.: Barre Publishing Company, 1962.

Crozier, William Armstrong. *General Armory.* New York: Fox, Duffield, 1944.

Dodge, Robert S. "A Grandmother Clock with Wooden Works." *Antiques* (March 1938).

Dow, George Francis. *The Arts and Crafts in New England, 1704–1775.* Topsfield, Mass.: The Wayside Press, 1927.

Downs, Joseph. *American Furniture: Queen Anne and Chippendale Periods.* New York: The Macmillan Company, 1952.

Edward Sands Frost's Hooked Rug Patterns. Dearborn, Mich.: Greenfield Village and Henry Ford Museum, 1970.

Fairbanks, Jonathan L., and Bates, Elizabeth Bidwell. *American Furniture, 1620 to the Present.* New York: Richard Marek Publishers, 1981.

Fales, Dean A., Jr. *American Painted Furniture, 1660–1880.* New York: E. P. Dutton, 1972.

Family Directory, in the Art of Weaving and Dyeing, The. Utica, N.Y., 1817.

Fraser, Esther Stevens. "Pioneer Furniture from Hampton, New Hampshire." *Antiques* (April 1930).

Fried, Frederick. *Artists in Wood.* New York: Clarkson N. Potter, 1970.

"From Tunbridge, Vermont, to London, England—The Journal of James Guild." *Proceedings of the Vermont Historical Society* new ser., vol. 5, no. 3 (1937).

Gaines, Edith. "Collectors' Notes." *Antiques* (August 1962).

———. "The Robb Collection of American Furniture." *Antiques* (September 1967).

Gentle, Rupert, and Field, Rachel. *English Domestic Brass.* New York: E.P. Dutton, 1975.

Gorley, Jean. *Old Wedgwood.* Wellesley, Mass.: Wellesley Press, 1941.

Greenlaw, Barry A. *New England Furniture at Williamsburg.* Williamsburg, Va.: The Colonial Williamsburg Foundation, 1974.

Groce, George C., and Wallace, David H. *The New-York Historical Society's Dictionary of Artists in America, 1564–1860.* New Haven and London: Yale University Press, 1957.

Hampton, Madeline. "Riley Whiting—Clockmaker." *The Decorator* 17, no. 1 (Fall 1962).

Hardie, James. *Description of the City of New York.* New York: Samuel Marks, 1827.

Holdridge, Barbara, and Holdridge, Lawrence B. "Ammi Phillips, 1788–1865." *The Connecticut Historical Society Bulletin* 30, no. 4 (October 1965).

Hutchinson, B. June. "A Taste for Horticulture." *Arnolda* (The Arnold Arboretum of Harvard University) 40, no. 1 (January/February 1980).

Hyde, Charles M. *Historical Celebration of the Town of Brimfield.* Springfield, Mass., 1879.

John Custis Letter Book, The. The Library of Congress, Washington, D.C.

John, W. D., and Baker, Warren, M.D. *Old English Lustre Pottery.* Newport, England: R.H. Johns, 1951.

Kimball, Fiske. *Mr. Samuel McIntire The Architect of Salem.* Portland, Me.: Southworth-Anthoensen Press, 1940.

Knapp, William D. *Somersworth: An Historical Sketch.* Somersworth, N.H., 1894.

Kugeler, Richard C. *William Allen Wall: An Artist of New Bedford.* Exhibition catalogue. New Bedford, Mass.: Old Dartmouth Historical Society, 1978.

Lea, Ziller Rider, ed. *The Ornamented Tray.* Rutland, Vt.: Charles E. Tuttle, 1971.

Lipman, Jean. *Rediscovery: Jurgan Frederick Huge.* New York: Archives of American Art, 1973.

Little, Nina Fletcher. *American Decorative Wall Painting, 1700–1850.* Sturbridge, Mass.: Old Sturbridge Village, in cooperation with Studio Publications, 1952; new enl. ed., New York: E. P. Dutton, 1972.

———. "The Cartoons of James Akin upon Liverpool Ware." *Old-Time New England* 28, no. 3 (January 1938).

———. *Country Arts in Early American Homes.* New York: E. P. Dutton, 1975.

———. "Dr. Rufus Hathaway, Physician and Painter of Duxbury, Massachusetts, 1770–1822." *Art in America* 41, no. 3 (Summer 1953).

———. "English Engravings as Sources of New England Decoration." *Old-Time New England* ser. 196, vol. 54, no. 4 (April–June 1964).

———. "European Redware and Its Chinese Ancestors." *Antiques* (January 1938).

———. "J. S. Blunt, New England Landscape Painter." *Antiques* (September 1948).

———. *Neat and Tidy: Boxes and Their Contents Used in Early American Households.* New York: E. P. Dutton, 1980.

———. *Paintings by New England Provincial Artists, 1775–1800.* Exhibition catalogue. Boston: Museum of Fine Arts, 1976.

———. "T. Chambers, Man or Myth?" *Antiques* (March 1948).

———. "Winthrop Chandler." *Art in America* 35, no. 2 (April 1947).

Lyman, Grace Adams. "William M. Prior, The 'Painting Garrett' Artist." *Antiques* (November 1934).

Marr, Harriet Webster. "The Four-Square School." *Antiques* (June 1954).

McKee, Linda Mitchell. "Captain Isaac Hull and the Portsmouth Navy Yard." Ph.D. dissertation, St. Louis University, 1968.

Merritt, Howard S. "Thomas Chambers—Artist." *New York History* 37, no. 2 (April 1956).

Miller, Edgar G., Jr. *American Antique Furniture.* Baltimore: The Lord Baltimore Press, 1937.

Montgomery, Charles F. *American Furniture: The Federal Period.* New York: The Viking Press, 1966.

Moore, N. Hudson. *The Old China Book.* New York: Frederick A. Stokes, 1903.

Nutting, Wallace. *Furniture Treasury.* New York: The Macmillan Company, 1948.

Old China Magazine, The. New York: Ceramic Studio Publishing, October 1901–September 1904: vol. 1, no. 1, to vol. 111, no. 12.

Parsons, Charles S. *The Dunlaps and Their Furniture.* Exhibition catalogue. Manchester, N.H.: The Currier Gallery of Art, 1970.

———. "G. G. Brewster, Watch-maker and Dentist." Typescript.

Peabody, Alfred. "On the Early Days and Rapid Growth of California." *Essex Institute Historical Collections,* Part I (January 1874).

Plain & Elegant, Rich & Common: Documented New Hampshire Furniture, 1750–1850. Exhibition catalogue. Concord, N.H.: New Hampshire Historical Society, 1979.

Prime, W. C. [The Youngest Member]. *The China Hunters Club.* New York: Harper & Brothers, 1878.

Ring, Betty. "Mrs. Saunders and Miss Beach's Academy." *Antiques* (August 1976).

———. "Saint Joseph's Academy in Needlework Pictures." *Antiques* (March 1978).

Rix, Guy S., comp. *Genealogy of the Foss Family in America.* Concord, N.H., n.d.

Roth, Rodris. *Tea-Drinking in 18th-Century America: Its Etiquette and Equipage. United States National Museum Bulletin* 225. Washington, D.C., 1961.

St. George, Robert Blair. *The Wrought Covenant: Source Material for the Study of Craftsmen and Community in Southeastern New England, 1620–1700.* Brockton, Mass.: Brockton Art Center, Fuller Memorial, 1979.

Sears, Clara Endicott. *Some American Primitives.* Boston: Houghton Mifflin, 1941.

Snow, Edward Roe. *The Islands of Boston Harbor.* Andover, Mass.: Andover Press, 1935.

Stalker, John, and Parker, George. *A Treatise of Japanning and Varnishing.* 1688. Reprint. London: Alec Tiranti, 1960.

Stanwood, James Rindge. *Direct Ancestry of the Late Jacob Wendell.* Boston: David Clapp & Son, 1882.

Stokes, I. N. Phelps, and Haskell, Daniel C. *American Historical Prints: Early Views of American Cities, . . .* New York: The New York Public Library, 1933.

Swan, Mabel M. "Some Men from Medway." *Antiques* (May 1930).

Tate, Joseph. *Journal 1769–1778.* New Hampshire Historical Society, Concord, New Hampshire.

Vanderpoel, Emily Noyes, comp., and Buel, Elizabeth C. Barney, ed. *Chronicles of a Pioneer School from 1792 to 1833.* Cambridge, Mass.: The University Press, 1903.

Waring, Janet. *Early American Wall Stencils.* 1937. Reprint. New York: William R. Scott, 1942.

Watkins, C. Malcolm. "North Devon Pottery and Its Export to America in the 17th Century." *U.S. National Museum Bulletin* 225. Washington, D.C.: Smithsonian Institution, 1960.

Watkins, Lura Woodside. *Early New England Potters and Their Wares.* Cambridge, Mass.: Harvard University Press, 1950.

———. "Highfields and Its Heritage." *Antiques* (August 1966).

Watkins, Walter Kendall. "John Coles Heraldry Painter." *Old-Time New England* (January 1931).

Wiegers, Claude R., and Fuller, Rosalie Trail. *Andrew M. and O. S. Smith, Sons of Maine . . .* Privately printed, 1979.

Wilmerding, John. *Fitz Hugh Lane 1804–1865: American Marine Painter.* Salem, Mass.: The Essex Institute, 1964.

Index

Page numbers in **boldface** refer to illustrations.

285